Beyond Bollywood

Beyond Bollywood

2000 Years of Dance in the Arts of South Asia, Southeast Asia, and the Himalayan Region

Exhibition Co-Curators
Ainsley M. Cameron and Forrest McGill

Editor
Forrest McGill

Essays
Ainsley M. Cameron, Esha Niyogi De, Padma Kaimal, Forrest McGill, Laura Weinstein

Contributions
Qamar Adamjee, Ainsley M. Cameron, Jeffrey S. Durham, Trudy L. Gaba, Forrest McGill, Natasha Reichle, Nathaniel M. Stein

Asian Art Museum
San Francisco

Asian
Art
Museum

Published by
Asian Art Museum–Chong-Moon Lee Center
for Asian Art and Culture
200 Larkin Street
San Francisco, CA 94102
www.asianart.org

Printed and bound in China
First edition

ISBN 978-0-939117-92-5

Library of Congress Cataloging-in-Publication Data

Names: Cameron, Ainsley M. (Ainsley MacDougall), 1979– curator. | McGill, Forrest, 1947– curator, editor. | De, Esha Niyogi. | Kaimal, Padma Audrey. | Weinstein, Laura (Art museum curator) | Asian Art Museum of San Francisco, organizer, host institution. | Cincinnati Art Museum, host institution.
Title: Beyond Bollywood : 2000 years of dance in the arts of South Asia, Southeast Asia, and the Himalayan region / exhibition co-curators, Ainsely M. Cameron and Forrest McGill ; editor, Forrest McGill ; essays, Ainsely M. Cameron, Esha Niyogi De, Padma Kaimal, Forrest McGill, Laura Weinstein ; contributions, Qamar Adamjee, Ainsely M. Cameron, Jeffrey Durham, Trudy Gaba, Forrest McGill, Natasha Reichle, Nathaniel Stein.
Other titles: Beyond Bollywood (Asian Art Museum of San Francisco)
Description: San Francisco : Asian Art Museum, [2022] | Includes bibliographical references and index.
Identifiers: LCCN 2022011329 | ISBN 9780939117925 (paperback)
Subjects: LCSH: Dance in art—Exhibitions. | Art, Asian—Exhibitions.
Classification: LCC N8217.D3 B49 2022 | DDC 704.9/4979280954—dc23/eng/20220426
LC record available at https://lccn.loc.gov/2022011329

The Asian Art Museum celebrates, preserves, and promotes Asian and Asian American art and cultures for local and global audiences. We provide a dynamic forum for exchanging ideas, inviting collaboration, and fueling imagination to deepen understanding and empathy among people of all backgrounds.

Beyond Bollywood: 2000 Years of Dance in Art is co-organized by the Asian Art Museum of San Francisco and the Cincinnati Art Museum. This exhibition has been made possible in part by a major grant from the National Endowment for the Humanities: Democracy demands wisdom. Catalogue support provided by the Society for Asian Art. Additional support provided by Vaishali Chadha and Family; Aarti and Sandeep Johri; SACHI, the Society for Art & Cultural Heritage of India; and an anonymous donor.

The exhibition in Cincinnati is generously funded by the National Endowment for the Arts.

EXHIBITION DATES
Cincinnati Art Museum
November 11, 2022–February 5, 2023

Asian Art Museum of San Francisco
March 31–July 10, 2023

Produced by the Publications Department, Asian Art Museum, Nadine Little, Head of Publications

Design and Production by Joan Sommers and Amanda Freymann, Glue + Paper Workshop
Edited by Tom Fredrickson
Proofread by Mark Woodworth
Indexed by Siobhan Drummond
Image and permissions procurement by Kathy Borgogno, KLBorgogno Management
Color separations by Professional Graphics Inc., Rockford, IL
Printed and bound in China by Asia Pacific Offset

Cover: Dancing Ganesha, approx. 1500–1700 (cat. 104, detail).
Back cover: The Lords of the Cremation Ground dancing, approx. 1400–1500 (cat. 12, detail).
Inside cover: *The Wedding Procession of Shri Shankar-ji [Shiva]* by Indira Devi, 1977 (cat. 109, detail).
Title spread: Krishna dances with the cowherd women, personifying the musical mode *megh malhar*, approx. 1720 (cat. 23, detail).
Page 6: A Jain spiritual teacher in a heavenly preaching hall surrounded by dancers and musicians, from a manuscript of the Sangrahani Sutra, approx. 1575 (cat. 29, detail).
Page 8: Shiva as slayer of the elephant demon, approx. 1800–1900 (cat. 45, detail).
Page 10: Shiva Nataraja, the Lord of Dance, approx. 1125–1175 (cat. 1, detail).
Pages 18–19: Dancers and musicians entertaining a deity or nobleman, approx. 1075–1125 (cat. 67, detail).
Page 20: Yogini lunging as she shoots a bow and arrow, from a yogini temple, approx. 900 (p. 25, fig. 11).
Page 32: Covering cloth with scene of Krishna dancing with the cowherd women, approx. 1850–1900 (cat. 19, detail).
Page 48: Maharana Ari Singh performs puja in Amar Vilas, 1765, by Shambhu (p. 53, fig. 7, detail).
Page 64: Shiva Nataraja, the Lord of Dance, approx. 1125–1175 (cat. 1, detail).
Page 76: Rekha, Indian Bollywood actress, Bhanurekha Ganesan, India, Asia, 1981.
Pages 90–91: Raja Prithvi Singh of Orchha watching a performance of Krishna's dance with cowherd women, approx. 1750 (cat. 81, detail).
Pages 92–93: The Lords of the Cremation Ground dancing, approx. 1800–1900 (cat. 13, detail).
Pages 116–17: Krishna dances with the cowherd women, approx. 1850–1900 (cat. 16, detail).
Pages 140–41: The dance of Shiva and Kali, approx. 1780 (cat. 47, detail).
Pages 184–85: Maharaja Sher Singh and companions watching a dance performance, approx. 1850 (cat. 91, detail).
Page 228–29: Hanging with celestial beings dancing and playing music, approx. 1650–1675 (cat. 112, detail).
Page 256: Two women dancing, approx. 1770 (cat. 122, detail).
Page 266: The boy Krishna holding a stolen butter ball and dancing, approx. 1600–1700 (cat. 107, detail).

Contents

Foreword

FROM BOLLYWOOD DANCE to bhangra, from the dancing devotions of members of the International Society for Krishna Consciousness (Hare Krishnas) to performances in Balinese tourist hotels, most people these days have seen or participated in the dances of the broad world of South Asia, Southeast Asia, and the Himalayan region. Artistic images such as Shiva as Lord of the Dance and Krishna round dancing with the cowherd women are admired worldwide.

This project, the first of its kind in the United States, shows how generations of sculptors, painters, and other visual artists—and the religious thinkers and patrons who inspired them—have made use of dance imagery for a variety of purposes, from embodying great spiritual ideas to lauding the victory of a hero or a dynasty. Some of these purposes, such as dancing for festive occasions or courtship, will seem familiar. Others will perhaps surprise: dancing to conquer, dancing to transcend, dancing to affect the cosmos. But even for these, we can probably all think of parallels in today's world. For example, the Bay Area has a dozen venues for ecstatic dance for self-realization, and dancing to demonstrate prowess and domination happens in street-dance battles in real life and in artistic performances such as the musical *West Side Story*. As always at the Asian Art Museum, we strive to connect art to life and to make Asian art and culture essential to everyone.

The splendid artworks included here originate from across southern Asia and the Himalayas. One link is that all the areas have adopted and adapted some aspects of the cultures of the Indian subcontinent, from religion and literature to the visual and performing arts. The works have been chosen to enrich, deepen, and complicate visitors' notions of dance and to make clear the importance and power of dance in the cultures—and sometimes even the politics and societal structures—of the region.

In addition to historical works from two millennia, a selection of contemporary works here suggests how visual artists continue to make use of dance imagery today. For example, a video artist fills street scenes with performances by dancers from Singapore's major ethnic groups. One of the messages here is that the rich variety of the dancing can help foster and maintain what the national motto of Indonesia calls *Bhinneka Tunggal Ika*: "Unity in diversity."

From its inception, this project has been multidisciplinary. Our museums' planning has drawn from and been shaped by the work of scholars of previous generations and today across a wide variety of fields: art history, religious studies, political science, history, gender and sexuality studies, language and literature, and performance studies. A major grant from the National Endowment for the Humanities, for which we are extremely grateful, has supported this broad approach.

Many people and institutions came together to make this extraordinary exhibition and its accompanying publication possible. Our sincere thanks go to the many museums and private collectors lending splendid artworks. We appreciate their working so cooperatively with us through all the logistical challenges of the pandemic lockdown. Thanks to the exhibition's co-curators, the Asian Art Museum's Forrest McGill, Wattis Senior Curator of South and Southeast Asian Art, and Ainsley M. Cameron, Curator of South Asian Art, Islamic Art and Antiquities at the Cincinnati Art Museum, for working tirelessly and in seamless choreography to bring the exhibition together and produce this exceptional catalogue. Essayists Ainsley M. Cameron, Esha Niyogi De, Padma Kaimal, Forrest McGill, Laura Weinstein, together with entry contributors Qamar Adamjee, Ainsley M. Cameron, Jeffrey Durham, Trudy Gaba, Forrest McGill, Natasha Reichle, Nathaniel Stein, put it all in context in the most compelling, accessible, and scholarly fashion. Thank you to the National Endowment for the Humanities; Vaishali Chadha and Family; Aarti and Sandeep Johri; SACHI, Society for Art & Cultural Heritage of India; and an anonymous donor for their generous support of this project. Special thanks to SAA, the Society for Asian Art, for its support of this catalogue. I am enormously thankful to the Akiko Yamazaki and Jerry Yang Endowment Fund for Exhibitions for its sustained support.

Jay Xu
The Barbara Bass Bakar Director and CEO
Asian Art Museum

Foreword

BEYOND BOLLYWOOD: 2000 YEARS OF DANCE *in the Arts of South Asia, Southeast Asia, and the Himalayan Region* is a joyful expression of scholarship, cultural intersectionality, and institutional partnership.

The Cincinnati Art Museum's earliest collections include works from across Asia, including the Indian cultural sphere. From the nineteenth-century founding of our museum, Cincinnatians have found both inspiration and aspiration in the art and artists of Asia. The museum's most generous benefactors were committed to building a global collection that could serve as instruction and study for a thriving community of artists and working creatives in Cincinnati and beyond. The exchanges have been bountiful and plentiful over the decades.

Recently, the Alice Bimel Endowment for Asian Art has allowed our museum to expand its scope and holdings as well as its curatorial focus and exhibitions. Momentum continues with the Anu and Shekhar Mitra Gallery of South Asian Art. Opening the same year as this momentous exhibition, the gallery will explore the interrelationship among courts, systems, empires, and religious traditions across South Asia.

It is fitting that at this moment the Cincinnati Art Museum joins with the Asian Art Museum and its collaborative team in San Francisco to bring the transcendent power of dance into the study of visual culture. It is my hope that this project will challenge the notion of boundaries—between art forms, academic schools of thought, temporal divisions, and even modern-day political borders—that define discrete areas of study. Creating connections between past and present, across religion, geographical space, and culture, *Beyond Bollywood* seeks to spark new conversations.

This exhibition and catalogue are the outcomes of a generous collaboration between Ainsley M. Cameron and Forrest McGill at our respective institutions. Their talents and energies brought together two lead museums, five authors, and esteemed contributors—including Cincinnati's Nathaniel M. Stein and Trudy Gaba—alongside a host of public and private lenders to make it possible. Thank you to each and every lender, as well as to the many funders who made this project possible in Cincinnati. The exhibition is generously supported through a grant from the National Endowment for the Arts, as well as through public and private donors. We are honored to work alongside these funding bodies and private individuals, each of whom continues to support the city's vibrant arts organizations.

It is my hope that the exuberance, graceful interdependence, and rigorous discipline of dance is felt through these pages and in the art galleries of Cincinnati and San Francisco.

Cameron Kitchin
Louis and Louise Dieterle Nippert Director
Cincinnati Art Museum

Introduction

FORREST McGILL AND AINSLEY M. CAMERON

When the lord moves his feet
the netherworld moves too,
when he moves his head
the highest heaven follows,
and when he shakes his wrists, bound with bracelets,
the four quarters tremble—
the stage will never bear the burden of his dance.

—early Tamil poet Karaikkalammaiyar[1]

LONG BEFORE BOLLYWOOD, dance played an exceptionally important role in the religious and cultural traditions of India and its neighbors. Dancing for entertainment—for oneself or an audience—was and is as common there as it is elsewhere around the globe. More so, in the Indian cultural sphere, dance can also have great power, not only conveying the profoundest religious, spiritual, and social messages, but also potentially disrupting or invigorating the world. The moments in cosmic time when Stillness begins to move and when Movement slows and stills could be envisioned as the motions and pauses of dance.

Dance is everywhere in South Asia, Southeast Asia, and the Himalayan region, whether it is sacred dance conjuring unseen realms or worldly dance diverting (or edifying) a king. More often than the divine beings of other cultures, some Hindu and Buddhist deities themselves dance. They express their energies through fluid rhythmic movements, setting the pulse of the universe. In benign moods, they dance gracefully in sublime play. In stern moods, they dance with a force that, if fully unleashed, could destroy worlds.

In various Buddhist and Hindu contexts, dance sometimes accompanies or even brings about the conquest of negative forces. Deities are shown dancing on corpses personifying death (and the fear of death), impurity, illusion, and ultimately ego attachment. Advanced adepts might identify themselves with these deities through meditation and rituals of initiation and then—conquering these negative forces themselves—gain control over both spiritual threats and earthly enemies. Devotion to the deities was (and often still is) expressed in dance. In some areas, temples once had corps of young women (*devadasi*, or temple courtesans) whose lives were devoted to ritual service

as dancers and attendants to the gods, some of them eventually becoming renowned performers and temple patrons.

In temple sculpture, the gods are often seen accompanied by dancers and musicians who celebrate the divine presence. In a parallel way, rulers—Buddhist, Hindu, Muslim, and Sikh—are depicted being honored and entertained by dancers, and on some occasions court dancers enacted pious legends for the ruler's benefit. Then, in both villages and cities, traveling actors, dancers, and musicians made (and continue to make) their livings performing at weddings and other celebrations. All of these sorts of dance, sacred and secular, have been represented—or embodied—by artists over many centuries in sculpture and painting as well as in video and new media in recent decades.

Dance continued to be a pervasive art form, one that became a key element in the outside world's image of India, Cambodia, and Indonesia. Even today, Indian "classical" dance, reinvented folk traditions such as bhangra, and, of course, Bollywood dance loom large in global perceptions of India, as do the Cambodian royal ballet and Balinese dance in perceptions of their countries.

Themes and Groupings

This book and the exhibition it accompanies focus on the religious and social functions of dance as represented or suggested in artworks. A basic question that has become a connecting thread between disparate artworks is "What is dance *accomplishing* here?" Less emphasized are the techniques, postures, schools of dance, and the history of performance that can also be interpreted through these works. In both the exhibition and

this publication, the artworks are grouped into five sections according to curatorial responses to the fundamental question of what is being accomplished: destruction and creation, devotion, subjugation, glorification, and celebration.

The first section, "Destruction and Creation," surveys divine dances that bring about cosmic or global transformation. Then, in "Devotion," the mutual longing of god and devotee is explored through dance that creates connections between earthly and divine realms. The third section, "Subjugation," explores the power of dance in the conquest of negative forces. "Glorification" complicates the idea of reverence and features art objects that honor the god and king. The final section, "Celebration," looks at dance and dancers as symbols of exuberance, charm, and joy. This organizing scheme is, of course, a curatorial creation, and the artworks could have been arranged differently by giving primacy to other aspects of their form or by focusing on other traits of the multiple narratives they each embody. We believe, though, that this is a useful way of arranging such multifaceted materials. The significance of this scheme is discussed further in the introductions to the catalogue sections in this book.

It is important to keep in mind that the meanings and implications of dance as performed or depicted were not necessarily fixed and have not been static. A sculpture of mother goddesses dancing or a painting that embodies the movement of exuberant villagers would have been interpreted differently by royal patrons, ordinary worshippers or viewers, and even the artists themselves. Meanings may have changed or accumulated through the centuries. How we understand these artistic forms today is complicated by political, economic, religious, and cultural histories, bringing nuance and insight to our understanding. The significance even of a depiction from our own time, of US President Barack Obama dancing like Shiva, has been the subject of friendly (and sometimes amusing) debate among those who have contributed to this publication, as we worked from our individual points of view toward a consensus.

Three thematic threads—power, gender, and sexuality—intertwine throughout, uniting artworks from different regions, religions, and cultures. For example, in instances across divine and earthly realms, dance embodies elements of power: Shiva dances to destroy and re-create the world, wielding immense power that controls the cosmos. Krishna dances on the head of a vanquished foe, his power displayed through physical force and perseverance. An earthly king emulates the king of the gods Indra by maintaining a troupe of dancers to entertain and exalt him (and to demonstrate that he has the wealth for such a status display), thus exercising and broadcasting his power.

Having a troupe of dancers attached to the palace was a customary attribute of kingship, situated within male-dominated power structures. In South Asia, Southeast Asia, and the Himalayan region, women seldom reigned as monarchs in their own right, leaving gaps in our understanding: Did queens or consorts maintain dance troupes? How and when were dance troupes permitted into female-sanctioned court spaces, and how were those troupes different from dancers already within female spaces? How did power and gender intersect in these courtly settings? Whether the rare female monarch paralleled herself with Indra in her royal symbolism and whether these queens supported court dancers remain uncertain. While many artworks show a king witnessing a dance performance, we have not found one of a female monarch doing so. Individualized portraiture of women, particularly courtly or noble women, is exceedingly rare in our region. Yet this dearth of artistic material may not necessarily be representative of lived experiences. While there are numerous exceptions, including traditions of male performers in the theater arts, the artistic record teems with images of women dancing and men watching. The complicated dynamics of this pointed gaze are imbued with overt hierarchies and imbalances of power, with gender and sexuality wielded as both a hindrance and a weapon.

Moving from the court to the divine realm, we find multiple male deities represented dancing, such as Shiva, Ganesha, and especially Krishna. Each is sometimes watched by goddesses, female celestial figures, or earthly women, encouraging us to consider the dynamics of viewing anew. Asking who does *not* dance—or at least is not shown dancing—is instructive. Among the incarnations of Vishnu, the hero Rama (Krishna's equal, and in some ways opposite) does not dance. Neither does the creator god Brahma.[2] Neither do exalted teachers and prophets such as Muhammad, the Sikh gurus, or the Jain tirthankaras, nor the Buddha, understood either as an earthly preceptor or as a cosmic abstraction. Monarchs and leaders, male or female, rarely dance.[3] There are vanishingly few equivalents of Henry VIII or Elizabeth I participating in social dancing or Louis XIV taking the stage in a ballet.

Why? No doubt there are many reasons, but one may be that dance—associated with the sensuous and erotic, with emotional and artistic expression, and, potentially, with the loss of control—seemed inappropriate in figures tasked with the establishment and maintenance of righteous order in the cosmos or on earth. Shiva and Krishna, as well as the Tantric Buddhist deity Hevajra, on the other hand, are transgressors, disregarding or flouting conventional social norms and offering transcendence through divine ecstasy. In other words, the power imbued in their dances disrupted established orders so as to transcend; such disruption within earthly and often political landscapes might be catastrophic.

Dance can also transcend accepted societal norms, including the ways that gender and sexuality are perceived. Documentation of historical practice and observation of current practice make clear that neither the sex nor the gender of a performer must correspond in a conventional manner with that of a character portrayed. Female-bodied dancers could and do portray Krishna, and male-bodied dancers could portray the cowherd women drawn to him through dance. Furthermore, in Indian "classical" dance today, female dancers may embody a male god and portray him without donning a male costume or taking on other external signs of male identity.

A challenge arises in looking at historic artworks, of course. We see a painting of Krishna dancing with cowherd women. How do we identify the sex or gender of the performers? We look for gender signifiers in dress and sex signifiers in bodily form, but the pitfalls of relying on such preconceived notions are obvious. There are established histories of cross-gender, transgender, and nonbinary communities in many cultures, where all possible permutations of self-representation are present. By applying the strictures of contemporary Euro-American gender identifiers to historic material we are essentializing our visual reading. To what end? And why and when does it matter? Performance, in the sacred and secular realms, often defies such categorization.

Then sometimes a myth or artwork provokes fresh considerations of power, gender, and sexuality. A male demon accumulates power that makes the gods uneasy; Vishnu then assumes the form of a beautiful woman, enraptures the demon, and lures him to his destruction (see cat. 66). The trope of a man being bewitched, bothered, and ultimately disempowered by a beautiful woman is a recuring theme, one that complicates

our understanding of the power relations we've noted here.[4] Are there examples of a woman being obstructed from her goal by a man's seductions? Could a male character be sidetracked or thwarted by the allure of a beautiful man, or a female character by a woman? Further work to queer the archive is needed as we continue to explore the subversive power of dance.[5]

How Has Dance Inspired the Visual Arts— and the Visual Arts, Dance?

Dancers and visual artists have long inspired each other. Most depictions of dance in sculpture and painting were no doubt informed by dance performance witnessed by the sculptors and painters. An early Indian text notes that "without a knowledge of the art of dancing, the rules of painting are very difficult to be understood. . . . The rules of the art of dancing imply (those of) the art of painting."[6] Carrying this thought forward, dancers must have had images of sculptures and paintings in their heads. When Indian "classical" dance was revived and reconstituted in the twentieth century, or when the Cambodian royal ballet sought inspiration for costumes and headdresses, dancers, choreographers, and designers studied ancient temple reliefs for postures, gestures, and attire. These entwined histories play a long and productive part in our understanding of dance in the arts (and the art of dance) today.

These histories and relationships are far from straightforward, however. When we see a twelfth-century sculpture depicting a deity dancing in a particular position and a film clip of a modern dancer in the same position, there seems to be an implication of cultural continuity through nine hundred years. The truth is a more complex one of change and transformation. Many traditional Indian dance forms were suppressed during the British colonial period, and many officials showed disdain toward the sensuous or erotic elements of dance and its supposed links to prostitution and immoral behavior. Some citizens, too, were wary of dance and were concerned to uphold the respectability of Indian culture in the eyes of the world. Only in the 1920s and 1930s did efforts to reenergize and re-create "classical" dance—now as a modern theatrical experience with tickets and programs—gain momentum. Much has been written about the reinvigoration of dance forms as artistic, cultural, nationalistic, and political expressions in this period.[7]

Dancers and choreographers studied ancient dance treatises; sought out, interviewed, and watched dance masters of the previous generation; and examined and photographed sculptures, temple reliefs, and paintings depicting dance. From these sources they substantially created today's classical styles, in which, as Alessandra Lopez y Royo says, "references to dance in temple sculpture were increasingly being made to authenticate the antiquity of specific dance forms and dance styles."[8] Claims of unbroken cultural continuity became enmeshed in nationalist assertions of prestigious antiquity for forms that in fact have never been static but always evolving.

What Is Dance?

What is dance, and how can we recognize dance in still images? How is movement portrayed? And how do we as viewers intuitively "read" dance in static imagery? The most common definitions of dance include "moving one's body rhythmically, usually to music." But mightn't this definition cover activities that we don't always associate with dance, especially if they happen to be accompanied by music (including drumming)? These parallel forms of movement and music include martial arts, yoga, calisthenics, and stylized movement incorporated into religious rituals. Reading dance in static imagery requires a sense of implied motion, perceptual expectations, and contextual knowledge. Once this groundwork is established, however, dance is suddenly all around and all encompassing. Decisions about whether a figure is dancing, how that dance can and should be categorized, and what definition of dance we, the curators, needed to uphold are grounded in critical thought and driven by empathic connection. Seemingly contradictory, this combined approach created opportunities to push boundaries in our thought and in our practice. Pathways to identify dance may include:

Texts and traditions
Sometimes centuries-old texts and traditions tell us that at a certain moment in a story, for a certain reason, a deity or other figure dances—as when Shiva assumes the identity of Nataraja, the Lord of the Dance (cat. 1). Languages of the regions covered here have words that clearly mean "dance" (as opposed to other kinds of movement) and have long had elaborate vocabularies for kinds of dance, dance postures, and so on.

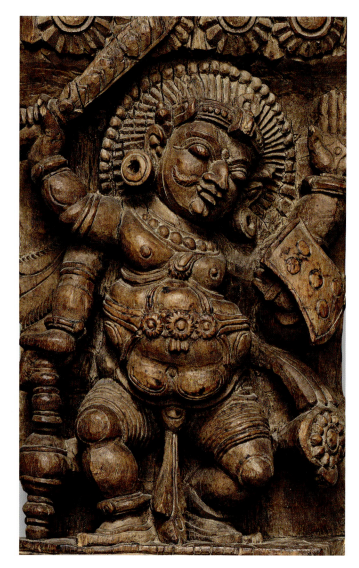

Fig. 1 Dwarfish figure (gana) dancing, approx. 1700–1900 (cat. 105).

Identities

Sometimes the characteristics of a figure indicate, according to the culture's lore, the identity or nature of the figure and associate that sort of figure with dance. For example, the four arms of a sculpted figure tell us that it is no everyday person, and its stubby body and wild hair suggest it is a *gana*, one of the dwarfish, unpredictable beings that attend the Hindu deity Shiva (fig. 1). Shiva sometimes dances; his child, the elephant-headed Ganesha, "Master of the Ganas," sometimes dances; and so ganas sometimes dance as well. But they are also known for other vigorous activities. Here, our best guess is that the gana is performing a mock-fighting dance, but he could be engaged in martial arts instead.

Contexts

Isolated from their context, the female figures in an eighteenth-century painting could be standing still (fig. 2). But their context is a depiction of an Indian ruler with attendants (fig. 3). Near the female figures are musicians, so the likelihood is that the young women are indeed dancers. Is their dance in progress? The drummer and cymbals player are actively making music, but the two players of lute-like instruments are not—at least at this moment.

Postures

Some postures are, in the cultures under discussion, explicitly associated with dancing (even though today's dancers may not use these postures often). For example, many figures in this catalogue stand on one bent leg, drawing the foot of the other leg up toward the crotch. This dance posture is sometimes called *ardhaparyanka*, "half-sitting" (figs. 4–6).

History of the Project

The notion of an exhibition on dance in the arts of the wider Indian cultural world originated with Laura Weinstein of the Museum of Fine Arts, Boston. She told Forrest McGill of her idea in 2017, and from their conversations grew a collaboration on an exhibition and publication. An earlier exhibition—*Dancing to the Flute: Music and Dance in Indian Art*—accompanied by a catalogue edited by Pratapaditya Pal—had been produced by the Art Gallery of New South Wales in 1997 and had pioneered the consideration of performance (of both music and dance) as

Fig. 2 Raja Tedhi Singh of Kulu entertained by dancers and musicians, approx. 1750 (cat. 87, detail).

Fig. 3 Raja Tedhi Singh of Kulu entertained by dancers and musicians, approx. 1750 (cat. 87).

Fig. 4 Pillar fragment with celestial dancers, approx. 1180–1220 (cat. 74).

Fig. 5 A nobleman dancing, approx. 1685–1690 (cat. 116, detail).

depicted in artworks. Now, though, twenty years on, it seemed timely to take up the subject again, with new emphases and the benefit of two additional decades of scholarship in fields such as history, religious studies, Sanskrit and Tamil literature, performance analysis, and gender and sexuality studies to draw upon. The new exhibition would narrow the focus in one sense by not including musical instruments, costume, or the artistic portrayal of musical performance without dance; it would also broaden the focus by drawing on artworks from Nepal, Tibet, Sri Lanka, Myanmar, Thailand, Cambodia, and Indonesia and by select contemporary artists who work with performance and dance in various mediums.

In February 2019 the Asian Art Museum hosted a workshop where eight scholars from diverse fields, including dance theory, religious studies, history, and art history, met with professionals from the museum, including curators, and specialists in museum education, interpretation, programming, and community relations. The diverse fields and specializations of the participants led to a fruitful discussion of potential exhibition

Fig. 6 The Buddhist deity Vajravarahi, approx. 1300–1400 (cat. 10).

topics and themes. Key themes discussed that eventually formed the backbone of the exhibition included the uses of dance and related art to bolster royal power and transmit royal messages and the dynamics of gender and sexuality in dance traditions and artworks.

Subsequent circumstances required the Museum of Fine Arts, Boston, to withdraw from the project. Weinstein encouraged the exhibition to move forward and agreed to continue to advise and to write an essay for the catalogue. Good fortune led to Ainsley M. Cameron's assuming the co-curatorship, and her institution, the Cincinnati Art Museum, becoming the co-organizer. Cameron's research had already led her to delve into the importance of dance in the arts of India, and she was well positioned to continue these lines of inquiry. The COVID-19

pandemic disrupted exhibition schedules and loan negotiations, but research and planning between the two institutions continued to evolve.

Scholars have studied dance in the arts of South Asia, Southeast Asia, and the Himalayas extensively for a century and more. We hope that in future years this publication will have added sturdy steps to the stairway to greater understanding, and that in the present it will enrich the appreciation of all who know the appeal—but perhaps not the deep, multitudinous meanings—of dance in the region.

1. Cutler, *Songs of Experience*, 120.

2. A performer portraying Rama may, of course, dance on stage. What is meant here is that Rama does not dance within the narratives of epics and tales. A performer in the guise of Brahma is seen in cat. 82. Exceptionally, Brahma himself is shown dancing in a twelfth-century lintel from Warangal, Telangana state, in the National Museum, New Delhi. He and Vishnu, also dancing, flank a dancing Shiva. The work can be seen by searching the web for "lintel Warangal."

3. Indra, a model of divine kingship, is seldom if ever depicted dancing, but Pratapaditya Pal notes that in the ancient religious text the Rig Veda, Indra is said to dance: Pal, "May the Immeasurable Wealth of Your Dance," 31–32. Mentions of Indra's dancing may be found, for example, in the Rig Veda, Book 5, Hymn XXXIII, and Book 8, Hymn LXXXI.

4. The seduction doesn't always work: the daughters of the demon Mara failed to divert the Buddha (see cats. 63–64).

5. See, among others, Gopinath, *Impossible Desires*, notably the chapter "Bollywood/Hollywood: Queer Cinematic Representation and the Perils of Translation."

6. Kramrisch, *Vishṇudharmottaram, Part III*, chapter 2, verses 4–5; Pal, "May the Immeasurable Wealth of Your Dance," 37.

7. See Warren, "Yearning for the Spiritual Ideal," 107, among others, for an introduction.

8. Lopez y Royo, "Issues in Dance Reconstruction," 66.

ESSAYS

PADMA KAIMAL

Why Do Yoginis Dance?

CHARMING AND HORRIFIC sculptures of yogini goddesses dance together in great numbers around the circular courtyards of their open-roofed temples in India. Forbidding on the outside, those temples are lively and receptive within (figs. 1–2). Light from the stars, moon, and planets or the sun pours down from the sky above. Dozens of goddesses—too many to see at a glance—surround and stare upon anyone who interrupts the web of intersecting gazes they exchange across the courtyard. Guests have walked into the middle of a lively conversation. The air is still crackling. Energy flows around as well as across the ring of goddesses as the subtle variations in their forms flash by like different phases of the same dance melting together like frames in a movie. The varied figures unite to create an illusion of constant, surging motion. Together they embody the South Asian idea of shakti: energy with a female identity, the force that motivates all action in the cosmos.

Who Are Yoginis?

Yoginis are powerful mistresses of yoga and magic who straddle the binaries of human and divine, nurture and destruction, beauty and terror. Esoteric texts on tantric ritual called Tantras from the sixth to seventh centuries describe yoginis as fierce, unpredictable, and powerful. They were thought to fly in large hordes—often of sixty-four—through the night sky, alighting on cremation grounds and other abandoned places to consort with men in deliberately transgressive rituals such as drinking alcohol, engaging in sex with the living and the dead, consuming or animating corpses, and devouring the living as well. To men who survived these encounters, yoginis could grant tremendous magical powers. These yoginis were understood to have divine powers, but the category also included human women who participated in such rituals. The concept of the yogini defines a place of intersection between human and divine females.[1]

The idea of yogini goddesses grows out of much older South Asian beliefs in goddesses that represent both danger and nurture, diseases and their cures, and particularly the risks of childbirth and infant mortality.[2] Mother goddesses (*matrichakra*) are mentioned in the Rig Veda hymns from the second millennium BCE, and they emerge as more fully developed characters in the Mahabharata epic and sculptures from the Kushan kingdom, sources from roughly 200 BCE to 200 CE.[3] Matrikas in sculptures from the Kushan period onward were ganged into groups of seven, eight, or nine and sometimes held children but could also be fierce, capricious, and part animal (cats. 52–53). Their iconography pegs each to a different male deity, suggesting that they are spouses or that they somehow animate or translate that god into a female sphere. Varahi has the boar's head of Varaha, the boar form the god Vishnu assumes to burrow down and save the world (cat. 53, far left figure on right fragment). Beside her, Indrani waves a curved elephant goad, an allusion to the regal mount of Indra, the king of the heavens. As umbrellas can signify royalty in South Asia and are held over the heads of kings in procession and enthroned, perhaps Indrani holds an extra umbrella, besides the one that hovers over her head, to reference Indra's regal status. Vaishnavi wields Vishnu's mace and discus-like weapon (*chakra;* cat. 54). Chamunda, waving a sword and adorned with a garland of skulls, embodies Shiva's manifestation as the lord of the cremation grounds, so hungry for corpses that she is emaciated (cat. 53, far right of the right fragment).

The six or seven maiden sisters of the Pleiades constellation, called *krittika* in Sanskrit sources, were another early version of these goddess gangs in South Asian cosmology. From the Mahabharata through much of the first millennium CE, stories connect the krittika to Skanda, a handsome, youthful god of war. They first attack and then suckle him when they find him as a newborn on a mountain top, defenseless and adorable.[4] The exact number of goddesses in each of these gangs

Matrika

The matrikas are mother goddesses associated with "the Goddess" (Devi), the powerful female deity who is, in some Hindu traditions, the supreme being. The matrikas are often found in groups of seven or eight and, though they have individual names and characteristics, are seldom worshipped separately. Many of these mother goddesses parallel male deities and are thought to personify their energy, occasionally expressed in dance. For example, Vaishnavi (cat. 54) reflects the male deity Vishnu and shares his attributes. One matrika, however—the grim, skeletal Chamunda (cats. 55, 56)—has no male counterpart, though she is sometimes associated with fierce forms of Shiva such as Bhairava.

varies from text to text and sculpture to sculpture, but more noteworthy is that these groups act collectively, as a unified group.[5] Their power seems to lie in their multiplicity and their variegated forms. They are distinct members of a powerfully unified collective. What also remains constant and significant among matrikas, krittika, and yoginis is their equally deadly and salvific nature. They could embody a deeply practical kind of knowledge for life in this world: an understanding of the interdependence between what may seem opposites—that poison can be medicine, that death can foster life, that life produces death. They could equally embody the capricious cruelty of a world where babies die.

Yogini Temples

Temples honoring yoginis as goddesses and representing them as stone sculptures started being built across South Asia in the ninth or tenth century CE, at least two centuries later than the texts describing wild and repulsive rituals enacted by tantric practitioners among corpses at burning grounds.[6] Translating living bodies into multiarmed stone sculptures (figs. 3–7, 9–17, 19, 21–22) and the circle of yoginis into a permanent building marked a taming of sorts in the worship of yoginis. What had been secret rites conducted by individuals in no-man's-land moved into towns or temple clusters where worship became more public as well as fixed in space. Ritual that had focused on initiation and accessing magical power gave way to more abstract devotional practices directed to embodied deities. Offerings could still include meat and alcohol, but late-night vigils may no longer have sought to consort with the dead. Professional priests became involved. So did local rulers, seeking the yoginis' aid in battle.[7]

Yogini temples did carry strong traces, though, of the yogini worship the older texts describe. Stone made the ephemeral and esoteric permanent and public, commemorating but probably also displacing older practices. Sculptures of yoginis

Fig. 1 Exterior of the Temple to Sixty-four Yoginis (Chausath Yogini Temple), approx. 800–1000. India; Odisha state, between the villages of Ranipur and Jharial.

Fig. 2 Interior of the Temple to Sixty-four Yoginis, approx. 800–1000. India; Odisha state, Ranipur-Jharial.

Fig. 5 Yogini seated above a winged figure, with devotees seated below, from a yogini temple, 1000–1300. India; Madhya Pradesh state, Naresar. *Gwalior State Museum.*

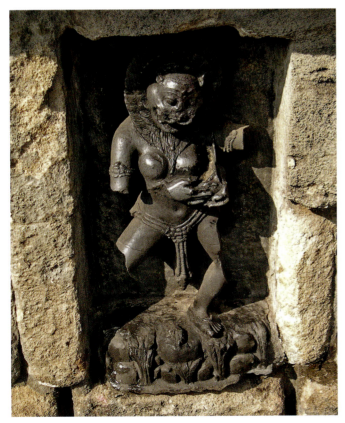

Fig. 3 Yogini holding a round shield and a club, from a destroyed yogini temple, 800–1000. India; northern Tamil Nadu state. *Detroit Institute of Arts,* 57.88.

Fig. 4 Lion-headed yogini dancing among rocks and plants, from a yogini temple, approx. 900. India; Odisha state, Hirapur.

rendered in stone some of those fierce rites by putting in the goddesses' hands cups made from human skulls for drinking alcohol or blood and by showing corpses, some headless, lying prostrate at yoginis' feet (fig. 3). Some sculptures captured the idea that yoginis had animallike powers by portraying the goddesses with animal body parts (fig. 4). Others expressed the yoginis' capacity for flight by perching them on birds (fig. 5).[8] So, too, the yogini temples were in most cases circular in plan, easy to read as permanent versions of the circle the mother deities gathered in, according to the early manuals on yogini worship (fig. 1).

Those manuals describe yoginis as portions (*amsha*) of or emanations from the matrikas, organizing yoginis into "clans" around each of the matrikas. Most yogini temples capture this idea by including matrika sculptures among the goddess sculptures.[9] A figure surviving from the yogini temple once at Hingalajgarh has the triple head and matted locks of hair identifying her as the matrika Maheshvari, a female counterpart to Shiva's three-headed manifestation as Maheshvara (fig. 22). Temples may also express the idea of emanation through mathematical metaphor, housing yoginis in quantities of forty-two, sixty-four, or eighty-one—sums that are multiples of seven, eight, or nine, the numbers assigned to the mother goddesses. Multiplication offered a device to make visual the concept of the female divine emanating outward through the cosmos in an infinite variety of material forms.

Dance and Yoginis

Dance, too, may have captured older ideas about yoginis. A text from the seventh century lists dance as one of the characteristics (*lakshana*) by which tantric practitioners might recognize the yoginis who could help them attain magical powers.[10] "Flirting with humor and amorous dance" is one of the erotically appealing qualities that marked human women as ideal consorts for sexual rituals with these practitioners.[11] Sculptures of the yoginis' progenitors, the mother goddesses, show them dancing in ninth-century temples of central India (fig. 18; cats. 52, 54–56).[12] Dance was also performed by people who were not yoginis themselves but participated in the worship of yoginis. For example, a festival of song and dance in Varanasi around 1000 CE celebrated male practitioners who venerated yoginis in a circular temple and thereby achieved union with the god Shiva.[13] Compare the image that scene evokes with the relief frieze in which figures offer music and dance as worship to Shiva and his wife Parvati (cat. 71).

Dancing yoginis seem to be more numerous in early yogini temples than in later ones. They fill nearly every alcove around the circular courtyard of a ninth- or tenth-century CE temple in Western Odisha between the villages of Ranipur and Jharial (figs. 6–7).[14] Their legs bend so deeply, their knees turn so far outward, that they almost look like they are sitting down—a particularly energetic and athletic way to dance. The four-faced Shiva at the center of their circle dances, too, and in the same posture (fig. 8). He and the yoginis pose calmly despite the difficulty of their dance. At least twelve of the sixty-one yoginis in the temple at Hirapur in Eastern Odisha, built around 900, also dance, though in more fluid poses.[15] Their legs are less deeply flexed (figs. 4, 9), and some shift their torsos to one side (figs. 10–11). Some of their postures could suggest fighting as well as dancing (figs. 11–12). On the battlefields of humans and gods in South Asian sources, dance was a way to perform conquest (see cat. 46, in which Shiva dances as he destroys an elephant demon). Some of the Hirapur yogini sculptures may be dancing to express conquest as they swing an animal skin overhead (fig. 10), but others dance in a rocky landscape (fig. 4), on a lotus (fig. 13), or on the backs of animals that support them as vehicles or familiars (figs. 9–12). Their asymmetries and sweet smiles add a lilting quality to the dance their postures imply.

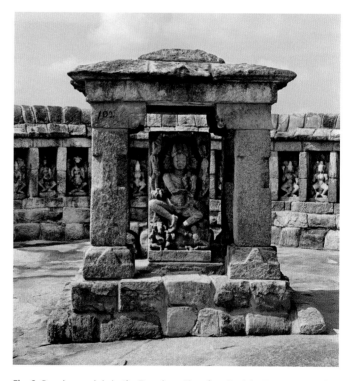

Fig. 6 Dancing yoginis in the Temple to Sixty-four Yoginis, 800–1000. India; Odisha state, Ranipur-Jharial.

Fig. 7 Two dancing yoginis in the Temple to Sixty-four Yoginis, 800–1000. India; Odisha state, Ranipur-Jharial.

Fig. 8 Four-headed Shiva dancing in the Temple to Sixty-four Yoginis, 800–1000. India; Odisha state, Ranipur-Jharial.

9

11

10

12

13

Fig. 9 Yogini dancing on two wheels and playing a drum, from a yogini temple, approx. 900. India; Odisha state, Hirapur.

Fig. 10 Yogini swinging an elephant skin overhead as she dances, from a yogini temple, approx. 900. India; Odisha state, Hirapur.

Fig. 11 Yogini lunging as she shoots a bow and arrow, from a yogini temple, approx. 900. India; Odisha state, Hirapur.

Fig. 12 Animal-headed yogini lunging, from a yogini temple, approx. 900. India; Odisha state, Hirapur.

Fig. 13 Yogini dancing on seven balls resting on a double lotus, from a yogini temple, approx. 900. India; Odisha state, Hirapur.

Yoginis in later temples move even less. In the late tenth-century yogini temple at Bheraghat, for example, which was reworked as late as the twelfth century,[16] most of the goddesses sit stationary like royalty or spiritual teachers (figs. 14–17). Like the yoginis at Ranipur-Jharial (figs. 6–7), they pull their knees wide apart and bend them deeply, but at Bheraghat a high-backed throne has been slipped under this posture, transforming athletic dance into a seated posture with both deeply bent legs resting on the chair or with one leg pendant. In a culture where most sitting is done with folded legs, a pendant leg strongly signals an exalted, majestic seat. Hieratic scale sets these goddesses apart from the much smaller figures at their feet, sitting or prostrating themselves in worship. The yoginis' spines are erect and symmetrical, erasing any hint of movement. Five goddesses at this temple do stand to dance (fig. 18 shows one of these), but those sculptures were carved for another temple several centuries before the seated figures and were later appropriated or revived for this site.[17] Their iconography marks them as mother goddesses, those older variants on the theme of goddess gangs. This figure has her matted locks of hair tied up on her head, a sign that she could represent Maheshvari.

The yogini sculptures dispersed from a ninth- or tenth-century temple in northern Tamil Nadu may offer a midpoint in this chronological shift from dancing to static, enthroned yoginis. They are seated, but they seem to sway softly (figs. 3, 19). If they are restored to the company of a Shiva figure that likely once shared their temple (fig. 20), they can be read as swaying to music he is playing. He holds the traces of a stringed instrument called a vina across his torso and rattles a drum in his raised left hand. His song could have had the yoginis dancing in their seats, each tilting her spine at a slightly different angle, each holding her lightly crossed legs in her own version of their shared, cross-legged posture. Their dance is nearly invisible, though, now that they sit separately in museums across North America, India, and Western Europe.[18]

These changes manifesting in material culture were of a piece with broader shifts in the worship of yoginis. What was in the early centuries of the Common Era a system of popular beliefs anchored in concrete, nature-based symbolism gradually became more abstract and philosophical by the second millennium. Tantric ritual was increasingly directed toward meditation that visualized practices people had previously enacted.

Fig. 14 Yogini hooded by five cobra heads with a bearded male reclining below her lotus throne, in a yogini temple, approx. 950–1000. India; Madhya Pradesh state, Bheraghat.

Fig. 15 Enthroned yogini, eyes bulging and loose hair radiating around her head, in a yogini temple, approx. 950–1000. India; Madhya Pradesh state, Bheraghat.

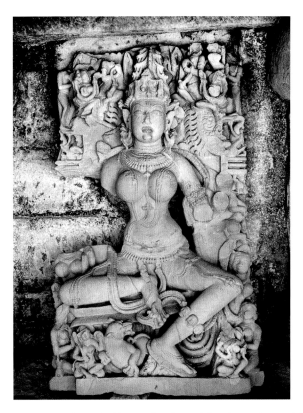

Fig. 16 Enthroned yogini with devotees and an elephant seated at her feet, in a yogini temple, approx. 950–1000. India; Madhya Pradesh state, Bheraghat.

Fig. 17 Seated yogini with a gryphon beneath her throne, in a yogini temple, approx. 950–1000. India; Madhya Pradesh state, Bheraghat.

Nature-based symbolism lingered most clearly in the earliest yogini temple sculptures, such as those at Ranipur-Jharial and Hirapur from the ninth century, whereas the later temple at Bheraghat reflects the more meditative turn.[19] So do the later yogini sculptures from temples at Shahdol and Hingalajgarh (figs. 21–22).[20] Instead of dancing or fighting, these very regal yoginis sit on tall-backed thrones encircled by attendants kneeling in devotion near their feet. The goddesses sit ready to receive their loving gazes and to serve as focal points for meditation for these sculpted figures and for any living devotees who come before them.

Yoginis and Time

Early beliefs linked yoginis with childbirth, infant mortality, diseases, and cures. They also identified yoginis with astral bodies used to map, measure, and embody Time itself. They drew on these natural phenomena of the world around them, in other words, to make sense of lived experience. These identifications of yoginis and astral bodies are evident in literature and architecture. Among the early goddess gangs that yoginis perpetuated were the above-mentioned krittika sisters, a constellation of stars used for reckoning time since the Vedic period as well as in contemporary Tamil ritual.[21] Early sources call goddess gangs *grahī*, which means "seizers"—as in those who steal children—and also "planets." Sculptural reliefs of

the mother goddesses and those of the nine planets are paired together across the courtyard of the Kailasanatha temple in Kanchipuram and in the elaborate sculptural programs surrounding temple doorways in central India.[22]

Yogini temples made these associations between yoginis, astral bodies, and time yet more vivid. The Agni Purana, which predates the ninth century, describes the circle of mother goddesses (*matrichakra*) in terms that make it sound much like a yogini temple.[23] It holds Shiva in his manifestation as the sun (Martanda Bhairava) at its center, like a sundial, his twelve arms as the twelve months, his five faces as the cardinal directions and up.[24] The yoginis circumambulate around him as the seasons, stars, moments, or cycle of the year. As the sun, he impregnates the yoginis, the Earth, the "mothers of space" (*akashamatarah*). In spatial terms, the circle is an emblem of the Earth; in temporal terms, it is the solar year.

The temples at Hirapur and Ranipur-Jharial may have served, in this system of representation, as calendars so detailed as to resolve the solar and lunar years over the course of a sixty-five-month sequence.[25] The architectural form of yogini temples enhances these associations further by encouraging people to look back and forth between the stone bodies in the temple and the astral bodies in the sky above. These buildings are ideal for star gazing and act as giant frames around the upward view. The heaviness of the surrounding masonry can equally draw attention and direct it upward to the

striking openness overhead, that source of light and air and sound filtering down. Perhaps to intensify their connections to the sky, some of these temples are built in elevated spots. The yogini temple in Khajuraho sits on a raised ridge; Bheraghat's is on a mountain pass; the Ranipur-Jharial temple sits atop a rocky hill.[26] They invite viewers to track celestial bodies across the sky while they worship sculptural embodiments of those stars and planets on the ground around them.

Comprehending and controlling time were crucial to the tantric practices used to worship yoginis. Temples that addressed the subject of time and made it tangible through astronomy could have been hospitable to practices aimed at controlling time and death. Some practitioners regarded time as the ultimate reality, the source at the origin of the cosmos. Understanding time gave one insight into those origins and thus to the meaning of the entire cosmos.[27] Understanding time could also enable practitioners to transcend it, which could mean deathlessness or an escape from rebirth in this world of form. Time and Death are synonymous in Sanskrit—both are expressed by the word *kāla*—and tantric ritual aimed to eradicate both. The Devi Mahatmya hymns (approx. 500–600), which praise the supreme form of the Goddess as Devi or Durga, emphasize that she stands outside of time.[28] Devi was understood as the source of all other goddesses, including the yoginis, and she became increasingly important in tantric practice over the centuries.

Dance and Time

I propose that temple designers used dancing yoginis, and the music their dance implies, to make the idea of time material. Dance and music are profoundly time-based art forms. They unfold over time, but they also count time, mark it, build upon it through repeated cycles, play mathematical games with it, illustrate it through melody and the bodies of dancers, and embed it in the bodies of an audience. A dance based on a rhythmic structure of sevens, for example, may divide each measure into three plus four (spoken: "takita takadimi"), multiply each measure four times, tack on a short measure of four more beats, and articulate all that with the feet while the hands gesture along four measures of eight. Sevens run against eights and resolve together after four measures of eight, much as the Hirapur yogini temple could resolve the solar and lunar

Fig. 18 Dancing matrika (mother goddess), in a yogini temple, 600–700. India; Madhya Pradesh state, Bheraghat.

Fig. 19 Yogini goddess holding tongs and a hammer, from a destroyed yogini temple, 800–1000. India; northern Tamil Nadu state. *Royal Ontario Museum*, 956.181.

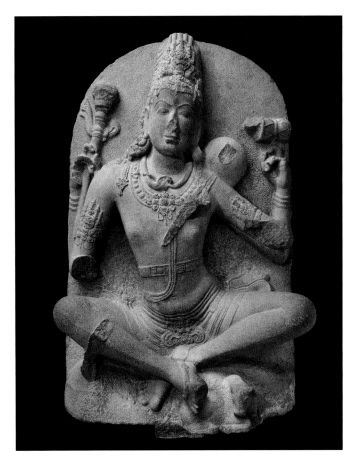

Fig. 20 Shiva playing a stringed vina across his chest, a drum in one hand and a skull on a staff (*khatvanga*) in the other, from a destroyed yogini temple, 800–1000. India; northern Tamil Nadu state. *Museum of Fine Arts, Boston, Marie Antoinette Evans Fund*, 33.18.

Fig. 21 Enthroned yogini from a yogini temple, 900–1000. India; Madhya Pradesh state, Shahdol.

Fig. 22 Three-headed yogini with a male figure reclining below her throne, from a yogini temple, 900–1000. India; Madhya Pradesh state, Hingalajgarh.

calendars in sixty-five lunar months. In other words, math has the metaphoric potential to express time, as it does to express the emanation of sixty-four yoginis from eight mother goddesses. Time builds the structure that supports the dance and the song. Dance unfolds its time-based structure across the space of the dance floor, linking time to space as yogini temples could do. Both could visualize time mapped across space. Representing figures engaging in dance and music could make time visible, audible, and spatial.

Representations of music could make time audible, too. Sculptures of dancing yoginis imply the music that would have accompanied their dance, but these temples also contain sculptures of figures playing musical instruments (figs. 9, 20). Their architecture, moreover, had excellent acoustic properties. The enclosing walls would have bounced and amplified the sounds of music and dance performed inside their courtyards. If meditative and devotional practices succeeded dance in later yogini worship, these sonorous enclosures would have made excellent spaces for chanting. Sound was closely associated with the matrikas, those forebears of yoginis and the sources from which yoginis were understood to emanate. The Tantra and Purana texts that describe yogini worship identify the matrikas as sounds and sound as signifying the beginning of creation.[29]

Sound and time were thus closely associated in tantric thought with that original moment.

These connections among yoginis, dance, music, and time were embedded within South Asia—and specifically within the tantric worship of yogini goddesses associated with Shiva. Brahmanical deities such as Shiva shared many associations with Buddhist deities from at least the fifth century, so it is possible that the dancing yoginis of Buddhist contexts carried similar symbolic connotations of time in Cambodia and the Himalayas. Dancing yoginis that surround dancing forms of the deity Hevajra in geometrically regular shapes, such as a sculpted lotus or painted mandala (cats. 32–37), could well convey the idea of emanation and multiplication that yoginis express in yogini temples. Their dance, too, may carry connotations of counting, and thus of time.[30] The mandalas they occupy are space-time maps of the cosmos, as are yogini temples.

In South Asia, at least, sculpted figures that dance, beat drums, or play stringed instruments likely echoed practices that were enacted inside the courtyards of yogini temples. Those figures may have substituted for such performances, representing the idea of music and dance when human performers were absent. Embodied or virtual, these ceremonies are likely to have enacted the principle of time as they reverberated off the courtyard walls and rose up toward the skies. Dancing yoginis, like yogini temple architecture, could signal to tantric initiates the marking and counting of time as well as the rhythm of the cosmos that their open-roofed temples invited people to track through the movements of the sun, moon, planets, and stars.

1. On descriptions of yoginis in early Indic sources, see Dehejia, *Yoginī, Cult and Temples*, 11–36; Hatley, "*Brahmayāmalatantra*"; Hatley, "What Is a Yoginī?"; Karambelkar, "Matsyendranātha and his Yoginī Cult"; Masteller, "Temple Construction, Iconography, and Royal Identity"; White, *Kiss of the Yoginī*; and Kaimal, *Scattered Goddesses*, chap. 2.

2. On krittika, matrikas, yoginis, and various other seizer/feeder groups of goddesses being fundamentally the same kind of goddess, see Mallmann, *Enseignements iconographiques de l'Agni-Purana*, 171; Hatley, "*Brahmayāmalatantra*," 31–47; White, *Kiss of the Yoginī*. The connection to matrikas remained strong in later conceptions of yoginis, with texts describing yoginis as organized in groups of eight around each of the eight matrikas. Mallmann, *Enseignements iconographiques de l'Agni-Purana*, 170. On these as goddesses of childbirth and disease, see Clothey, "Skanda-Ṣaṣṭī," 242; and L'Hernault, *L'iconographie de Subrahmanya*, 14.

3. Meister, "Regional Variations in Mātṛka Conventions," 238.

4. Clothey, "Skanda-Ṣaṣṭī," 241; Mallmann, *Enseignements iconographiques de l'Agni-Purana*, 169–76; Hatley, "*Brahmayāmalatantra*," 31–47; L'Hernault, *L'iconographie de Subrahmanya*, 10–21; Meister, "Regional Variations," 238; White, *Kiss of the Yoginī*, 35–63. The sources connecting krittika to Skanda include Puranic and Tantric texts, sculpture from the Kushan and Gupta periods, inscriptions from the Gupta period, the Agni Purana from before the ninth century, and the *Brahmayāmalatantra*, which is a later copy of a pre-ninth-century document: Hatley, "*Brahmayāmalatantra*," 8.

5. White finds that the exact number of such fierce "seizer" goddesses fluctuates quite a bit and can also total nine. He argues that matrikas were only formalized into groups of seven rather late in the history of worshipping them. White, *Kiss of the Yoginī*.

6. Hatley, "Goddesses in Text and Stone," 209. Dehejia postulated on the basis of sculpture fragments that people began building temples to yoginis long before that. Her research indicates that yogini temples once existed all over the subcontinent. Dehejia, *Yoginī, Cult and Temples*, 68–70, 77.

7. For a close study of these transitions, see Hatley, "Goddesses in Text and Stone."

8. For more on the yogini sculptures from Naresar, see Dehejia, *Yoginī, Cult and Temples*, 145–53.

9. Dehejia finds that the two extant yogini temples in Orissa are the only ones that do not include matrika images. Dehejia, *Yoginī, Cult and Temples*, 91.

10. Hatley, "Sisters and Consorts," 23–24, citing verses 74.61–65 of the *Brahmayāmalatantra*.

11. Hatley, "Sisters and Consorts," 15–16, citing verses 40.2–8b of the *Brahmayāmalatantra*. Stietencron, "Cosmographic Buildings of India," 72–74, cites folklore about yoginis dancing before reviving a corpse to have sex with him. Dance was of a piece with their enchanting and seducing men in tantric ritual.

12. Meister, "Regional Variations," 242 and fig. 10. His example is at Pathari in Madhya Pradesh. Meister notes that this was a change from the matrika sculptures of the Kushan period, which have the matrikas seated with legs pendant, a posture that indicates enthronement.

13. Peter Bisschop finds this in a twelfth-century *mahatmya* (a composition celebrating the greatness of something), which describes a circular, hypaethral temple used by about 1000 CE for worshipping yoginis in Varanasi. Bisschop, "Abode of the Pañcamudrās," 51. In support of his argument that people danced in association with yogini worship in Cambodia, Sharrock cites a Chinese report that women danced in temples in Cambodia and notes the possible presence of dance halls in later phases of royal Cambodian architecture. Sharrock, "Yoginīs of the Bayon," 119–25.

14. Beglar, *Report of Tours in the South-eastern Provinces*, 132, assigns the Ranipur-Jharial temple to no later than the ninth century. Das, *Temples of Ranipur-Jharial*, 47, dates it to about 900.

15. Mahapatra assigns the Hirapur temple to the eighth or early ninth century. Mahapatra, "Note on the Hypaethral Temple," 98–100, dates it to about 900.

16. On the initial construction of the stone circle at Bheraghat being done in the second half of the tenth century, see Banerji, *Haihayas of Tripuri*, 78; Cunningham, *Report on a Tour in the Central Provinces*, 71–72; Krishna Deva, "Kalacuris of Tripurī," 48; Sharma, *Temple of Chaunsatha-Yogini*, 39. Dehejia pushes it to the late tenth or early eleventh century. Dehejia, *Yoginī, Cult and Temples*, 48.

17. Mitra attributes the matrika sculptures to the seventh century. Mitra, "Dancing Mātṛkās of Bheraghat."

18. On their current homes as well as what home they might once have shared, see Kaimal, *Scattered Goddesses*.

19. Mallmann observed these shifts in tantric emphasis, the purpose of temples, and sculptural form. Mallmann, *Enseignements iconographiques de l'Agni-Purana*, 8–10, 181. On these transformations of yoginis worship, see also Desai, *Religious Imagery of Khajuraho*, 91–98; and Hatley, "*Brahmayāmalatantra*," 128.

20. For more on the remnants of yogini temple sculpture from Shahdol and Hingalajgarh, see Dehejia, *Yoginī, Cult and Temples*, 163–74 and 153–55, respectively.

21. Clothey, "Skanda-Saṣṭī," 238–42.

22. See, for example, the Kailasanatha temple in Kanchipuram, Tamilnadu, where the panels face each other from opposite sides of the large courtyard. Kaimal, *Opening Kailasanatha*. Meister finds them paired in Madhya Pradesh, too. Meister, "Regional Variations," 240.

23. Mallmann, *Enseignements iconographiques de l'Agni-Purana*, 7–8, 80–91, 170. She also finds a stele bearing the relief of a solar mandala that corresponds closely to these forms, though it has seven rather than eight goddesses (91–93). Dehejia reflects on connections between yogini temple form, chakras, mandalas, and yantras in *Yoginī, Cult and Temples*, 42–43.

24. Mallmann, *Enseignements iconographiques de l'Agni-Purana*, 9, citing the Agni Purana 310, *shloka* 301.12b.

25. Stietencron, "Cosmographic Buildings," 75–81. Referencing a range of Tantra and Purana texts, he finds correspondences between all the sculptures, astral bodies, and units of time. The goddesses each correspond to one phase ("mansion") of the lunar month. The largest goddess sculpture at Hirapur, which is placed directly opposite the temple's east-facing entry, he reads as the new moon, Yogeshvari. The temple shows the sun to be the ruler over space and time. His reading of Shiva's role depends, however, on there being a four-faced Shiva at the center of the Hirapur temple. No such sculpture survives.

Thomsen too finds Puranas assigning yogini worship to precise moments in the lunar calendar and associating yoginis with particular compass points. Thomsen, "Numerical Symbolism," 54–55, citing Kashikhanda 45 of the Skanda Purana, and the Garuda Purana, *adhyaya* 59, 10–13. White, too, believes astronomical time to have structured the worship of yoginis. White, *Kiss of the Yoginī*, 10, 90.

26. Mallmann notes that the hypaethral form provides a view of the sun and discusses the relevance of its high sides and elevated siting: Mallmann, *Enseignements iconographiques de l'Agni-Purana*, 7, 176. Thomsen, too, believes that, because they are open to the sky, these temples had astronomical applications. Thomsen, "Numerical Symbolism," 53–56.

27. Stietencron, "Cosmographic Buildings," 75.

28. Coburn, *Encountering the Goddess*; Lyons, "Śimla 'Devī Māhātmya' Illustrations."

29. Stietencron, "Cosmographic Buildings," 74. Meister sees rhythm as associated with creation in the context of the mother goddess sculptures in ninth-century temples of Madhya Pradesh. Shiva was "moving the mothers themselves to dance" since he was "lord of the rhythmic pulse that both creates and destroys the universe." Meister, "Regional Variations," 242.

30. Sharrock suggests that yoginis dance in sculptures at the thirteenth-century portions of the Bayon in Cambodia because these yoginis are part of the tantric deity Hevajra, who dances on or tramples corpses. He sees dance as a meditation that has become dangerous and violent. Sharrock, "Yoginīs of the Bayon," 122–23.

FORREST McGILL

Dancing in Circles

PEOPLE SEEM TO HAVE DANCED in rings in just about every culture through the ages; even square dances go in circles sometimes. What is far less common is for high deities to be seen joining circle dances with other deities or with mortals. These dances reveal—even reify—deep truths of Hindu-Buddhist worldviews.

Noticing the similarities (and differences, too, of course) between sections of a fifteenth-century Tibetan Buddhist painting of a mandala (fig. 1) and an eighteenth-century Indian Hindu one of Krishna's circle dance (fig. 2) suggests a trail of investigation. In both, a pair of figures is encircled by other dancing figures arranged radially. In one, the central figures are in sexual union; in the other, they aren't. The dancers ringing the central pair are deities in one, humans (apparently) in the other.

How often does this configuration appear in various religious and cultural traditions in South and Southeast Asia and the Himalayas, and in what contexts? What can the configuration mean, and what can it do?

The Hevajra Mandala

The trail can be traced further back. Bronze Buddhist lotus mandalas of twelfth-century northeastern India share a similar circle-dance configuration and may be the conceptual ancestor to not only the Tibetan Buddhist mandala of Hevajra (to which they bear a clear historical connection) but also the later Hindu painting.[1] One example is the lotus mandala of Hevajra (fig. 3). On the inside of each of its eight bronze petals dances a yogini, a powerful female adept with, here, the status of a Tantric Buddhist goddess. The eight yoginis once surrounded a freestanding central figure or pair of figures (now missing). Comparison with other bronze lotus mandalas suggests that these were the Tantric deity Hevajra (literally "Hail, Vajra"—vajra being a symbolic weapon associated with both diamond and lightning, often symbolizing the power to defeat negative forces both internal and external) and his consort Nairatmya ("No Self") in sexual union.[2]

Hevajra is a major deity in Tantric Buddhism, and the Hevajra Tantra, composed more than a thousand years ago, is an important text known in Tibet, Cambodia, Mongolia, and China as well as India.[3] It comes out of the latest phase of Indian Tantric Buddhism and is dense, arcane, and, for outsiders, often nearly impenetrable. Like other such texts, it is written in "allusive, indirect, symbolic, and metaphorical forms of language," in which only surface meanings are understood by the uninitiated and more difficult or challenging meanings are reserved for those in the know.[4] For example, the phrase "fragrant ointment and musk, frankincense and camphor"

Chakra and Mandala

Two key Sanskrit words, *chakra* and *mandala*, have "circle" among their several important meanings. Both words long ago entered many Southeast Asian languages, as they have, more recently, English. Chakra, with related meanings such as a disc, a disc-shaped weapon, and an energy center in the human body, descends from the same Proto-Indo-European root as "circle" and "wheel."

Mandala is today probably most frequently used for a diagram (often a painting) for meditation and visualization usually resembling the ground plan of a palace, with deities arranged in patterns. But it also can mean a disc, an orbit, a conceptual circle of neighboring kingdoms surrounding a central kingdom, or, by extension, a district or province.

Tantra, Tantric

Tantras are a special kind of Hindu or Buddhist esoteric religious text that deals with acquiring power, both spiritual and worldly (though this distinction may be illusory). The means to acquiring this power may include rituals, meditation, yoga, alchemy, sexual practices, and visionary identification with benevolent or fierce deities. These activities, which sometimes involve ecstatic dance, may be carried out in the exterior world, in meditation, or both simultaneously.

In many tantric traditions participants need to have undergone considerable training, cultivation, and perhaps ceremonial initiation to understand the practices, assimilate them, and perform them. Outsiders will misunderstand the symbolic imagery of the tantras and fail. The practices can bring about transformations both internal and external. The adept can achieve unity with—become—a specific deity; rituals performed correctly, under the right circumstances, can obliterate enemy armies or make the sun reverse its course.

may actually mean "faeces and urine, blood and semen."[5] The question then arises whether "faeces and urine" are to be taken literally or metaphorically, and, if metaphorically, as metaphors for what.

The text tells of the great deity Hevajra, with whom the consecrated adept (who was usually assumed, within the tradition, to be male) seeks to identify through empowering rituals, meditation, and visualizations. When this identification is accomplished, the adept realizes (real-izes) that "pure" and "impure" are meaningless categories. The adept further understands that they are equivalent to Hevajra, and adept and deity are not ultimately differentiated from the Buddha and the cosmos. Having reached this summit, the adept gains a variety of supernatural powers.

The Hevajra Tantra describes the deity taking several forms, the most common of which in artistic representations is a figure with eight heads, four legs, and sixteen arms (fig. 4). When engaged in sexual union with his consort he is often surrounded by dancing yoginis. The yoginis are specifically said to be in the "half-seated" dance posture of *ardhaparyanka*—that is, standing on one leg with the other bent upward and inward at the knee.[6]

The intercourse of Hevajra and his consort and the dancing of the yoginis—as well as adepts' enactment of these activities, whether in real life or meditation—take place in a cemetery or cremation ground. (In many Buddhist traditions, it is not uncommon for monks to meditate on corpses and cremation as a reminder of the inevitability of death and decay.[7]) Setting

Fig. 1 Mandala of Hevajra, 1461 (cat. 36, detail).

Fig. 2 Circle dances with Krishna, approx. 1700–1725 (cat. 18, detail).

Fig. 3 Lotus mandala of Hevajra with eight dancing yoginis and eight cremation grounds, approx. 1100–1200 (cat. 32).

Fig. 4 Dancing Hevajra surrounded by dancing yoginis, probably 1050–1100 (cat. 33).

such actions in these most polluted and inauspicious places, together with sexual activity condemned by society and the consumption of substances likewise disapproved of or thought repugnant, reinforces the idea that the best prepared and most highly evolved adept can and must see beyond notions of impurity held by ordinary people in everyday life.[8] For brahmans and monks, maintaining purity and correct behavior brings power; but ignoring these stances, or indulging their opposites, may also, as we will see in a moment, bring power.

If the guidance of the Hevajra Tantra is followed, the adept achieves a state of transcendent spiritual and philosophical understanding: "There is no bodily form, neither object nor subject, neither flesh nor blood, neither dung nor urine, no sickness, . . . no passion, no wrath, no delusion, no envy, . . . no friend is there, no enemy, calm is the Innate and undifferentiated."[9] This state is characterized, according to most Buddhist traditions, not just by wisdom but also by compassion, as the tantra's interpretation of the name "Hevajra" indicates: "By HE is proclaimed great compassion, and wisdom by VAJRA."[10]

Shortly after this statement, the tantra describes—again in terms familiar from other Buddhist traditions—how liberation from the bondage of existence may be achieved through understanding the nature of existence.[11] At the same time, though, the tantra also speaks of its special usefulness in this world, saying, "The technical proficiency of this tantra is known to be manifold. This tantra teaches the Gazes, how to attract, the great Secret Sign Language . . . , how to drive away, and the magical power of paralyzing an army."[12] Further on, it includes spells for "subduing," "causing hatred," and "causing a city to tremble." It describes rituals for producing rain as well as for destroying an enemy army, causing enemies to "become headless," and for the "destruction of gods," presumably those of an enemy.[13]

The tantra periodically mentions the importance of dance. Referring to rituals the adept performs, it asserts that "if in joy songs are sung, then let them be excellent vajra-songs, and if one dances when joy has arisen, let it be done with release [*moksha*] as its object. Then the yogin [the adept], self-collected, performs the dance in place of Hevajra. . . . Song represents mantra, dance represents meditation [*bhavana*], so singing and dancing the yogin always acts."[14] (A mantra is a formula of sounds or words that have spiritual potency. Here, it seems that *bhavana*—translated as "meditation"—indicates

the active use, by the adept, of meditation to produce or emanate divine beings or states through visualization. The pairing of song-mantra and dance-bhavana in the sentence may contrast a still activity with a dynamic one.) The point is that the package of the tantra, its symbols, imagery, spells, and rituals—prominently including dance—wields great power on both the spiritual plane and the earthly plane of natural phenomena, human interactions, and warfare.

Surely kings would be interested in gaining and making use of such power. A number of images of Hevajra dancing while encircled by dancing yoginis survive from the time of Jayavarman VII, the imposing king of Angkor (r. 1181–approx. 1220).[15] Before him, the complex state religion focused on the Hindu deity Shiva (or, during one reign, Vishnu). Several sorts of Buddhism were practiced, but their importance seems to have waxed and waned. Only under Jayavarman VII was Buddhism established at court, and the beliefs and symbols of this Buddhism spread, with royal encouragement, throughout the realm in what is now Cambodia and parts of Thailand, Laos, and Vietnam.[16]

 Spotty documentation and abundant but contested material evidence make understanding the political, social, and cultural history of Jayavarman VII's period challenging.[17] The king's Buddhist beliefs appear to have changed, at least in emphasis, throughout his reign. Furthermore, during his reign, "Hindu gods were worshipped and were considered one aspect of a total system that had the Buddha at the apex."[18]

 Many sculptures testify to the importance of a triad of the serpent-enthroned Buddha flanked by the compassionate bodhisattva Avalokiteshvara and the goddess of transcendent wisdom Prajnaparamita, and many more to that of Avalokiteshvara alone. But at some point in Jayavarman VII's reign, Tantric Buddhist beliefs and rituals, in which Hevajra had a major role, grew in importance, at least in court circles, while not necessarily supplanting other currents of Buddhist (and other religious) belief.[19] Frustrating scholars' efforts to understand is the fact that Hevajra is not mentioned in the only surviving documents of the reign, inscriptions.

 An enormous stone statue of a dancing Hevajra found in the city of Angkor (fig. 5), which survives only in large fragments, indicates the prominence of the Hevajra cult.[20] Two of Jayavarman's most important temples, the Bayon and Banteay

Fig. 5 Bust of Hevajra, late 12th–early 13th century. Cambodia. Stone. *Metropolitan Museum of Art, Fletcher Fund,* 1936, 36.96.4.

Fig. 6 Miniature shrine with Hevajra in a circle of yoginis, late 12th–early 13th century. Cambodia. Gilded bronze. *National Museum of Cambodia,* Ga2494.

Chhmar, may well have incorporated Hevajra-related concepts and symbolism, though precisely how (and even whether) has been the subject of lively scholarly debate in recent years.[21]

Building on the pioneering research of Hiram Woodward and others, Peter Sharrock proposes that major rituals based on the Hevajra Tantra were performed in the state temples.[22] In them the king underwent consecrations and empowerments that would identify him with Hevajra and give him extraordinary spiritual and worldly capabilities. He could, if he chose, employ these capabilities to protect his kingdom and defeat enemies. Sharrock points out that Kublai Khan apparently received Hevajra consecration some decades after Jayavarman and discusses other examples of kings harnessing the power of the Hevajra rites.[23]

Certain artifacts hint at how images of Hevajra and the yoginis might have been arrayed in a temple. In an elaborate bronze grouping in the National Museum of Cambodia in Phnom Penh, Hevajra and the yoginis dance within a shrine with an architectural base, columns, and pediments (fig. 6).[24] The miniature shrine must once have had a towerlike

superstructure, now missing. Tablets (and molds for making them) from the Angkorian realms take the shape of a temple tower with tiered superstructure and have, in what would be the shrine, Hevajra encircled by eight dancing yoginis arranged in a flattened, mandala-like way (fig. 7).[25]

If Hevajra was present in the Bayon temple or Banteay Chhmar as a now-missing statue, were there yoginis, too? Some scholars think so. In the reliefs of the Bayon appear more than six thousand dancing female figures. Of them, Sharrock writes that "the sacred dancers function on the exoteric level in new sacred dance rituals allied to the *bhakti* devotional cults (which emphasized passionate, emotionally charged worship) then sweeping India, while at the same time they function on an esoteric level and project a yogini-Hevajra cult."[26] Sharrock lays out arguments to support the connection of the dancers with the Hevajra cult, including an indirect Chinese report of 1225 mentioning that in a Cambodian temple three hundred women danced in Buddhist rituals and that they were called *anan*, construed as a Chinese version of the Sanskrit *ananda* (bliss), a term that would comport with Tantric thought and

Fig. 7 Bronze mold with a mandala of Hevajra, late 12th–early 13th century, and a modern plaster cast from the mold. *National Museum of Bangkok.*

terminology.[27] Issues remain, however. The dancers ringing Hevajra in other depictions number eight. Why so many at the Bayon with no set of eight (or a multiple of eight) given special placement or treatment? Also, Hevajra's yoginis usually dance on corpses, but the dancers in reliefs at the Bayon do not. The profusion of female dancers in reliefs on twelfth- and thirteenth-century Angkorian temples implies important ritual or symbolic roles for dance and dancers, but the specifics are hard to establish.

In Angkorian representations of dancing Hevajra and yoginis, Hevajra's consort Nairatmya, whom the Hevajra Tantra describes Hevajra clasping in sexual embrace, is most often not present.[28] In Tibet, though, where the surviving representations of Hevajra are generally a century or more later than those in the Angkorian realm, Nairatmya usually is present.[29] Another difference is that Tibetan mandalas showing the couple in sexual embrace also depict the cremation grounds mentioned in the tantra. Why the Angkorian examples downplay or avoid depicting the explicitly sexual and gruesome aspects of the tantra, when those aspects are depicted elsewhere, is a puzzle. Southeast Asian artists tended, in general, to tone down the sex and violence in some South Asian and Himalayan art, but the reasons are unclear. In Tantric practice these aspects could always be added back through imaginary projection, of course.[30]

A common Hevajra mandala of Tibet is of the "nine deity" type, showing eight dancing female figures surrounding a central dancing Hevajra-Nairatmya pair, with Hevajra having, as in Angkor, sixteen arms (fig. 1). The two central deities are "non-dual" and so count as one. Surrounding this configuration are the square walls and gates of the mandala palace, and in an outer ring are eight great cremation grounds where dogs and vultures tear at corpses (cat. 36). The Hevajra Tantra reminds us that "This Lord plays [kriḍate] in the cemetery surrounded by his eight yoginīs."[31] For an adept to frequent cremation grounds or cemeteries (alternate translations of the Sanskrit word śmaśāna) was a kind of aversion therapy, helping them to overcome fear of death, disgust with repellent sights and smells, and engagement with sense perceptions altogether. For the deities to dance there signals their utter transcendence of the dualities and illusions of the phenomenal world, recalling that ultimately the cremation ground and the world are not different but share the quality of emptiness.

As in Angkor, it is possible that in Tibetan ruling circles the creation of Hevajra mandalas and the execution of Hevajra-related rituals and empowerments could be employed for worldly purposes. "Throughout Tibetan history, we find abundant evidence that Buddhist tantric masters frequently resorted to such rites of magic and sorcery in attempts to gain power or defend against hostile forces, compelling wrathful deities, expelling demons, and causing harm or death to rivals and enemies," affirms Brian J. Cuevas (speaking in general and not of Hevajra-related rituals specifically).[32]

The challenge to understanding Hevajra rituals in Cambodia and Tibet—how exactly they were carried out and to what purposes—is that they have not been performed for many centuries, having been superseded by other religious traditions. Additionally, the role and nature of ritual dance—that is, actual dancing as opposed to references in religious texts—are impossible to determine because the practices have long since disappeared. Tibetan Tantric Buddhist dances (cham) continue to flourish and may offer hints of what the dances of Hevajra and his yoginis were like more than five hundred years ago (fig. 8). We may move closer, perhaps, observing the charya nritya ritual dance of Nepal. In one such dance the performer impersonates Nairatmya, and the chanting accompanying her mentions Hevajra.[33]

The Rasamandala

The eighteenth-century Indian Hindu painting we began with (fig. 2) shows the rasamandala, the ecstatic circle dance of the Hindu deity Krishna and a group of women from a cowherd village. Here, we seem worlds away from the fearsome occult dances of Hevajra and the yoginis.

Krishna—an incarnation of the great god Vishnu and in some traditions the highest god of all, the Absolute—has come to earth to vanquish a wicked, powerful king whose depredations threaten righteous order. Krishna grows up more-or-less incognito among cowherders (called gopas and gopis, male and female) in rural north India. He entrances the local people with his charm, his heroic deeds, and his irresistible attractiveness. One moonlit night, Krishna, having "turned his mind toward love's delights," goes out into the forest and plays alluring music on his flute.

Fig. 8 Cham ritual dance, from "Tibetan Dancing," April 4, 2018, Tibetpedia.com.

Upon hearing that sweet music, their passion for him swelling, the young women whose minds were captured by Krishna, unaware of one another, ran off toward the place their beloved was waiting, with their earrings swinging wildly. Some left abruptly while milking the cows. Some suddenly stopped dressing themselves; others no longer fed their children their milk. Some left their husbands who had not yet been served. Their garments and ornaments in utter disarray, they hastened to be with Krishna.[34]

Dancing will begin soon, but several points need to be underlined. The wilderness at night is menacing. Krishna says, "Night has a frightening appearance; inhabiting this place are fearsome creatures!" The cowherd women must overcome their unease and risk their safety to join him. Many of the women have husbands and children. For a woman to abandon domestic and connubial duties to meet a man for a nocturnal tryst was an unthinkable, immoral offense against responsibility and proper conduct. The women can expect only condemnation and rejection when they return home.

The women having found him, Krishna reminds them of their duties and urges them to go back. They weep, thinking that Krishna is "disinterested in love," and affirm that their passion is that of a worshipper for the "supreme soul," the "Lord, the original Person." They implore him to "place your hand, beautiful like the lotus, on the heads and impassioned breasts of your maid-servants." Then, "embracing them with wandering arms; playfully touching their hands with the tips of his fingernails which then fell upon their breasts, belts, thighs, and hair; he joyfully awakened the god of love in those beautiful young women."

The Bhagavata Purana itself and many later commentators treat the seemingly erotic love of the young women for Krishna as an analogy for the all-consuming, but incorporeal, love of the worshipper for "Krishna, the supreme Lord of yoga; by him

the entire world is liberated." At the same time, the voluptuous language and imagery of these scenes sound to impious ears for all the world like sexual love play. Just after arousing the women with caresses, Krishna disappears—"to quell their pride." Bereft, the women imitate him. "Through their movements, smiles, glances, speech, and other gestures, the bodily forms of his lovers became similar to those of their beloved. The young women, their selves fully absorbed in him, thus declared, 'I am he!'"

They search for Krishna and, not finding him, "began to act out the līlā [here, activities] of their Beloved Lord." They perform tiny skits of familiar episodes from Krishna's earthly career, such as recovering lost cows, killing demons, overcoming the serpent Kaliya, and so on. The use of the word līlā is telling. It means "play," and like the English word, it has several important senses. It can mean effortless, undirected activity and also what theatrical artists perform. The actions of a high deity such as Krishna are upwellings of divine energy requiring no exertion or strain. They are self-justifying and may or may not have any more goal than a child's play. And because godly doings often involve shape-shifting and the manipulation of reality and illusion, they may suggest, to mortal eyes, the appearance of stagecraft.[35] The women eventually find Krishna, and then "the festival of the Rāsa dance commenced with a circular formation of Gopīs [gopī-maṇḍala]. Krishna entered among them between each pair [using the power of illusion to multiply himself]—each thought she alone was at his side."[36]

This episode, the rasamandala, is famous and became the subject of countless paintings and other artworks (cats. 16–17, 19–20). According to tradition, there are eight principal cowherd women, though various other numbers are sometimes shown.[37] The rasamandala has also long been reenacted by

dancers in a variety of contexts as both devotion and entertainment—not that these need be distinct categories. In the Bhagavata Purana, the women have what sound like erotic experiences while dancing with Krishna. For example, one of them, smelling the fragrance of Krishna's arm, "became elated with bodily ripplings of bliss, and kissed his arm tenderly." But, we are told in the final verse of the chapter, "This is the divine play of Vishnu with the fair maidens. One who is filled with faith, who hears or describes this play, having regained the highest devotion for the Beloved Lord, has lust, the disease of the heart, quickly removed without delay."[38]

Now, noticing this rare instance in the Bhagavata Purana of Krishna being called Vishnu calls to mind artworks in which the identities of Krishna and Vishnu are fused (or the identity of Krishna and Vishnu is reinforced). Of course, Krishna is conventionally thought of as one of the incarnations (*avatara*) of Vishnu. As some of the quotations above demonstrate, however, Krishna is also viewed as the supreme being. In artistic representations, the characteristics of Krishna and Vishnu are separate: Krishna usually has two arms, his frequent attribute is a flute, and his accompanying creature is a cow. Vishnu usually has four arms; among his attributes are a club, a conch, and a discus-like weapon (*chakra*); and his accompanying creature is the bird-human hybrid Garuda.

Occasionally, however, the characteristics are mixed. Glancing at a large stone sculpture from the old south Indian kingdom of Vijayanagara (fig. 9), we see Krishna in his frequent dance-like posture, playing his flute. Then we notice two more arms holding in their hands—or rather balancing on their fingertips, since the gods do everything effortlessly—Vishnu's discus and conch.[39] This would seem to be Krishna in a supreme form, coequal with Vishnu and ultimately equivalent. A bronze work from approx. 1700–1900 connects this form with the rasamandala (fig. 10). Here is Krishna in a similar posture and again playing the flute, but having not two arms or four, but ten.[40] He again holds the discus and conch associated with Vishnu. Positioned behind him is a star hexagram, a key component of important mystical diagrams (yantra) associated with Krishna and his heaven. Surrounding that is a ring of eight cowherd women dancing with eight projections of Krishna.

During the rasamandala dance, Krishna, still presenting himself as a human, displays only two arms, but here a divine form is shown. We are reminded that the dance takes place not only at a certain moment in history at a certain locale in

Fig. 9 Krishna playing the flute, approx. 1400–1500. Southern India; former kingdom of Vijayanagara. Granite. *Asian Art Museum, The Avery Brundage Collection*, B64S9.

Fig. 10 Krishna plays the flute and dances with the cowherd women (rasamandala), approx. 1700–1900 (cat. 20, detail).

northern India but also eternally, unceasingly, in the highest heaven of Krishna.[41] The cowherd women are in one sense ordinary women, our representatives with whom we can associate ourselves in devotion to Krishna. In another sense, they are viewed, in some religious traditions, as goddesses in their own right, embodiments of Krishna's shakti (divine energy): "eternally perfected beings . . . co-eternal with the supreme Lord."[42]

Another depiction of a supreme Krishna (cat. 24) takes us a step further in visualizing his cosmic nature. Here he is portrayed in gigantic proportions, ten armed and multiheaded, with fields, mountains, and palaces arrayed on his torso and limbs.[43] At his pelvis (in yogic terms, the lowest chakra—wheel- or lotus-like power center—of the body) is represented the rasamandala dance: a large Krishna stands at the top, and smaller Krishnas alternate with cowherd women around the circle (fig. 11). Far above the head of the enormous figure—that is, in Krishna's empyrean—we see another version of the dance. Here, a supreme form of Krishna occupies the center, and heavenly cowherd women ring him, this time with no Krishnas joining them (fig. 12). The lower circle is understood, in theological terms, to be an earthly correlative of the timeless celestial epitome.

Fig. 11 Cosmic form of Krishna showing the rasa dance at the pelvis, approx. 1800–1900 (cat. 24, detail).

The center of the dance circle is treated differently in various artworks. In the painting of Krishna in cosmic form, the center of the lower dance circle is unoccupied, while in the upper circle Krishna stands alone, not dancing.[44] Elsewhere, Krishna dances alone at the center (fig. 13), or dances with one woman (cats. 16 and 18), or sits with one woman (cat. 19). Other possibilities exist as well, such as Krishna dancing with

Fig. 12 Cosmic form of Krishna showing the rasa dance in Krishna's heaven, approx. 1800–1900 (cat. 24, detail).

Gopa, gopi

These terms just mean male and female cowherding folk and in this book are usually replaced by phrases such as "cow-herd women." They are the country people among whom the deity Krishna, more-or-less in disguise, grows up. But the cowherd women achieve a special status: because they are so drawn to Krishna (without knowing his true nature) that they risk all to be near him, they become exemplars of the intense devotion all worshippers should feel toward the divine. The cowherd women who join with Krishna in ecstatic dance are sometimes thought to hold saintly status themselves, and a special one to whom Krishna shows particular favor, often identified as Radha, is revered as a goddess. In some traditions she is coequal, or nearly so, with Krishna himself.

one woman while apparently holding aloft another, much smaller woman (cat. 17). To the extent scholars understand them, these variations must reflect choices made by artists or patrons or be based on traditions particular to a time, place, or sect, and, of course, may reflect real-life performance practice.

When artworks show Krishna dancing with a single woman at the center of the circle, who is she? She is the "special Gopī" referred to in several verses of the Bhagavata Purana. The other cowherd women complain, "The Beloved Lord . . . was worshipped by her perfectly. Having abandoned us, being so pleased with her, Govinda [Krishna, "lord of cows"] led her to a secret place."[45] The text, however, mentions no special gopi dancing with Krishna or joining him at the center of the rasamandala.

In some sects of Krishna worship, notably that associated with the saint Chaitanya, the special gopi is identified as Radha, Krishna's beloved in the *Gitagovinda* and many devotional songs and poems. Like other aspects of Krishna's lila, his loving inter-action with Radha in our world is a reflection of their eternal union in the heavenly realm.[46] The two sometimes come to be thought of as virtually a single entity standing for the undif-ferentiated Divine. "Radha and Krishna are one soul, yet they possess two bodily forms."[47]

Comparisons

The visual similarities between the fifteenth-century Tibetan Buddhist painting and the eighteenth-century Indian Hindu one we started with can now be seen to reflect significant conceptual similarities. A central male and female couple are understood to complement each other and comprise the ulti-mate supreme reality or being. Their union is either explicitly or implicitly sexual—though whether devotees understood it literally or figuratively, and whether they imitated it in real-life rituals or only in imaginative meditation, is subject to debate.

This couple (or sometimes Hevajra or Krishna alone) dance encircled by dancing female figures, sometimes eight in num-ber and positioned at the points of a compass rose (fig. 13). These figures can be seen as human participants in a sacred event or as deities themselves, partial projections or emana-tions of the central couple. The female figures are the means to bliss, *ananda*.[48] The whole configuration is thought to emulate aspects of the cosmic scheme. Circularity (presumably related to notions of unity) and dancing (presumably manifesting divine energy) are fundamental.[49]

After long ritual and internal preparation, a Tantric Buddhist adept may realize self-identification with Hevajra. They may then imitate Hevajra dancing with the yoginis and achieving sexual union with them or with Nairatmya—possibly in a real earthly rite or, more commonly, through visualization. For some worshippers of Krishna the same is true, mutatis mutandis, in approaching Krishna, the cowherd women, and Radha.

Of course, the comparison has limits. Practices associated with the Hevajra mandala occasionally appear to have had as a goal not just spiritual but this-worldly power—essentially magic—that kings might strive to attain and deploy. The rasa-mandala, and re-creations of it in performance and in profound meditation, do not seem to have had real-world power as a goal in a similar way, and kings are not reported utilizing the rasa-mandala and related rituals to overcome their enemies.

Fig. 13 The rasa dance, approx. 1525–40. India; Uttar Pradesh state. Page from a dispersed series of the Bhagavata Purana; opaque watercolor on paper. *Philadelphia Museum of Art, 125th Anniversary Acquisition, Alvin O. Bellak Collection, 2004-149-7.*

Some Indian kings were devout worshippers of Krishna. They built temples, honored sacred images, undertook pilgrimages, and commissioned both paintings of the rasalila of Krishna and reenactments performed by dancers. Because hiring painters and supporting festival performances were costly, this patronage displayed a king's status. The raja of a small kingdom is portrayed in a painting from about 1750 watching such a performance in an attitude of piety (fig. 14). What he was thinking or feeling we have not a clue, but for a devout person, watching could be experiencing. "No longer is the devotee imagining Krishna through actors and the roles they have adopted, but seeing Krishna himself. Through the same feeling of bliss, the devotee transcends the metadramatic levels of the physical world of which the performance and himself

Fig. 14 Raja Prithvi Singh of Orchha watching a performance of Krishna's dance with cowherd women, approx. 1750 (cat. 81, detail).

are a part." The devotee then "does not imagine . . . but lives in Krishna's eternal playground."[50]

How might the parallel configurations of circles of dancing Hevajra and yoginis and dancing Krishna and cowherd women have come about? Scholars have not gone far in investigating the question. If there are historical connections (as I suspect there are) they should be sought in eastern India. The Tantric Buddhist Hevajra traditions developed in the eastern regions of Bihar, Bengal, and Odisha before being adapted in Cambodia, northeastern Thailand, Tibet, and China. The later Tantric Hindu traditions of some sects of Krishna worship were—and are— strong in Bengal. Sculptured representations of the rasamandala are rare in architectural contexts, but several dating to the mid-seventeenth century can be seen at the Shyam Rai Temple in Bishnupur, West Bengal (fig. 15).[51]

Other Dances and Circles

In the art of the Indic world, representations of dances with one or several dancers in the center of a circle of other dancers are not uncommon. Sometimes, as in a depiction of dancing celestials, the connection seems primarily visual (fig. 16). In the dance of Muslim dervishes, the configuration reflects ritual performances unrelated to the traditions discussed here (fig. 17). In other instances—for example, of dancing celebrating the birth of Krishna (fig. 18)—there would seem to be a straightforward echoing of representations of the rasamandala. In the dance of Ganesha surrounded by aspects of the Goddess (fig. 19), some of whom dance, the resonances are both conceptual and visual.[52] Ancient yogini temples were typically round, and in them both Shiva and his son Ganesha might join the yoginis sometimes shown dancing. Additionally, in the painting of Ganesha, the niches in which the yoginis reside call to mind the appearance of many a lotus mandala.[53]

However common circle dances may be in prosaic traditions around the world, they assume exceptional importance and bear a range of profound meanings in the Indian cultural sphere when engaged in by the greatest gods. The artworks discussed here suggest how the external world of everyday experience and activity, the interior world of our awareness and intuition, and the greater world of the cosmos relate, and how changes in one can bring about changes in the others (which ultimately are not different, after all). Dance has the ability not just to reflect, but to effect, these changes.

Fig. 15 Rasamandala from the Shyam Rai Temple, 1643. India; West Bengal state, Bishnupur.

This essay has been improved by the generous comments, written and oral, of a number of scholars, including Ainsley Cameron, Jeffrey S. Durham, and Graham Schweig.

1. Notice also an elaborate bronze attributed to twelfth-century Bengal showing a dancing eight-headed, sixteen-armed Hevajra, illustrated in Linrothe, *Ruthless Compassion*, fig. 194. Seven dancing female figures are positioned around Hevajra on the flat upright backing behind him; an eighth is in front below. Hevajra is not shown in sexual embrace with a goddess, as he usually is in northeastern Indian and Tibet. In Cambodia, Hevajra's partner is most often not shown. Questions of when and why in various traditions and places Hevajra's partner is or is not depicted together with him in embrace have not been studied in detail.

2. See, for example, items 8358 and 66761 at Himalayan Art Resources, https://www.himalayanart.org.

3. The date of the text is uncertain. Hypotheses range from late eighth or early ninth century "at least" (Samuel, *Tantric Revisionings*, 101) to late ninth or early tenth century (Davidson, *Tibetan Renaissance*, 41). Several twelfth-century eastern Indian images of dancing Hevajra, including one surrounded by eight dancing yoginis, are illustrated in Linrothe, *Ruthless Compassion*, figs. 191–94.

4. Williams, Tribe, and Wynne, *Buddhist Thought*, 148.

5. Snellgrove, *Indo-Tibetan Buddhism*, 169. For more on coded language in the Hevajra Tantra, see Davidson, *Indian Esoteric Buddhism*, 263–64.

6. Snellgrove, *Hevajra Tantra*, pt. 1, 112; pt. 2, 80; Farrow and Menon, *Concealed Essence of the Hevajra Tantra*, 251. The term is *ardhaparyaṅkanāṭyasthā*.

7. Jeffrey Durham, email to the author, May 3, 2021: "The practice of meditating in cemeteries has a venerable pedigree in Buddhism and is described extensively in Pali canonical and Sanskrit sources as a method of overcoming anxious fear and craving by realizing impermanence (*anityatva*). In practices such as those recommended in the Hevajra Tantra,

Fig. 16 Fragment of a canopy with celestial dancers and musicians, approx. 1800–1830 (cat. 78, detail).

Fig. 17 Dervishes dancing before a group of Muslim divines, approx. 1760 (cat. 28, detail).

Fig. 18 Celebrations in honor of Krishna's birth, approx. 1680–1690 (cat. 21, detail).

Fig. 19 Dancing Ganesha and aspects of the Goddess, 1800–1900. India; Orissa state, Puri. Paint on "pata" canvas. *Art Gallery of New South Wales, D. G. Wilson Bequest Fund 2000, 87.2000.*

the sexually charged dance of a Buddha in a death-ridden atmosphere is perfectly suited to challenge and dissolve the conventional distinctions between pure and impure, sacred and profane, indeed life and death, understood in Tibetan Buddhism to weave the fabric of ordinary, anxiety-ridden (*duhkha*) experience. In other words, because the cemetery comprises a congeries of forces deemed extremely polluting, it becomes an ideal place to realize that such pollution is merely conceptual and, just like the anxiety it causes, has never really existed (*anutpada*)."

8. See, for example, Garrett, "Tapping the Body's Nectar," 300–26.

9. Snellgrove, *Hevajra Tantra*, pt. 1, 83.

10. Snellgrove, *Hevajra Tantra*, pt. 1, 47.

11. Snellgrove, *Hevajra Tantra*, pt. 1, 47–48; Farrow and Menon, *Concealed Essence of the Hevajra Tantra*, 9–10.

12. Farrow and Menon, *Concealed Essence of the Hevajra Tantra*, 9.

13. Snellgrove, *Hevajra Tantra*, pt. 1, 50–53.

14. Snellgrove, *Indo-Tibetan Buddhism*, 168. Jeffrey Durham believes that a stronger translation is justified: "The dance is the meditation itself."

15. Some Angkorian images of Hevajra of this sort—such as cat. 33—are earlier; see cat. 33, note 1. A list of Angkorian representations of Hevajra can be found in Lobo, "Reflections on the Tantric Buddhist Deity Hevajra in Cambodia," 114n4.

16. It should be noted that Angkorian court religion in different periods mixed various religious currents, including reverence for ancestors and spirits of the land and localities, and may have been more pragmatic or instrumental than doctrinaire. On various religious currents in Jayavarman VII's period, see Hiram W. Woodward, foreword to Clark, *Bayon*, 7–8.

17. Vickery, *Bayon: New Perspectives* Reconsidered." For stimulating insights on the important role of Jayavarman VII's queens in generating and wielding spiritual and political prowess (though not in relation to the Hevajra cult), see Thompson, *Engendering the Buddhist State*, 120–43.

18. Woodward, "Bronze Sculpture of Ancient Cambodia," 70. Also worth remembering is that for centuries the court religion had also included reverence for ancestors.

19. See, for example, Woodward, "Esoteric Buddhism," 352. In that article, Woodward adds that "in the early 1200s, probably within Jayavarman's lifetime, Cambodian beliefs underwent radical transformations, in the direction of a Buddhism that was essentially Hinayana."

20. A credible reconstruction of this image can be seen in Sharrock, "Tantric Roots," fig. 4.9, and in Sharrock, "Hevajra at Banteay Chhmar," fig. 15.

21. On where the large stone Hevajra may have been placed (and much other recent information), see Cunin, "Case of the Bayon." Also, Sharrock, "Hevajra at Banteay Chhmar," 54–55; Sharrock, *Banteay Chhmar*, 39; Sharrock, "Yoginīs of the Bayon"; Green, "Two Internal Pediment Scenes"; and (responding to Green) Sharrock, "Smiling Hevajra."

22. An example of Woodward's pioneering research is "Tantric Buddhism at Angkor Thom."

23. Sharrock, "Hevajra at Banteay Chhmar," 54–55; Sharrock, *Banteay Chhmar*, 39. See also Walser, *Genealogies of Mahayana Buddhism*, 53–54; Huntington and Bangdel, *Circle of Bliss*, 455; Nihom, "Identification and Original Site of a Cult Statue on East Java," 485; and Bade, "(Spi)ritual Warfare," 141–59. For a clear summary of how tantric practice, including visualization, could, it was thought, bring about change in the everyday world, see Williams, Tribe, and Wynne, *Buddhist Thought*, 169–70.

24. Discussed and pictured in detail in Zéphir, "Notes à propos d'un *maṇḍala* d'Hevajra."

25. A mold in the National Museum of Cambodia is illustrated in Cort and Jett, *Gods of Angkor*, 68–69, and in Bunker and Latchford, *Khmer Bronzes*, 383. Another example in a private collection, identified as a "bronze matrix for making a mold for clay tablets," is shown in Bunker and Latchford, *Khmer Bronzes*, 383, 385.

26. Sharrock, "Yoginīs of the Bayon," 117. On reliefs of female dancers at Banteay Chhmar, see Sharrock, *Banteay Chhmar*, 101–02; and Chemburkar, "Banteay Chhmar: Ritual Space of the Temple," 154–69. It is always possible that different viewers made different interpretations. Woodward, speaking of a relief at Ta Prohm that shows dancers celebrating the Buddha's victory over the demon Mara, speculates, "Maybe only those with secret knowledge understood that [the] dancing figures and yoginis were one and the same." Hiram Woodward, email to the author, May 22, 2020. The Ta Prohm relief may be seen at "Temptation of Mara Ta Prohm Angkor" on Wikimedia Commons, https://commons.wikimedia.org/wiki/File:Temptation_of_Mara_Ta_Prohm_Angkor1303.jpg. Of Tantric Buddhist ritual dance in the Indian milieu, Davidson says, "Vajrayāna siddhas were, for all appearances, the first Buddhists to employ singing (not chanting) and dancing (not simple hand gestures) in the acts of offering before images." Davidson, *Indian Esoteric Buddhism*, 223–24.

27. Sharrock, "Yoginīs of the Bayon," 119; Chemburkar, "Banteay Chhmar: Ritual Space of the Temple," 156.

28. Snellgrove, *Hevajra Tantra*, pt. 2, 109–10; Farrow and Menon, *Concealed Essence of the Hevajra Tantra*, 242–43. A few Angkorian representations of Hevajra do show Nairatmya: Prachoom, *Buddha Images*, 128–29; and Bunker and Latchford, *Khmer Bronzes*, 255. I appreciate Hiram Woodward's calling these examples to my attention.

29. On early representations of Hevajra (with Nairatmya) in Tibet, see Linrothe, *Ruthless Compassion*, 272–74.

30. This suggestion comes from Hiram Woodward, email to the author, May 22, 2020.

31. Snellgrove, *Hevajra Tantra*, pt. 1, 59; Farrow and Menon, *Concealed Essence of the Hevajra Tantra*, 44.

32. Cuevas, "Politics of Magical Warfare," 172. Jeffrey Durham noted that killing enemies is understood as liberating them. Jeffrey Durham, in conversation with the author, November 23, 2020.

33. General information on cham dance is found in Pearlman, *Tibetan Sacred Dance*. On charya nritya, see Shaw, "Dancing Compassion"; and Shaw, "Tantric Buddhist Dance." See also Samuel, *Origins of Yoga and Tantra*, 315–22. The Nairatmya dance may be seen at Dance Mandal Temple, "Nairatma (Blue dakini)," June 9, 2010, video, 2 min. 22 sec., https://www.youtube.com/watch?v=-cSjgvGnbT4.

34. This and subsequent quotations are from a canonical life of Krishna, the Bhagavata Purana, as shortened, condensed, and slightly altered from Graham Schweig's translation in *Dance of Divine Love*, 25–77.

35. On "play" in relation to Krishna, see Kinsley, *Divine Player*. In addition to Krishna's play, Kinsley discusses "the importance of playacting as a technique of devotion to Kṛṣṇa" (169). For lila in general, see Sax, *Gods at Play*.

36. Schweig defines *rāsa* (as distinct from *rasa*, with a short first *a*) as an ancient dance "in which a circle of women with interlocking arms is formed, each woman having a male partner who places his arm around her neck" and notes that an early Indian commentator "points out that Rāsa also refers to the sum of all *rasas* [short first *a*] or all intimate experiences with the supreme." He also considers the uses of the terms "rāsalīla" and "rāsamaṇḍala." Schweig, *Dance of Divine Love*, 265, 351. Schweig discusses the exact arrangement of women and multiple

Krishnas: Schweig, *Dance of Divine Love*, 267–68. It is worth noticing that Indian artistic representations of the circle dance show different arrangements of women. The likelihood that *rāsa* was a real dance, and evidence of what sort of dance it was, is discussed in Hardy, *Viraha Bhakti*, 600–05.

37. Holdrege, *Bhakti and Embodiment*, 225–27, 378n140.

38. Whether human devotees ever took the erotic mood literally enough to imitate Krishna and a cowherd woman making love seems to be a matter of debate. Hein says that some "outsiders" believed that "tantric groups had arisen" and that "in secluded places they were said to hold lawless congress in meetings comparable in some ways to the gathering for the Rāsa. . . . Not at all, according to our best records. No report is known, made by either friend or foe, that Bhāgavatas ever performed the Rāsa as carnal act, either as holy rite or in folk festivals." Norvin Hein's foreword to Schweig, *Dance of Divine Love*, xv.

On the other hand, some scholars assert that in the seventeenth and eighteenth centuries it was not uncommon for a practitioner to move "from mental to physical practice" and seek "a suitable female partner for a disciplined yogic-based sexual intercourse," but that this practice "began to move underground as pressures within and from outside the community mounted." Clooney and Stewart, "Vaiṣṇava," 180.

39. When he was born in human form, Krishna was four-armed. The majesty of his appearance awed his human parents, who recognized him as "*brahman*, unmanifest, original, . . . pure being. . . . You are Viṣṇu himself, the light of the self." Krishna quickly assumed the two-armed appearance of an ordinary child. Bhagavata Purana, 10.1,3.24–46; and Bryant, *Krishna: The Beautiful Legend of God*, 21–23.

40. In the Bhagavata Purana we are not told that Krishna plays the flute while at the center of the circle dance, but he is fairly often depicted doing so in artworks.

41. A description of Krishna's heaven in the Brahma Vaivarta Purāṇa, a devotional text possibly from the fifteenth or sixteenth century, is quoted in Kinsley, *Sword and Flute*, 26–27. Another description, from another Krishna-focused tradition, is discussed and quoted in Dimock, *Place of the Hidden Moon*, 165–80. All of Krishna's lilas, not just the circle dance with the cowherd women, take place in his heaven and by reflection in the human world. Margaret Case states the situation clearly: "For the devotee, the līlās narrated in the *Bhāgavata Purāṇa* are taken as having happened historically, but they also happen eternally. Krishna participates in the recurring daily, monthly, and yearly patterns of the natural world, and his devotees can also participate in his activities in this eternal realm, through visualization, development of refined emotional involvement in the stories, and service to those who are placed in a position to be served." Case, *Seeing Krishna*, 6.

42. Schweig, *Dance of Divine Love*, 206, 255; Kinsley, *Sword and Flute*, 53.

43. The best-known description of the cosmic Krishna, the Vishvarupa, "All-encompassing Form," appears in the Bhagavad Gita when Krishna momentarily reveals his absolute form to the hero Arjuna. Arjuna sees "all gods, O God, within your body, and every kind of being all collected. . . . I see your many arms, your bellies, your faces; I see you everywhere, whose form is boundless, endless." Flood and Martin, *Bhagavad Gita*, 92. What Arjuna does not see is the rasa dance. This is because the traditions emphasizing the lilas of Krishna, including the rasamandala dance, developed long after the Bhagavat Gita was composed.

44. Krishna here is in the form of Shri Nathji, whose image is enshrined in an important temple in Nathdwara, Rajasthan.

45. Schweig, *Dance of Divine Love*, 47. The term "special Gopī" is Schweig's.

46. Dimock, *Place of the Hidden Moon*, 139.

47. Kṛṣṇadāsa Kavirāja Gosvāmī, *Chaitanya Charitamrita*, 1.4.56, as quoted in Schweig, "Divine Feminine in the Theology of Krishna" 441–42. The same verse is translated by Bhaktivedanta as "Radha and Krishna are one and the same, but They have assumed two bodies." A 1975 edition of *Śrī Caitanya-Caritāmṛta of Kṛṣṇadāsa Kavirāja Gosvāmī*, by Kṛṣṇadāsa Kavirāja Gosvāmī and A. C. Bhaktivedanta Swami Prabhupāda, can be found at http://prabhupadabooks.com/pdf/CC1974/adi1.pdf. See also Dimock, *Place of the Hidden Moon*, 138–39; and Clooney and Stewart, "Vaiṣṇava," 178–79.

48. The link of Hevajra's yoginis with bliss (*ananda*) is mentioned above. On Radha as a means to bliss, see Dimock, *Place of the Hidden Moon*, 134. In Tantric Buddhism, "bliss" is associated with semen. As in some other yogic traditions, the adept is meant to achieve bliss but retain semen and pass it upward through the body to the head. Similar yogic practices are employed in some Krishna traditions, either physically or figuratively in meditation; see Dimock, *Place of the Hidden Moon*, 176–77.

49. On the importance of Krishna's dancing and that of the inhabitants of his supreme heaven in several episodes, see Kinsley, *Divine Player*, 116–17.

50. Mason, *Theatre and Religion*, 41–42. For a discussion of how devotees in certain traditions undergo "long exercises devoted to the construction of interior landscapes replete with the sacred geography" where Krishna's lilas take place and identify themselves with various participants, see Clooney and Stewart, "Vaiṣṇava," 179.

51. Jinah Kim reflects on ecstatic dancers in an eleventh-century sculpture of the bodhisattva Avalokiteshvara in the Bangladesh National Museum and is reminded of the dance of Krishna and the cowherd women, which is a later tradition in the same region. Kim, "Faceless Gazes," 222. Kim mentioned to me that she and Pika Ghosh had been discussing the possibility of connections between Hevajra-yogini mandalas and later representations of the rasamandala in Bengal. Kim says she intends to venture "further into Krishna territory" in forthcoming work. Jinah Kim, email to the author, September 14, 2020.

52. These aspects of the Goddess are the ten Mahavidyas; see Pal, *Dancing to the Flute*, 68.

53. Another example: "The mātṛkā [mother] deities, often expanded to eight so as to form the eight members of a circle in the maṇḍala, are subordinated to the power of the male deity (or male-female couple) at the centre . . . a pattern that would appear to reflect the idea of a male Tantric magician, with or without a female partner, controlling the powers of these deities for magical ritual purposes." Samuel, *Origins of Yoga and Tantra*, 250.

AINSLEY M. CAMERON

Painting Performance: Recording Dance at the Later Indian Courts

DANCE WAS A DOMINANT feature of courtly culture. It was practiced at many of the royal courts of north India and documented through a robust and highly valued form of artistic expression: the painted record. These paintings revealed the activities at court and functioned as a means by which rulers asserted their dynastic legitimacy. The historic, literary, and visual cultures of the court make clear that the entertainment of the ruler through music and dance was a prominent feature of daily life. Depictions of rulers in the presence of dancers populate the visual record of the Mughal empire, the Rajasthani courts, and the so-called Pahari courts in the westernmost foothills of the Himalayas. The interplay of dance, music, literature, and poetry in the visual repertoire of the Mughal court has received the attention of numerous scholars, leaving the latter, often later courts, still to be discussed.[1] Paintings at the north Indian Hindu courts, created alongside and after the Muslim Mughals, reveal a set of practices and protocols that were adopted, adapted, and shared. The transmission of these court practices was facilitated by the movement of itinerant dance troupes, where the transfers of people, dance forms, costumes, and customs were broadly shared among these complex and otherwise distinct cultural regions.

Dance research has often focused on iconography, encouraging a reading that treats images like infallible documents that reveal the history and evolution of dance movements, postures, and styles.[2] In practice, dance images can more usefully guide an understanding of the multiple roles that dance—and the representation of dance—played in its cultural context. Representative of court culture, these images address the intersections of political, economic, religious, pleasure, and martial activities. Indeed, it is advisable to study the symbolic effect (and affect) of dance without necessarily tethering that reading to the postures presented or the kinetic qualities of dance. When painting performance, it is the statement inherent in the portrayal of dance, not only its execution, that is to be explored.

Paintings of north Indian courtly dance scenes are most often positioned within intricate architectural milieus, either vast and expansive or intimate. If the scene portrayed is set beyond the palace compound walls, the surrounding landscape and figures are recorded in painstaking detail. These paintings that depict dance are rarely focused solely on dance, physically or metaphorically, and instead create an elaborate visual history that reinforces dominant court hierarchies. In many ways, to understand dance is to understand its function as emblematic of a larger court performance.[3] The visual record of Kota's Maharaja Ram Singh II's reign (1828–1866) often emphasized his power and vitality by positioning him in the midst of a hunt, in battle, or in processions (fig. 1)—situations where dance is instrumental in the creation of such court aesthetics.

Here, Ram Singh is portrayed atop a richly adorned elephant in a crowded composition. He is accompanied by his son Chhattar Sal and unnamed courtiers who ride smaller elephants alongside and wave fly whisks for the maharaja (a luxury reserved for royals and gods). The ruler holds a sword, has a nimbus around his head, and has a small canopy suspended above. Walking alongside are male courtiers and attendants carrying staffs, flags, maces, and other symbols of royalty. The rooftop courtyards are crowded with women catching a glimpse of the procession, but the only other female figures within the central scene are the performers: three walking in front of the elephant and a dancer atop a platform supported by the maharaja's elephant's grand tusks (fig. 2). She is depicted at a significantly smaller scale than the ruler and, indeed, most of those in attendance, signifying perhaps her youth or status at the court. The female performers below are surrounded by five male musicians who provide the accompaniment to the dancer's delicately balanced performance. All elements of this painting—elephants, weapons, royal emblems held aloft, the presence of the maharaja's heir, the nimbus, even the procession itself and the scale at which it is presented—are symbols of prestige and

power.[4] Dance is here used to amplify opulent accoutrements of court in a record of royal display.

Recording Performance

At the later north Indian courts, paintings that depict a ruler in the presence of dancers would have been commissioned by the court and, most often, painted by artists in affiliated workshops.[5] When created under royal authority and supervision, these works functioned to record, for posterity, important historic events, personages, or pastimes. They might include scenes of visiting dignitaries (to form strategic alliances), the ruler seated with his progeny (to establish or solidify lineage), the ruler at worship (to signal his devotional practices), or an intimate scene of a ruler with select courtiers—all within the context of a dance performance. Dance and other delights played a pivotal role in the establishment of power and prestige at court by integrating politics and pleasure. Fusing these shared cultures shaped the way political communities were motivated by aesthetic experiences.[6] And yet, while paintings can create a visual record based on historic events, it would be naive to assume that these portrayals are necessarily accurate

depictions. Rarely is the painted record an informed and unbiased history. The propagation of a ruling family's own narrative superseded accurate representation, especially when commissioned by a person of authority. As posited by the musicologist Thomas F. Heck and paraphrased by later authors: "Art usually imitates *art* more than it imitates life."[7] Written another way, perhaps art imitates the ideal more than it imitates a shared lived experience.

The patron's motives to obtain a visual record affect the way events are perceived and remembered; likewise, the very act of making (a process involving the artist, their own subjective experience, brush, and paper) can itself distort the event. The resulting visual record documents fragments or traces of a larger whole.[8] One of the most frequently cited examples when addressing performance, dance, and history in the context of Indian painting is the masterful sequence from Udaipur depicting Maharana Jagat Singh II of Mewar enjoying an elaborate performance of the rasalila dance drama (cats. 82–83). Traveling theater and dance troupes performing the rasalila as a series of plays are documented from at least the seventeenth century, and the performances could last from several days to a month.[9] While recording such performances was not unknown,

Fig. 1 Procession of Ram Singh II of Kota, approx. 1850. India; Rajasthan state, Kota. *Victoria & Albert Museum, Given by Colonel T. G. Gayer-Anderson, CMG, DSO, and his twin brother Major R. G. Gayer- Anderson, Pasha,* IS. 564-1952.

Fig. 2 Procession of Ram Singh II of Kota, approx. 1850 (fig. 1, detail).

the scale and dedication required to capture this particularly lengthy and elaborate performance was an extraordinary feat. The Udaipur series consists of at least ten (possibly more) large paintings, each depicting a different *lila* (play or sport). Some are recognizable as particular episodes from Krishna's life; others record actors portraying the gods Ganesha, Balarama, or Indra dancing exuberantly in the maharana's presence.

Consuming these images, which combine multiple views of a particular historic event, is itself a performative act. While "serial multiplicity" (where one painting would encapsulate multiple scenes or sequences of events) was often employed in Udaipur painting, rarely would one event be represented through multiple images.[10] Here, though, we have a series of monumental paintings, each capturing a single lila or dance event. In each, the maharana is seated in a dazzling white marble courtyard, surrounded by attendants and noblemen and under the light of a full moon. The palace is shown from

multiple points of view: from the exterior street below, up toward the manicured gardens, the interior arched hallways leading into other courtyards and apartments, and, finally, the Mor Chowk (Peacock Courtyard), which is animated by this elaborate performance.[11] The opulent setting, rich and vibrant palette, and multiplicity of the paintings shape our reception: the series is grand, extravagant, and likely demonstrative of the maharana's desired presentation. The performance occurred in the month of Karttika (October–November) 1736, but the series was likely painted four years later, around 1740.[12] Such a temporal discrepancy is not unknown in Udaipur painting; it does, however, call into question the motives behind recording *this* event. Was this particular performance so riveting and indeed transformative that it was considered relevant to record four years later? Did the commission of this elaborate series take years to fulfill? Or did the symbolic performance—the meaning behind the act—lend the event a weight of historic importance?

The temporal sequence within each painting of this series is also interesting to consider. Jagat Singh is seen smoking different hookahs in several of the paintings, which hints at the passage of time and length of performance. In a rasalila performance, the circular dance of Krishna and the cowherd women may be accompanied by any combination of other episodes from the life of Krishna. These episodes need not follow a linear pattern, as the stories themselves were often familiar to the audiences and would be accompanied by songs with descriptive narrative lyrics. Likewise, within a particular painting, the temporal sequence of a dance may remain undefined. In a painting that may depict the Brahma Lila (cat. 82), the actor playing the god is seen three times: conversing with the cowherd women, dancing independently, and clasping the hand of the maharana's young son, Prince Bhim Singh. In the Brahma Lila, the god makes a congratulatory visit to Krishna's foster parents, Nanda and Yashoda. They honor the god with myriad gifts, but he only accepts a piece of yellow cloth in which the baby was once wrapped.[13] Here Brahma is dressed in a yellow dhoti (fig. 3), creating connection to narrative but leaving the sequential understanding of dance ambiguous. To picture performance, the language of dance must be legible to the artist who depicts the dance as well as the viewer who receives it.[14]

If, as we assume, Maharana Jagat Singh II commissioned the series of paintings, what was his motivation? James Tod,

Fig. 3 Maharana Jagat Singh II and nobles watching the rasalila dance drama, approx. 1736–1740 (cat. 82, detail).

Fig. 4 Maharana Jagat Singh II watching the rasalila dance drama, approx. 1736–1740 (cat. 83, detail).

the emissary of the East India Company resident in Rajasthan from 1818 to 1823 who penned a history of Rajasthan dappled with local memory, first-person accounts, and his own observations, described Jagat Singh as one of several maharanas of Mewar who was determined "to be happy amidst calamity" and who had an addiction to "festivals devoted to idleness and dissipation."[15] Rereading Tod today through the lens of postcolonial scholarship and decentered readings of colonial India, the implied value judgment of an East India Company officer at the Udaipur court is difficult to ignore, especially as Tod himself dismissed many of the Mewar rulers as indolent and addicted to pleasure. And yet the court was experiencing a period of political and economic decline in the eighteenth century, with incursions from the Marathas threatening both its territory and its coffers.[16] It could very well be that hosting an elaborate performance was a diversionary tactic: a moment to escape the realities of decline.[17]

Another theory could see the maharana's pronounced enthrallment with the rasalila plays as a form of personal connection and devotion to Krishna, where worship is sometimes enacted through performing his life events.[18] A second page from this monumental series features Radha and Krishna displayed three times: standing among the cowherd women, standing together under a gold canopy, and again as they perform a whirling dance (fig. 4 and cat. 83). As the other cowherd women stand nearby, unmoving, one imagines the dance of Radha and Krishna as one of connection, their swirling bodies

Fig. 5 The story of Krishna enacted before Jagat Singh II, 1736. India; Rajasthan state, Udaipur. *San Diego Museum of Art, Edwin Binney 3rd Collection*, 1990.623.

Fig. 6 The story of Krishna enacted before Jagat Singh II, 1736 (fig. 5, detail).

Fig. 7 Maharana Ari Singh performs puja in Amar Vilas, 1765, by Shambhu. India; Rajasthan state, Udaipur. *Freer Gallery of Art / Smithsonian National Museum of Asian Art, Purchase—Charles Lang Freer Endowment, F1986.7.*

symbolizing an intimacy that references that between a devotee and their god. A third painting from the series depicts Krishna twice, once carrying a staff and again dancing with exuberance with a larger group of cowherd women (fig. 5). The animated group they form is the closest approximation to the circular dance of divine love presented in this series (fig. 6). Indeed, it is interesting to note that no painting recording the circular dance of Krishna with the cowherd women from this series is known. It seems surprising that such an elaborate, painstaking recording of performance does not include this pivotal dance, and one can only assume it was lost as opposed to left unrecorded. When considered in its entirety, this series of paintings (which, again, numbers ten or more) was an ambitious undertaking to commission within the first few years of Jagat Singh II's reign. Though we cannot pinpoint an exact reason behind its creation, we can deduce that the commission was likely defined by an attempt to legitimize the maharana's role as a political ruler, a devoted man, and a patron of the arts.

Another similarly grand painting from Udaipur that combines dance, devotion, and a clear articulation of the ruler's power shows Maharana Ari Singh performing puja (p. 46 and fig. 7). Here, the ruler is at worship before an enthroned linga, an aniconic form of Shiva, while seated in a crowded arched courtyard of the City Palace. Situated below the ruler, in an open courtyard and to the right of the water feature and bountiful trees, are a group of musicians and two dancers. The dancers are not depicted in recognizable postures and instead stand

with arms outstretched, gazing toward the ruler. As dance was an important part of devotional practice and the dissemination of religious beliefs through narrative-based performances in temples and at court, as well as a way to honor or entertain the god, the inclusion of dancers here has great merit. However, this painting, with its large size, crowded composition, and opulent use of gold, is not strictly about dance. Nor, ostensibly, is it only about the ruler's devotion. Similar to the series of rasalila paintings already discussed, this work likely speaks to the calculated portrayal of a ruler in the seat of power in an unsettled period.[19] Court-sponsored dance performances in honor of the god derive merit for the ruler, and the act of including dancers in his devotional practice further underscores his perceived piety. By manipulating the convention of court painting into what presents itself as court reportage, Ari Singh endeavored to authenticate his position through the assertion of his virtues, his values, and his interests.

The patron's outsized role in their production makes court paintings unreliable historic records. But what of the motivation of the artist? Does an artist capture and record performance with an impartial eye? How does artistic agency and agenda actualize dance representation? Capturing movement in static imagery is most likely a mélange of memorable episodes, moments, and expressions conveyed in a dance event, as opposed to a single punctuated moment in time.[20] The result is an unavoidable posed quality even in attempts to capture movement.[21] When confronted with quirky and unexpected compositions that represent dance at court—paintings that wholly or in part subvert dominant and comparatively formal visual languages—there is an interesting intersection of patronage, artistic agency, and authenticity of record to consider.[22] This can be seen in two Udaipur paintings: one showing Maharana Jai Singh and Prince Amar Singh watching acrobatics (fig. 8), another depicting Maharana Amar Singh II, Prince Sangram Singh, and courtiers at a performance (cat. 86). In both compositions, the ruler, heir apparent, and nobles are presented formally within an enclosed architectural milieu.[23] Columns articulate space and compartmentalize the ruler and heir apparent, as well as, separately, those in attendance. This formal presentation is incongruously joined by an open field of acrobats, dancers, and acts of debauchery.[24] These works display a freedom of expression, a whiff of intoxication, and plenty of individual antics to explore.

Fig. 8 Maharana Jai Singh and Prince Amar Singh at an acrobatic performance, c. 1685. India; Rajasthan state, Udaipur. *Harvard Art Museums/Arthur M. Sackler Museum, Gift in gratitude to John Coolidge, Gift of Leslie Cheek, Jr., Anonymous Fund in memory of Henry Berg, Louise Haskell Daly, Alpheus Hyatt, Richard Norton Memorial Funds and through the generosity of Albert H. Gordon and Emily Rauh Pulitzer; formerly in the collection of Stuart Cary Welch, Jr., Cambridge, MA, 1995.77.*

Looking in detail first at the painting of the acrobatic performance, the composition follows late seventeenth-century Udaipur painting convention. Bold colors are used to articulate space with little modeling or recession, and static and staid figures in the ruler's attendance are arranged in a line. Below, two female musicians (one playing cymbals, the other a drum) are surrounded by undulating figures who contort their bodies. One manages to smoke the hookah he has cradled in his left hand while bending deeply at the knees. Another male figure clutches a woman in a close embrace, an unexpected intimacy amidst the surrounding figures. Despite the decorous presentation of the ruler, the performers are in a state of frenzy. The compact compositional format adds to this state, as the

Fig. 9 Maharana Jai Singh and Prince Amar Singh at an acrobatic performance, c. 1685 (fig. 8, detail).

Fig. 10 Maharana Amar Singh II, Prince Sangram Singh, and courtiers watching a performance, approx. 1705–1708 (cat. 86, detail).

teeming life of the performers is barely contained by the conventional painted borders.

By about 1705–08, when the painting of Maharana Amar Singh II, Prince Sangram Singh, and the courtiers was likely created, the formal presentation of seated ruler and retinue would have already become a dated compositional format.[25] And yet here he is, seated formally in mimicry of a previous composition but on a monumental scale. A female acrobat balances atop a pole, with male musicians below. Couples dance and embrace, scattered across a large picture plane. To

the right stand soldiers carrying arms with a line of horses and elephants behind them. These figures are as formally presented as the ruler, his son, and retinue. Together they assert authority among figures that otherwise operate outside expected court etiquette.

Amar Singh is presented in both paintings, dated around twenty years apart: first as a young prince and later as a king (figs. 9–10). In the intervening years, the Udaipur court had experienced great turmoil, much of it by his hands.[26] Re-creating a painting in a deliberately outdated style and

positioning himself with his son to mirror the patrilineal connections evident in an earlier composition may have been an assertion of the maharana's position on the throne—and a personal testament to the rocky relationship with his father. It is very possible that Amar Singh and his son Sangram Singh did not witness a dance and acrobatic performance of this nature but that the workshop was instructed to convey a more elaborate version of the painted performance that occurred around 1685 for Jai Singh. Whether or not this performance occurred, one imagines that the authorial voice (and imagination) of the artist, under the directive of his patron, was allowed to dominate.

The Activated Space

Court paintings that portray dance express the opulence and power of a particular ruler, hint at his devotional tendencies, and uphold his dedication to the arts. They also reveal how performance functioned within a palace setting—including the physical spaces activated by dance, how that space is conveyed, and the position and proximity of the dancers to the ruler. Performance spaces were not always formal, and presentations often occurred in lavish courtyards, with or without a floor covering or a temporary platform. These multipurpose palace localities were then activated through performance as well as the rules and regulations that governed the movement of people through public and private palace spaces.

In many instances, paintings that record dance show large, expansive vistas that provide a rich architectural backdrop for the performance. These images portray dance from a great distance, often a bird's-eye view, and incorporate dance into the larger performative nature of court life. Maharana Jagat Singh II's rasalila set (figs. 3–6; cats. 82–83) and the painting of Maharana Ari Singh performing puja (fig. 7) all explore how dance performance was integrated into devotional practices at court. This expansive presentation of space was also utilized in paintings from Udaipur that portray celebratory dance—that is, dance that does not overtly convey narrative, devotion, or a larger theatrical performance.[27] A work showing Maharana Ari Singh with his courtiers at the Jagniwas Lake Palace (cat. 85) was painted in 1767 and attributed to Bhima, Kesu Ram, Bhopa, and Nathu, all established artists in the Udaipur court workshop who were well versed in this large-scale pictorial approach

Fig. 11 Maharana Ari Singh with his courtiers being entertained at the Jagniwas Water Palace, 1767; attributed to Bhima, Kesu Ram, Bhopa, and Nathu (cat. 84, detail).

to presenting court life.[28] The performance is displayed from above in a composition that both expands and contracts: the grand viewpoint is also focused on one section of Jagniwas and does not convey the architectural space in its entirety.[29] The white marble contrasts effectively with the gray (once silver) of Lake Pichola, isolating Jagniwas in space and lending a sense of intimacy and exclusivity to the scene. The many dancers, male and female, crowd a checkerboard courtyard (fig. 11). Some dance or sit in pairs or threesomes with arms outstretched and legs active under their long skirts. Several clutch daggers in their outstretched hands, perhaps to symbolize the importance of weaponry in the martial life and culture of the Sisodias, the ruling family of Mewar centered at Udaipur.[30] Nine dancers form a circle around a couple (not unlike the rasalila), who twirl while leaning back and clasping hands.

The activated space is teeming with movement and expression, and the dancers impart a sense of rhythm to the composition. The eye is guided to follow the performers as they move and turn through time and space.[31] The maharana is seen twice: seated on a low platform, watching the performance through an archway; and elevated (as expected) above the dancers and surrounded by noblemen, his progeny in a line before him. The temporal sequencing of these portraits is unrecorded, but there are several visual cues that connect the ruler to his enjoyment of dance. Seated in the archway, he has an intimate view of the performance. Several of the musicians and singers and many

Fig. 12 Sansar Chand celebrating a festival of Krishna, c. 1790. India; Himachal Pradesh state, Punjab Hills, Kangra. *National Museum of India, New Delhi,* 62.2389.

of the dancers face toward the ruler; he, in turn, directs his gaze to the activated space. For such an expansive architectural scene, there is a sense of connection between patron and performance: Ari Singh watches the dance while his courtiers, standing along the far wall of the performance space, watch him being danced at, to, or for. In the second portrait, he is seated regally and surrounded by multiple noblemen and courtiers who all direct their gaze at him. Less intimate in nature, this formal seated posture aggrandizes his status and creates a sense of distance between ruler and the performance.

When dance and performance are wielded as symbols to convey the complexity of power at court, the overall effect is often one of opulence and extreme wealth. And yet there exist many scenes of dance that were created on a much more intimate level, where the observer is clearly connected to the activated performance space. A work presenting Raja Prithvi Singh of Orchha watching a performance of Krishna's dance with the cowherd women (cat. 81) was likely painted at the kingdom of Datia in Madhya Pradesh around 1750. It portrays the ruler in an unadorned courtyard setting with a white canopy above and two low thrones to the right of the composition. Prithvi Singh—portrayed at a larger scale than the dancers, musicians, and court attendants wielding torches—stands in the foreground with his hands folded in a gesture of reverence before

a troupe of itinerant performers. The dancers are depicted mid-performance under a separate cloth canopy, likely in the midst of the "dance of divine love," wherein Krishna multiplies himself to dance with all of the cowherd women at once. While the event is portrayed as an unembellished scene, hosting a traveling dance troupe is itself a demonstration of the ruler's wealth: he will house, feed, and pay the performers during their stay. It is also a demonstration of his cultured status: Prithvi Singh is seen as a strong proponent of dance and the theater arts as well as a devotee of Krishna. Much like the grand paintings already considered, this intimate scene conveys a heavily constructed message, recording how Prithvi Singh aspired to be perceived.

Another intimate court scene, this time of Sansar Chand celebrating a festival of Krishna (fig. 12), explores how compositional format, the careful placement of figures, and loaded imagery are all calculated cues of presentation. The scene is viewed through a set of architectural archways, which act to demarcate space. Within the central archway, Sansar Chand is accompanied by his brother Fateh Chand, who holds the heir apparent, Sansar Chand's son Anirudh. The ruler, significantly larger in size, occupies a place of importance: at the center of the composition, smoking a hookah, and in close proximity to the shrine, which is framed by two priests. Sansar Chand was

a devout follower of Krishna, and the compositional framing highlights his role as both devotee and royal patron.[32] Mostly enclosed within the left arch are a troupe of animated musicians and expressive dancers. The column obscures the dancers, whose bodies writhe and undulate to the music, creating highly expressive movements not always witnessed at the later north Indian courts. The sinuous candle flames, flower garlands, decorative hangings, and the gentle curve of the hookah tube all embody and add to this sense of movement. While the dancers, and to a lesser extent the musicians, are the most lively figures present, the composition is not focused on them or their performance. These smaller, focused compositions offer an intimate view of the royal culture of the Punjab Hills, as opposed to the larger and more expansive "contextual portraiture" we have explored from the Rajasthani courts.[33] And yet, the symbolism of royalty remains pronounced in both.

Alternative Structures of Power

The paintings discussed thus far reveal a record of dance contained within scenes of courtly life that reinforce an individual ruler's preferred narrative and aspirational political stature. To pivot now from patron to performer, there is much to understand about the position of the dancer and the power that dance and performance could wield.[34] Much of the court hierarchy and protocol practiced in the courts of Rajasthan and the Punjab Hills mimicked those established by the Mughal empire. Firsthand Mughal accounts, including the imperial memoirs the *Baburnama* and *Akbarnama*, contain detailed descriptions that disclose the movement, position, and role of courtesans (often trained as dancers and performers) within the strict Mughal social structure. While such record-keeping was not nearly as robust as it was at the Hindu Rajput courts, it appears that the social position of dancers, singers, musicians, and performers within the dominant court structures of north India was often shared.[35]

Obtaining, maintaining, and trading female dancers was a desirable symbol of status at the Sultanate, Mughal, and Rajput courts, one that was often preceded by political upheaval.[36] This movement of skilled labor—of individuals—occurred between different Rajput courts as well as between Mughal and Rajput courts.[37] Whole communities of dancers and musicians could be imprisoned or transported as political bounty; others would

travel of their own volition. The commodification of dance, music, and performance regulated political power relationships, just as the transfer of performers between courts occurred as part of entrenched hierarchical systems.[38] And yet these performers gained prominence and privilege within such systems, depending on their proximity (and intimacy) with the dominant rulers.[39] Elite members of courtesan communities were trained to master other aspects of respectable society, such as reciting and writing poetry, enacting court etiquette, managing independent wealth, owning property, and wielding political influence. The social position of a courtesan could at times be leveraged to transcend the strict boundaries of patriarchal societies to create alternate lineages within cultural realms.

The movement of performers, whether forced or of free will, encouraged the dispersal of dance styles throughout a large region. This influx of new influences meant that painters and other artists associated with the court were also likely privy to multiple and varied dance and music traditions. A work from about 1750 showing Raja Tedhi Singh of Kulu being entertained by dancers and musicians presents a peripatetic troupe who have arrived at court to perform (fig. 13 and cat. 87). The raja is seated on a low throne against a large flower-patterned bolster with a falcon perched on his gloved right hand.[40] The significantly smaller forms of the female dancers may indicate their positioning as both women and visitors at the court. Alternatively, it may reference their youth; peripatetic dancing troupes in north India often employed young performers, dedicated to their art form since early childhood.

The inscription in the upper red border identifies the figures present. The raja is greeted by a figure named Singh Rae, whose hands are clasped in a respectful greeting, while the musicians and dancers who stand nearby are identified, collectively, as a *kanchani* troupe (fig. 13). Such a troupe typically consisted of male musicians accompanying female performers who sang and danced.[41] Female kanchani performers belonged, in many ways, to a male world. They lived outside the court and provided services for payment; some performed at royal functions, some at the weddings of noblemen, and some danced in city centers. The kanchani dance troupe was not part of the larger elite social structure at the court of Raja Tedhi Singh, and they should instead be classified as autonomous, itinerant agents; the male musicians and female dancers were able to move freely between the male-dominated space at court and

Fig. 13 Raja Tedhi Singh of Kulu entertained by dancers and musicians, approx. 1750 (cat. 87).

the rest of society. This freedom can be understood as a conscious mode of self-representation, a "self-fashioning" of identity through performance and social mobility.[42]

In many ways, the space that delineated female and male spheres at the north Indian courts was exemplified by the freedoms or restrictions placed on skilled courtesans. Distinct categories of female dancers performed in different realms, and rare was the woman who crossed between the confines of these male and female spaces—such as the zenana, an intimate space shared by ruler and women.[43] A painting of Maharaja Bakhat Singh and Prince Vijai Singh (fig. 14) offers a glimpse into both life in the zenana and the complicated power structures that continued to exist even in this more secluded part of the palace. The heir apparent of the Jodhpur throne is presented to his father, who is seated under a canopy

Fig. 14 Musical merriment for Maharaja Bakhat Singh and Prince Vijai Singh, approx. 1736. India; Rajasthan state, Marwar, Nagaur. *Mehrangarh Museum Trust, Jodhpur.*

surrounded by women during a dance performance. The two men—the only ones in the scene—are positioned facing each other on a large marble courtyard terrace. The delicate and detailed architecture of the palace, from the backdrop of arched pavilions to the formal garden in the foreground, is intricately portrayed. The musicians and dancer are behind the prince, performing, one assumes, for the ruler and not his heir, whose back is to the performance. The composition, both an intimate foray into the zenana and an extravagant vista of the architectural space, requires an active decoding on the part of the viewer. The painting appears to position the women of the zenana as active participants in an intimate interaction between two figures of authority. And yet, the multiplicity of the women in attendance, most notably the long line of figures in the foreground, removes any marker of intimacy, or individualization, and commodifies their presence. They are, collectively, a wealth of abundance in the service of Maharaja Bakhat Singh. Likewise, the position of the heir further minimizes the role of dance in this scene, as the performance seems to occur primarily to mark and aggrandize the encounter.

If female performers operated within alternate structures of power at court through their proximity to the ruler, the possession of property, and their political influence, how and where is that demonstrated within the pictorial record? The performers discussed thus far represent the "anonymous ideals" of the female figure that dominate north Indian court painting.[44] While not unknown, it is rare to encounter an individualized courtesan in a painting or to witness an intimate exchange between ruler and courtesan in a painted performance.[45] Since music and dance have the ability to arouse emotion, or *rasa*, in the body of the listener, the visceral power of such performance has the potential to overwhelm a man's self-control. In Indo-Persian historical and literary materials, the protagonist's love of wine, women, and music is often used to signal his imminent downfall; indulging was perceived as a potential threat to masculine control, and the effort required to overcome such temptation is lauded as a strength. Seduction embodied in the figure of the courtesan posed a threat to normative codes of behavior and, in turn, the social and political order.[46] And so this sexual potential of the courtesan is, in effect, often left unrecorded.

The drawing of Mian Zorawar Singh watching a woman dancing (fig. 15) is one of the few works portraying dance from

Fig. 15 Mian Zorawar Singh watching the dancing girl Zafar, approx. 1740–1745, attributed to Nainsukh. India; Himachal Pradesh state, Guler. *Government Museum and Art Gallery, Chandigarh*, 419/23.

the period under discussion that seems to be aimed at arousing the senses. Here, the ruler, holding a hookah tube, sits posed in suspended animation as he gazes at the dancer. Written in Takri by two separate hands, the inscription names her as Zafar, "who is giving an emotionally charged performance and not even taking a penny."[47] Zafar's gaze is lowered, and her body is in motion. Behind her, three male musicians lean forward with a sense of urgency as they play, conveying the mood of love and creating a sense of expectation as they, too, watch the dancer's movements. It is through the portrayal of the musicians, and not the patron, that we sense love, lust, and expectation. The inscription describes Zafar's dance through the lens of economic transaction: we are to assume that, by "not even taking a penny," she performs a dance imbued with passion, one that comes from a place of emotional connection that transcends her position at court. Rather, the courtesan controlled performance through her body, song, and skilled arts, and through this, she was able to actively manipulate performance to gain emotional power.

The successful ways in which courtesans could wield that emotional power can and should be read as a conscious subversion of male-dominated power hierarchies at court.[48] The aesthetics of this image hint at an alternative pictorial record that divulges the sensuous experiences embodied by dance.

Fig. 16 Dancing villagers, approx. 1730 (cat. 111, detail).

Conclusion

Dance is a fugitive art form, and there is no fully reliable way to record performance. It is unstable, based on memory, and the artwork created in its image is affected by human error, artistic interpretation, and, in the case of the later north Indian courts, the whims of a dominating patron. And yet perhaps the ephemerality of dance is part of its virtue, where—much like the intensity of human emotion—there is no guarantee of repeatability or permanence.[49]

Most of the paintings discussed in this essay include historic personalities within grand architectural contexts in which to situate dance. But what of works that forefront dance untethered from a recognized location, event, or time? A painting of dancing villagers, made about 1730 at Guler, does just that (fig. 16). Previous publications have described this painting as portraying dancing dervishes, and yet neither description captures the expressive nature of the composition. Seven male dancers move with abandon to the tune of four musicians. Arms extended and knees bent, these animated figures are positioned against a monochromatic red backdrop, with only a hint of ground below and elevated horizon line above. There is an intensity and dedication to movement, if not a subtle rhythm and organized presentation. Here, dance is not in the context of court, personage, theater, or larger presentation but the image itself and in its entirety. In this portrayal, we could be witnessing an organized or spontaneous dance; dance that represents a freedom of movement and abandonment of protocol;

an imaginative scene of physical release; or perhaps a combination of all of the above.

Attempting to create a record of dance through the medium of painting is in itself flawed; it is better, perhaps, to celebrate court painting as "a multiplicity of authorial voices contextualizing historical events."[50] Some of those voices were present at specific performances; others manipulated the historic record after the fact. The effort should not be in recording performance but in exploring the role of dance in the performative nature of court.

This essay is dedicated to the memory of my dear friend and mentor Jerry Losty (1945–2021). May his kindness, intelligence, and humor live on through his family and loved ones.

The title of this essay is inspired by the work of Thomas F. Heck, whose edited volume *Picturing Performance: The Iconography of the Performing Arts in Concept and Practice* (Rochester, NY: University of Rochester Press, 1999) is instrumental in my understanding of the complexities involved in "reading" art, performance, dance, and history.

I am indebted to Catherine Glynn, Holly Shaffer, and Nathaniel M. Stein who each read and commented on early drafts of this essay.

1. See, among others, Wade, *Imaging Sound*; Schofield, "Courtesan Tale"; and Brown, "If Music Be the Food of Love." This essay is indebted to this scholarship and will pivot to focus on the Hindu courts of Rajasthan and the Punjab Hills.

2. Kapila Vatsyayan's impressive body of scholarship explores the artistic imagery of dance in India predominantly through a reading of dance poses and postures, tracing a history of dance from the *Natyasastras*—a treatise on the performing arts written around the second century CE and later translated into Sanskrit—through to modern Bharatanatyam, kathak, Odissi, and other established dance traditions. See Vatsyayan, *Classical Indian Dance*; Vatsyayan, *Dance in Indian Painting*; and Vatsyayan, "Arrested Movement of Dance," 22–25. For work by dance theorists who propose readings that move beyond linear and descriptive narratives of dance history, see Seebass, "Iconography and Dance Research"; Heck, *Picturing Performance*; and Sparshott, *Measured Pace*.

3. See Desai, "Timeless Symbols," where the author coined the phrase "contextual portraiture" to explore large, expansive Rajput portraits. Desai discusses Mewar's large panoramic scenes in depth as "conceptual rather than perceptual" interpretations of life at court, a reading that is adaptable and relevant for many of the works under discussion here.

4. Aitken, *Intelligence of Tradition*, 113: "Rajput portraiture operated through a precise balance of what one might call witness-effect, the semblance of something reported as it was, and rhetorical structuring intended to convey relationships of power."

5. While not every court and fiefdom in north India had a workshop of painters in constant employ, many did. For information on the workshop system in Rajasthan and Himachal Pradesh, see Cameron, *Drawn from Courtly India*, 25–35.

6. Khera, *Place of Many Moods*, 89–113.

7. Heck, *Picturing Performance*, 79–80; and Van Zile, "Interpreting the Historical Record," 168.

8. Contemporary thinker on historical dance research Susan Manning as quoted in Van Zile, "Interpreting the Historical Record," 154: "An event bound in space and time, a performance can only be read through its traces—on the page, in memory, on film, in the archive. Each of these traces marks, indeed, distorts, the event of performance, and so the scholar pursues what remains elusive as if moving through an endless series of distorting reflections. But this pursuit leaves its own sort of illumination, and that illumination is what the scholar records, in effect penning a journal into the process of inquiry."

9. As recorded in Dimock, *Place of the Hidden Moon*; and Singer, *Krishna Myths, Rites, and Attitudes*; and summarized in Vatsyayan, *Dance in Indian Painting*, 136. Vatsyayan also asserts that sequential, episodic theater performances influenced the compositional patterning of paintings as "pictorial counterparts of the dramatic practices" seen first in the sequential tradition of paintings in a Ramayana manuscript and later in the form of scroll paintings from Bengal and Pabuji cloth-stories in Rajasthan.

10. Topsfield, *Court Painting at Udaipur*, 156; and Dehejia, "Treatment of Narrative in Jagat Singh's 'Rāmāyaṇa.'"

11. Topsfield, *Court Painting*, 156. The palace courtyard (now known as the Mor Chowk) is shown in both extension and recession throughout the series.

12. Topsfield, "Udaipur Paintings of the Raslila," 58. Topsfield was the first scholar to speculate that this set of paintings was likely created four years after the performance it records; he bases this date on the age and appearance of Prince Pratap Singh, portrayed in each painting alongside the ruler.

13. Hein, *Miracle Plays of Mathurā*, 173. The possible attribution to the Brahma Lila is based on an iconographic comparison between the painting and Hein's description of various lilas that could feature in performance (Hein, *Miracle Plays of Mathurā*, 165–78). While many of these lilas were recorded in the Bhagavata Purana or other texts, no textual reference is provided for the Brahma Lila. Of course, Hein was studying later dance and theater performances than those presented in the paintings under consideration, but elements of the traditions he studied likely resonated with those practiced at Udaipur.

14. Seebass, "Iconography and Dance Research," 35–36. Seebass refers to this two-level understanding of dance as "kinemic recognition": the creation of units of gestural expression as combined with their study and comprehension. As here, Seebass describes how, if the positions/movement depicted are insufficient to identify dance, the props (headdresses, costumes, scarfs, weapons, objects) can be used to do so. This reading, however, does not describe the dance itself; only the dance's function.

15. Tod, *Annals and Antiquities of Rajasthan* [1971], 1, 363.

16. Topsfield, "Udaipur Paintings of the Raslila," 55. During the same year as this performance (1736) Jagat Singh was forced to receive the Maratha ruler Baji Rao and agree to pay him tribute. See Hooja, *History of Rajasthan*, 697–704, for historical context, and Khera, *Place of Many Moods*, 5, for a discussion of how Tod's writing both maligned the Mewar rulers and romanticized its environment and the concept of court culture.

17. See Shaffer, "Take All of Them," 73, for a discussion of the use of devotional practices in royal aggrandizement.

18. Topsfield, *Court Painting*, 156. As eloquently expressed by Kishan Lal Rasdhari of Vrindaban and paraphrased by Hein, *Miracle Plays of Mathurā*, 130: "All who have love for Krishna in their hearts are gopis, regardless of their sex. Krishna is the true object of their love, their real 'husband.' The most urgent business of their lives is to search for the Lord through the jungle of this world until they find him. Like the gopis of old, we should express our affection and longing for Krishna by performing and seeing the imitation of his lilas. And as Krishna himself soon appeared before those cowherd girls who rehearsed dramatically his greatness and charm, we too, through hearing and seeing his lilas, will sooner be blessed by the beatific vision (darśán) of Krishna himself."

19. Hooja, *History of Rajasthan*, 697–704: The Maratha threat had reached a new height during Ari Singh's reign, when Holkar and Scindia, two leaders of Maratha armies, attacked Mewar repeatedly to collect arrears in tribute from the Udaipur court.

20. Fermor, "On the Question of Pictorial 'Evidence'"; and Smith, "Dance Iconography."

21. Smith, "Dance Iconography," 120–21. The assumption that a visual representation of dance is a representation of reality or lived experience is extremely problematic and "reflects an unabashedly twentieth-century mentality, formed and informed by the phenomenon of the photograph." See also the discussion of photography and dance in this publication (cats. 93–97) for further ruminations on capturing movement in static forms.

22. Likewise, "the observer effect" influences artistic output in that the act of witnessing an event causes a change in the event, and knowing the dance is being recorded alters the performance. See Smith, "Dance Iconography," 120–21.

23. This compositional format was well known at Udaipur and was also utilized in a *Suryavamsha* series (a genealogical series of paintings recording the solar dynasty of Mewar), painted about 1690; of particular note, see *Maharana Raj Singh in darbar*, folio. 231, painted by Tasahi, City Palace Museum, Udaipur; published in Topsfield, *Court Painting*, fig. 79.

24. Acrobatic performances are closely related to dance and the theater arts and are often on offer from performers in itinerant troupes: "an all-inclusive spectacle where a variety of physical skills can be used creatively." See Vatsyayan, *Dance in Indian Painting*, 123.

25. Amar Singh (r. 1698–1710) was responsible for one of the most innovative and creative court workshops in Udaipur's history, where the leading artist created beautiful and detailed works in a grisaille style. See Aitken, *Intelligence of Tradition*, 57–109; and Glynn, "Stipple Master," 515–30, for descriptions of this artist.

26. Amar Singh rebelled against his father Jai Singh, established the fiefdom of Rajnagar, absconded to Bundi, and returned to Udaipur to occupy the throne. See Hooja, *History of Rajasthan*, 697–704, for historical context.

27. For further examples, see V&A Museum (IS.77-1990); National Museum of Asian Art, Smithsonian Institution, (F2000.17); and National Gallery of Victoria, Melbourne (AS183-1980).

28. Topsfield, *Court Painting*, 208. The large-scale paintings at Udaipur that incorporate architecture (interiors combined with courtyard settings) and Lake Palace subjects had been in vogue since the reigns of Maharana Sangram Singh (1710–1734) and Maharana Jagat Singh II (1734–1773). And yet this work is a remarkable and effective late take on the form. It references an idyllic final flourishing of the genre; in just a few years, this opulent and expansive genre of painting ceased to exist.

29. See Khera, *Place of Many Moods*, 93–113, for a discussion of Lake Palace architectural abodes as spaces for leisure activities.

30. Rachel Parikh has explored both the importance of weaponry in Rajput culture and how the dagger called a *katar* could also have links to the deity Durga; Rachel Parikh, email to the author, November 10, 2020. Celebrations surrounding the goddess (Durga Puja, Navratri celebrations) often incorporate the katar as it is one of Durga's weapons and used in battle against the demon Mahishasura. Mrinalini Rajagopalan furthered these ideas and considered whether the dancers could be paying tribute

to the Sisodia lineage through their dance while the maharana's sons are presented to him above; Mrinalini Rajagopalan, in conversation with the author, April 6, 2021. Rajagopalan also introduced me to another painting with female dancers clutching katars: British Library (Add.Or.2522).

31. Seebass, "Iconography and Dance Research," 44. While time and space are categorically different, "artists can give the illusion of temporality to their image by superimposing the awareness of kinetic succession on a planometric base."

32. Desai, *Life at Court*, 112. This painting is likely a representation of the festival of Phul-dol ("swing of flowers"), celebrated by rocking Krishna on a flower-covered swing and connected to the festival of Holi. The joyous atmosphere portrayed indicates that the artist captured events that likely occurred later in the evening, after the *shayana darshana* ceremony, when the god is put to bed and delicate curtains are placed in front of the shrine for the night.

33. Desai, "Timeless Symbols," 331. Two further paintings from the Punjab Hills that follow a similar treatment of space to depict dance at court are: *Young Raja Raj Singh of Chamba Watching a Dance Performance*, c. 1772, Gujarat Museum Society, Ahmedabad, published in Beach, Fischer, and Goswamy, *Masters of Indian Painting*, 2:715; and *Raja Sansar Chand with His Small Son and Courtiers*, c. 1800, Philadelphia Museum of Art (1955-11-3).

34. While much of it is beyond the scope of this essay, numerous studies of courtesans offer a unique view into class and gender relations at India's royal courts. These long and complex histories connect to communities of women such as *tawa'ifs* (royal courtesans) and *devadasis* (temple courtesans) and record how during the eighteenth and nineteenth centuries these communities were culturally debased and subjected to harsh colonial regulation and nationalist moral crusades. Recent scholarship has recentered the narrative around female agency and self-representation. See Schofield, "Courtesan Tale"; Jha, "Tawa'if as Poet and Patron"; Malhotra, "Bhakti and the Gendered Self"; Oldenburg, "Lifestyle as Resistance"; Qureshi, "Female Agency and Patrilineal Constraints"; and Srinivasan, "Royalty's Courtesans." See also Orr, *Donors, Devotees, and Daughters of the Gods*, 3–17, for a thorough discussion of how the history of devadasis and temple women has oft been written. Women with agency, position, and power in the medieval period and beyond are often understood through the positionality of women in the nineteenth and twentieth centuries, distorting the historic record.

35. Sreenivasan, "Drudges, Dancing Girls, Concubines," 136. The author identifies disparate standards of record keeping, the nature of the archive, and the complicated history of discussing women in public in Rajasthani society as reasons for the dearth of information in court accounts.

36. Wade, *Imaging Sound*, 84. As one example among many, and as recorded in the *Baburnama*, the treasure Babur gained from the defeat of Sultan Ibrahim Lodi included gold, silver, jewels, and slaves, including "dancing girls."

37. Sreenivasan, "Drudges, Dancing Girls, Concubines," 142. Rajput rulers went to great lengths to acquire skilled performers. As one example among many, in the seventeenth century Maharaja Jaswant Singh of Jodhpur was sent to Jamrod in present-day Afghanistan by the Mughal emperor. As recorded in the Register of the Jodhpur State, he there obtained ten fine singing women (*gayin*) between 1668 and 1672 whom he sent back to his zenana in Jodhpur.

38. Sreenivasan, "Drudges, Dancing Girls, Concubines," 142–43. The author defines the courts as having a type of slave pyramid, with skilled performers near the top. Variations in terminology denoted different skills and functions, as well as different positions in the household hierarchy. These categories included female slave-performers (*patars*), usually dancers; female slave-performers who also sang (*olagani*); and female slaves who were elevated to the rank of concubine (*khavasin* or *pasvan*). This mirrors the work of Katherine Butler Schofield, who has defined three broad categories of female performers at the Mughal court, each encompassing a number of communities and categorized by the space they were customarily permitted to perform within: those who performed in the zenana only (which included sexual exchange); those who were given "cultural sanction" to perform in both male and female spaces (no sexual exchange); and those who performed only in male spaces (sexual exchange). See Schofield, "Courtesan Tale," 154.

39. Schofield, "Courtesan Tale," 153. Schofield describes the concept of space at the Mughal courts as one to be understood through a spectrum of distance or proximity to the male head of household, as opposed to more narrowly defined "public" or "private" spaces.

40. As a representation of the hunt (another established court activity), the falcon functions as an iconographic cue further referencing elevated status and taste. Other indications of royal stature include the attendant waving a peacock-feather fan (*morchhal*) and the raja's larger size in comparison to the attendants nearby.

41. Schofield, "Courtesan Tale," 156–57. Anglo-Indian dictionaries written in the nineteenth century initially classified kanchanis as female dancers and later as *tawa'ifs*, another more nuanced term for courtesans often linked to the courts of Lucknow and Hyderabad. The etymology of words associated with court performers evolved over time. See Jha, "Tawa'if as Poet and Patron," 142; Srinivasan, "Royalty's Courtesans," 162; and Malhotra, "Bhakti and the Gendered Self," 1510, for discussions of overlapping language and terminology.

42. Jha, "Tawa'if as Poet and Patron," 142–44.

43. Schofield, "Courtesan Tale," 153. In contrast to the Mughal definition of space, there is some evidence of courtesans entering the zenana at the Rajput courts; see Sreenivasan, "Drudges, Dancing Girls, Concubines," 142–43.

44. Much has been written on the portrayal of women in Rajput painting; see, for example, Aitken, "Pardah and Portrayal," 247.

45. As an aside, it is interesting to consider the lore that surrounds depictions of Radha and Krishna at the Kishangarh court that have been conflated with the representation of Raja Samant Singh (1748–1764) and his consort Bani Thani. Yet here again ruler and consort are not depicted together, and images of the divine couple (and the intimacy they share) are later interpreted to represent the romance shared between Samant Singh and Bani Thani.

46. See Tandon, "Presence of the Marginalised," 70, for a historic account of the subversive power of the courtesan: Baz Bahadur "let the foundations of his power go to the winds and the waves, that is, because he became so addicted to wine and music . . . employed all his energies in collecting dancing girls, particularly Rupmati (the head of the troop) for whom he wrote Hindi love songs. Similarly, Aurangzeb had to renounce music (and his love for a courtesan, Hira Bai Zainabadi) as he thought that it was leading him astray, leading to his political downfall."

47. Desai, *Life at Court*, 111.

48. Brown, "If Music Be the Food of Love," 62; Oldenburg, "Lifestyle as Resistance," 273.

49. Sparshott, *Measured Pace*, 420.

50. Van Zile, "Interpreting the Historical Record," 154.

LAURA WEINSTEIN

Worshippers of Nataraja Still

IN THE EARLY TWENTIETH CENTURY, Indian dance and works of art depicting dance were among the first types of South Asian art to receive respect and admiration in Europe and America. Art historian Ananda K. Coomaraswamy played a major role in making these arts more widely known and valued. His writings about Indian dance and dance imagery between 1908 and 1918 reflect the global dialogue on the nature and role of art in the modern world that was flourishing in these years and connect particularly with the nascent world of modern dance.[1] By writing about Shiva Nataraja, gesture and pose in Indian sculpture, and dance performance itself, he crafted a discourse that, while very much centered on dance, changed the way all Indian arts would be viewed throughout the twentieth century and, arguably, up until today.

In museums in America, for example, visitors still find echoes of his ideas about the nature of Indian art on gallery walls and in bookshops. The selection of works of art they encounter will have been influenced by the canon he established as well. Thanks to his work on images of the Hindu god Shiva dancing in a ring of fire (cat. 1), one finds sculptures of this god in art museums, yoga studios, and dance venues across Europe and America.

Few art lovers realize, however, that the vision of Indian dance and dance imagery that Coomaraswamy bequeathed to the West tells us as much about the period and milieu in which he was writing as it does about India's visual and performing arts traditions. Looking closely at the arguments that Coomaraswamy put forth about dance reveals why and how India's arts went from being excluded from the highest echelons of art by European and American critics to being widely collected, studied, and even emulated.

Ananda K. Coomaraswamy became involved in the study, promotion, and preservation of Indian traditional arts in the early years of the twentieth century (fig. 1). Born in Sri Lanka but raised and educated in England, he devised an approach that was shaped by intellectual trends prevalent in Europe at the time.[2] Orientalist methods and principles, and the Romantic ideal of a synthesis of all art forms, for example, were fundamental to his work. He was also influenced by the anti-industrialist ideas of the Arts and Crafts movement, modernist theories about the need for a radical revitalization of art, and movements like Theosophy that adapted Asian religions to Western needs. These schools of thought looked to the religions and arts of ancient eras and Eastern lands for tools to bring about social and cultural renewal.

Coomaraswamy circulated within a network of artists, critics, and scholars based in Britain, India, and America.[3] So it was not only because dance is important to India's culture that he focused, early in his career as an art historian, on this subject; it was also due to the fact that, by the time he began to write about art in 1906, dance in general was already a subject of fascination among his contemporaries. It was also receiving increased attention within the broader urban populations of Europe and America.

Among dance traditions, dance from across Asia, including the Islamic world, were of particular interest to scholarly and general audiences in the early twentieth century, despite the fact that most Europeans and Americans had only vague ideas about dance from these regions. Ballets based on "Oriental" mythology were popular, as were presentations of dance from various parts of Asia at colonial exhibitions and world's fairs. To some audiences, these unfamiliar dances were simply mysterious, erotic spectacles, but others saw in them a means to refresh Western art forms that had lost their spiritual power, connection to nature, and roots in ancient philosophy. Dancers especially saw these traditions as a way to revitalize their work and to find new modes of movement and expression. Likewise, pioneers of modernist sculpture found in Asian dances sources of new approaches to the human body.

Indian dance was a specific focus of attention. The myth of the Indian temple dancer—enigmatic, passionate, dangerous, and seductive—had been present in European literature since

at least the sixteenth century. European artists of the eighteenth and nineteenth centuries made it a prominent subject of paintings, prints, and eventually photographs. It appeared on stage in ballets like *Le dieu et la bayadère* (The god and the bayadère—*bayadère* being the French word for an Indian female dancer), which premiered in 1830. Just a few years later, in 1838, a troupe of actual dancers from India performed in Paris and London. One of them, a female dancer named Amany, particularly captured popular imagination. Seeming to fuse secular with sacred and spiritual with sensual, the *bayadère* mesmerized audiences for the exciting tensions she embodied.

Indian dance also carried negative associations. Although dance performances had once been eagerly enjoyed by British parties in India, by the end of the eighteenth century they came to be seen as a distinctly low form of entertainment. A century later, these negative assessments had become campaigns to ban particular forms of dance associated with *devadasis* (female dancers in service to Hindu temples) on the grounds that they were morally reprehensible. Large parts of Hindu society also perceived devadasis and nautch dancers (professional female dancers) as pollutants in respectable and civilized society. With many traditional sources of patronage and employment off limits, female dancers were sometimes forced into prostitution, further cementing the association of Indian dance with women's degradation.[4]

Such concentrated attention to dance in the West set the stage for the emergence of an early form of modern dance often called "Oriental dance."[5] In the early twentieth century, practitioners of Oriental dance combined European dance forms (e.g., ballet, Delsarte, skirt dancing) with themes, moods, costumes, and poses associated with "Oriental" cultures. Despite its mixed reputation, Indian dance was a prominent source of inspiration for exponents of Oriental dance in both Europe and America. Early examples include Liane de Pougy's performance in 1901 as a Hindu priestess; Mata Hari's 1905 performance as a temple dancer before a sculpture of Shiva; and Ruth St. Denis's 1905–06 performances of *Radha*, in which she played the role of Radha, the Hindu goddess and lover of Krishna (fig. 2). To audiences in Europe and America, these performances began to link Indian dance with spiritual power, cultural authenticity, and artistic legitimacy.[6]

Fig. 1 *Portrait of Ananda K. Coomaraswamy, approx. 1916, by Alvin Langdon Coburn. Museum of Fine Arts, Boston, 1996.257. Curator's Discretionary Fund, 1996.255.*

Fig. 2 *Ruth St. Denis in Radha, 1908–09, by Otto Sarony. New York Public Library for the Performing Arts, DEN_0085V.*

Fig. 3 "Nataraja: from a Tamil craftsman's notebook (early 19th century)," from Ananda K. Coomaraswamy, *The Aims of Indian Art* (1908), 18.

Shiva Nataraja

Coomaraswamy's first publications relating to dance appeared soon after these early Indian-style dance performances in Europe. While it is often said that he introduced the West to the figure of the dancing Shiva in 1918, he in fact began as early as 1908 to write about dancing images of a particular form of the Hindu god known as Nataraja, or "Lord of Dance." This representation of the dancing god emerged in South India during the Chola period (approx. 880–1279). While Nataraja often appeared carved in stone on Chola temples, the bronze images of Nataraja posed within a flaming circle made for processions and rituals were Coomaraswamy's focus. This manner of representing the dancing god was mainly known in and around the temple town of Chidambaram until the nineteenth century, when a late eighteenth-century Chola-style sculpture of Nataraja owned by Émile Guimet was put on view in Paris.[7] It was in front of this sculpture that Mata Hari famously debuted in 1905.

When Coomaraswamy first published on this subject, the Nataraja image was familiar to few Europeans and even fewer Americans. He dedicated a section of his 1908 publication *The Aims of Indian Art* to Nataraja, placing it immediately before a section on the Buddha (which he acknowledged was better known to his audiences), implicitly asserting its importance.[8] According to Coomaraswamy's text, Shiva's dance should be seen as a metaphor for his role as the primary animator of the cosmos. The dance signifies "the effortless ease with which the God in His grace supports the cosmos; it is His sport. The five acts of creation, preservation, destruction, embodiment, and gracious release are His ceaseless mystic dance."[9]

Coomaraswamy also attributed to Indian dance an aesthetic value, praising its "marvellous grace and rhythm."

Further into this text, Coomaraswamy wrote about two specific representations of Nataraja—one a rough sketch by an "old Tamil craftsman" (fig. 3), the other an elegant bronze sculpture—and argued that the meaning was the same in both. Showing nevertheless a preference for the latter, he described its maker not as a craftsman but as an "imager" and a "man of genius." Waxing poetic about this artist, Coomaraswamy speculated that art and life were one and the same for him:

> The imager grew up under the shadow of a Śivan temple in one of the great cathedral cities of the South. . . . [H]e had worked with his father at the columns of the Thousand Pillared Hall at Madura. . . ; himself a Saivite, he knew all its familiar ritual, and day after day had seen the dancing of the *devadasis* before the shrine, perhaps in his youth had been the lover of one, more skilled and graceful than the rest; and all his memories of rhythmic dance, and mingled devotion for *devadasi* and for Deity, he expressed in the grace and beauty of this dancing Śiva.[10]

This passage's emphasis on the life of the "imager" as inseparable from his work reflects the impact of the Arts and Crafts movement on Coomaraswamy's thinking at this time, which can be credited to his first wife, the weaver and designer Ethel Mary Partridge. It was probably she who introduced him to Charles Ashbee, a protégé of William Morris who would compose the foreword to Coomaraswamy's 1909 book *The Indian Craftsman*.[11] *The Aims of Indian Art* itself was produced on a printing press that once belonged to Morris, which Coomaraswamy had purchased and set up in his home in Broad Campden, once a center of the Arts and Crafts movement.[12] Also notable in the passage is the positive view it offers of the devadasi, who, like the artist, exercises her art as devotion to the god for whom she dances. There is no expression of doubt in the propriety or authenticity of her dance.

Coomaraswamy polished his presentation and analysis of Nataraja in Indian journals between 1909 and 1913.[13] Some elements evolved, such as the passage about the craftsman, which never reappeared after 1908. Occasionally he wrote about paintings rather than sculptures of Shiva dancing, as in one article that presents a Kangra-school painting from the collection of Abanindranath Tagore depicting a large group of Hindu gods dancing.[14] Other elements in the argument remained constant. He reiterated again and again, for example, the symbolism of the five cosmic acts mentioned above.

If the Arts and Crafts movement was one influence, Theosophy was another. Some of Coomaraswamy's earliest publications were responses to articles in *The Theosophist*, a journal based in Madras (now Chennai), that expressed confusion and curiosity within Theosophical circles about Shiva's dances. One author wrote, "A complete essay on Nataraja would be indeed valuable but just now we have no opportunity of doing more than merely drawing attention to this interesting figure in symbology and mythology."[15] Coomaraswamy's article in that same journal, just a few months later, filled the void.

By 1912 Coomaraswamy had begun to include substantial excerpts from Tamil and Sanskrit texts that lent weight to his interpretation, as well as extended passages from European literature that he used to argue that the religious ideas behind Nataraja had equivalents in the spiritual traditions of Europe and America.[16] Then, in 1918, this work came to its defining moment. Coomaraswamy published a book of essays, one of which was about Nataraja, under a title that reflects his preference for this particular image: *The Dance of Śiva: Fourteen Indian Essays*. Published not in India but with an American press based in New York, the book's essay about Nataraja became for the West the definitive guide to this representation of Shiva.[17]

Today, some of what Coomaraswamy wrote about Nataraja is still considered valid by art historians. The five activities of Shiva do seem to have been among the meanings of the Nataraja image in South India, at least during and after the thirteenth century.[18] And yet, as historian Partha Mitter has written, "however persuasive Coomaraswamy's interpretation may have been it did not really bring us any closer to the understanding of Indian art."[19] There were many other texts Coomaraswamy could have drawn from, other aspects of Nataraja's character he might have explored, and other representations of Shiva dancing that he could have examined (cat. 6). He could also have discussed the aesthetic qualities of the Chola-era Nataraja images he favored, but he instead focused almost exclusively on the sacred concepts and mythology they represent.

The Dance of Śiva was widely read in Europe and America in the years following its publication. A French edition was released in 1922, a second English version in 1924, and another was in development in 1947, the year Coomaraswamy died. Many more have come since then. The image of Nataraja has continued to hold a prominent place in American culture. It is valued as a work of "high" art, for example, by collectors of Indian art, for whom there is no more prized possession. It also echoes through popular culture. The image was fused with a photograph of President Barack Obama on the cover of *Newsweek* in 2010 with the headline "God of All Things" (cat. 4). To borrow Coomaraswamy's own words in the final sentence of his famous essay: "We are worshippers of Nataraja still."[20]

While it is difficult to pinpoint what has given Nataraja its remarkable staying power in the West, it is clear is that the 1918 essay had a major role to play in launching its celebrity. Coomaraswamy's arguments, his own identity as both English and South Asian, his timing, his choice of a subject, and his difficult but alluring language all contributed to the essay's powerful impact. But equally, it was the way it spoke to modern artists, especially dancers.

For example, Coomaraswamy described Shiva's dance as "the manifestation of primal rhythmic energy."[21] He then linked this idea to the ancient rhetorician Lucian of Samosata, who wrote about dance as primeval and likened it to the movement of the planets and stars. In this way, Coomaraswamy connected the rhythms and movements of Nataraja's dance with both spiritual power and the natural world. By quoting an ancient Greek text, he also conveyed that the principles governing Indian dance were as relevant in the West as they were in Asia. In one fell swoop, he showed the image and dance of Nataraja to possess the qualities most valued by modern dance practitioners and theorists: ancient roots, a basis in nature, and strong connections to the divine.

Another connection with modern dance can be seen in Coomaraswamy's use of quotations that explicitly link the dancing divinity to the movements of human dancers. For example, he included these lines from the Tamil *Tiruvatavurar Puranam*: "Our Lord is the Dancer, who, like the heat latent in firewood, diffuses His power in mind and matter, and makes them dance in their turn."[22] Later in the essay, Coomaraswamy commented that, like Shiva's dance, "even the dances of human dancers . . . lead to freedom."[23] Modern dancer Ted Shawn was one of many who took these words to heart, creating a dance inspired by Nataraja's five activities called *Cosmic Dance of Shiva* (1926), in which Shawn himself performed as the god (cat. 3).

The 1918 essay connects also with modernist trends in sculpture. European artists such as Georg Kolbe, Gaston Lachaise, Alexander Archipenko, and Auguste Rodin were, in the second decade of the twentieth century, attempting to

infuse sculpture with motion. Coomaraswamy's writing makes clear that he doubted that modern artists could create as dynamic an image as Nataraja, but he was not above attempting to impress and even recruit them to his cause. In 1910–11 Coomaraswamy was traveling in India with the collector and scholar Victor Goloubew when the latter acquired (or possibly made) photographs of two bronze sculptures of Nataraja (fig. 4). Goloubew sent the photographs to Rodin, who composed a series of meandering but reverent reflections in 1913 that were published posthumously in 1921 as "La danse de Çiva" and appended by an explanation of Shiva's various forms by Coomaraswamy.[24] In his composition, Rodin described the Nataraja bronzes as "ready to burst into movement."[25]

Gesture and Pose

A keen interest of modern dancers and artists in Europe and America at this time was the movement and position of hands (fig. 5). Dancers were in search of an alternative to ballet—widely seen at the time as sterile and artificial—which emphasized the movement of the legs and feet. Visual artists were mesmerized by the hand gestures of Asian dancers. Rodin, for example, owned a large collection of plaster casts of hands and arms, some apparently made from Javanese dancers, and created a famed series of hand sculptures.[26] Rodin's sculptures in turn inspired the American dancer Loie Fuller's *The Dance of Hands* (1909), in which only her hands were visible to the audience.[27]

In his writing about Nataraja, Coomaraswamy had explored the meaning of Shiva's hand gestures and the positions of his limbs. For example, he identified the dramatically lifted left leg that crosses over the god's torso as symbolizing the final stage of release or salvation. The closely cropped photographs provided to Rodin similarly directed attention to the gestures and positions of Nataraja's hands and feet. In this period, Coomaraswamy also expanded this work on gesture beyond Nataraja. In a 1914 article titled "Hands and Feet in Indian Art," he argued that in Indian art hand gestures represent a symbolic language by which artists make inner and ideal states visible to the eye.[28] The faces of sculpted figures were always serene, he wrote, because their inner state was conveyed entirely by the position of their hands, feet, and limbs (cat. 26).

In contrast to the artificial motions of ballet, these gestures were derived from the natural motions of daily life,

Fig. 4 *Hands of Shiva Nataraja*, 1911. *Musée Rodin*, PH.16472.

Fig. 5 Image from the article "Dancing with the Arms," by Anna Steese Richardson, 1920–1930. *New York Public Library for the Performing Arts*, V417_043.

Coomaraswamy claimed. And yet they were not intended to be naturalistic but rather were coded references to mental and emotional states. Thus, although he praised the vigorous and expressive hands of Gupta sculptures and the graceful fingers of images from Nepal, Coomaraswamy asserted that it was

philosophy and aesthetics, not naturalism, that drove Indian artists' work.

Coomaraswamy's emphases on the connection between inner meaning and outward bodily position, on the natural roots of the gestures, and on the systematic nature of the gesture language mirrors Western dance theories of the time. Followers of the French theorist François Delsarte, for example, were teaching a precise system of movements that supposedly correlated with inner states, emotions, and moral qualities. This system taught movements that were also rooted in natural gesture but were not spontaneous; on the contrary, they were carefully formulated postures that, by their correct adoption, could also begin to shift one's inner and moral condition toward higher and more cultivated states.

As with Oriental dance, Delsarte's and other European and American movement theories of this era were influenced by Asian art, filtered through eighteenth- and nineteenth-century European Romantic and Orientalist thought. Genevieve Stebbins, a follower of Delsarte whom Ruth St. Denis cited as an important influence, claimed that her system was shaped by "those ideal and charmingly beautiful motions of sacred dance and prayer practiced by various oriental nations for certain religious and metaphysical effects."[29]

Stebbins was one of many who taught "statue posing," a practice in which individuals struck poses in imitation of admired statues in order to acquire the grace, beauty, and spiritual elevation they were thought to embody. Ruth St. Denis was among the first to incorporate in her performances "statue posing" movements inspired by Indian art. In *Radha*, for example, St. Denis struck a "statue pose" early in the performance: a "yoga position" in which her hands assumed a sequence of five positions that resembled Indian symbolic gestures.[30] Coomaraswamy's "Hands and Feet in Indian Art," along with his other publications on this topic, provided a dancer like St. Denis with a reliable source from which to learn the proper form of various hand gestures and their meaning.

Performance

Although we think of him as primarily an art historian, Coomaraswamy also wrote about dance performance. During the period addressed in this essay—1908 to 1918—he produced a number of publications that directed attention away from associations with sexuality that had accrued to Indian dance in the Western imagination during the nineteenth century. Disputing the view that Indian dance was synonymous with performances at world's fairs, nautch dances, and the alleged debasement and exploitation of devadasis, Coomaraswamy presented Indian dance as a fundamentally spiritual and cultivated art form.

Coomaraswamy's shift from the representation of dance to dance itself was facilitated by his second wife, Alice Richardson, a musician who brought him into the performance world. In 1911 the two of them spent time in Kashmir, where she studied Indian music while he built a collection of Rajput and Pahari paintings. When they returned to England the following year, she began performing as a singer under the name Ratan Devī and published *Thirty Songs from the Panjab and Kashmir*, with an introduction by her husband.[31] Her success allowed the couple to travel on tour to America in 1916 and 1917, trips that opened doors socially and professionally for them both. Coomaraswamy gave talks on Indian music at the opening of her performances, becoming well known in New York as an expert on a range of Indian art forms. During this time, they joined a bohemian circle of artists, writers, and critics based in New York through which Coomaraswamy became connected to the Sunwise Turn, an anarchist bookshop that published *The Dance of Śiva*, and met his third wife, the dancer Stella Bloch.

In these years Coomaraswamy also became involved with theater. This is not a surprise given that dance, music, and drama have always been intertwined in the Indian cultural landscape. But factors independent of Indian art also had a hand in turning him toward theater. Around 1912 Coomaraswamy began corresponding with Edward Gordon Craig, an important figure in the modernist movement in European theater and the founder of a journal called *The Mask*. In 1913 Coomaraswamy published in that journal "Notes on Indian Dramatic Technique," in which he argued that, when well trained, Indian actors' bodies became automatons, moving only according to a rigorous system and not reflective at all of the performer's emotions or experience.[32] This claim was a direct response to Craig, who was skeptical that the human body could create an art that transcended an individual performer's body and spirit.

Two years later, in 1915, Coomaraswamy began an ambitious project at the intersection of dance and drama.[33] Craig had asked him to look out for books about Indian dramatic technique that could be translated into English, and Coomaraswamy soon settled on the *Abhinaya Darpana of Nandikeśvara*, a Sanskrit

treatise on the art of gesticulation. In collaboration with the scholar Duggirala Gopalakrishnayya, he produced *The Mirror of Gesture: Being the Abhinaya Darpana of Nandikeśvara, Translated into English*, published in 1917.[34] Even today, it is considered a critical text among those who teach and perform Indian dance and theater. The dedication reads: "Inscribed by the translators with affectionate greeting to all actors and actresses." The first plate was, of course, an image of Nataraja.

In a manner that must be familiar by now, Coomaraswamy used his introduction to *The Mirror of Gesture* to assert the spiritual essence of Indian dance and, through copious quotations of Western sources, its relevance to artists in the West. He argued that it offered access to the past, saying that the hand gestures described by Nandikeshvara had existed unchanged for 2,000 years. He again claimed that Indian dance training allowed performers to achieve the mechanical perfection that Craig craved, saying that the performance of an Indian actor is "altogether independent of his own emotional condition."[35] And, finally, he reiterated his claims about the unity of Indian visual and performing arts and their sources in a common philosophical tradition and gesture language.

This last point had a particular resonance at the time, as many artists and dancers at the turn of the twentieth century were excited by the prospect of reuniting the arts as a way to resist the fragmentation and isolation of modern life. With roots in German Romanticism, this idea had been developed by thinkers like Richard Wagner and Friedrich Nietzsche, who suggested that a great unified artistic tradition was needed to rescue human beings from their current state of isolation from nature and one another. It found avid adherents among early modern dancers like Isadora Duncan, Loie Fuller, and Ruth St. Denis, who all spoke in their own particular ways about their search for a unified and natural form of movement.[36] Also exemplifying this trend were the productions of the Ballets Russes, which placed almost equal emphasis on music, acting, dance, costume design, and stage sets.

Given the strong connections between Coomaraswamy's writing about dance and the concerns of modern dance and theater, it should not be surprising that his publications and activities in this period also engaged directly with dancers of his time. He had, for example, personal ties to a dancer named Roshanara (originally Olive Craddock), the Calcutta-born daughter of an Anglo-Indian father and a British mother.

Fig. 6 *Ratan Devi and Roshanara*. 1917, by Arnold Genthe. *The Genthe Photograph Collection, Library of Congress, Prints and Photographs Division,* LC-DIG-agc-7a15488.

Roshanara sometimes performed alongside Ratan Devi, and Coomaraswamy offered introductory comments at their performances and reviewed them in print (fig. 6).

Coomaraswamy's article "Oriental Dances in America," published in *Vanity Fair* the same year *The Mirror of Gesture* was released, discussed Roshanara's dancing as well as Indian and Oriental dance generally.[37] He praised her performance of the story of Radha and the cowherd women (*gopis*) dancing and playing with Krishna, which he valued for the way it revealed "esoteric meaning" to the audience through gesture and posture. Coomaraswamy's interest in the romance of Radha and Krishna can, in fact, be tracked throughout his writing in this period. Whether discussing dance, literature, or paintings, Coomaraswamy stressed that the story of Krishna and Radha was no ordinary romance but rather a metaphor for the yearning of the human soul for God. This is conveyed in his coauthored book containing translations of the fourteenth-century poet Vidyapati's compositions illuminating the world of Radha and Krishna, a volume illustrated with Rajput paintings, as well as in his discussions of paintings depicting the activities of Krishna in the 1916 book *Rajput Painting*.[38] He went so far as to assert in the latter that the Radha-Krishna "cult" is "the most modern and most universal development of Indian religion."[39]

This would have all been in his mind when, in the article "Oriental Dances in America," Coomaraswamy praised

Roshanara for bringing to life this "dominant theme of medieval Hindu painting, poetry, and pantomime." She so fully animated the theme, he suggested, that the performance could be described as the only "authentic Nautch" then to be found on American stages. Presumably he found her dance "authentic" because it seemed to him to effectively convey the dance's most esoteric meanings, because it was based on the "right" systematic movements, and because it appropriately brought together music, dance, and acting.

Coomaraswamy wrote that, in comparison to Roshanara, Ruth St. Denis merely evoked the "atmosphere of Indian life" with "sensibility and art." Coomaraswamy was making a pointed distinction here: A performer who can evoke the mood of Indian dance or life is entirely different from one who can accurately execute the highly complex discipline of Indian dance and, thereby, convey its deepest meanings. A more emphatic articulation of this statement can be found in one of his most extended discussions of Indian dance in print: an article that Coomaraswamy published in 1917 in *Modern Dance Magazine*, "Spiritual Freedom Expressed in India's Dances."[40] As this article has been almost completely overlooked in previous scholarship on this topic, it will be explored here in some detail.

In "Spiritual Freedom," Coomaraswamy wrote with obvious frustration about the imitations of Indian art forms then to be found in American theaters and dance halls, music venues, and literary magazines. His words about Oriental dance are little short of scathing:

Amongst the last fashions to be seen in Europe and America is a kind of dancing called "Oriental." It is taught in academies, like the Tango or the Hula Hula, and practiced on Broadway stages by insufficiently trained actresses. It seems to reflect certain mannerisms of Indian or Siamese art, but it is certainly not Oriental dancing; for one cannot evolve out of one's own head or learn from American or Russian dancing masters an ancient art of severe convention, spiritual purpose, and intensively cultivated technique.[41]

This critique led Coomaraswamy to ask why Americans in particular were giving their attention to these half-baked imitations. And with this, he made an important leap from dance to visual art, asking, "What proportion of American museums possess a single important example of Indian painting or sculpture, or five years ago possessed a single important example of Chinese art apart from porcelain?"[42] Having shown through various publications that Indian dancing, acting, literature, and visual art were based on profound and universal foundations, he now challenged Americans to begin to bring into art museums real works of Indian art. We will return to this idea below.

It must be noted here that Coomaraswamy wrote more in this article about dancing *in* India than perhaps anywhere else. Indian dance had been suffering from neglect and outright suppression under British colonialism and would not begin to thrive (in a transformed state) once again until the 1930s. He had argued in several publications, however, that spiritually pure and artistically valuable Indian dance could still be found within India.[43] In *Modern Dance Magazine* he forcefully asserted the genuine artistry of female dancers in India, as well as the modesty of their dress and behavior. He also, remarkably, shared personal memories of encountering such dancers:

I recollect an occasion in Lahore, when a very famous dancer, rejoicing as every Indian woman rejoices, in the birth of a son, invited all the dancers of the Panjab to a splendid festival which lasted many days. Upon another occasion, climbing the stairs that led to a little upper room in the city of Lucknow, we found a singer and sitting on the floor listened to a fairly good entertainment. Presently a child cried in the next room, and the singer nodded to a young man, who brought out the baby and gave it to the mother, who laid it on her lap and fed it while she sang, with the most admirable grace and Madonna pride.

Again I remember sitting with the Raja of Ramnad and a southern bayadere in Madura. When she had sung in several modes, he suddenly stopped her and entered into a highly technical discussion with her as to whether or not she had introduced a note foreign to the mode she was using.[44]

These vivid anecdotes supported his assertion that Indian dance, both in history and in its surviving forms, was an art deserving of respect: "long-inherited, well-considered, and well-bred."[45] One only wonders why he didn't write more about living dancers.

Returning to the larger context of "Spiritual Freedom Expressed in India's Dances," Coomaraswamy's argument can be summed up as making a series of assertions that add up to a call for a major shift in the attitude of Americans toward both Indian dance and art. Voicing a desire to see Americans turn from imitations of Indian or other "Oriental" arts to art actually produced in Asia, he came finally to a specific call to action. American museums, he asserted, should collect Indian art, saying that "to exhibit here the Indian art as it actually survives might be a worthy task for one who should bring to the task the necessary sensibility and devotion, for the opportunity is still open to study Oriental dancing as it exists, and to offer it to a western audience, as Ratan Devi and Madame Gautier have

Fig. 7 Partial rasamandala, approx. 1800. India; Pahari. *Museum of Fine Arts, Boston,* 17.2465.

Fig. 8 *Stella Bloch in Javanese Costume,* 1924, by Mortimer Offner. *Museum of Fine Arts, Boston,* 1996.258.

offered Indian and Japanese singing, or as Chinese painting is to be made accessible in Mr. Freer's museum at Washington."[46]

This was more than an abstract argument. Coomaraswamy had offered to sell his personal collection of Indian art to Charles Lang Freer in 1916, after a series of meetings between the two men and Freer's attendance at one of Ratan Devi's concerts.[47] When that collector declined, Coomaraswamy instead found a buyer in Denman Waldo Ross, an important early benefactor of the Museum of Fine Arts, Boston (MFA), who, like Coomaraswamy, felt that studying the great art traditions of the world was the best way to enrich American art and design. By the end of 1917 Coomaraswamy had been installed as a curator at the MFA along with much of his collection of Indian art.

It will come as no surprise that among the paintings and drawings he had collected from the courts of Rajasthan and the Punjab Hills, many were depictions of Krishna with Radha and the cowherd women (fig. 7). The addition of such works of art to the collections of the MFA signaled the culmination of Coomaraswamy's decade-long effort to convince the West that Indian dance, sculpture, and painting were arts based in ancient traditions, rigorously produced, and rooted in universal principles. These ideas, once accepted, allowed him to secure both his own position and the position of Indian art within the broader art world.

Although his most active work on dance was concentrated in the period we have examined here, Coomaraswamy remained engaged with dance after that time. His third wife, Stella Bloch, was a dancer, artist, and critic. She and Coomaraswamy traveled to Indonesia together in 1920–21, during which time they closely observed Javanese dance, a version of which Bloch performed to American audiences upon her return (fig. 8). This trip not only saw Coomaraswamy purchase objects related to dance and theater, such as shadow puppets, but also provoked him to

publish an article on Javanese dance and theater.[48] Afterward, in 1922, he composed an introduction to Bloch's own book, *Dancing and the Drama: East and West.*[49] Together, in 1923, they wrote an article called "On the Appreciation of Art" in which they held up "the dramatic dances of India and Java" as models of art in its purest form.[50]

Well into the 1930s and 1940s Coomaraswamy continued to write about dance, both in the abstract and as seen on Western stages. In 1937, for example, he wrote a piece in *Magazine of Art* about Indian dance in general and about the Indian dancer Uday Shankar. Shankar's dances based on Hindu mythology—including Nataraja—presented on prominent American stages had helped to cement the high status of Indian dance, but Coomaraswamy hinted in the essay that Shankar's performances reflected European and invented elements that did not truly represent Indian dance.[51] A large photograph of a bronze Nataraja that Coomaraswamy had acquired for the MFA accompanies his text, standing in for India's unadulterated artistic traditions. He appears to have been more comfortable with the form of Indian dance practiced by La Meri (originally Russell Meriwether Hughes), if one is to judge based on his 1941 introduction to her book *The Gesture Language of the Hindu Dance* and his participation in a radio program about dance with her two years later.[52]

Coomaraswamy's impact on dance in America was not ended even by his death in 1947. His publications on dance

continued to influence generations of performers. Merce Cunningham and Martha Graham, for example, both acknowledged their debt to Coomaraswamy.[53]

Conclusion

In the second decade of the twentieth century, Coomaraswamy saw that Indian art was dismissed or even reviled by many in Europe, even while European modernism was being profoundly shaped by contact with the cultures of lands under British colonialism. Encounters with Indian art were occurring in Europe's expositions and museum galleries, as well as through the publications, performances, lectures, and conversations of people like Coomaraswamy: individuals who served as cross-cultural translators. This was a role in which he excelled. Stepping into it around 1908, Coomaraswamy soon became a highly visible representative for India's arts.

One of his greatest achievements was refocusing popular and scholarly conversations about Indian dance.[54] Beginning with his study of Nataraja and continuing on into gesture and pose in Indian art, Indian dramatic theory, and even into contemporary dance performance, Coomaraswamy rewrote the story of Indian dance, finding modern elements in its deepest strata and highlighting them again and again. This brought greater attention to Indian dance and established it as an important source of inspiration for the development of modern dance. Through these wide-reaching conversations about Indian dance, and alongside his publications on other subjects, he was gradually able to effect a broader change in Western public opinion about Indian art. It is no coincidence that this intensive work on dance culminated in 1918, right after Coomaraswamy became the first curator of Indian art in an American museum.

After he arrived at the MFA, the concepts Coomaraswamy had developed in the prior ten years shaped the way he presented Indian art. In 1918, for example, he published his first article on sculpture in the museum's bulletin.[55] In it, he wrote about a small bronze sculpture of Avalokiteshvara from Sri Lanka (fig. 9). Describing it as reflecting "Indian art at its moment of deepest and freest expression," he brought readers' attention to its representations of "spontaneous gesture" deriving from a set of motions that "have never been excelled in truth of feeling and movement." Though it was not a dancing figure, he identified in it those same systematic and "modern"

qualities that he valued in Indian dance, saying: "There is nothing fanciful or dreamy about it. There is a definite idea to be expressed, a definite problem to be solved; there are equally definite means of expression, determined by canonical prescription and by tradition."[56]

While most lovers of Indian art today no longer think of sculptures like this one as having any relation to dance or sense the connection with modernism that Coomaraswamy saw so clearly, other aspects of his work still shape the way we see Indian art. His focus on hand gestures, for example, remains reflected in museum displays in both Europe and America illustrating the symbolic hand gestures (mudras) that appear in Indian sculpture. In these spaces and in popular discourse around Indian art, one often finds mythology, iconography, and religion taking center stage, leaving little room to discuss aesthetics or artistic traditions.

As much as Coomaraswamy accomplished in terms of expanding knowledge of Indian art and ensuring its preservation in museums (not to mention his galvanizing effect on dance in India, which is an equally fascinating story), his success came with a cost. It reduced the idea of Indian dance and Indian art to a fairly narrow set of ideas, leaving out entire worlds of Indian performance history and artistic practice. It has taken many years for dance and art historians to notice these elisions; to locate evidence of these lost dimensions, objects, and traditions; and to explore them afresh. For example, art historians in recent decades have challenged the notion of Indian art and dance as essentially impersonal—the expression of timeless tradition or divine power rather than the product of an individual artist's vision. Their efforts have granted long-denied respect to those who created countless superb works of art.

In the hundred years or so that have passed since Coomaraswamy's period of intense focus on dance, some of what he excluded has disappeared altogether, perhaps partly as a result of falling too far outside the enduring categories he erected. Contemporary studies of Indian dance and dance imagery (such as are to be found in the pages of this catalogue) demonstrate that it is critically important to look beyond the frameworks erected by Coomaraswamy. And yet we may still appreciate his dedication to dance, which ensured that the world would see the astounding beauty, meaning, and power of India's art and dance traditions.

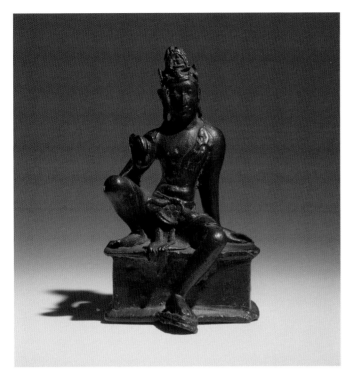

Fig. 9 The bodhisattva Avalokiteshvara, 700–800. Sri Lanka. *Museum of Fine Arts, Boston*, 17.3213.

1. A key source for this essay is Diana Brenscheidt gen. Jost's excellent *Shiva Onstage*. I am grateful to the author for her excellent scholarship, as well as to Janice Leoshko for her support and contributions to this essay.

2. For two quite different biographies of Coomaraswamy, see Lipsey, *Coomaraswamy*; and Pal, *Quest for Coomaraswamy*.

3. On Coomaraswamy's European networks, see Turner, "Essential Quality of Things"; and Ganser, "Coomaraswamy's Mirror of Gesture."

4. Spear and Meduri, "Knowing the Dancer"; Bor, "Mamia, Ammani, and Other *Bayadères*"; Engelhardt, "Real *Bayadère*."

5. Erdman, "Rethinking the History of 'Oriental Dance.'"

6. Pritchard, "Mystery and Sense of Awe."

7. This work is now in the Musée Guimet (MG18529).

8. While here I refer to Coomaraswamy's self-published work of this title—*The Aims of Indian Art* (Broad Campden: Essex House, 1908)—he also published almost the same text that year in the Calcutta-based journal *Modern Review*.

9. Coomaraswamy, "Aims of Indian Art," 18.

10. Coomaraswamy, "Aims of Indian Art," 17–20.

11. Coomaraswamy, *Indian Craftsman*.

12. Pal, *Quest for Coomaraswamy*, 100–02.

13. These pre-1912 versions of Coomaraswamy's discussion of Shiva Nataraja have been almost entirely overlooked in the scholarly literature despite their importance in the development of an interpretation that transformed Nataraja into a symbol of near-global reach. It should also be noted that at the same time—and perhaps even before he began publishing interpretations of Nataraja—Coomaraswamy was submitting photographs of Shiva Nataraja bronzes in Chennai to periodicals for publication as stand-alone units in an effort to expose more people to Indian art. See Van Manen, "Shiva as Nataraja"; Coomaraswamy, "Śiva as Nataraja"; Coomaraswamy, "Śiva's Dance"; Coomaraswamy, "Shiva's Dance"; Coomaraswamy, "Dance of Siva"; and Coomaraswamy, *Arts and Crafts of India and Ceylon*.

14. Coomaraswamy, "Shiva's Dance."

15. Van Manen, "Shiva as Nataraja," 766.

16. The 1912 version is extensively explored in Wessels-Mevissen, "Introducing a God."

17. Coomaraswamy, *Dance of Śiva*.

18. Smith, *Dance of Śiva*; Kaimal, "Shiva Nataraja."

19. Mitter, *Much Maligned Monsters*, 285.

20. Coomaraswamy, *Dance of Śiva*, 66.

21. Coomaraswamy, *Dance of Śiva*, 56.

22. This quotation appears first in 1909 in a one-paragraph note Coomaraswamy contributed to Van Manen, "Shiva as Nataraja," 765. It recurs in most later versions of the essay, including Coomaraswamy, *Dance of Śiva*, 59.

23. Coomaraswamy, *Dance of Śiva*, 64.

24. Rodin, "La danse de Çiva."

25. Rodin, "La danse de Çiva," 9. This intriguing episode is explored in Légeret-Manochhaya, *Rodin and the Dance of Shiva*.

26. Gerstein, *Rodin and Dance*, 95–97.

27. DeVaan, "Sculpting in Time."

28. Coomaraswamy, "Hands and Feet in Indian Art."

29. Ruyter, "Intellectual World of Genevieve Stebbins," 392.

30. Eisler, "Origins of Modern Dance," 89.

31. Ratan Devi, *Thirty Songs*.

32. Coomaraswamy, "Notes on Indian Dramatic Technique."

33. Ganser, "Coomaraswamy's Mirror of Gesture."

34. Coomaraswamy and Gopalakrishnayya, *Mirror of Gesture*.

35. Coomaraswamy and Gopalakrishnayya, *Mirror of Gesture*, 4.

36. Brenscheidt gen. Jost, *Shiva Onstage*, 85–109, 112, 176.

37. Coomaraswamy, "Oriental Dances in America."

38. Coomaraswamy and Sen, *Vidyāpati*; Coomaraswamy, *Rajput Painting*, 1:26–40.

39. Coomaraswamy, *Rajput Painting*, 1:28.

40. Coomaraswamy, "Spiritual Freedom."

41. Coomaraswamy, "Spiritual Freedom," 15.

42. Coomaraswamy, "Spiritual Freedom," 15.

43. Ganser, "Coomaraswamy's Mirror of Gesture," 116–17; Coomaraswamy, "Oriental Dances in America," 61.

44. Coomaraswamy, "Spiritual Freedom," 15.

45. Coomaraswamy, "Spiritual Freedom," 16.

46. Coomaraswamy, "Spiritual Freedom," 16.

47. Kumar, "Of Networks and Narratives," 56.

48. Coomaraswamy, "Notes on the Javanese Theater."

49. Bloch, *Dancing and the Drama*.

50. Coomaraswamy and Bloch, "Appreciation of Art."

51. Brenscheidt gen. Jost, *Shiva Onstage*, 245–46, 280–84.

52. Hughes, *Gesture Language of Hindu Dance*.

53. Kisselgoff, "Merce Cunningham, Explorer and Anarchist."

54. Ganser, "Coomaraswamy's Mirror of Gesture," 124.

55. Coomaraswamy, "Indian Bronzes."

56. Coomaraswamy, "Indian Bronzes," 32.

ESHA NIYOGI DE

Dancing Change in South Asian Cinema: Performers, Erotics, and Politics

AS THE PAKISTANI-BORN WRITER Shah Asad Rizvi said, "Dance is the timeless interpretation of life." It follows, then, that as lives and circumstances change, so must the dance. I have always been struck by the fact that so many dancing figures on Bollywood screens resemble the poses and recall the themes we find in South Asian paintings, sculptures, and photography from earlier periods. Likewise song lyrics, which invariably embellish and interpret movement in Bollywood cinema, evoke imagery from early paintings and poetry. These dip into a wellspring of religious and social arts that appear to connect ancient dance culture to present-day India. This South Asian practice of reanimating the early dancing arts in modern productions stretches well beyond big-budget Bollywood entertainments made for mainstream (increasingly international and diasporic) audiences. It is found in small-scale, mainstream Pakistani films centering on professional women entertainers or made by them. Moreover, the practice is reincarnated in works of independent cinema, such as the Bangladeshi Bikalpa Dhara (alternative stream), taking up causes of gender or religious violence and minority rights. What fascinates me about such various evocations of pose and image is how often these alter the point and meaning of the dance at the same time that they want to reach into artistic memory. Why do we find this persistence in recalling the early dancing arts in modern South Asian narrative films? What do we make of the changes, of the bodies and hands behind the change?

Take, for example, the resplendent performance of a *raas garba* dance in the Oscar-nominated Bollywood blockbuster *Lagaan* (2002; dir. Ashutosh Gowarikar). Set in the yard of a temple, the festive group dance celebrates the birth of the Hindu deity Krishna. It starts with a high-angle shot of the hero, Kanhaiya (Amir Khan), encircled by female dancers. He is twirling in synchrony with the women and pairing his dancing sticks with each and every one of them. The soundtrack picks up a solo female voice singing of how Krishna meets the

cowherd women (*gopis*) in the honey garden (*madhuvana*). Then, the voice asks with some ire, "*Radha kaise najale?*" (How can Radha [Krishna's favorite] not be jealous?). Meanwhile, the circle dance is being reconfigured by the Radha-like heroine (Gracy Singh). She cuts into the center to partner with the dancing hero and gaze upon him with jealous intimacy. Soon after, she is locked in a duet performance with her flute-playing partner (fig. 1). The unmistakable inspirations—indeed, the templates—for the choreography and its lyric are rasalila paintings and associated poetic visions of dance found from earlier Indic religious traditions.

Paintings of the rasalila circle dance draw on the legacy of the tenth-century Sanskrit text Bhagavata Purana, which conceives the love of a feminized devotee (imagined in the form of a cowherd woman) for the divine flute-player Krishna as an "intimate and esoteric" bond; the mystical union of god with devotee is depicted as an enchanting circle within which the god "dances with every cowherd maiden [devotee] at once."[1] Some artworks depicting the rasalila trace an intense erotic attraction between the lover god and his unique devotee, often identified in later traditions as Radha (fig. 2). Reenacted in the *Lagaan* performance, this drama of erotic ecstasy and jealous longing came into popular practices of the rasalila from the *Gitagovinda*; attributed to the poet Jayadeva, this twelfth-century mystical lyric is known to have drawn on diverse oral traditions and everyday resources.[2]

There is little doubt that such appealing performances as this of the rasalila and similar traditional dances on New Bollywood screens re-create for local and global audiences the imaginations and attitudes permeating both devotional artworks and quotidian celebrations in India. Transported to a village festival set in colonial India, the erotic mysticism of the rasalila tradition provides the heroine of *Lagaan* with a cultural pretext for defying patriarchal propriety. She claims the sexual agency to publicly profess her attraction for a man through leading him in an eroticized partner dance. Dances and song

lyrics in Indian films, typically allowing for a greater display of hidden longings than their realistic plots and dialogue, by the late twentieth century were depicting women as bold agents of erotic desire.[3] In this case, the paradox lies in the fact that both the partner dance and the circular dance lead to a drama of gender power and interests at odds with their mystical roots. The erotic spirituality of rasalila—portrayed in earlier arts and literature as trysts between a personal god and the feminized devotee—presumes a detachment from self-interest and social mores. Lagaan reinvents the tradition as an ethnocentric celebration of authentic Indian family life and patriarchal romance. As we see more and more men joining the dance to perform aggressive movements and banter, the circular formation transforms into a mating dance staged under the approving eyes of village elders. The traditional meaning of the deity Krishna dancing in loving synergy with Radha and the cowherd women evolves too, becoming a racially charged triangle pitting the love interests of the pure Indian village girl against a white temptress.[4]

A story of British colonial injustice, Lagaan initially depicts a white British woman (Rachel Shelley) as something of a missionary educating oppressed Indian villagers in the skills of cricket so that they will be able to win a match against a British team and be rewarded with tax relief. Subsequently, the British woman's attraction for the Indian hero leading the fight against injustice transforms her from a virginal missionary figure, appropriately clad in a high-neck white dress, into a temptress erotically decked in revealing scarlet and white. Likewise, the circular rasalila dance evolves into a triangular dance-drama through which all three characters (the hero, the Radha-like Indian village girl, and the white British woman) perform their longings, moving to the refrains of "Oh my girl / Oh my boy / I am in love." The choreography stages a Krishna-like hero caught between legitimate desire for his future bride and clandestine longings for the aggressive white temptress. Whereas the Indian heroine/bride-to-be sings of her love for births to come (janam janam) as she genuflects to the hero/would-be groom (performing Hindu marital vows and patriarchal customs), the white temptress casts a seductive spell by magically appearing and unveiling herself in the hero's home or in his arms (fig. 3).

The scarlet-clad-temptress's dance certainly draws on images of the whore (versus the virgin) known to global audiences from Hollywood and related Western cinemas. Scrambled and remade on Indian grounds, this trope speaks both to local cultural memories and to ethnocentric Indian interests. The dance of seductive magic evokes Hindu mythic and artistic depictions of the illusory erotica of the temptress. The misogynist myth of the shape-shifting temptress is found in stories of demon-women such as the widow Shurpanakha, appearing in some versions of the Hindu epic Ramayana. As depicted in the myth as well as in artistic re-creations, the demon Shurpanakha, who possessed the

Fig. 1 The Radha-Kanhaiya dance from Lagaan (2002).

Fig. 2 Krishna dances with the cowherd women, approx. 1675–1700 (cat. 17, detail).

Fig. 4 Shurpanakha disfigured in the video installation *Indrajaala/Seduction*, 2012, by Pushpamala N (cat. 65).

power of shape-shifting, momentarily transformed herself into a beautiful woman in an attempt to entice the heroes Rama and Lakshmana and infiltrate their homes. In the Ramayana, Shurpanakha is brutally reprimanded with a form of "punishment reserved for unchaste women": Lakshmana attacks and disfigures the demon by chopping off her nose (fig. 4).[5] A kinder fate awaits the woman in *Lagaan*, as her role of foreign temptress is superseded by that of a white savior leading the Indian underdog to victory. Celebrating a form of "cricket nationalism" that invokes traditional arts, this big-budget Bollywood production aligns with other globalized industries

trading in spectacle such as those of Indian sports and tourism.[6]

 Lagaan rides the crest of a plethora of erotic imagery that began proliferating in Indian public culture in the 1990s; this prolific spread accompanied the opening of the market to spectacles, goods, and corporate trade in ways such that "the yearning for erotic pleasure [came to be] conjoined with that for commodities."[7] It is quite possible that, in this milieu, reenactments of women-centered erotic performance, drawn from the exploits of Krishna and other artistic memories, gained fresh currency. Indeed, they were continuing a tradition of

Fig. 3 The white temptress from *Lagaan* (2002).

flirting, seduction, and lovemaking that had always maintained a tense relationship with another Hindu religious ethos, that of male asceticism. This tension comes alive in another Bollywood blockbuster, *Hum Aapke Hain Koun* (Who Am I to You?; 1994; dir. Sooraj Barjatiya). This production—the erotic spectacle par excellence of 1990s India, widely known as *HAHK*—pits a dance-and-song of sexual longings against the male ascetic pose. This opposition between the erotic and the ascetic evokes on screen Hindu myths and arts depicting celestial court dancers such as the female spirit (*apsaras*) Rambha performing seductive moves to entice hermits to break their vow of celibacy (fig. 5). The song lyric pairing the ascetic with his female devotee invokes as well the myth of the ash-covered ascetic god Shiva breaking his austere practice to consort with his divine paramour Parvati. In the case of *HAHK*, the mythic tradition is reinvented against the backdrop of a landscaped backyard with a glistening pool—the denial of austerity being dovetailed with yearnings for impossible lifestyles.

The dance number in question begins with the rupture of the reverential ascetic pose, performed with a derisive kick by hero Salman Khan in response to an enticing ditty (fig. 6). Dancer-heroine Madhuri Dixit has started to sing of the devotee she has become. Soon enough, the shot-reverse-shot dramatizing this song and response is transformed. It mutates into a group performance in which multiple characters—high and low, parents and offspring—join in a gyrating display of sexual desire that momentarily queers the equation of heterosexual romance between the hero and the heroine. Replete with gender-bending mimicry, this screen choreography brings to life the "large canvas of erotic possibilities" and deviant yearnings animating spectacles in *HAHK*. We also see a rasalila circle of dancing male and female bodies, with a Krishna-like flute player in their midst. Yet the dance number ends with the telling return of male-dominant heterosexual romance. A momentary shot of stolen touches shows the hero guiding the hand of a now appropriately modest heroine/bride-to-be.

Not unlike *Lagaan*, the poses and movements recalling Indic artistic themes in *HAHK* play with the fluidity of dancing bodies and sexuality recurrent in early artworks. At the same time, these recent Bollywood dances reinvent and regulate erotic fluidity in ways that conform to contemporary Indian dynamics of gender power and marital and lifestyle choices. What do the changes tell us about the backstories of dance making on modern South Asian screens—about who makes the dance and finds and controls its inspirations and resources? Or how meanings of screen dance change with the bodies and hands that make it? The complex story of dance making takes us to histories of erotic spectacle and female performers in the national film cultures of South Asia. In following this story, I

Fig. 5 The sage Shuka remains unmoved as Rambha dances before him, approx. 1600 (cat. 62).

encounter striking historical differences between the industries and their women performers in India and in Pakistan.

• • •

Staying with India for the moment, I arrive upon a legacy of religious nationalism animating reproductions of early Hindu artistic themes in cinema. The Indian pioneer of the narrative feature film D. G. Phalke, by his own testimony, was motivated to make films by claiming the medium of cinema for the portrayal of indigenous traditions and beliefs. As he watched the silent feature film *La vie du Christ* (France, 1906; dir. Alice Guy) in a Bombay (now Mumbai) cinema hall in 1910, Phalke "thought of the gods Krishna and Ramachandra and wondered how long it would be before Indians would be able to see Indian images of their divinities on screen."[8] The Hindu mythological

film, whose traces are recalled and reinvented in present-day Bollywood cinema, was born of this pioneering inspiration. Upon his return from London with the necessary equipment, Phalke set up his film company in a semirural landscape populated with shrines that were believed to mark the authentic sites of events in the Hindu epic Ramayana.[9] Starting in 1913 he produced a series of Hindu mythologicals whose cinematography closely reproduced early religious paintings and sculptures. A case in point: *Kaliya Mardan* (1919) depicts Phalke's five-year-old daughter Mandakini as the mischievous prankster god-as-child Krishna (fig. 7). In this narrative, the child-god goes on to become the redeemer of humankind, mounting and overpowering the snake demon Kaliya. Krishna is then adulated by Kaliya's liberated wives as can be seen in early paintings (fig. 8). *Kaliya Mardan* closes with the scenic construction of a processional

Fig. 6 The ascetic and the erotic from *Hum Aapke Hain Koun* (1994).

dance, joined by both male and female devotees, leading to the site of worship. Such images of Hindu religious arts and performances entered early national cinema through the influence of parallel practices and media such as print (poster and calendar art), lithography, and photography, as well as live theater and dance.[10] These exchanges of inspiration and resources between the cinema and contiguous channels of spectacular commerce—such as advertisement, sports, and tourism (as noted above)—continue and expand today.

Yet, the public spectacle of male and female bodies engaged in a communal dance, which comes to stand for the ideal national community, also raises questions: Who were the women on Phalke's screen? Were they, in fact, women at all? (Some, at least, appear to be men.) And if they were women, from which social background did they hail? Phalke himself cited the authority of early Sanskrit literature to argue for the potential role a specific category of women could play in the moral uplift of the spectacular national medium of cinema. His ideal of actresses comprised "ladies from good families . . . [emanating on screen] inborn cultured behavior and the glow of marital bliss." He added that, at one point, he had "encouraged" his own wife to take up this role of a moral touchstone of national femininity by acting in films. There is little doubt that he failed in the endeavor, for in the same speech Phalke went on to deplore that all he could recruit were "vamps" who brought to the studio the stigma of "brothels."[11]

Particularly worrisome for Phalke were women's dance performances on screen. He maintained that, although dance in its essence was a "truthful reproduction of life," the practice was being "reduced to vulgarity" by the available dancers; as such, dances on screen could become downright "embarrassing" for viewers from respectable families.[12] In point of fact, Phalke's classifications of women and dance were to prove prophetic for the evolution of film dance in India. Through subsequent decades of talkie cinema, Indian feature films of the Hindi cinema (known now as Bollywood) pitted vamps performing cabaret-style exotic numbers against the more controlled displays of sexual desire found in heroines' performances. Even though the titillating heroine numbers on contemporary Bollywood screens are far bolder in the expression of erotic desire, they tend still to dovetail with male-dominant movement arts and nationalist romance. To wit, *Lagaan* and *Hum Aapke Hain Koun*.

Fig. 7 Poster for *Kaliya Mardan* (1919).

Fig. 8 Krishna overcoming the serpent Kaliya, 1400–1500 (cat. 59, detail).

Fig. 9 A ruler and his court watching a dancer, 1800–1900 (cat. 92).

Fig. 10 *Nautch Performance*, approx. 1862, by Shepherd & Robertson (cat. 96, detail).

Writing in late colonial India, Phalke assumed an attitude toward female performers—encapsulating patriarchal nationalism of the educated upper-caste variety—that was shared among the reformist elite of the era. The stance shows the unmistakable influence of the Victorian ethos of respectable domestic femininity ("the angel in the house") upon a Western-educated Hindu elite versed in early Sanskrit literature and religious arts. Phalke's repugnance toward the dancer-vamps overrunning film studios intersected with a larger social purification movement that had been sweeping across the colonial subcontinent since the 1890s. Led by European missionaries and the reformist native elite—and upheld by colonial policy— this antinautch (antidance) campaign targeted professional entertainers descending from the hereditary performer and courtesan communities of the region.

These entertainer communities ranged from elite courtesans—once patronized by the courts and later by the native nobility and British colonial elite—to the more common performers frequenting religious and seasonal festivals, fairs, and marriages. Paintings and photographs from different decades of the nineteenth century constitute an ethnographic register of female performers at their sites of patronage and visibility (figs. 9–10). In fact, such images of nautch parties were being put to contradictory uses in this period. On one side, they were colonial ethnographic tools for navigating native terrain and classifying population groups as well as promoting European travel to the exotic colonies (through the circulation of photo postcards).[13] On another side, the relatively inexpensive technology of photographic reproduction enabled female dancers and courtesans to circulate images of their arts beyond the traditional circuits of patronage and control and by these means to seek an independent commercial status. The typical positioning of female performers at the forefront of such nautch party photographs is suggestive of both their artistic leadership and their entrepreneurial agency "in the management of the performing group."[14]

By the 1890s, however, the antinautch crusade—gaining momentum from a concerted movement for "national purification and women's upliftment"—was targeting traditions of the erotic that were deeply entwined with both religious and quotidian performances across South Asia.[15] Female performers of sensual dance and theater, including the courtesans and nautch dancers of north India as well as the temple dancers

(*devadasis*) of south India, came to be stigmatized as prosti-tutes. Further, what once were "fluid categories" of performers affiliated with different religions (Hindus, Muslims, Sikhs) and castes also were reinvented and rigidified such that the prostitute/public performer (*tawa'if*) emerged as a subcaste in some parts of South Asia.[16] D. G. Phalke's words illustrate that, despite the stigma, professional women entertainers and dancers were populating film screens and public stages in early twentieth century India (replacing cross-dressed men in these venues). Under the heightening nationalism of the Indian film industry, however, the drive for respectable femininity was intense. By the early 1930s, the cinema and the image of the female dancer alike were being systematically sanitized. Opening room for upper-caste and upper-class women to enter both the Indian cinema and the reformed (de-eroticized) dance traditions—classical kathak in north India and Bharatanatyam in south India—professional women entertainers were dis-placed from these performance venues. Gramophone recording, radio broadcast (All India Radio), and, later, playback singing did enable some hereditary female performers to survive in the industries and attain a respectable professional status precisely because these media were disembodied: they took the dance out of erotically suggestive songs.[17] As noted above, dance-and-song performances by female stars from respectable backgrounds have been "re-eroticized" on Bollywood screens since the globally influenced 1990s, even though the dances themselves as well as the plots of these films tend to control the bodies of heroines cast in respectable roles by making them unavailable.[18] Meanwhile, the (theoretically available) "erotic body" of hereditary female performers who now dance in the bars of Mumbai confront a fresh antinautch crusade in the twenty-first century, led by local governments and NGOs such as the antitrafficking organization called Prerana. A "dance ban" was enforced in 2005, making some 75,000 bar dancers "redundant."[19]

• • •

Turning now to the role taken by performing communities in the Pakistani film industry, I find a remarkably different pic-ture—one that brings to modern life the artistic and business leadership suggested by the nineteenth-century photographs of female dancers discussed earlier. In Pakistan, not unlike in India, indigenous traditions of dance and art have been a fount

of resources and inspirations for modern narrative cinema made in the local languages. What differ between these two locations and cultures of cinema are the bodies and hands that perform on screen.

In Pakistan, by contrast to India, professional women entertainers and hereditary practitioners have been indispens-able to the growth of dance, song, and performance vignettes in the mainstream cinema and in its entertainment networks (such as audio recordings). There is no doubt that an inflexible ideal of modest femininity governs Muslim women's public visibility, having been reinforced by patriarchal nationalism since the early twentieth century and subsequently built into state discourse in the new Islamic Republic of Pakistan. As maintained in 1949 by Sardar Nishtar, minister of industries, "Muslims should not get involved in filmmaking. Being the work of lust and lure, it should be left to the infidels."[20] Thus, a pall of disrepute hangs heavy over the visible commerce of cin-ema, dance, and theater in Muslim-majority Pakistan. Yet the paradoxical fact is that the sensual arts of performance have grown and flourished in Pakistan through subsequent decades, even under Islamist regimes of extreme censorship.

One ironic and telling exception was a period of national development and reform (1999–2008) in which a new anti-nautch ban came to be imposed on the so-called obscene danc-ing and vulgar comedy found in popular practices. The ban had been provoked by complaints from elite practitioners of Marxist theater as well as from educated middle-class audiences, which for the first time were being exposed to popular performance through DVDs and satellite television.[21] Exploring the rise of an indigenous Pakistani film industry, from the ashes of commu-nal riots surrounding the Partition of India and Pakistan at the close of British rule (1946–47), I find that hereditary female entertainers led its growth (as actresses, dancers, film direc-tors, and producers) precisely because women from the elite classes mostly stayed away and withheld the mantle of respect-ability from entertainment film. Instead, the "beauty bazaar" (*chakla*) culture of Lahore, deriving from earlier eras of feudal male patronage of courtesan erotic dance and song (*mujra*), functioned as a "school" for female film artists, notwithstand-ing stigma and intermittent policing.[22]

This is not to claim that women entertainers engaged with the cinema in Lahore as a group were homogenous. From the 1950s through the 1970s, many among them, especially the successful "stars," were being gentrified through marriage with

Fig. 11 Noor Jehan as a dancer from *Neend* (1959; dir. Hassan Tariq).

college-educated male directors and producers (or other men of the elite classes) as well as through travel and filmmaking in different parts of South Asia and the world. Nonetheless, the aura of respectable modesty remained uncertain for even the foremost among the women who danced, sang, and performed on screen. Today, low-budget local entertainment films tied to the hereditary performing classes are still produced in parallel with a transnationally supported New Pakistani Cinema involving educated elite women filmmakers. Historically speaking, what did the agency of professional women entertainers and performance artists mean for the making of the customary South Asian dance-and-song on Pakistani screens? How did female bodies and erotic performance arts relate to viewers on and off the screen?

The performance repertoire of Madam Noor Jehan, Pakistan's foremost female entertainer personality, is a revealing case in point. Born in 1926 to a struggling entertainer family in a red-light district close to Lahore, with her mother's profession said to have been listed as prostitute, Noor Jehan proceeded through dancing and singing for a pittance at fairs and in the intermissions of silent-film screenings to becoming a child star in Calcutta (now Kolkata) in the 1930s.[23] Thereafter, she worked her way up through stardom in Bombay (now Mumbai) to become the leading recording artist as well as an actress, director, and studio owner in independent Pakistan. Throughout the 1950s, while she was taking the Pakistani recording industry by storm, Noor Jehan also danced and acted on screen. Thus, all components of her performative skills were always and equally visible in the public media of Pakistan. In contrast to the disembodied voices on recordings and radio broadcasts that permitted some singers from courtesan backgrounds to gain acceptance in Indian public culture (as noted above), Noor Jehan's sensual singing on records and radio

came with a visibly erotic dancing body. Her cinematic poses brought to celluloid the vocal and movement arts of the courtesan dance (fig. 11), sometimes staged on screen with the male patron–female dancer relations customary to live performances. Within Noor Jehan's fulsome rendition of the hereditary arts and erotic performance in Pakistani media is a larger story of the creative agency that artists from the courtesan and performing communities have held in Pakistan's entertainment film culture. Following the evolution on celluloid of courtesan dance, in tandem with the gender-bending comedy found in popular Pakistani theater, we witness the provocative outcomes.

Let us take the portrayal of a courtesan dance in the Urdu courtesan film *Aag Ka Darya* (River of Fire; 1966; dir. Humayun Mirza). The performer is the renowned actress, director, and producer of Urdu cinema Shamim Ara. She came from another hereditary performer family, her mother having acted on the professional stage with Noor Jehan.[24] Praising the *mujra* performance in *Aag Ka Darya*, Pakistani cinema historian Mushtaq Gazdar suggestively observes that Shamim Ara "had received her lessons in acting and dancing from . . . unrecognized schools of the performing arts."[25] Although with these words Gazdar attributes Shamim Ara's skills to training on nonstandard grounds, at the same time, he credits the performer herself for the skillful dance. Indeed, the reality of these small-scale productions from Lahore is that while "dance masters" do exist and sometimes double as "fight masters," more often than not the choreography is collaborative rather than guided by a specialized choreographer. The virtuoso artists cultivated in the "unrecognized schools" of *mujra* and performing arts make and lead the dance.

In *Aag Ka Darya*, the courtesan dance is set in the hall of a wedding being held at a landowner's village home. Dancing to entertain the groom's party, the courtesan performs the customary kathak. Shot mostly at medium to long range, the dancing space is choreographed largely for a *khadi mehfil*—that is, for standing (rather than seated) kathak movements replete with rapid footwork and pirouettes that emphasize the dance (*nritta*). Moreover, the pirouettes are executed in widening circles that encompass space and take the performer to different parts of the room and segments of viewers. By shooting the gathering of viewers (*mehfil*) from various angles, the screen choreography largely highlights the communal nature of the (all-male) assembly (fig. 12)—except for a few moments of

departure. One long close-up depicts Shamim Ara performing the experience of an erotic mood (*shringara*) customary to the kathak repertoire, with the soundtrack picking up a song about the fragrance that fills her body while she awaits the arrival of her lover. With the camera holding steady on her lowered eyes and heaving breasts, the female body is shown to be performing sexual desire in and for itself in what could be viewed as an autoerotic posture rather than one for male eyes. At another point, the camera takes us to the back of a gesticulating male figure: facing the dancer, he performs mimicry and burlesque in parallel to her movements.

All in all, *Aag Ka Darya* offers a visual register of how erotic dancing and female performing bodies appear on the traditional entertainment screens of Pakistan. On the one hand, the erotic courtesan dance is shown to be a customary part of everyday domestic celebrations. It appears as an art form open to pairing with other traditions of physical performance, such as the gender-bending antics of the male hereditary comedian (*bhand*) common to wedding entertainment in Pakistan.[26] On the other hand, Shamim Ara's performance of the courtesan dance as an autoerotic movement art connects to a rich legacy of female-focused erotic dancing on Pakistani screens. Before turning to that legacy, let me briefly note some striking differences between the courtesan dance setting in *Aag Ka Darya* and similar scenes in the shared tradition of courtesan cinema in neighboring India.

The classic "Islamicate" strand of the courtesan genre in Bollywood includes such glamorous productions as *Pakeezah* (1972; dir. Kamal Amrohi) and the two more recent iterations of the literary narrative *Umrao Jaan* in 1981 (dir. Muzaffar Ali) and 2006 (dir. J. P. Dutta).[27] In these productions, scenic constructions of the *mujra* re-create the courtly past of male patronage to which elite courtesans were bound. The opulent scenography draws on Mughal architecture with occasional touches of Hollywood-style "Arabian Nights" fantasy to exoticize the heavily bejeweled bodies of courtesans, depicted as performers who have cultivated extraordinary skills yet are doomed to the tragic fate of fallen women.[28] We see highly ornamented women performing solely for the ears and eyes of male patrons the erotic genres of song (*thumri*) and sophisticated gestural arts (*abhinaya*) more often from a seated than a standing position (fig. 13). Characteristic of the elite style of *baithaki mehfil*, the seated performances of song and *abhinaya* privilege the performer's "virtuosity as a vocalist" rather than as a dancer.[29]

Fig. 12 Shamim Ara's wedding *mujra* from *Aag Ka Darya* (1966).

Fig. 13 Rekha performing the *baithaki mehfil* from *Umrao Jaan* (1981).

Seen another way, the vocal skills supersede the gestural arts, in effect controlling the body of the dancing woman associated with the debased history of hereditary performance. It is noteworthy that the Pakistani Urdu version of the biography of Umrao Jaan Ada, released the same year as the Hindi courtesan film *Pakeezah*, offers a more down-to-earth depiction of everyday lives and struggles in the courtesan quarters. Furthermore, the Pakistani *Umrao Jaan Ada* (1972; dir. Hassan Tariq) deploys the irreverence of local *bhand* comedy to ridicule the authority of feudal male patronage.

Returning to the Pakistani tradition of women's dance on screen, I find that the erotic performances we see in courtesan

films such as *Umrao Jaan Ada* and *Aag Ka Darya* gain a fresh lease on life in what could be seen as a contrary narrative film tradition of the 1950s and 1960s, that of dancing and singing in the zenana, or women-only quarters of respectable homes. Erotic movements drawn from the kathak repertoire and related dance traditions from the village regions of western South Asia—the border zones of Pakistan and India—are strewn through many such scenes wherein women dance for other women in secluded women's quarters. One such domestic dance scene celebrating female friendship in the Pakistani Punjabi narrative feature *Kartar Singh* (1959; dir. Saifuddin Saif) is noteworthy for my purposes. In this dance sequence, the two female dancers hold poses that look provocatively like early paintings of female-paired performances from that western region. Note, for example, an eighteenth-century painting from Rajasthan (an Indian region adjacent to Pakistan) depicting two women engaged in a dance of intimacy, with bodies curving toward each other and eyes locked in a deep gaze of mutual longing (fig. 14).

Fig. 14 Two young women dancing, approx. 1770 (cat. 122).

Turning to *Kartar Singh*, I find a similar dance of female intimacy that occasionally reproduces the pose. Two female friends (played by Bahar Begum and Musarrat Nazeer) are dancing for each other in a secluded garden (fig. 15). They twirl to a duet through which they tease each other about the awakening of sexual desires in anticipation of marriage. At the same time, marriage is derisively likened to imprisonment. The song lyric depicts how the groom will place the handcuffs of golden bangles around his bride's wrists and take her away.[30] In effect, the song lyric implies that this dance is the perfect, female-focused moment of erotic immersion. This image seems to evocatively reinvent the purpose and mood of female-friendly dance paintings from the region. Moreover, what we find in this animation of the erotic pose in the screen arts of *Kartar Singh* are the unmistakable traces of regional dancing traditions, *ghumar* among others, which have contributed to the repertoire of kathak dance developed by courtesan communities.[31]

Moving on from the "golden era" of domesticity-centered Pakistani cinema (1950s and 1960s), I arrive upon the cinemas of upheaval produced in Pakistan in the 1980s, a time when the country was under an Islamist military dictatorship and saw violent Cold War maneuvers in the region. By that point, the eminent Urdu actress and dancer Shamim Ara had grown into a film director and production-company owner in her own

Fig. 15 Female-friendly dance in women's quarters from *Kartar Singh* (1959).

right. Dances of female friendship in women-only spaces return to Shamim Ara's screen, and they again are paired with gender-bending male *bhand* dancing. The comedic *bhand* acts are performed by Shamim Ara's frequent collaborator, Pakistan's irresistible comedian, film producer, and drag-movie director Rangila. Yet keeping with the times, its fears and its hopes, the dances once again have changed. Carrying a veiled reference to the brutal injustice that was being inflicted on common Pakistani people by the military state and antisocial forces,

the action film *Lady Smuggler* (1987; dir. Shamim Ara) tells the tale of three women hurled into prison on false charges of drug smuggling. In a central sequence of the narrative, we see a subtly erotic dance of female solidarity turning into an opportunity for escape and revenge. It begins in the yard of a women-only prison and ends up encircling the warden called Rangila Jailer (played by the eponymous actor) and queering his erect militarized posture. As the women twirl around him, Rangila begins to imitate their moves, performing gender-bending curves evocative of the *bhand* acts popular in Pakistani (notably Punjabi) theater. The symbolic identity of the prison warden—as a powerful man and a punitive state disciplinarian—crumbles through this comic act (fig. 16), allowing the women to take him hostage and exact reprisal for statist injustice.

• • •

The challenge to nation-state power, performed with gender-bending irreverence in the mainstream film *Lady Smuggler*, takes other forms in independent political films produced across South Asia. In conclusion, then, I turn to the consciously critical use to which dance and the erotic are put in independent South Asian cinema. My focus is on an aesthetic movement called Bikalpa Dhara (alternative stream), an independent cinema born of film clubs in Bangladesh, and a 2014 antiwar film directed and produced by Tanvir Mokammel. The critical nationalist film *Jibondhuli* sets the performance of a local drummer-dancer in the context of the brutality waged by the Pakistani state upon its Bengali citizens in 1971, circumstances leading to the Liberation War and the birth of Bangladesh. The narrative opens with a dance performed by both male and female drummers and musicians belonging to a devotional sect of *namasudras*, the lowest caste of Hindus. This communal dance evokes on screen the performative fluidity of ecstatic devotionalism (*bhakti*), a spiritual practice deriving from mystical movements that swept across South Asia during the fourteenth and fifteenth centuries and involved many lower-caste Hindus, Muslims, and women as prominent practitioners.[32] Especially strong in the Bengal delta, the bhakti movement fostered syncretic spiritual practices led by the Hindu mystic Chaitanya, Islamic Sufis, and Bengali poets. Paintings depicting Chaitanya and his devotees reveal that dancing, music, and percussion were central to the experience of collective ecstasy (fig. 17). *Jibondhuli* performs this syncretism on screen by showing lower-caste Hindus and Muslim villagers

coming together in sites of ecstatic devotion and worship. However, the drummer-devotee protagonist Jibon (literally, "life") dances not simply to celebrate community and interfaith harmony. His movements reinvent devotional performance as a form of resistance to wartime violence and to religious and ethnic cleansing.

The focus of Mokammel's narrative on the religious practices of the minority Hindu community and its low-caste members—situated in the context of Muslim-majority East Pakistan (now Bangladesh)—is meant to shine light on the violence

Fig. 16 The dance of Rangila Jailer from *Lady Smuggler* (1987).

Fig. 17 The saint Chaitanya dances in ecstasy, approx. 1750 or later (cat. 27, detail).

Fig. 18 The rejuvenative drummer dance from *Jibondhuli* (2014).

perpetrated on such minority communities during the war. As such, *Jibondhuli*'s evocation of Hindu religious imagery in favor of minority rights poses a significant contrast to the majoritarian use of Hindu artistic themes in the mainstream Indian (Bollywood) films discussed earlier. An early scene in *Jibondhuli* presents Jibon the drummer dancing at a local landowner's home to celebrate the annual Durga Puja mother-goddess worship festival (central to Bengali Hindu religious practice). As he dances in spiritual ecstasy to the beat of his drum, Jibon turns his devout eye to the maternal deity and meets the gaze of the young mother/lady of the home standing with the deity in a pose of worship. Implicit in the scenic construction of his reverential look is an erotic longing evocative of the Hindu concept of mystical *darshana*, the reciprocal look exchanged between devotee and the divine. This lovelorn longing of the devotee for the female icon is soon reenacted in a revolutionary mode. In the closing shots, we see Jibon the drummer-devotee dancing again to the ecstatic beats of his drum. Only now he dances in front of a shack set ablaze by brutal soldiers, the same woman trapped inside the hovel going down in flames (Jibon having arrived on the scene too late to attempt her rescue). The soundtrack picks up a song of invocation drawing on the cyclical myth of the mother goddess: the myth of ritual sacrifice that promises a new feminine arrival for the rejuvenation of humanity. This closing dance by the drummer-devotee reinvents the performative legacy of mystical bhakti to prophesy for Bangladesh the arrival of a (national) community beyond oppression and division (fig. 18).

In the end, dance indeed is a timeless interpretation of life—precisely so because dancing is bound to times, to locations, to power conflicts, and to the many longings for new worlds that dance makers express. As the times and the longings change, so must bodily energies and their impulsions to make the dance.

Note: Scenes from most of the films mentioned in this essay can be found by searching YouTube, Dailymotion, or similar websites.

1. Schweig, *Dance of Divine Love*, 2–3.

2. Dimock, "Religious Lyric in Bengali," 157.

3. Mankekar, "Dangerous Desires," 419, 421.

4. Dark, "Crossing the Pale," 129–31.

5. Van Buitenen, "*Ramayana* Story," 64.

6. Mannathukkaren, "Reading Cricket Fiction."

7. Mankekar, "Dangerous Desires," 403, 408.

8. Dissanayake, "Issues In World Cinema," 143.

9. Rajadhakshya and Willemen, *Encyclopedia of Indian Cinema*, 177.

10. Krishnan, *Celluloid Classicism*, 3–4.

11. Phalke, "Ladies from Cultured Families," 102.

12. Phalke, "Ladies from Cultured Families," 102.

13. Tula and Pande, "Re-inscribing the Indian Courtesan," 77.

14. Tula and Pande, "Re-inscribing the Indian Courtesan," 78.

15. Chakravorty, *Bells of Change*, 44–45.

16. Morcom, *Illicit Worlds of Indian Dance*, 34.

17. Tula and Pande, "Re-inscribing the Indian Courtesan," 77.

18. Morcom, *Illicit Worlds*, 110–11.

19. Morcom, "Indian Popular Culture and Its 'Others,'" 126–27. See also Morcom, *Illicit Worlds*, 143.

20. Nishtar quoted in Gazdar, *Pakistani Cinema*, 24.

21. Pamment, "Split Discourse," 203, 214; Pamment, *Comic Performance in Pakistan*, 3–4.

22. Gazdar, *Pakistani Cinema*, 13–14.

23. Gul, *Mallika-e-Tarannum Noor Jehan*, 79.

24. Jaffrey, "Shamim Ara."

25. Gazdar, *Pakistani Cinema*, 96.

26. Pamment, *Comic Performance*, 6–7.

27. Bhaskar and Allen, *Islamicate Cultures of Bombay Cinema*, 54.

28. Bhaskar and Allen, *Islamicate Cultures of Bombay Cinema*, 52.

29. Bhaskar and Allen, *Islamicate Cultures of Bombay Cinema*, 54.

30. I thank Gwendolyn Kirk for her help with translations from *Kartar Singh*.

31. Chakravorty, *Bells of Change*, 26.

32. Naim, "*Ghazal* and *Taghazzul*," 181; Vanita, "Medieval Materials in the Sanskrit Tradition," 56.

Entries written by Qamar Adamjee (QA), Ainsley M. Cameron (AMC), Jeffrey S. Durham (JSD), Trudy L. Gaba (TLG), Forrest McGill (FMcG), Natasha Reichle (NR), and Nathaniel M. Stein (NMS)

Destruction and Creation

THE EXTRAORDINARY POWER OF DANCE to affect the cosmos, the universe, and earthly order has often been envisioned in Hindu and Buddhist contexts. Through the vigorous dance of Shiva—the Hindu god associated with creating, sustaining, and destroying the universe—dance is transformative. In his form of Nataraja (King or Lord of Dance), Shiva dances the world into and out of existence through endless rhythmic cycles. Today, the depiction of Shiva Nataraja has become symbolic of Hindu civilizations, where strength and perseverance are witnessed through the force of the god's form—a form echoed through rhythm and endless motion.

In Hindu and Buddhist realms, the life of the universe moves in cycles, with cosmic destruction and creation recurring eternally. Beyond Shiva Nataraja, other deities also embody creative and destructive tendencies. Vajravarahi empowers creative and destructive forces through meditative practices while adorned with the severed heads of enemies. The otherworldly pair known as Shmashana Adhipati, or Chitipati, are the glorious lords of the cremation grounds who transform fear through dance. And Bhairava, who also wanders the cremation grounds, dances through darkness with his dog companion. Each of these deities harnesses power through awe, energy, stasis, and more to demonstrate that anything concrete can be dissolved. They are embodiments of wisdom that transcend human limitations and continually transform the universe through dance.

The Dance of Shiva

Siva, as we have already said, is a great master in the art of dancing.

This statement, opening a long chapter on the subject by the scholar T. A. Gopinatha Rao, had "already" been made in 1916 and suggests the challenge of adding anything that doesn't repeat the thoughts of generations of scholars.[1] Shortly after, in 1918, Ananda K. Coomaraswamy discussed the meanings of the iconic Chola-period bronzes of Shiva as Nataraja, the lord of dance in, his widely read essay "The Dance of Śiva." It became influential and has remained so—though eventually strongly challenged.

These images, perhaps the most familiar of all in Indian art, are characterized by features not shared by all representations of Shiva dancing, because in sacred stories associated with him, the deity dances a number of times in various circumstances. Among the key features of Chola bronze Natarajas are the left leg lifted high and angled across the body, the four (as opposed to more) arms, and the dwarfish figure, usually associated with ignorance, that Shiva dances upon to subdue (see cat. 1).

Coomaraswamy saw Shiva in this form as balancing the forces of creation and destruction. A key revising notion of more recent scholars is that, in considering early bronzes of Nataraja, Coomaraswamy underemphasized the destructive side, connections with cremation grounds, and the importance of conquest. (It should be noted that destruction, in most Hindu worldviews, is not entirely negative, as it allows for creative change.) "Shiva's powers to create and enlighten," writes Padma Kaimal, "which balance his destructive (or *tamasic*) aspect in Coomaraswamy's interpretation," are likely to have come to the fore several centuries after the initial creation of the classic Chola bronze Nataraja.[2]

The symbolism of Shiva's bodily position and the attributes he holds were discussed by Coomaraswamy. More modern interpretations have been laid out by Kaimal, who has stressed that the icon and its elements cannot be thought to have fixed meanings valid through the centuries but, rather, must be considered for various periods and audiences.[3]

In the twentieth century, new meanings were attached to the Nataraja. It became a sort of emblem of India, used on posters and travel brochures. Today it is a meme that can be echoed visually with few or none of its deep religious resonances surviving, as when its posture and multiple arms are used to show Barack Obama trying to manage many huge tasks at once (cat. 4).

A vital point, which may be obvious but bears underlining, is that the images of Shiva (and those of other deities) in this exhibition were created for worship and not just for aesthetic affect, though their beauty has no doubt moved viewers through the centuries as it does us today. But bronze Natarajas were (and are) seen by worshippers as embodying the god himself. When they were (and are) processed through the streets on chariots during festivals, decked in sumptuous garments, jewels, and flowers, pious viewers felt (and feel) a true revelation of the divine.—FMcG

1. Rao, *Elements of Hindu Iconography,* vol. 2, pt. 1, 223–70.

2. Coomaraswamy, "The Dance of Śiva," in *The Dance of Shiva,* 52–62. For more on Coomaraswamy, see Laura Weinstein's essay in this volume. An admirably clear and thorough critique of Coomaraswamy's theories, which reviews the history of the Nataraja image while presenting convincing new interpretations, is Kaimal, "Shiva Nataraja," 390–419. Other notable discussions of the dancing Shiva (among many) are O'Flaherty, "Death as a Dancer in Hindu Mythology," 201–16; Kramrisch, *Manifestations of Shiva;* Gaston, *Śiva in Dance, Myth, and Iconography;* Zvelebil, *Ānanda-tāṇḍava of Śiva-Sadānṛttamūrti;* Soundararajan and Kalidos, *Naṭarāja in South Indian Art;* and Smith, *Dance of Śiva.*

3. Kaimal, "Shiva Nataraja," 390–419.

1 *also pp. 10, 64*

Shiva Nataraja, the Lord of Dance

Approx. 1125–1175
India; Thanjavur district, Tamil Nadu state
Copper alloy
H. 98.1 cm × W. 71.1 cm
Virginia Museum of Fine Arts, Richmond, Adolph D. and Wilkins C. Williams Fund, 69.46

2

Shiva as Nataraja enshrined with deities

Approx. 1825–1875
India; Tamil Nadu state
Pigments, gold leaf, and limestone paste on cloth stretched over wood
H. 80.7 cm × W. 65.6 cm × D. 5.7 cm (outer frame)
Minneapolis Institute of Art, the Jane and James Emison Endowment for South Asian Art, 2014.57

The iconic Chola-dynasty bronze Nataraja (such as cat. 1) first appeared some eleven hundred years ago, and superb examples continued to be made for several centuries.[1] These works represent Shiva's vigorous "dance of bliss," the *ananda-tandava*, which is said to have taken place, in its earthly iteration, at Chidambaram in southeastern India.[2] The great temple there is a center of worship of Shiva Nataraja and a major pilgrimage site. In its inner sanctum—where, in most temples to Shiva, a linga would

be the focus of devotion and ritual—there is instead a bronze Nataraja. The sculpture must not be photographed, so our best idea of its visual aspects and context come from paintings (such as cat. 2). There is no doubt that the primary sanctuary of the Chidambaram temple, with its unusual gold-covered roof and nine pot-like ornaments along the ridge (fig. 1), is shown there. The icon of Shiva, surrounded by a ring of fire, looms large in the small space. Flanking the dancing Shiva are, on his left, Shivakami, as his consort is known at Chidambaram, and on his right, his son the elephant-headed Ganesha, also dancing.—FMcG

1. For detailed information on this Nataraja, see Dye, *Arts of India,* cat. 57.

2. For a discussion of the Nataraja cult at Chidambaram, including possible early links to cremation-ground imagery and later adjustments of the key stories, see Kaimal, "Shiva Nataraja," 405–07. A number of excellent essays by Indian and Western scholars, together with copious illustrations, are found in Nanda et al., *Chidambaram: Home of Nataraja.* For more on the rituals of the Nataraja Temple at Chidambaram, its history of patronage and construction, and the poetry associated with it, see Younger, *Home of Dancing Śivaṉ.*

Cat. 2

Fig. 1 The roof of the inner shrine, Nataraja Temple, Chidambaram.

Permutations of Shiva Nataraja's Form and Dance

The recognizable stance of Shiva Nataraja, with left leg lifted and multiple arms outstretched, has a long history of changing interpretation. Outside India its meanings have been speculated on, sometimes with little direct knowledge, and its form has been reused or evoked in a variety of contexts. The imagery and imagined splendor associated with Nataraja, as well as other aspects of South and Southeast Asian cultures, have been woven into Western theatrical dance from at least the seventeenth century. And yet this predated any understanding of the movement-based traditions from this region and was based instead on conjecture and lore. Indeed, ballets and operas performed across Europe and the United States until the twentieth century were largely unconcerned with authenticity or religious and cultural understanding and were instead seated in exotic notions of kings, elephants, and romantic tales.[1]

In the early twentieth century, the reception of Indian art and dance was infused with connotations of the "Orient" and associated spiritual ideals. European and American dancers such as Anna Pavlova, Ted Shawn, and Ruth St. Denis traveled to India to view what they considered "authentic" forms. In the 1910s and 1920s—and even later—a profusion of original dances, including Shawn's *Cosmic Dance of Shiva* (see cat. 3), infused choreography with spiritual ideals and religious narrative. Received with great appreciation by American audiences (it was never performed in India), *The Cosmic Dance of Shiva* was staged often by Shawn until the 1950s.[2]

The visual presentation of Shiva Nataraja, now part of the lexicon of Western popular culture, has continued to morph and adapt. The form, and the dance it signifies, has now become an iconic international emblem, mostly devoid of spiritual meaning. Among multiple other permutations, Nataraja has been transmuted into Barack Obama and emblazoned on a magazine cover (cat. 4), adopted as the logo for a beer brewed in Asheville, North Carolina (fig. 1), and gifted from the Indian government to the European Organization for Nuclear Research (CERN) as public sculpture (fig. 2).[3] Emblematic of India, these representations harness Shiva's power but not necessarily the complexity of the god's meaning.—AMC

Fig. 1 Asheville Brewing Company's Shiva IPA. Beer in the collection of the author.

Fig. 2 A life-sized sculpture of Shiva Nataraja, a gift from the Indian government in 2004, outside the European Organization for Nuclear Research (CERN) headquarters in Meyrin, Switzerland.

1. See Kaimal, "Shiva Nataraja" and Laura Weinstein's essay "Worshippers of Nataraja Still" in this volume (pp. 65–75).

2. Warren, "Yearning for the Spiritual Ideal," 107.

3. See Warren, "Yearning for the Spiritual Ideal," for a detailed discussion of the many dances, ballets, and operas infused with Indian ideals that were created during these decades, including Sergei Diaghilev's *Le dieu bleu* (1912; danced by Vaslav Nijinsky), Anna Pavlova and Uday Shankar's *Oriental Impressions* (1923), Martha Graham's *The Flute of Krishna* (1926), and Ruth St. Denis's *The Nautch* (1944).

4. Controversy surrounding the Asheville Brewing Company's Shiva IPA was widely reported in the press. Addressing Hindu activists in Nevada and California, the co-owner of the brewery stated that the name was chosen in honor of the god's power and strength.

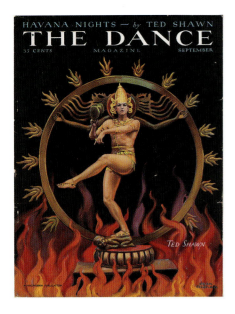

3

Ted Shawn in *The Cosmic Dance of Shiva*, cover, *The Dance* 10, no. 5 (September 1928)

Magazine
H. 32.5 cm × W. 25 cm
Asian Art Museum of San Francisco,
Library Special Collections

Ted Shawn was one of the most influential dancers in the first half of the twentieth century, traveling throughout the United States, Cuba, Europe, and Asia and presenting original choreography. He taught dance for fifty-five years and created almost two hundred original compositions. After a visit to India with his wife, Ruth St. Denis, in 1925–26 to research dance and to perform, Shawn and St. Denis further infused their practice with spiritual ideals.[1] In 1926 they choreographed *The Cosmic Dance of Shiva*, with Shawn in the central role. Slowly moving his body into position, with left leg raised, he twirled as if to signify his being was the center of universal energy. Shawn based his dance on sculptural and painted depictions of the god.[2]

Shawn posed as Shiva Nataraja for the cover of *The Dance*, a popular periodical still in production today as *Dance Magazine*.[3] The cover is based on a painting by Jean Oldham, which was

itself based on a photograph of Shawn posing mid-performance. Oldham was an accomplished illustrator active in the early twentieth century who was responsible for many cover illustrations, transforming movement into a static painterly form.—AMC

1. Ted Shawn and Ruth St. Denis were personal and professional collaborators from 1914 to 1931. They founded the Denishawn School of Dancing and Related Arts that had locations across the United States and taught "Denishawn Dancing," a style that combined ballet with free, expressive, and experiential movements inspired by the Delsarte technique and Dalcroze education. These foundational theories were then infused with St. Denis's interest and training in various Indian, Javanese, and Balinese dance techniques. See Mumaw and Sherman, "Ted Shawn, Teacher and Choreographer."

2. Warren, "Yearning for the Spiritual Ideal." It is believed that Shawn commissioned the large metal ring of fire that acts as a backdrop to his performance—and to this image—from a Calcutta foundry. Clips of the dance can be found on YouTube.

3. The periodical has been retitled numerous times since its founding, including *The American Dancer* (vols. 1–15, no. 5; June 1927–April 1942); *Dance* (vol. 15, nos. 6–9; May–August 1942); *Dance Magazine* (vol. 15, no. 10–vol. 19, no. 1; September 1942–January 1945); *Dance* (vol. 19, no. 2–vol. 22, no. 5; February 1945–May 1948); *Dance Magazine* (vol. 22, no. 6; June 1948)–present. At the time of writing, the most recent issue (vol. 94, no. 12) was published in December 2020. Utmost thanks to Cincinnati Art Museum Assistant Librarian Jennifer Hardin for her assistance.

4

"God of All Things," cover, *Newsweek*, November 22, 2010

Magazine
H. 26.7 cm × W. 19.7 cm
Asian Art Museum of San Francisco,
Library Special Collections

When published in November 2010, this cover of *Newsweek* caused much consternation among diasporic Indian American communities as well as communities in India.[1] Obama-as-Nataraja here does not

destroy one universe to reinvent a new one. Instead, judging from the attributes that he holds, he is an arbiter of war (helicopter), capitalism (paper currency), and an economic recession caused by the mortgage crisis (house). The world, dove, and stethoscope may represent the positive aspects of his presidency, one that faced multiple challenges and required a delicate balance between action and ideas.

The conflation of Shiva Nataraja with the president of the United States demonstrates the ubiquitous nature of the form, as well as the Western media's comfort in adopting religious symbols and deities for their popular use. By so doing, the form of Nataraja is stripped of its cultural context and religious meaning. Yet aspects of Nataraja are still apparent: Obama-as-Nataraja embodies a superhuman power and a dynamic energy harnessed through the transformative potential of dance.—AMC

1. Credited to "R. Mutt Studios," the image photoshopped Barack Obama's head (photo credited to Ron Sachs-Pool/Getty Images) on a multiarmed body. The controversy was reported in *India Today*, *Times of India*, and *HuffPost*, among other media outlets.

5

Dancing Shiva

Approx. 800
India; Madhya Pradesh state
Sandstone
H. 74.9 cm × W. 40.6 cm × D. 16.6 cm
Los Angeles County Museum of Art,
from the Nasli and Alice Heeramaneck
Collection, M.82.42.4

In stone sculpture, Shiva was represented
dancing well before the development of
the classic Chola bronze Natarajas (see
cat. 1).[1] While his dance may be shown
in a variety of vigorous ways, Shiva does
not lift his left leg to cross in front of his
body in these earlier representations.
Here we find a feature not found on Chola
Natarajas: Shiva's penis is erect, recalling
the god's link with male reproductive
power and his frequent symbol, the
linga—a usually abstract cylindrical
emblem that has a range of associa-
tions, from a sign of the unrepresent-
able Absolute to a cosmic pillar to a
phallus.[2]—FMcG

1. At least by the early sixth century, according
to Kaimal, "Shiva Nataraja," 394.
2. This sculpture is discussed in Pal, *Indian
Sculpture*, vol. 2, cat. 40.

6

Dancing Shiva

Approx. 800–900
West central India
Sandstone
H. 43.1 cm × W. 27.9 cm × D. 20.3 cm
Museum of Fine Arts, Boston, Frederick
L. Jack Fund, 69.1047

Here, the pinwheeling of the eight arms of this form of Shiva gives an animated sense of movement that we can imagine a human dancer emulating. In the evocative words of Stella Kramrisch, "The inner calm of Śiva's three-eyed face shows the god as the still center of the turbulence of his arms."[1] This work at first seems to be an independent sculpture, but it may well have once been part of an overdoor panel, with Shiva joining the goddesses known as the "Seven Mothers" (cats. 52–53).[2]—FMcG

1. Kramrisch, *Manifestations*, cat. 36.
2. Desai and Mason, *Gods, Guardians, and Lovers*, cat. 60.

7

Overdoor panel with dancing Shiva

Approx. 1750
Nepal
Wood
H. 81.3 cm × W. 152.4 cm
Los Angeles County Museum of Art, Gift of Mr. and Mrs. Harry Lenart, M.76.483

Large panels such as this hang, leaning forward, over doors and windows of Nepalese temples. They are called toranas, or gateways, and function symbolically to mark the transition from the outside world into the sacred space of the temple.

Many different deities may take center stage on toranas; they are said to judge whether those seeking entrance are worthy.[1] Here, the central figure is an eight-armed dancing Shiva whose glaring eyes, knitted brow, and garland of severed heads suggest that here Shiva dances in a fierce and protective mood (fig. 1).[2] Shiva is flanked by unidentified figures that dance and play drums. The smaller of these, with animal heads, may be *ganas*, legendary grotesque followers of Shiva. The other elements of the panel—crocodile-like creatures, snakes, snake deities, and a now-missing mythical bird (Garuda)—are common to Nepalese overdoor panels and have no special significance here.[3]—FMcG

1. Slusser and Jett, *Antiquity of Nepalese Wood Carving*, 207, referring to the work of Gautama Vajracharya.
2. Images of Shiva dancing are sometimes found situated over doors in Southeast Asian temples—for example, at Banteay Srei in Cambodia, Phanom Rung in Thailand, and Po Klong Garai in former Cham territory in Vietnam.
3. Pal, *Art of Nepal*, 129.

8
Strut with dancing Bhairava

Approx. 1700
Nepal; Kathmandu Valley
Wood with traces of pigments
H. 72.4 cm × W. 45.7 cm × D. 17.8 cm
Walters Art Museum, F.167

With hair flaring upward, eyes bulging, and mouth grinning frighteningly, Bhairava (a form of Shiva) dances on the back of a dog. The deity's terrifying nature is emphasized by the garland of skulls adorning him and his association with the dog, as dogs were seen as scavengers in cremation grounds.

But just as dogs can also be fierce protectors, in Nepal, Bhairava could be a powerful guardian, repelling or overcoming threatening negative forces. This protective function may have been foremost in the creation of this image, because it was not an icon in a shrine but rather part of an architectural strut supporting the eaves of a temple roof (fig. 1).[1]

In Nepal, Bhairava, like a number of other deities, is important in a variety of religious contexts. "For Hindus, Kāla Bhairava . . . punishes the immoral and beats back demons; for Buddhists, he is the aggressive manifestation of the celestial bodhisattva Mañjuśrī, who provides protection to individuals."[2]

This particular form of Bhairava, with three (visible) heads and six arms, dancing on the back of a dog, is very rare and has not been identified.[3]—FMcG

1. Shakya, *Cult of Bhairava*, 137, 145; Pal, *Desire and Devotion*, 211.
2. Kim and Lewis, *Dharma and Puṇya*, 149. For more on Buddhist and Hindu views of Bhairava, see Ladrech, "Bhairava et Mahākāla au Népal."
3. Pal, *Desire and Devotion*, 211. Other three-headed dancing Bhairavas are a twelfth-century Pala one in the Indian Museum, Kolkata, and one from the twelfth century at the Airavateshvara Temple at Darasuram, Tamil Nadu. Neither of these has six arms, however, and neither dances on the back of a dog. Both are viewable by searching Wikimedia Commons.

Fig. 1 Roof eaves and struts, temple in Basantapur district, Kathmandu, Nepal.

9

The Buddhist deity Vajravarahi

Approx. 1700–1800
Eastern Tibet; Kham province
Pigments on cotton
H. 37.5 cm × W. 27.3 cm
Rubin Museum of Art, Gift of Shelley
and Donald Rubin, C2006.66.396
(HAR 839)

In Tibet there are many female Buddhas, including Vajravarahi, the Lightning Sow. She can be instantly recognized by the pig's head jutting up from her own flaming hair. Such imagery invokes the symbolism of the pig, which can consume all negativities without harm. By visualizing Vajravarahi's form, meditators intend that a parallel consumption of all negativities will occur within their own mindstreams.

In this thangka painting, Vajravarahi spins uncannily atop a golden sun disk and a pink lotus flower, which, between them, sandwich a corpse that represents the ego. Dangling from her neck is a garland of fifty severed heads, each of which represents a letter of the Sanskrit alphabet and thus of the internal dialogue that ordinarily sustains the ego. In this respect, her imagery makes Vajravarahi a veritable hieroglyph of ego slaying.

Yet she has still more weaponry, for in the crook of her left elbow Vajravarahi bears a long-staffed trident called a *khatvanga*. It is laden with symbolism both gory and profound. At the top of the staff is a golden device symbolizing a thunderbolt (*vajra*). Beneath it are staked three horrors: a skull, a desiccated head, and a fresh, bloody head. Clearly related to corpses and their disposal, such imagery nonetheless represents three successive—and very sophisticated—stages in the abstraction of the state of Buddhahood from the earthly to the transcendent: from the historical (freshly chopped) to the visionary (desiccated) to the ultimate (skull). And there is still more symbolism to Vajravarahi's dancing

costume, for the three prongs of her trident represent the three subtle "channels" through which energy is thought to flow in the subtle body, a constituent of the human organism typically thought visible only to practitioners of yoga.

The ferocity of Vajravarahi's dance generates a ring of orange wisdom flames (*jnana-jvala*), lofting her hair upward and floating her long green scarf on waves of heat. Yet the dance generates more than destructive heat, for just inside the lurid flames lies a region of cool indigo punctuated at successive intervals by finely drawn curved and straight lines. Symbolically, they represent the wisdom and compassion that emanate from Vajravarahi's heart, however funereal her imagery might seem.

Vajravarahi is not alone but dances in the midst of four smaller-scale replicas. Configured like the five spot on a die, they comprise her mandala, with Vajravarahi at the central point and the replicas in the cardinal directions. Nor does a painting such as this stand alone as an objet d'art. Instead, it is part of a chain of transmission of visual teachings. Here, the teaching lineage can be discerned by the lama above Vajravarahi. His black hat reveals that the teacher belongs to the Karma Kagyu teaching lineage, a presumption confirmed by the work's telltale minimalist style.—JSD

10 *also p. 17*

The Buddhist deity Vajravarahi

Approx. 1300–1400
Tibet
Bronze with gilding and inlaid turquoise
H. 36 cm (overall)
Cleveland Museum of Art, Leonard C.
Hanna Jr. Fund, 1982.50

During the second diffusion of Buddhism in Tibet in the eleventh century, Vajravarahi was one of the most important fierce deities whose dynamic visualization meditation was transmitted to the region. She appears in some of Tibetan Buddhism's earliest painted artworks, but early sculptures are rather rare. This Vajravarahi is one of the world's most sublime examples.

With minimalist grace, Vajravarahi—manifestation of full enlightenment in female form—raises her right leg toward her sacrum as she balances masterfully on her left. This early example from Tibet contrasts with a more ornate counterpart likely cast two centuries later at Densatil Monastery (cat. 11). Apart from her slightly furrowed brow and just-parted lips, we might miss that Vajravarahi's expression verges on fierce. Indeed, Tibetan tradition understands her as an aspect of the supremely peaceful Perfection of Wisdom, a goddess extolled as Mother of All Buddhas.

A closer look reveals that Vajravarahi is as much a butcher as a theologian. In her left hand she holds a skull top. Inside, waves of negativity ready for destructive transmutation into nectar roil back and forth, awaiting the blow of her upraised right hand, which bears a wickedly curved flaying knife. Its convexity perfectly complements the concavity of the cranium such that together the knife and the skull symbolize emptiness and compassion, whose union leads to enlightenment. This butcher, in other words, is neither angry at anyone nor a slayer of beings. Instead, her anger is directed toward the emotional poisons that obscure pure awareness.—JSD

11

The Buddhist deity Vajravarahi

Approx. 1400–1500
Tibet; probably Densatil Monastery
Copper alloy with gilding, gemstones, and traces of paint
H. 28.6 cm × W. 24.8 cm
Los Angeles County Museum of Art, Purchased by the Los Angeles County Museum of Art Board of Trustees in honor of Dr. Pratapaditya Pal, Senior Curator of Indian and Southeast Asian Art, 1970–95, AC1996.4.1

Vajravarahi's name translates as "Lightning Sow." Her telltale pig's head sprouts from the right side of her head (but is only visible from the rear), and her brow furrows as she bares her fangs while brandishing a flaying knife above her head, ready to chop and liquefy the contents of the skull bowl she holds in her left hand. She does all this while twirling on the toes of her left foot, which would originally have delicately balanced on a lotus platform, now missing, to which the metal tang under her heel would have secured her.

Like other figures here, Vajravarahi is a denizen of the cremation ground and wears a crown of skulls to confirm her predilection. Beautifully cast and inlaid by the artisans of Densatil Monastery in Tibet, each skull represents one of the five psychological poisons that meditation on her form can transform into wisdom consciousness: anger, attachment, pride,

jealousy, and delusion. She also wears five kinds of ornaments, made of bone, that represent the five components into which Buddhism classifies the components of human experience: form, feeling, thinking, impulses, and consciousness. Like her crown, Vajravarahi's bone ornaments bear exquisite inlay of lapis, coral, and turquoise that mark this sculpture as a product of Densatil's artists.

Vajravarahi's garland of fifty skulls represents the fifty letters of the Sanskrit alphabet. Visualizing these severed skulls in meditation eliminates the discursive thoughts they otherwise enable. This garland sways heavily with Vajravarahi's motion as her scarves float in the transformative space of her ritual dance.—JSD

12

The Lords of the Cremation Ground dancing

Approx. 1400–1500
Tibet
Pigments and gold on cotton
H. 45.1 cm × W. 36.2 cm
Rubin Museum of Art, Gift of the
Shelley & Donald Rubin Foundation,
F1996.16.5 (HAR 462)

A cremation ground might not initially seem an ideal place either for dancing or for meditation, but the art-historical record—as exemplified by this painting and cat. 13—suggests that the fearsome cremation grounds (shmashana) of medieval northern India (approx. 700–1200) were wellsprings for both practices. Deities from Shiva to Hevajra to Vajravarahi all dance there, each with their own forms, stories, and practices. Indeed, it is difficult to find a more spiritually creative environment in the history of human religion than the northern Indian cremation ground.

As Buddhist texts and imagery were transmitted to Tibet first in the eighth and again in the eleventh centuries, the visual culture of the cremation ground, which had previously been quite specific and local in character, became generalized and standardized. A set of Eight Great Cremation Grounds eventually attained canonical status. Each of these places received its own terrifying name, like Shrieking Kilikili, and a panoply of disturbing imagery, from decaying bodies and threatening serpents to religious memorials and madman yogis (see cat. 36).

The figures called Shmashana Adhipati—the Luminous Overlords of the Cremation Ground, or Chitipati—first appear in Tibet in the art of the Sakya order of Tibetan Buddhism.[1] They dance at the center of this superb artwork; the leaflike whorls of wisdom flames at the edges of the ruddy aureole surrounding them reveal that it was created at the famous Sakya studios at Ngor Monastery. The deities smile in a way that seems almost unaffectedly friendly—were it not for that fixated, hypnotic gaze in their six eyes. This time, the eyes look not at each other (as in cat. 13) but at us: the deities' viewers. Each figure holds a red staff crowned by skulls in their right hand and skull cups filled with blood or ambrosia in their left. They both sport rainbow-colored fans behind each ear, and a diadem of still more smiling skulls crowns the head of each overlord. At the top of this composition an eerie canopy of bones "protects" the sacred precincts of the dance as if it were a tent, which has as its foundation a golden sun disk, the source of the heat of the red wisdom flames around the pair.

Adepts contemplating this painting find themselves imaginatively projected into the transformative realm of the cremation ground. There, contemplatives dance and chant the fierce rites of visualized meditations; there, the mystery of death and generation is confronted once and for all in an apocalypse that seems destructive only when seen from the mistaken perspective of the illusory and impermanent fiction we experience as the ego. From the enlightened perspective of Shmashana Adhipati, which sees all things as empty, blissful, and luminous, even the apparently noxious forces of the cremation ground become potent fuel for enlightenment.—JSD

1. See Linrothe, Watt, and Rhie, "Smashana Adipati."

13 *also pp. 92–93*

The Lords of the Cremation Ground dancing

Approx. 1800–1900
Tibet
Pigments on cotton
H. 33.7 cm × W. 28.6 cm
Rubin Museum of Art, Gift of the
Shelley & Donald Rubin Foundation,
F1997.40.9 (HAR 590)

The tutelary lords of the cremation ground, Shmashana Adhipati, reign over the center of this painting. The two lovers gaze into each other's three black-on-red eyes, rapt and smiling. The blue-clad male figure on the left holds two gruesome implements: a spinal column and a skull cup filled with blood. His counterpart on the right holds a gold feather and a flask. Both dance on shells—he on a conch, she on a cowrie—symbols of the emptiness each naturally embodies.

The dancing platform here is cosmic in form, consisting of a ruddy disk symbolizing the sun and a lotus flower of spontaneous manifestation. These items are rather standard iconographic paraphernalia in Himalayan Buddhism, but the platform itself is restricted to the terrifying deities. Indeed, a closer look will reveal that the white, truncated pyramid on which the platform rests is in fact a mountain of bones. And although the entire scene appears gruesome, the flames of pure awareness radiate from the pair. These two, therefore, must be regarded as expressions of the full enlightenment (bodhi) that generates such flames.

The suggestions of dynamism in the gestures and postures of Shmashana Adhipati are confirmed by the environment in which their manifestation takes place. Surrounding the overlords appear a series of offerings, along with the musical instruments required to realize them. On either side are placed the so-called Eight Outer Offerings of sense-pleasures in golden footed bowls. Between these bowls are six skull bowls that hold the Inner Offerings of the five senses themselves. Such offerings generate for the adept merit and a powerful spiritual connection with the deity so represented.

Because such imagery can be disturbing, it is essential that it be studied under and transmitted by a qualified lama. Accordingly, thangka paintings depicting such imagery may also depict lamas in its transmission lineage. Thus, the lama Tsongkhapa, founding figure of the Gelug lineage of Himalayan Buddhism, appears wearing a pointed yellow hat while seated cross-legged on a lotus just above Shmashana Adhipati in this work. At the top left is the Buddhist visualization deity Chakrasamvara; he is blue and embraces his consort Vajrayogini, a form of Vajravarahi (see cats. 9–11). Indeed, the meditations that focus on the overlords come from the same text that describes Chakrasamvara, whom they guard. They must be differentiated from the dancing skeletons that clear the dancing area for the cham dance; these skeletons are minor attendants of the god of death, Yama (see cat. 15).[1]—JSD

1. For more on the cham dance, see the essay "Dancing in Circles" in this volume (pp. 33–47).

14

The deity Rahula and other figures, from a manuscript of Buddhist iconography

1700–1800
Nepal
Ink and opaque watercolors on paper and wood
Manuscript: 8.9 cm × 20.3 cm × 3.2 cm (closed)
Los Angeles Museum of Art, Gift of Dr. and Mrs. Robert S. Coles, M.81.206.5.1

In Nepal the ostensibly discrete religions of Buddhism and Hinduism have fused and commingled artistic representations for a millennium and a half. Divinities dance from one identity—indeed, one tradition—to another, revealing transformations like the impressive Rahula at the center of this composition.

With his face on his belly, Rahula is the ancient Indian deity of eclipses—those periods when the Earth comes between the sun and a given celestial body, casting the latter in shadow. In standard presentations of Rahula, we typically see nine heads, each representing one of the planets susceptible to eclipse. And yet here the central figure has many

more heads than nine, at least fifteen by visual count. Moreover, in addition to his telltale belly-face and characteristic bow and arrow, this impressive personage carries the trident called a *khatvanga*, an item not part of Rahula's traditional imagery. What has happened here?

The prone animals and humans writhing beneath the main figure's dancing feet provide a clue. They are an iconographic peculiarity of Vajrabhairava, a fierce Buddhist meditation deity. Indeed, there is a legend from a thirteenth-century "treasure" text that claims parentage of Rahula by the god Vajrabhairava.[1] Here, the animals and humans represent figures from Rahula's

mythology, such that his imagery overlaps with that of his parent Vajrabhairava in what appears a classical syncretism.

On either side of Rahula dance two more divinities, each with a third eye open on their foreheads. On the left, a four-armed Ganesha dances on his characteristic animal, a mouse, while on the right, a four-armed yogi balances atop a human corpse. The iconographic innovations and amalgamations here may reflect patterns observable in the Nepalese art historical corpus or they may reflect the vision of the artist to whom this sketchbook belonged.—JSD

1. See Cameron Bailey, "Buddhist Worldly Protector: Rahula (History, Narrative & Myth)," Himalayan Art Resources, May 26, 2015, https://www.himalayanart.org/search/set.cfm?setID=4051.

15

Masked ritual dance at Erdene Zuu Monastery

Approx. 1961
By Sh. Baatar (Mongolian)
Colors on canvas
H. 84.5 cm × W. 165.5 cm
Asian Art Museum of San Francisco,
Museum purchase, 1992.342

The vast Mongolian monastery of Erdene
Zuu engulfs our field of vision as the
sacred Mongolian dance called cham
unfolds before us. We are partially
suspended in midair, looking down on
the proceedings at an angle. Along the
horizon, at the center of the painting, a
row of white stupas with pointed spires
marks out the precincts of the monastery.
Erdene Zuu's main building serves as the

is blue and wears a tiger-skin skirt as he stands in a halo of wisdom flames stoked by his ferocity. (Note that we see the banner from the back, as all the iconography is reversed.)

In this contemporary painting, we join the ceremony in progress. Two skeletons resembling the Lords of the Cremation Ground known as Shmashana Adhipati or Chitipati (see cats. 12–13) have already danced around the *zor*, ritually transforming the circular space into a symbolic cremation ground where negativities will die. With the area so transformed, a whole cast of familiar Mongolian characters can now appear on the scene. Thus, just inside the Vajrapani banner is Sagaan Ubgen (White Old Man), a Mongolian guardian of health and wealth. White Mahakala (to the left of Sagaan Ubgen) and red Begtse (opposite Sagaan, on the far side of the seven circles) are also important catalysts of wealth in Mongolia. The other masked dancers drive evil into the *zor*, and the deer-headed figure to the right of Sagaan Ubgen will eventually shred it, symbolically destroying collective evils and preparing the way for the prosperity generated by wealth deities.

The climax of the rite takes place when the buffalo-headed god of death, Yama, or Erlig Khan in Mongolia, begins dancing. In this painting, Erlig Khan is a blue, long-horned figure to the right of Sagaan Ubgen. His manifestation visually, kinesthetically, and ritually expresses the insight that death is both inevitable and necessary to renewal. —JSD

backdrop to the scene, while an assortment of Mongolian yurt huts dot the area at the upper right between the monastery and its stupa-topped wall.

At the center of seven concentric circles drawn on the ground lies the focus of the rite: a cone of barley dough called a *zor*. Cham ritualists dance around it, their masks so large that the wearers must look out from the characters' mouths to

ensure that their intricate movements remain synchronized. At the upper left, a monastic orchestra, including two monks with long trumpets, drives the proceedings. Just outside the circle in the center foreground, celebrants have erected a large banner of the Buddhist deity Vajrapani, who symbolically presides over the ceremony. With a crown of five white skulls atop his fierce visage, Vajrapani

Devotion

THE MUTUAL LOVE AND LONGING of god and devotee, or *bhakti*— a relationship so intimate and emotional that it is akin to conjugal love—is often explored through dance. In the bhakti movement, devotion is often expressed through rhythmic motion and organized postures that create connection between earthly and divine realms. This and other devotional dance represents the reunification of opposites, the transcending of dualities, and the achievement of ultimate oneness. These states of achievement resonate with many forms of Hindu, Buddhist, and sometimes Muslim thought. In recent centuries, the religious and spiritual importance of bhakti has increased; it has become a central aspect of worship practices and directs how people live their lives.

The most frequent depiction of dance as devotion comes from a Hindu context, one that imparts the important role of music, dance, and drama in the propagation of religious beliefs. This is the circle dance of Krishna and a group of cowherder women who dance together in a circle of divine bliss. Krishna, an incarnation of the Hindu god Vishnu, lives in a village and is indistinguishable from the other young male cowherders except for his strength, cleverness, and beauty. One night he goes deep into the forest and plays his flute; his music is irresistible to the cowherder women, who abandon their families and rush to join him. They dance a dance of connection that enthralls the senses and transcends earthly bonds. Worshippers of all sexes long for Krishna and identify with Krishna's female beloved, Radha.

The Rasamandala

The entrancing god Krishna has been joining in amorous play with the women of a cowherd village (with whom we mortals identify) who have left their families to join him in the moonlight of a beautiful forest. The women grow overconfident, and, to teach them (and us) a gentle lesson, Krishna vanishes. Before long, though, again using the divine power of illusion, he reappears in their midst. Krishna multiplies himself so that each cowherd woman can be close to him. Then begins the circle dance depicted untold times in Indian art, which comes to be known as the rasamandala, the "circle of the rasa dance."[1]

The descriptions of the circle dance in the canonical text the Bhagavata Purana are, or seem, a little confusing on the number and deployment of Krishnas:

> The supreme lord of yoga, Krishna, entered among them between each pair—
> Each thought she alone was at his side as he placed his arms around the necks of those young women. (X.33.3)
>
> Having multiplied himself in as many forms as there were cowherd women,
> He . . . delighted in loving them in this divine play. (X.33.19)[2]

Some artists depict one Krishna for two women, and some depict one for one. It is not clear whether artists are following different verses in the Bhagavata Purana, different versions of the text, or different local or personal versions of the story altogether.

The circle dance is understood to take place both at a particular time and place in our world and perpetually in Krishna's heaven. Either way, other gods observe: "Hundreds of celestial chariots crowded the sky, carrying the captivated denizens of the heavens along with their wives, their souls anxious to behold that scene."

Depictions of the rasamandala dance tend to fall into two categories: one showing the ring of dancers arranged radially, with the feet of all participants pointing inward; the other showing all the dancers "upright," with their feet pointing toward the groundline. The first orientation is more schematic and conceptual, the second more "realistic" and narrative. Whether the difference depends on time period, region, religious sect, or the preference of a patron or an artist is not known.

For more on Krishna and the cowherd women and artistic representations of them, see the essay "Dancing in Circles" in this volume (pp. 33–47).—FMcG

1. On this dance, "a special ancient sophisticated dance form of India," see Schweig, *Dance of Divine Love*, 351, and the many pages noted in its index under "*rāsa* dance." Note that *rāsa*, meaning a kind of dance, is a different word from the more common *rasa*, meaning flavor or aesthetic experience.

2. Schweig, *Dance of Divine Love*, 66, 70. Other translations include these seemingly contradictory accounts; see, for example, Bryant, *Krishna: Beautiful Legend*, 139, 141.

16 *also pp. 116–17*

Krishna dances with the cowherd women

Approx. 1850–1900
India; Nathadwara, Rajasthan state
Opaque watercolors, gold, and silver on cotton
H. 300 cm × W. 300 cm
Cincinnati Art Museum, Museum Purchase: Alice Bimel Endowment for Asian Art, 2018.115

Here, in a carefully composed portrayal, are all the main components of the rasamandala: Krishna joins the circle dance of the cowherd women (one Krishna per two women) and appears again dancing in the center with a single woman. (This woman is often thought to be Radha, Krishna's beloved in many other stories, poems, and songs, but Radha is not mentioned explicitly by name in the Bhagavata Purana.[1]) To the sides, female musicians play a variety of instruments. Above the dance hangs the moon, which, in the text, casts such an enchanted glow over the proceedings. Near it, various godly couples hover in their celestial conveyances.

The forest in which Krishna and the women gather and dance is suggested by clumps of palm, banana, and other trees in which monkeys cavort. Interestingly, along the lower edge of the scene—at the front edge of the stage, as it were—is a wall with steps to a lotus-filled stream. This separates us from the action and also calls to mind real-world performances of the dances of Krishna and the cowherd women for princely audiences on palace terraces (cat. 83).

The orientation of the circle dancers, all with their feet pointing downward, follows the "narrative" layout mentioned in the introduction to this grouping of works on the rasamandala. Large paintings on cloth such as this were hung behind the main image in a shrine. This one surrounds the rasamandala with thirty-one vignettes of other episodes in Krishna's life.—FMcG

1. On the identity of an especially important but unnamed cowherd woman mentioned in the Bhagavata Purana—sometimes called the "special gopi," or cowherd woman, and thought by some to be Radha—see Schweig, *Dance of Divine Love*, 147–51.

17 *also p. 79*

Krishna dances with the cowherd women

Approx. 1675–1700
India; Rajasthan state, former kingdom of Bundi
Opaque watercolors and gold on paper
H. 30.2 cm × W. 21.6 cm (image);
H. 36.5 cm × W. 24.8 cm (sheet)
Los Angeles County Museum of Art,
Museum Acquisition, M.75.66

Here, a hundred and fifty years or more before the Nathadwara painting (cat. 16), all the standard components of depictions of the rasamandala are present: the circle dance with Krishna at the center, musicians, trees, night sky, moon, hovering deities. In certain details this painting seems closer to what is described in the Bhagavata Purana than the later work. The red dance field may be based on the text's reference to the reddish radiance cast by the moon (X.29.2–3). The deities in the sky are not given attributes that allow them to be identified, just as in the text they are not named.

Seven Krishnas (rather than the frequent eight) occupy the circle, one Krishna per two women. The work includes two quite unusual features: the Krishna in the center and his partner dance not on the ground but on a little platform, and Krishna raises aloft on one hand a very small female dancer. The significance of these features is not known.—FMcG

18 *also p. 34*

Circle dances with Krishna

Approx. 1700–1725
India; Madhya Pradesh state
Opaque watercolors and gold on paper
H. 20.3 cm × W. 37 cm
San Diego Museum of Art, Edwin
Binney 3rd Collection, 1990.969

In this painting the dancing of Krishna and the cowherd women is far more patternized and less narrative than usual.[1] The circle dancers are arranged radially like the spokes of wheels with lotus-petal rims, with Krishna and his partner at the hub of each wheel. The effect is of a symbolic diagram rather than an approximation of how a staged performance would appear from a balcony seat.

The patternmaking continues: six similar trees and three similar blue hillocks flank the circles, and in the upper register, arranged in rough bilateral symmetry, are, from the middle out, a dancer, musicians, deities in celestial conveyances, and players of kettledrums (which are mentioned in the Bhagavata Purana as accompanying the circle dance of Krishna and the cowherd women).[2] Only the moon is off center.

In the formal terms of the painting's composition, the placement of the moon creates an unexpected beat amid regular rhythms. In fact, the artist, while creating patterns that lead us to expect uniformity, has introduced a number of small variations and syncopations, just as a musician or dancer might do. The six similar trees are of three varieties, arranged AAB BCC; two of the hillocks lean in one direction, one stands upright; the musicians flanking the dancer in the upper register are slightly (but clearly with calculation) irregularly spaced.—FMcG

1. This painting is discussed in detail in Goswamy and Smith, *Domains of Wonder*, 56. Other examples of the "radial" type of rasa-mandala can be found in the British Museum (1959,0411,0.7) and the Philadelphia Museum of Art (2001-89-1 and 2004-149-7; see fig. 13 in the essay "Dancing in Circles" in this volume, pp. 33–47).
2. Bhagavata Purana X.5.4–5, where they are called *dundubha*.

19 *also p. 32*

Covering cloth with scene of Krishna dancing with the cowherd women

Approx. 1850–1900
India; Himachal Pradesh state,
Chamba region
Cotton with silk embroidery
H. 82.6 cm × W. 85.7 cm
Asian Art Museum of San Francisco,
Transfer from the Fine Arts Museums of
San Francisco, Gift of Carlotta Maybury,
1993.91

Four Krishnas dance with four cowherd women in a radial arrangement, but unlike the dancers in another radial version (cat. 18), their heads are toward the center and their feet point out. In the center, where we often find Krishna dancing with or without a partner, he sits ready to play his flute, while a young woman, perhaps to be understood as his beloved Radha, offers him refreshment. What she offers is hard to make out, but above her is a vessel with spout and handle.

The patterning here is even more insistent than in the painting from Madhya Pradesh (cat. 18). Around the circle of dancers are arrayed in regular fashion eight cows, eight banana plants, and sixteen cowherd boys. Again, though, the artist seems to delight in introducing small variations into the pattern. The cows are of different colors, and some are spotted; three sets of boys cavort with herding sticks and branches, while others play musical instruments; peacocks are regularly positioned above the cows: we expect eight, but one is a different sort of bird.—AMC

20 *also p. 40*

Krishna plays the flute and dances with the cowherd women (rasamandala)

Approx. 1700–1900
Southern India
Bronze
H. 19.7 cm × W. 15.9 cm × D. 6 cm
Asian Art Museum of San Francisco, The Avery Brundage Collection, B77B5

Though Krishna is often seen playing his flute, and does so alluringly when the cowherd women are first drawn to him in the nighttime forest, he is usually not depicted playing it when he dances in the center of the rasamandala. Here, though, he is—or was, because his flute, which was presumably of silver or gold, is missing. However, he is not the usual Krishna of the rasamandala but a multiarmed Krishna as supreme deity.[1]

The arrangement of the dancers in the circle would at first glance seem to be of the radial type, with all oriented feet inward, but the artist has reversed the dancers in the lower half of the circle to keep them upright. Thus, the pairs of dancers at the transition points find themselves dancing with partners who are upside down.

This work is discussed at length in the essay "Dancing in Circles" in this volume (pp. 33–47).—FMcG

1. The closest visual parallel for this unusual sculpture (though it is none too close) is a bronze of the Sudarshana Purusha in the Museum für Asiatische Kunst, Berlin, as pointed out in Cummins and Srinivasan, *Vishnu*, 202, and cat. 8.

21 *also p. 45*

Celebrations in honor of Krishna's birth

Approx. 1680–1690
Central India
Opaque watercolors on paper
H. 23.2 cm × W. 35.9 cm (sheet)
Virginia Museum of Fine Arts,
Richmond, Gift of Mr. and Mrs. Jay
Dehejia, 86.169

Village dancers and musicians playing hand cymbals, drum, and flute join in a celebratory circle dance. The dancers hold sticks, so presumably their dance resembles the traditional stick dances of northern India and Pakistan, such as the *dandiya raas*.[1]

The occasion of the dance is the apparent birth of Krishna. To protect him from a wicked king, the infant Krishna was secretly exchanged with another baby and raised by foster parents. Here his foster father, Nanda, is being feted for the arrival of a son. He stands in the middle of the circle while cowherds, who have brought pots of milk and curds, lustrate him. Compartments around the central circle show related happenings, such as Nanda's bathing himself, priests

reading holy texts, and so on. An inscription on the back of the painting explains what is going on.[2]

Celebrations of the arrival of Krishna are commemorated to this day in the Nandamahotsava (Nanda's great festival).[3]—FMcG

1. Such stick dances may be seen on YouTube by searching "dandiya dance" or "garba dance."
2. Joseph Dye provides a translation and other detailed information about this painting in *Arts of India*, cat. 133.
3. The festival is also known as Nandotsava, Nand Mahotsav, Nandmahotsav, etc. Again, pertinent videos, some including circle dances, may be found on YouTube. The festivities for the appearance of Krishna as Nanda's son are described in the Bhagavata Purana (see Bryant, *Krishna: Beautiful Legend*, 29–30) and Surdas's *Sursagar* (see Surdas, *Sur's Ocean*, 7–15).

राग वसंत कुलि षेलन गोपीबजन वाजित्रवाजंत उ‍हैलालगुल
ल अबीर ऊपचैब वा नस्या बऊ नी रा रागवसंता ॥ ३२

22

Krishna dances to the accompaniment of female musicians, personifying the musical mode *vasanta ragini*

Approx. 1675–1700
India; Marwar region, Rajasthan state
Opaque watercolors and gold on paper
H. 17.9 cm × W. 14.3 cm (image);
H. 20.6 cm × W. 15.4 cm (sheet)
Los Angeles County Museum of Art,
Gift of Paul F. Walter, M.81.280.3

Under a dense canopy of mango tree blossoms, a quartet with musical instruments dances atop the red-powdered ground and infuses the air with sweet melodies to denote the arrival of spring.[1] Inscribed above is a descriptive verse that identifies this painting as an expression of the ragamala *vasanta ragini*, a musical mode associated with spring (see below). This *ragini* is frequently personified by Krishna and his women who have gathered along the banks of a river to celebrate the Hindu Holi festival, which welcomes the arrival of spring.

The artist who created this work heeded the iconographical conventions for depictions of the musical mode *vasanta ragini* yet introduced reasonable subtleties and improvisation within the composition.[2] The body of the female cymbal player in the lower right corner is posed as if she were about to walk across the border of the painting like a tightrope. Her feet are lightly planted one before the other, hips lowered, and her taut torso conveys the precision and control needed to maintain balance. The positioning of the cymbal player and the other musicians creates a loose circular formation with Krishna at the center. Was this an intentional visual strategy employed by the artist to reference the circle dance of love (rasalila)? The playful allusion of the tree trunk emerging from under Krishna's diaphanous robe is yet another unexpected detail that reimagines the compositional scheme of *vasanta ragini* in a way that is recognizably distinct.—TLG

1. Pal attributes the red ground to a coating of colored powder from Holi celebrations. See Pal, *Classical Tradition in Rajput Painting*, 164–65.
2. For comparative examples, see Metropolitan Museum of Art (1999.148), Virginia Museum of Fine Arts, Richmond (68.8.68), Museum of Fine Arts, Boston (30.644), V&A Museum (IS.118-1955), and the Laud Rāgmālā Album, Rajasthan, Bikaner, Folio 66b at the Bodleian Libraries, University of Oxford.

Ragamala

A *ragamala* ("garland of ragas") is a series of paintings that envision musical melodies in divine or human forms. Each melody, or *raga*, is based on a specific progression of five, six, or seven notes distributed over the octave scale. Through the progression of these notes, a raga has the potential to evoke an emotional response in the listener. Ragamala paintings, often paired with poetic texts, are perceived to have a similar emotive effect on the viewer. The visualization of the raga is often linked with a season or time of day, and certain deities, individuals, or even a particular tableau can come to represent a particular musical mode. These modes may also be personified as male (raga) or female (*ragini*) and organized into families of related modes. Painted ragamala series are typically compiled in sets of thirty-six or forty-two unbound pages that represent the different modes.

These painted melodies were commissioned and exchanged by members of the royal courts of India from the second half of the fifteenth century until the late nineteenth century. For nearly four hundred years ragamala was one of the most popular genres of court painting, produced primarily in the northwest region of India (Rajasthan and the Pahari region in the foothills of the Himalayas) and the Deccan region in south-central India.

The study of ragamala painting is necessarily complex, involving knowledge of Indian musicology, literature, and painting. Debate continues as to the inherent relationship between these art forms. Many scholars contend there is a close parallel between a chosen color palette and musical notes, while others argue that the mood of the painting is only revealed when listening and looking occur simultaneously. Regardless of the intended meaning, these paintings blend music, image, and poetry through the depiction of lush landscapes and elaborate court scenes.

23 *also title spread*

Krishna dances with the cowherd women, personifying the musical mode *megh malhar*

Approx. 1720
India; Pratapgarh, Rajasthan state
Opaque watercolors on paper
H. 26.2 cm × W. 18.9 cm
San Diego Museum of Art, Edwin
Binney 3rd Collection, 1990.654

The act of viewing this painting of Krishna's monsoon dance, performed while surrounded by attentive female figures, evokes the classical raga *megh malhar* ("cloud thunder") and arouses in the knowledgeable viewer a sense of love and longing. A musician playing a "cloud melody" from the *malhar* family would awaken these feelings and could also bring the monsoon rains.

The conduit connecting the emotional power of music to the arousal of love and longing were musicians and dancers, who were often perceived as the embodiment of this yearning.[1] Here, the sound of the heavy downpour adds to the cacophony of the musicians' performance, Krishna's movements, and the intense longing for union. The result is an experience stimulating both aural and visual senses at once, writes Kapila Vatsyayan: "Many aspects of Indian dance are heard rather than seen, and many aspects of Indian music are seen rather than heard."[2]

Until the seventeenth century, the monsoon was depicted in paintings through peacocks, thick clouds, and swirling lighting, but such works often lacked the painterly effect of rain falling heavily from the sky. By 1700, and as seen so clearly here, dense vertical lines of rain add a textural effect to the page.[3] Other painterly references that

evoke dance, melody, and rhythm include Krishna's peacock-feather crown, garland, and three-tiered multicolored skirt. Recognizable as a dance costume worn by traveling rasamandala troupes, this attire influenced painted depictions of dance and became predominantly associated with the dance of Krishna.[4]—AMC

1. Brown, "If Music Be the Food of Love," 62.
2. Vatsyayan, *Dance in Indian Painting,* 133.
3. Khera, *Place of Many Moods,* 72.
4. The earliest sourced depiction of the three-tiered skirt can be traced to a *Mrgavati* manuscript from Uttar Pradesh, dating to approx. 1525–1570, that illustrates a literary and romantic tale. It also appears in a painting from the Akbar court from about 1530–1560 in the V&A Museum (IS.2-1896, 16/117); another in the Cleveland Museum of Art (1971.88; cat. 89 in this volume); and later surfaces in depictions of dance dramas performed at court and in temple courtyards. See Coomaraswamy, *Rajput Painting,* 4–5; Vatsyayan, *Dance in Indian Painting,* 145; and Topsfield, "Udaipur Paintings of the Raslila," 65; as well as a painting of *vasanta ragini* in the Art Gallery of New South Wales, Sydney (82.1997), among others.

24 *also p. 41*

Cosmic form of Krishna

Approx. 1800–1900
India; Rajasthan or Gujarat state
Opaque watercolors and ink on cloth
H. 132 cm × W. 90.2 cm
Lent by Julia Emerson

For those who worship him, Krishna is the Supreme Being, encompassing every aspect of the universe. In a famous passage of the great epic Mahabharata, Krishna allows the hero Arjuna to see him in his transcendent form.[1] Devotees may see Krishna in his true form, too, through meditation and visualization.

Here, the immense form of the supreme Krishna looms into space. The circle dance with the cowherd women is seen twice: on Krishna's lower body and again, far above, in his heaven. We are reminded that the dance of divine love takes place eternally in this celestial realm, while the earthly version is an instantiation at a particular moment and place.[2] In the lower representation, Krishna, multiplied, joins the cowherd women in the circle dance. In the upper, he stands in the center of a circle only of women. Ultimately, at least in some traditions, the cowherd women are themselves "eternally perfected beings" or are even manifestations of Krishna himself.[3]

The Krishna who stands at the center of the upper circle here is a specific form known as Shri Nathji, recognizable by his long, narrow eyes; his stance; and, above all, by his raised left hand (figs. 1 and 2). The image of Shri Nathji is enshrined in the pilgrimage town of Nathdwara, where this painting may have been created.[4]

This painting is discussed further in the essay "Dancing in Circles" in this volume (pp. 33–47).—FMcG

Fig. 1 Detail of cat. 24 showing Krishna as Shri Nathji in the center of the upper dance circle.

Fig. 2 Krishna as Shri Nathji, late 19th century. India; Nathadwara, Rajasthan state. Opaque watercolors and gold on paper. *Victoria & Albert Museum*, IS.185–96.

1. See note 43 in the essay "Dancing in Circles" in this volume, pp. 33–47.
2. On Krishna's heavenly realm mirrored in the earthly, see Eck, *India*, 349, where she quotes from Entwistle, *Braj*; see also Kinsley, *Sword and the Flute*, 26–27; and Dimock, *Place of the Hidden Moon*, 165–69. On "entering Krishna's presence" in his heavenly realm through long cultivation of the imagination, see Clooney and Stewart, "Vaiṣṇava" 179.
3. Schweig, *Dance of Divine Love*, 206; Kinsley, *Sword and the Flute*, 53; Dimock, *Place of the Hidden Moon*, 165.
4. Several similar paintings are known. One, in the National Museum, New Delhi, is reproduced in Ahuja, *Rūpa-Pratirūpa*, 110; another can be seen in Cummins and Srinivasan, *Vishnu*, 220–21. This painting was published and discussed in Pal, *Puja and Piety*, cat. 54.

वृंदावन

यांवदावटदि
न्नलितिरिरु
यालबालल
धलिधमरइ
दावनक्रम
बसातसमा
एवादनपर
गमिक्रमा

25

Krishna dances with the cowherd women, from a manuscript of the *Balagopalastuti* (Praise for the Young Lord of the Cowherds)

Approx. 1450–1475
India; Gujarat state
Opaque watercolors, ink, and touches of gold and silver on paper
H. 10.5 cm × W. 10.8 cm (image);
H. 10.5 cm × W. 23.2 cm (sheet)
Los Angeles County Museum of Art, Purchased with funds provided by Lizabeth Scott, M.88.49

In an image that merges Krishna's form as a young cowherder with his divine self, the god is here shown with four arms. Two hands hold a flute to his lips, with another he sounds a horn, and the fourth arm is flung above his head in ecstatic dance. The playing of musical instruments adds an aural, visual, and devotional quality to Krishna's portrayal.[1] Music and dance are aspects of the god's divine power, intrinsically linked to his physical expression and emblematic of his power of attraction. Here, two cowherd women flank the god on either side, intoxicated by his presence. The fifteenth-century *Balagopalastuti*, from which this image originates, is one of the earliest surviving manuscripts dedicated to Krishna. It praises the god in a series of Sanskrit verses:

While the sound "dhunga, dhunga"
 is softly
tapped out on the drum, and the
 women of
Vraja [cowherd women from Braj]
 follow him,
Madhava [Krishna], the son of Devaki,
dances on the charming courtyard
 stage and
plays his flute.[2]

—AMC

1. Masselos, afterword to Pal, *Dancing to the Flute*, 305; Smith and Goswamy, *Domains of Wonder*, cat. 6.
2. Hymn 54, in Wilson, *Bilvamandalastava*, 107.

26

The poet-saint Sambandar

1200–1400
India; Tamil Nadu state
Bronze
H. 61.6 cm × W. 35.6 cm
Asian Art Museum of San Francisco, The
Avery Brundage Collection, B60B1016

Sambandar, one of sixty-three Hindu saints devoted to Shiva, is often shown as a child wearing a crown and multiple strands of jewels across his body while dancing in exultation. His religious expression is centered on singing and dancing, with his emphasis on worship through ecstatic poetry and movement likely informing this imagery.[1] Dancing images of the child-saint show him with one leg raised and arms spread wide. The index finger of his right hand points upward, while his left arm is extended to the side in a gesture of dance.

A historical figure born in the seventh century, Sambandar as a young child was left hungry next to a sacred tank while his father took a ritual bath. Shiva's wife Parvati appeared and gave him milk.[2] Sambandar is then said to have burst into song honoring the god and goddess. He went on to compose over four hundred hymns (or four thousand verses) in praise of Shiva over the course of his life and made pilgrimages to important Shiva shrines, performing miracles and singing his poems as he traveled. In parts

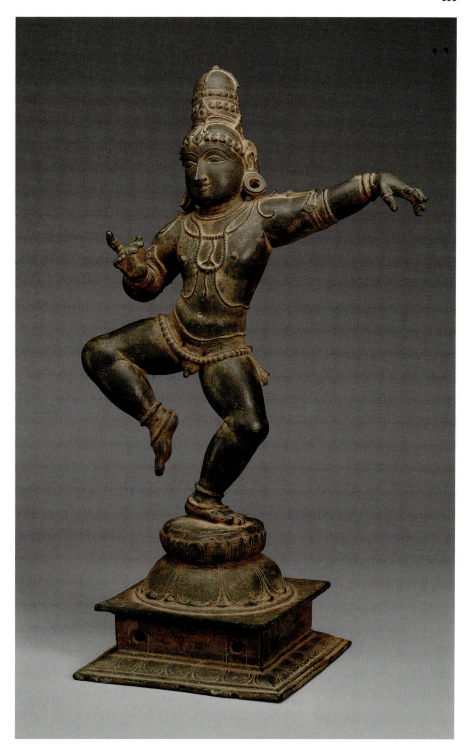

of southern India, Sambandar remains a much-revered saint whose poems continue to be sung in temples today.—AMC

1. Dehejia, "Iconographic Transference," 142–45.

2. When not portrayed dancing, Sambandar is seen standing with an empty cup in his left hand (a remnant of Parvati's gift of milk) and the index finger of his right hand pointing upward and toward the goddess.

27 *also p. 88*

The saint Chaitanya dances in ecstasy

Approx. 1750 or later
India: Rajasthan state, former kingdom of Kishangarh
Opaque watercolors on paper
H. 23.8 cm × W. 27.8 cm
The Kronos Collections

Dancing, dancing whichever way Lord
 Chaitanya goes,
thousands light lamps, some sing "Hari."
. . .
By the names of Hari [Krishna], Lord
 Chaitanya has saved even the outcastes.
. . .
Shouting "Praise Lord Krishna," he weeps.
In love his two eyes are full of tears: how
 many rivers from them flow?
. . .
With his companions he wanders around,
 constantly saying "Praise Lord Krishna."
Placing his two arms on the shoulders of
 friends, leaning and swaying he moves.
Filling the world with love.[1]

The earth-born saint Chaitanya, who lived some five hundred years ago, is thought of by his followers as an incarnation of Krishna himself, or as incorporating both Krishna and Krishna's beloved Radha. His singing and dancing were said to have been filled with rapturous love that radiated to all who saw him. He might become so overwhelmed with emotion that tears poured from his eyes while he danced.

In this painting, Chaitanya's exaltation—an expression of passionate devotion (*bhakti*) to a god, particularly Krishna—inspires his followers. They throw their arms into the air as they play instruments and dance; one prostrates himself or perhaps faints. Such overt displays of emotion are rare in the painting traditions of Rajasthan.

Traditions developed by Chaitanya have descended, by complicated routes, to become the International Society for Krishna Consciousness (the "Hare Krishna" movement), whose members still express their devotion to Krishna and their hopes for peace and universal love through music and dance.—FMcG, AMC

1. Adapted for the sake of readability from translations of Bengali songs in Delmonico, "Chaitanya Vaishnavism," 558, 560. The adaptations made to the translated verses in this context affect the translator's work; readers should refer to the original version. For more on Chaitanya, his teachings and activities, and their context, see Dimock, *Place of the Hidden Moon*, and Holdrege, *Bhakti and Embodiment*. For a detailed discussion of this painting, with translations of its inscriptions, see McInerney et al., *Divine Pleasures*, cat. 31.

28 *also p. 45*

Dervishes dancing before a group of Muslim divines

Approx. 1760

South-central India (Deccan)

Opaque watercolors and gold on paper

H. 27 cm × W. 17.6 cm

San Diego Museum of Art, Edwin Binney 3rd Collection, 1990.544

Many mystical Sufi orders include in their meditative spiritual practices the "audition" (*sama'*): a specific liturgy comprising prayer, devotional poetry, singing, music, and sometimes dance.[1] Such gatherings have strict codes, applicable not only to the conduct of individual participants but also to the proper time, place, and company in which they are convened. In this context, rhythmic dance-like movement—or *raqs*—is understood as the expression of rapture experienced by the mystic who, while listening to devotional poetry and music with the "ear of the heart," finds a heightened understanding and awareness of the divine.[2]

This painting depicts a nighttime gathering at the Sufi meeting house of a prominent teacher (*shaykh*).[3] The upper half shows the teacher leaning against an orange bolster and engaged in discussion with a senior disciple in the company of other followers who are in varying stages of contemplation on the elder's teachings. A *sama'* is in progress in the painting's bottom half. The devotional music and poetry of the musicians and singer (*qawwal*) have helped one Sufi enter an ecstatic state, and he is seen dancing at the center of the circle. His eyes are closed and his finger points skyward, as if attesting to the unity of divine existence (and perhaps to his teacher's guidance). Fellow disciples protectively encircle him so that his transported state remains undisturbed, while other attendees look on from a respectful distance.—QA

1. Issues of the permissibility of dance and music have prompted much debate between the supporters and detractors of those arts in Muslim societies across geographies and time. Many Persian, Indian, and Turkish Sufi orders have a long history of *sama'* in their spiritual methods, even as they have faced critique by other Sufi orders. Much scholarship is available on this subject, and some useful sources include Aquil, "Music and Related Practices"; and Lewisohn, "Sacred Music of Islam."

2. Lewisohn, "Sacred Music of Islam," 4; see also During et al., "Hearing and Understanding in the Islamic Gnosis."

3. I thank Murad Khan Mumtaz for generously sharing his thoughts on images of Sufis.

29 *also p. 6*

A Jain spiritual teacher in a heavenly preaching hall surrounded by dancers and musicians, from a manuscript of the Sangrahani Sutra

Approx. 1575
Western India
Opaque watercolors and ink on paper
H. 11.4 cm × W. 26.2 cm
Lent by Gursharan and Elvira Sidhu

With lively footwork and varied gestures, celestial dancers—three female and one male—join acrobats and musicians in honoring a spiritual teacher in the Jain religious tradition who has recently achieved omniscience, or Enlightenment. Celestials have descended and built a tiered structure (seen here from above) at the summit of which the Jina ("victor") sits enthroned. He delivers to all corners of the universe his inaugural disquisition on spiritual matters for the benefit of hearers everywhere. According to tradition, gods—including the king of the gods, Indra (not represented)—and other beings laud him and celebrate the great event.

One of the dancers holds what appears to be a kerchief; another brandishes what might be a small drum or rattle or fan. Yet another holds a spray of flowers and an unidentifiable conical object. The artist has positioned some of the dancers facing toward and some away from the direction they appear to be moving, imparting a high-spirited dynamism that contrasts with the serene stillness of the Omniscient One at the center. The animation of the dancers, acrobats, and other figures, together with the vibrant color scheme, suggests the joyousness, as well as the solemnity, of the occasion.[1]—FMcG

1. Pal, *Dancing to the Flute*, 138–39. I deeply appreciate Gursharan Sidhu's sharing an as-yet-unpublished scholarly analysis of the painting and discussing it with me.

30

Initiation card depicting a dancing dakini

1700–1800

Central Tibet

Opaque watercolors on paper

H. 14.1 cm × W. 11.1 cm

Virginia Museum of Fine Arts, Richmond, Purchased with funds provided by Mimi and Perk Wilson, 88.62.2

Himalayan art traditions employ a variety of techniques for visually and ritually depicting a mandala, the geometric series of squares and circles into which these traditions arrange visualized environments and the symbolic beings who populate them. Thangka paintings that depict the entire company in one composition are one means that Himalayan teachers employ to introduce students to an entire mandala all at once (see cat. 37).

Another, perhaps more practical technique involves creating a small painting of each visualized being in the mandala, and then introducing them in succession to the initiated student. This image of a female adept called a *dakini* (sky-walker) appears on just such an initiation card here. She is without clothing, indicating that she is completely transparent and without guile. Her wild hair and ostentatious display suggest complete spontaneity, the goal of the dance in which she is engaged and a state coterminous with complete enlightenment.

Such imagery, which clearly contravenes accepted standards of physical display in Tantric Buddhist societies in Nepal, is secret and is only disclosed to properly prepared students under ritual circumstances. Otherwise, the sexual imagery might be taken as a literal injunction to or reflection of actual behavior, either of which might entail serious repercussions to the practitioner known to be involved with such activity and to the Tantric Buddhist community at large.—JSD

Subjugation

IN SOUTH ASIAN, SOUTHEAST ASIAN, AND TIBETAN Hindu and Buddhist contexts, dance sometimes accompanies—or even brings about—the conquest of negative forces. Deities are shown dancing on corpses personifying death and ignorance or atop demons who attempt to overthrow order. The Buddhist deity Hevajra steps on four demons that embody evil, his dance transcending their combined power. Shiva slays an elephant demon through dance, releasing the negative forces that threatened to overcome him. Krishna dances atop the serpent-demon Kaliya, restoring universal order. And the mother goddesses dance with ecstatic abandon to overpower negative forces. Through dance, the fear of death, impurity, illusion, and ultimately ego-attachment are defeated. These dances are extreme spiritual religious practices that foster transformation: deities dance to release, to overcome, to remove illusion, and to mark the victory over time and death. By harnessing deities' dances of subjugation and staging rituals in which the dances were evoked or even enacted, kings could mobilize supernatural powers to aid in their conquests and assertions of hegemony.

Negative forces can be expressed through dance as well, often in attempts to seduce and disempower in circumstances where romance and sexuality are potent weapons. The demon Mara, a personification of evil, sent his daughters to tempt the Buddha as he sat meditating. The demon daughters appeared before him as women of different ages and occupations, suiting any taste or fancy. The Buddha's stoic resistance to temptations of the flesh is a demonstration of power, strength, and good over evil; to overcome is to transmit such earthly desires into a manifestation of wisdom and knowledge. This, too, can be witnessed through dance.

31

Hevajra and his consort dancing

1000–1200
Northeastern India, Bangladesh, or possibly Tibet
Stone (perhaps kaolinite) and pigments
H. 8.57 cm × W. 5.4 cm
Virginia Museum of Fine Arts, Richmond, Bequest from the Estate of Mary Shepherd Slusser, 2018.128

The Hevajra Tantra describes a frequent form of the deity as wearing a garland of skulls and having eight heads, sixteen arms, and four legs, as he does here, though several of the heads and legs can be seen only from the back (see fig. 1).[1] The variety of emblems he holds "symbolize his universal mastery over all matter and beings, alive and dead, on earth, in the underworld, on the planets, and in the heavens."[2] Also, it is clear when viewed from the back that Hevajra is dancing. The importance of dance is underlined in the Hevajra Tantra:

> Dancing as Śri Heruka, with mindful application, undistracted, . . .
> Buddhas and Masters of the Vajra-doctrine, goddesses and *yoginīs*,
> Sing and dance to their utmost in this song and dance.
> There comes thereby protection for the troupe and protection for oneself. Thereby the world is reduced to subjection, and all reciting of *mantras* (is perfected) by it.[3]

Where this tiny but intricately carved image was made is not certain, but

Fig. 1 Reverse of cat. 31.

northeastern India or Bangladesh is very likely. A similar image was found in the excavation of a Buddhist monastery in Parharpur in Bangladesh.[4]—FMcG

1. Snellgrove, *Hevajra Tantra*, 110.
2. The emblems he holds are enumerated in Snellgrove, *Hevajra Tantra*, 111; the explication of their symbolism can be found in Linrothe, *Ruthless Compassion*, 269.
3. Snellgrove, *Hevajra Tantra*, 102. Heruka is a deity closely linked with Hevajra, and sometimes the names are essentially interchangeable.
4. Linrothe, *Ruthless Compassion*, 269, fig. 192.

Dancing Hevajra

The deity Hevajra is of great importance in Tantric Buddhism. In art objects from northeastern India, Cambodia, northeastern Thailand, and Tibet he is shown in multiheaded, multilimbed form dancing, sometimes with his consort or surrounded by dancing yoginis. In the worship of Hevajra, initiated practitioners meditated and undertook rituals—probably including dancing—to merge with the deity. If they were successful, they gained great powers in both spiritual and secular realms, powers that we might think of as magic. For example, they could not only conquer the mental and psychological forces that impeded their progress but also defeat worldly enemies such as rival armies.

The key text for understanding the nature, powers, and symbolism of Hevajra and his retinue is the Hevajra Tantra, composed in Sanskrit more than a thousand years ago in northeastern India or Bangladesh.

The cult of Hevajra, and some of these artworks, are discussed further in the essay "Dancing in Circles" in this volume (pp. 33–47).—FMcG

32 *also p. 35*

Lotus mandala of Hevajra with eight dancing yoginis and eight cremation grounds

Approx. 1100–1200

Northeastern India

Copper alloy

H. 32.1 cm × W. 19.4 cm × D. 19.4 cm

Rubin Museum of Art, C2003.10.2 (HAR65207)

At the center of this eight-petaled lotus there once would have been figures—now missing—of Hevajra and his consort Nairatmya dancing in sexual embrace.[1] Arrayed around the center are the eight dancing yoginis who often accompany Hevajra (fig. 1). Represented on the outside of the lotus petals are the eight great cremation grounds in which the dancing takes place. Above these on each petal is a tantric adept (*mahasiddha*) who has, through intense meditation and ritual practice, attained extraordinary spiritual and this-worldly powers (fig. 2). These adepts undertook some of their practices in cremation grounds, where, surrounded by the frightful and repulsive, it was thought they could overcome ego attachment and death itself, achieving

even greater supernatural capabilities. The fact that the deities, the dance, and the cremation grounds are situated in a supermundane realm is indicated by the cosmic-axis-like lotus stem that elevates them, with representations of the sun and moon at the upper end of the stem and powerful serpent-beings supporting its lower end.[2]—FMcG

1. For more on this object, see the Rubin Museum of Art's online collection database: https://rubinmuseum.org/collection /artwork/lotus-mandala-of-hevajra. The eight great cremation grounds are discussed, with references to sources, in Linrothe, *Ruthless Compassion*, 237 and 247n107.

2. Many bronze lotus mandalas may be seen at Himalayan Art Resources (https://www. himalayanart.org/) by searching for "Lotus Mandala Main Page."

Fig. 1 Detail of cat. 32 showing a dancing yogini.

Fig. 2 Detail of cat. 32 showing a tantric adept.

33 *also p. 35*

Dancing Hevajra surrounded by dancing yoginis

Probably 1050–1100
Northeastern Thailand; former kingdom of Angkor
Bronze
H. 46 cm × D. 23.9 cm
Cleveland Museum of Art, gift of Maxeen and John Flower in honor of Dr. Stanislaw Czuma, 2011.143

In a striking three-dimensional realization of the mandala of Hevajra, the god, with features described in the Hevajra Tantra, dances on a demonic corpse embodying delusion, fear, and other obstructions. He is surrounded by eight dancing yoginis who also follow the iconography described in the Hevajra Tantra. In that text, Hevajra is described embracing his consort Nairatmya, and though she is usually included in Indian and Tibetan representations, in ones like this from Cambodia or northeastern Thailand—for reasons that are not clear—she is usually not shown.[1]

Angkor—an empire that included present-day Cambodia and parts of Thailand and Vietnam—had long been in touch with centers of religious learning in India, and clearly a version of the Hevajra Tantra was available there. However, Hevajra is not mentioned in the only surviving records (inscriptions in Sanskrit and Old Khmer), and though a number

of pertinent artworks survive, the details of how the Hevajra cult in the Angkorian domains functioned remains obscure.

This cultural context of this object is discussed in the essay "Dancing in Circles" in this volume (pp. 33–47).—FMcG

1. This object has been dated by the Cleveland Museum of Art to about 1200, in the reign of Jayavarman VII. The dating of such objects is complex. This one seems likely to be earlier and related to Tantric Buddhist traditions in northeastern Thailand. Thanks go to Hiram Woodward for discussing the dating with me in emails of January 2022. For the Phimai traditions and Hevajra, see Woodward, *Art and Architecture of Thailand*, 154–55; and Woodward, "Esoteric Buddhism in Southeast Asia," 349–50 and n64. Several Angkorian bronze dancing Hevajras, including several surrounded by dancing yoginis, are illustrated in Bunker and Latchford, *Khmer Bronzes*, 7.24–.25, 8.42, and 9.13–.16. For a discussion of one of the few stone depictions of Hevajra from the Angkorian realm, see Brown, "Buddhist Deity Hevajra."

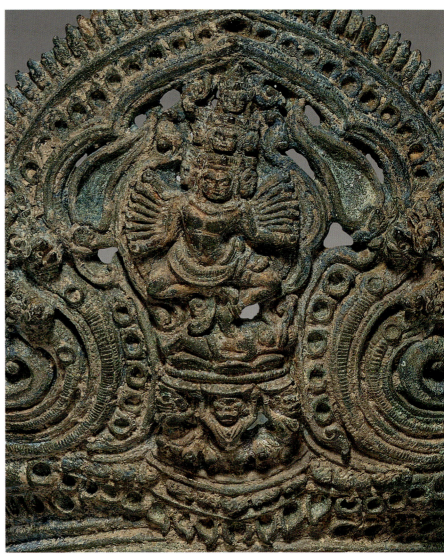

34

Ritual conch shell with depiction of Buddhist deity Hevajra

Approx. 1200
Cambodia or Thailand; former
kingdom of Angkor
Shell and bronze
H. 35 cm (overall)
Cleveland Museum of Art, John L.
Severance Fund, 1977.176

Here, Hevajra, in his eight-headed, sixteen-armed form, dances without his troupe of yoginis.[1] He is poised on the corpse of a demon representing obstacles the adept overcomes through identification with Hevajra.

Dozens of ritual conches from the kingdom of Angkor bearing the image of Hevajra are known, suggesting that rituals invoking him were, at certain places and times, widespread. Some, like this one, are actual conches with bronze fittings; others are made entirely of bronze. Many have a hole at the pointed end of the whorls, which would have allowed them to be blown like a trumpet. This one has no hole and would have been used (as such conches sometimes still are)

for holding and pouring sacred liquids in religious rites.[2] The staff of the Cleveland Museum of Art note that the stand for this conch is probably not the one that originally went with it.—FMcG

1. The eighth head is presumed to be behind the others. This object is discussed in Woodward, *Sacred Sculpture*, 92. Some Angkorian ritual conch shells show Hevajra flanked by two dancing yoginis; see Bunker and Latchford, *Khmer Bronzes*, fig. 9.21. Some show eight dancing yoginis, as, for example, one on the website of the London dealer Michael Backman: https://www.michael-backmanltd.com/object/cambodian-bay-on-style-ritual-bronze-conch-shell/.
2. For their use in modern Tantric Buddhist ceremonies see Brauen, *Mandala*, 103, 115, 135n110.

35

Mold for tablets depicting the Buddhist deity Hevajra

Approx. 1175–1225
Thailand or Cambodia; former kingdom
of Angkor
Earthenware
H. 7.6 cm × W. 5.7 cm
Asian Art Museum of San Francisco,
Gift of Mr. and Mrs. Frank H. Koehler,
1989.16.4

Only two dancing yoginis flank Hevajra on this small mold (left) and the modern impression made from it (right), but presumably they stand for the usual eight.[1] Several metal molds for making terra-cotta tablets of Hevajra are known (see fig. 7 on p. 35), but this is the only extant one of earthenware. The existence of molds suggests that tablets were needed in some numbers, but nothing is known about how they were used. Did they have a function in rituals? Were they offerings? Did the more elaborate ones have a different purpose from the simpler ones that would have been made from this mold? Future archeological research will conceivably help us resolve these questions.—FMcG

1. Only two dancing yoginis are shown with Hevajra in a composition not unlike this one on the bronze fitting of a ritual conch in Bunker and Latchford, *Khmer Bronzes*, fig. 21.

37

Mandala of Hevajra

Approx. 1400
Central Tibet
Opaque watercolors on cloth
H. 81.3 cm × W. 72.4 cm
Virginia Museum of Fine Arts,
Richmond, Berthe and John Ford
Collection, gift of the E. Rhodes and
Leona B. Carpenter Foundation, 91.509

More than ninety deities dance in this complex mandala, whose forms multiply in a fractal-like way. The central eight-petaled lotus with Hevajra and eight yoginis is surrounded by four similar lotus configurations, and dozens more figures dance beyond the circular boundary of this system. We may imagine such a spectacle as it might have been enacted in a large-scale performance of ritualized movement and dance, versions of which are still carried out today, or we may visualize it as taking place in the cosmic realm.[1] The ceaseless energy represented by dance is here marshalled and subjected to order.—FMcG

1. Videos of large-scale Tantric Buddhist ceremonies may be seen by searching YouTube for terms such as "Kalachakra ritual dance" and "Mahakala cham."

36 *also p. 34*

Mandala of Hevajra

1461
Tibet
Distemper on cotton
H. 62.2 cm × W. 55.8 cm
Museum of Fine Arts, Boston,
Gift of John Goelet, 67.823

Within a stylized palace surrounded by cremation grounds, the eight-headed, sixteen-armed Hevajra dances with his consort and eight yoginis. This is a two-dimensional, elaborated version of the mandala described in the Hevajra Tantra and represented in an abbreviated way in the Angkorian bronze grouping (cat. 33). Specialists in Tibetan Buddhism can assign names to, and explicate, most of the many figures and symbols in the mandala.[1]

For more on the context of this mandala, see the essay "Dancing in Circles" in this volume (pp. 33–47).—FMcG

1. See Himalayan Art Resources (https://www.himalayanart.org), where the iconography of this particular thangka (item no. 87225) is described in detail. See also Tanaka, *Illustrated History of the Mandala*, 210–13.

38

Temple banner with the Buddhist deity Padmanarteshvara dancing

Approx. 1600–1700
Nepal
Pigments and black ink on cloth
H. 124.5 cm × W. 231.1 cm
Art Institute of Chicago, James W. and
Marilynn Alsdorf Collection, 1984.1503

Large horizontal banners like this are important parts of Tantric Buddhist ritual in Nepal. Far from mere representations of things, these banners are magical in the strictest sense of the word: Their imagery symbolically transforms the environment they occupy into the sacred space known as a mandala and aids meditators in visualizing the deities that populate it. As the flower-and-skull garlands overhead suggest, that sacred ground is where life and death meet.

At the center of this banner dances Padmanarteshvara (Lord of the Lotus Dance), a secret form of the Buddhist deity Avalokiteshvara seldom seen outside Nepal. Each of his eighteen hands bears the lotus flower (*padma*) from which his name is derived, and he dances on a lotus as well. An aureole of cool indigo light with a three-tone border surrounds him despite his vigorous dance. With a little imagination, this can seem like time-lapse photography, with the dancer's arms geometrically coordinated with hummingbird-like precision.[1]

To either side of Padmanarteshvara dance bird-headed figures—one a crow, one a vulture, both female—with ritual implements in front of their fiery haloes of wisdom. Because Padmanarteshvara's ritual manual is not divulged except to practitioners of his meditation, the identity of these two figures remains obscure.[2] Beneath and around the three main figures are seated sponsors of and participants in the ceremony focused on Padmanarteshvara. It is not possible to tell from the painting whether they were spectators of a physical dance or ritualists actually participating in the symbology and perhaps even the actuality of the performance. In either case, they would expect this auspicious dance to generate vast amounts of the positive energy that leads to better rebirths and ultimately enlightenment.—JSD

1. Another Padmanarteshvara can be found at Himalayan Art Resources (https://www.himalayanart.org), item no. 65866.
2. The figures could be the deities blue Kakasya and green Ulukasya, both of whom appear in the company of Vajrayogini—and elsewhere as well.

39

The deity Simhavaktra

Approx. 1736–1795
China; Beijing or vicinity, Hebei province
Qing dynasty, reign of the Qianlong
emperor (1736–1795)
Dry lacquer with inlaid semiprecious
stones
H. 142.2 cm × W. 72.4 cm × D. 33 cm
Asian Art Museum of San Francisco, The
Avery Brundage Collection, B60S600

In Tibetan and related Chinese Tantric
Buddhist traditions it is a common-
place that the genesis of enlightenment
requires the elimination of negativity.
The tantric deity (or *dakini*) Simhavaktra
is the Lion-Faced Sky-Walker, so called
for her ability to not only fly through
the sky but also reduce all negativity to
emptiness via meditation. In Himalayan
religious practice, she is thought to be
particularly effective in eliminating trou-
blesome entities (or patterns, depending
on the interpretive perspective).

 In this monumental lacquer sculp-
ture, Simhavaktra's right leg is drawn
upward as she balances on her left in a
variation of a classical Indian dancing
position. In Tibetan Buddhist imagery,
this posture signifies incipient dyna-
mism; in Simhavaktra's case, it shows her
transforming five psychological poisons
into five corresponding wisdoms. This
transformation takes place when she is
visualized in meditation as a consciously
selected deity. The meditation that repro-
duces Simhavaktra and her dancing pos-
ture must be precise in form and infused
with full knowledge of all the symbolism
involved. In the case of this dancing
Simhavaktra, this could be difficult as two
key symbols are missing: Simhavaktra
would have held in her right hand a
curved flaying knife (see cats. 10–11) and

in her left an inverted human cranium.
When worked together like a mortar
and pestle, these attributes symbolically
transmute the five negative emotions into
ambrosia. Her jewelry, too, is made of
bone and symbolizes the transformation
of the five poisons referenced above.

 This bone-centered imagery is
associated with the cycle of destruction
and transformation always occurring in
ancient Indian cremation grounds, for

it was there that yogis—and dakinis—
attempted to attain enlightenment in
this life by realizing that all objects of
attraction or aversion are impermanent.
Indeed, in the Sarma traditions of Tibet,
Simhavaktra is associated with the deity
Chakrasamvara, a Buddhist reflection
of the dancing Hindu deity Shiva. All are
associated with the practices of crema-
tion grounds (*shmashana*).—JSD

40

The Buddhist deity Kurukulla

1500–1600
Tibet
Distemper on cotton, mounted on silk brocade
H. 40 cm × W. 32.4 cm
Museum of Fine Arts, Boston, Gift of John Goelet, 67.819

41

The Buddhist deity Kurukulla

Approx. 1700–1800
China
Bronze with gilding
H. 28 cm × W. 20.3 cm
Asian Art Museum of San Francisco, The Avery Brundage Collection, B60B137

When the power of love overcomes the love of power, the Buddhist deity Kurukulla dances out her passion, in both bronze and painted form. In the painting (cat. 40), she appears if caught by a time-lapse camera, pulling one leg upward in a classical Indian dancing posture. She draws her bow, nocks an arrow, and, just as she fires, we notice that the arrowhead is a flower! And when it strikes its target, the victim will be smitten. Not overcome by pain, mind you, but subjugated by love.

Despite her sumptuous physicality and passionate mien, Kurukulla may well seem an unlikely lover. After all, she is laden with symbolism that betrays her affiliation with death. Here, she treads upon a corpse and wears jewelry of bone, while the fierce flames of the crema-tion ground dance behind her. But any

incongruity is only apparent, for love and death are not, of course, the diametric opposites they might seem. Kurukulla reveals that the dance of life and the dance of death are not two separate per-formances, but rather two aspects of the same soiree.[1] —JSD

1. For a detailed extract from the root text containing Kurukulla's visualization, see Shaw, *Buddhist Goddesses of India*, 440. The Sanskrit term that translates as "subjugation" is *vashi-karana*, which includes in its semantic range both control via external force and con-trol via emotional power.

42

Dancing Ganesha

Approx. 1700–1800
Probably Tibet
Brass and silver with gilding, cold gold
and other paint, and coating, with
affixed turquoise and glass gems
H. 54 cm × W. 36.8 cm
Asian Art Museum of San Francisco, The
Avery Brundage Collection, B60B228

In an unusually opulent image, a multi-
armed dancing Ganesha is enriched
with gilding, silver, and stones such as
turquoise. The iconography is quite sim-
ilar to that of painted representations of
the Maharakta Ganapati (the Great Red
Ganesha; see cat. 44), but here the deity
is surrounded by an aureole of flame,
which is said to symbolize the "burning of
all hindrances and ignorance."[1] Ganesha
is the remover (or sometimes creator) of
hindrances, so the destructive flame is
appropriate.

 It is not entirely clear where this
image was made; Tibet is very likely,
but scholars have seen possible con-
nections in both iconography and style
with Mongolia, and even China can-
not be entirely ruled out as a place of
manufacture.[2]—FMcG

1. See the detailed discussion of this and
related images in Bartholomew, "Spirit King,"
129.
2. Bartholomew, "Spirit King," 129, refers to
a Mongolian pantheon published by Lokesh
Chandra and notes the possibility of stylistic
affinities with "Sino-Tibetan" and Mongolian
art. The sculpture bears no inscription.

43

Eight-armed dancing Ganesha

Approx. 1600–1800
Nepal; Kathmandu Valley
Wood
H. 88.5 cm × W. 47.5 cm × D. 19.5 cm
Art Institute of Chicago, gift of Marilynn
B. Alsdorf, 2014.1042

A crowned multiarmed Ganesha performs a stately dance, while another crowned figure dances energetically at his side. Deities seem to hover overhead. What does all this add up to? In fact, it isn't easy to say.

In the blended religious traditions of Nepal—especially Tantric traditions—deities that are conventionally thought of as Hindu or Buddhist can appear together, as they evidently do here. Ganesha, commonly thought of as Hindu, is flanked by a dancing figure that may be a form of the Buddhist bodhisattva Manjushri, who has special importance in Nepal. Two problematic features would help secure an identification—if they were clear. A flaming sword is a key emblem of Manjushri, and if what this figure holds in the left hand is such a sword, then the figure may well be Manjushri. But Manjushri usually holds the sword in a right hand and brandishes it at head level. Then, if the garland hanging from the figure's neck is made of flowers, it could adorn any number of deities; but if it made from skulls, then the figure is likely Tantric—perhaps a Tantric Manjushri.

In Nepal, Ganesha is understood to have the power both to remove and to create obstacles. Propitiated—or in a Tantric context, identified with—he can protect and instill wealth and both earthly and supernatural power.[1] But how his dancing, his eight-armed form,

and his positioning among this group of deities are to be understood more specifically remains unclear.

The female figure on the other side of Ganesha has not been identified; again, whether her garland is of flowers or of skulls would be an important clue. The figures in the five medallions above Ganesha seem to comprise male and female bodhisattvas (including more Manjushris) and Buddhas, but damage and wear to details makes them difficult to identify with certainty.—FMcG

1. Shakya, *Gaṇeśa in Medieval Nepal* includes a discussion of a painting of Ganesha dancing, but it does not help in solving the puzzles of this object. See also Wilkinson, "Tantric Gaṇeśa."

44

Maharakta Ganesha

Approx. 1575–1625
Central Tibet
Opaque watercolors on cloth
H. 31.1 cm × W. 26.4 cm
Virginia Museum of Fine Arts,
Richmond, Gift of Berthe and John
Ford, 91.511

This deity—the Tibetan Buddhist Great Red (Maharakta) Ganesha (or Ganapati; the meaning is essentially the same)—is said to dance "beside a lapis lazuli rock mountain" but is seldom shown doing so.[1] Here, however, the blue and green crags of the mountain are represented in detail, with trees and birds adorning them. The mountain rears up in a night sky scattered with flowers and auspicious Buddhist symbols, emphasizing the celestial vastness of the scene. In the corners of the painting are (clockwise from upper right) one type of the tantric deity Mahakala, another type of Mahakala, a monk, and a dancing one-headed Hevajra with consort. All relate to the Sakya school of Buddhism in Tibet, which derives its teachings from the Hevajra Tantra.[2]

This form of dancing Ganesha is much more common in the Tantric Buddhist traditions of Tibet than elsewhere. A centuries-old text provides guidance to worshippers and to artists as well: "The worshipper should conceive himself as god Gaṇapati of red complexion, wearing the crown of chignon, who is decked in all ornaments, has twelve arms, protruding belly and one face, stands in the Ardhaparyaṅka [half-sitting pose; that is, with one leg bent upward] in a dancing attitude, is three-eyed, and has one

tusk; . . . and rides the mouse on the red lotus."[3]

As in other traditions, both Hindu and Buddhist, Ganesha is associated with overcoming obstacles and gaining benefits.—FMcG

1. The phrase "lapis lazuli rock mountain" comes from a text written in the sixteenth century by the Tibetan monk Ngorchen Konchog Lhundrup; see Jeff Watt, "Ganapati (Indian God & Buddhist Deity)—Red (12 hands)," Himalayan Art Resources website, updated February 2011, https://www.himalayanart.org/items/89964, which pertains to a painting of Maharakta Ganapati in the collection of the Rubin Museum of Art (C2005.11.1).

2. I am indebted to Jeffrey Durham for his help in identifying these figures.

3. Bhattacharyya, *Indian Buddhist Iconography*, 142.

45 *also p. 8*

Shiva as slayer of the elephant demon

Approx. 1800–1900
Southern India
Wood
H. 35.2 cm × W. 26 cm × D. 8.4 cm
Simon Ray, London

Shiva dances on multiple occasions, and his body morphs and changes in response. Often, he dances to invoke destruction, praise, or joy. Here, he dances in triumph after defeating the elephant demon Gajasura. Shiva is portrayed with eight arms, seen only in his most aggressive and combative forms. Two of those arms are raised overhead, presumably to hold the flayed skin of the elephant demon aloft; the others hold a sword, a snake, a drum, his trident, and a mace. His final hand presents a gesture of fearlessness, reflected as well in his serene expression. Shiva dances on the decapitated head of the demon, transcending the wickedness of the demonic force and once again restoring order.—AMC

46

Shiva as slayer of the elephant demon

Approx. 1000–1100
India; Tamil Nadu state
Granite
H. 72.4 cm × W. 48.3 cm × D. 20.3 cm
Cleveland Museum of Art, John L.
Severance Fund, 1962.164

In a striking posture that evokes the dominance and strength of the god, the wrathful Shiva is portrayed with bulging eyes, protruding fangs, and wild hair. His left leg is raised high, revealing the head of the lifeless elephant demon tucked behind his form.[1] He holds the elephant's flayed skin overhead in a dance of triumph. In the culmination of this dance, Shiva flings the skin high into the air before it comes to rest around his shoulders as a garment.[2] The rhythm of his dance is provided by the attendant (*gana*) beating a drum in the lower left corner; Shiva's wife Parvati dances along in the lower right.

The demonic form of the elephant has been understood as a metaphor for the wandering mind of the devotee. His distracting presence needs to be vanquished by Shiva so that devotees can better focus their attention on the god himself.[3]—AMC

1. A relief in the Brooklyn Museum (1999.99.2) depicting Shiva as the slayer of the elephant demon portrays the god with a similarly lifted leg and bent knee. However, in that work he stands on the elephant head with his left foot.
2. Kramrisch, *Manifestations of Shiva*, 46.
3. "Shiva as Slayer of the Elephant Demon," Cleveland Museum of Art website, accessed February 15, 2021, https://clevelandart.org/art/1962.164.

47 *also pp. 140–41*

The dance of Shiva and Kali

Approx. 1780
India; Punjab Hills, former kingdom of Guler
Opaque watercolors and gold on paper
H. 23.2 cm × W. 20.3 cm
Virginia Museum of Fine Arts, Richmond, Adolph D. and Wilkins C. Williams Fund, 82.141

The goddess Kali dances with wild abandon, and her garland of skulls, tiger skin skirt, and loose hair are all thrust to the right by her vigorous movements. Her emaciated form signifies a primordial hunger; she feasts on animals and drinks their blood to replenish her energy, needed to sustain the universe.[1] Her attendants hold weapons and drink skull cups brimming with intoxicating blood, signifying Kali's power to defeat false consciousness or ego. Shiva, clad only in serpents (his animal-hide loin cloth has fallen to the ground) and accompanied by his animal-headed attendants, provides the rhythm for her dance. Kali shares Shiva's attributes and marks—a third eye, crescent moon, animal-hide loincloth or skirt, and garland of skulls—as emanations of his energy, or shakti.

Shiva and Kali dance in many instances: the dance of joy following Kali's destruction of the demon Daruka, where Kali shakes the universe through ferocious movement;[2] after defeating the demons Shumbha and Nishumbha, when Kali and her attendants terrorize the world by their fierce dance until Shiva challenges her to a contest and is victorious;[3] when Shiva and Kali join their rhythmic forces and perform a destructive dance together, nearly destroying the universe by their combined energy.[4] Whether or not this painting evokes a textual source, the dance it presents is imbued with the ability of the goddess to transform negative elements prevalent in the universe.—AMC

1. Dehejia and Coburn, *Devi, the Great Goddess*, 235–36.

2. Kramrisch, *Manifestations of Shiva*, 184–85; and as recorded in the Linga Purana. Kramrisch initially identified the dance depicted in this painting as this dance of joy, and it has been echoed by subsequent authors.

3. Dye, *Arts of India*, 344–45. While the battle is recorded in the Devi Mahatmya, Dye indicates the after-battle dance is predominantly discussed in South Indian traditions.

4. As recorded in Bhavabhuti's eighth-century Sanskrit lyric drama *Malatimadhava*; cited in Kinsley, *Tantric Visions*, 78; and discussed in Dye, *Arts of India*, 345, and Dehejia and Coburn, *Devi, the Great Goddess*, 235–36.

48

Rarung, a demonic figure

Approx. 1800–1900
Indonesia; Bali
Wood with metal, paint, and leather
H. 59.7 cm × W. 41.9 cm
Asian Art Museum of San Francisco, Gift of Thomas Murray in memory of his father, Eugene T. Murray, 2000.37

To those familiar with Balinese culture, this sculpture immediately evokes Rangda, a character in the story of Calon Arang (see p. 163).[1] Rangda is considered the queen of the dangerous practitioners of black magic who roam graveyards at night. Yet a close examination of the statue suggests it represents a different character from that tale. The figure's black hair, smaller breasts, and dark face are characteristics

of one of Rangda's apprentices, Rarung. And indeed, at the base of the statue letters in faded Balinese script faintly spell out this name.[2] In some of the many different dramatized versions of this story found in Bali today, Calon Arang meets in the graveyard with her acolytes, including Rarung, to dance. In this statue, Rarung stands in a posture common to Balinese dance: knees half-bent and slightly splayed, elbows raised to shoulder height.

A description of this scene brings the graveyard dance to life: "[Calon Arang] called her disciples together in the graveyard under the shadow of the great banyan tree and cried: 'Beat the drums and let us dance one by one.' First Goejang danced with outstretched arms; she clapped her hands and dropped to the ground and circled sitting. Her eyes darted to and fro, her head moved from side to side. . . . Then Larong [Rarung] danced; her movements were like a tiger about to spring. Her eyes were red, her hair hung loose."[3]—NR

1. Poerbatjaraka, "De Calon-Arang."
2. We do not know where on Bali this statue might have been originally sited. While stone statues decorated temples and in some cases portrayed dancing figures, large wooden statues such as this were used mostly as architectural ornaments.
3. De Zoete and Spies, *Dance and Drama in Bali*, 116.

Calon Arang in Balinese Dance Performances

Tales about a widow and sorceress called Calon Arang have a long history in literary and performance traditions in Bali.[1] Many written renditions of this story exist in both prose and poetic forms. The oldest extant text is dated to the sixteenth century, but the narrative is likely much older. The events described in these tales are set in the eleventh-century east Javanese kingdom of King Erlangga, a historical figure of Balinese and Javanese heritage.

A common version of the narrative tells of a land stricken by a plague caused by a widow called Calon Arang, whose daughter had been spurned because of her mother's reputation as a black magician. The king sent his priest and adviser Bharada to investigate; he in turn directed his disciple Bahula to marry the daughter and to steal the widow's book of magic. Bharada fought the widow using the stolen book, and in anger Calon Arang transformed herself into the terrifying form of Rangda, a powerful witch associated with the Hindu goddess Durga. In the text, she is eventually defeated by Bharada.[2]

Today this story has become part of many different performance traditions in Bali.[3] In the past some of these performances lasted from dawn until dusk and were part of exorcistic rituals carried out for the protection of a village. Adaptations more suited to tourist audiences were commissioned in the 1930s, when European tourists began visiting Bali. In some of these dances other Balinese performance traditions were incorporated into the narrative. Today two elements commonly seen in dances for tourists are the inclusion of the Barong (a protective animal spirit) and the addition of a kris dance, in which the warriors repelled by Rangda turn their kris daggers upon themselves.—NR

1. Poerbatjaraka, "De Calon-Arang."
2. Dramatized versions of the story differ strikingly in different villages, and they also diverge from the written narrative. In many performances today, Rangda retreats but is not defeated.
3. The transformation of the Calon Arang from literature to performance is discussed in Bandem, Rota, and Bagiartha, *Transformasi sastra Calonarang*.

49

Dance performance with Barong and Rangda

Approx. 1935–1939
By I Dewa Nyoman Leper (Indonesian, 1917–1984)
Ink and colors on paper
H. 36.2 cm × W. 49.8 cm (image);
H. 44.8 cm × W. 58.7 cm (sheet)
Asian Art Museum of San Francisco, Gift of David Salman and Walter Jared Frost, 2016.288

The long shaggy body of the Barong, a lionlike tutelary spirit, forms a diagonal across this painting. His front half crouches as he twists both head and tail toward the men on one side of him, forming a barrier between them and the hulking presence behind him. In the background stand two of his attendants wearing tall headdresses and carrying banners.[1] A female figure, with bulging eyes, fangs, and a long, lolling tongue, looms over the Barong holding a magic cloth that renders her invisible. She is likely Rangda, a fierce female practitioner of black magic.[2] On the far right, two men turn their kris daggers upon themselves in the face of Rangda's power—a performance known in this tradition as the kris dance.

The Barong and Rangda are central figures in a variety of ritual performances that occur throughout southern Bali. Music and dance do more than just punctuate Balinese ritual life; they can form

the core of certain sacrificial offerings. Barongs take part in processions and in dances at the time of temple festivals, during Galungan (an annual celebration of ancestral spirits), in rituals to ward off dangers, and on other occasions, including tourist performances (see cats. 50–51).[3] It is difficult to tell exactly which event the Balinese artist I Dewa Nyoman Leper might have depicted in this painting.—NR

1. An early photograph of a Barong in Ubud shows similar attendants: Tropenmuseum, Amsterdam (TM-10026826). I Dewa Nyoman Leper was from Padangtegal, a village in Ubud.

2. Some performances include acolytes of Rangda, either identified as students or her daughter. These figures have similarly frightening visages and long fingernails but have dark hair, indicating their younger age; see cat. 48.

3. For a description of the ways in which the two dancers move as a Barong, see De Zoete and Spies, *Dance and Drama in Bali*, 92–93.

50

Barong dance, Bali

1960
By Ben Shahn (American, 1898–1969)
Gelatin silver print
H. 6 cm × W. 8.1 cm
Harvard Art Museums/Fogg Museum,
Gift of Bernarda Bryson Shahn,
P1970.5257

51

Barong dance, Bali

1960
By Ben Shahn (American, 1898–1969)
Gelatin silver print
H. 9 cm × W. 14.5 cm
Harvard Art Museums/Fogg Museum,
Gift of Bernarda Bryson Shahn,
P1970.2358

We know little about Ben Shahn's trip to Bali in 1960. He admired Henri Cartier-Bresson and was perhaps inspired to visit the island by the photographs of Bali taken by the great French photographer a decade earlier.[1] Unlike the more carefully composed images taken by his predecessor, Shahn's dance photos are less intimate and seem to have been taken mostly from a single vantage point: the covered pavilion set up for foreign tourists outside of the village temple of Singapadu, Pura Singapadu.

Since the early 1940s Pura Singapadu had been a site for tourist performances of the *Kunti Sraya*, a dance drama based on an episode of a local version of the Hindu epic the Mahabharata.[2] It also has roots in an hours-long exorcistic dance based on the tale of Calon Arang that would have been performed from late evening till dusk for the protection of a village. Expatriates and Western visitors were fascinated by these exorcistic performances, especially when dancers fell into trance.[3] In the 1930s they began commissioning Balinese artists to present shorter performances staged especially for tourist entertainment.[4]

In this dance drama the guardian animal spirit called a Barong faces off against the witch Rangda. The confrontation between these two is often described as a battle between good and evil, but this is an oversimplification. Rangda is both feared and respected in Bali, and ultimately the performance concerns not her defeat but "establishing a rapport with the fearsome but ambiguous demonic."[5]

Shahn's first photo here (cat. 50) shows the encounter between a follower of Rangda named Kalika, who has taken on her terrifying form, and Sadewa, a young nobleman who has taken the form of the lionlike Barong. The two fight, and eventually the Barong's followers come to try and help him, as shown in the second

photo (cat. 51). Dressed in the protective black-and-white checkered *poleng* cloth, the young men wield their kris daggers as they approach Rangda. The witch uses her magic to turn their weapons upon themselves, and some dancers fall into trance. Eventually the Barong forces Rangda to retreat, and felled dancers are revived by the Barong and a priest.

For almost a century, Balinese artists have been taking part in ritual dances for community needs and also performing for tourists. Despite efforts by the Balinese government to distinguish secular and sacred dances, the line between these genres is fluid; dances considered sacred are performed for tourists, and dances first presented in a secular context are now performed at temple ceremonies. Because Balinese gods are omnipresent, a tourist performance can be considered an offering to the gods as well as entertainment for a paying audience.[6]—NR

1. Cartier-Bresson, *Les danses à Bali*.

2. Some sources claim the dance was invented in 1948. See "Barong Kunti Sraya Dalam Film Dan Timbang Pandang," Suarabali.com, August 14, 2017, http://suarabali.com/barong-kunti-sraya-dalam-film-dan-timbang-pandang/.

3. A film made by the Mexican artist Miguel Covarrubias in the early 1930s demonstrates the frenetic drama of the dancers in trance. See Bali1928.net, "Bali 1928, vol. III—Barong, Sandaran, Rangda & Ngurek in Kesiman," video, 7:41, posted July 27, 2015, https://www.youtube.com/watch?v=L0_QcNMOziE.

4. A version of this dance was performed at the 1931 Paris Colonial Exposition; see Savarese and Fowler, "1931."

5. Lovric, "Balinese Theatre," 42.

6. See Picard, "'Cultural Tourism' in Bali."

The Dancing Mother Goddesses

When [the demonic force Raktabija] was slain, the band of Mothers danced about, intoxicated by his blood.[1]

The Hindu text known as the Devi Mahatmya recounts how a group of mother goddesses (*matrikas*)—who are themselves female manifestations of the energy (shakti) of the male deities—joined the Great Goddess to overcome a powerful demon and his destructive force. They celebrate by drinking the blood of the vanquished and dancing frenetically. Afterward, the mother goddesses are absorbed by the Great Goddess, which suggests they were and are always part of her creative energy.[2]

Sculptural images of the mother goddesses were incorporated into the architectural program of temples and venerated as a set from the fifth century onward in parts of India. By the ninth and tenth centuries, carved mother goddess panels were often positioned as lintels above temple doorways.[3] Sometimes depicted holding children, seated, dancing, or carrying weapons, the mother goddesses embody both creative and destructive elements. Their limitless feminine energy can take the form of guardians, warriors, loving mothers, and custodians of supreme knowledge.—AMC

1. Devi Mahatmya, 8.62, in Coburn, *Encountering the Goddess*, 67.
2. Dehejia and Coburn, *Devi, the Great Goddess*, 244.

3. The mother goddesses maintain a strong connection to Shiva but can also appear above doorways of temples of any sectarian affiliation.

52

Shiva, the seven mother goddesses, and Ganesha dance

Approx. 800–900
India; Madhya Pradesh state
Sandstone
H. 26.7 cm × W. 89.5 cm
Los Angeles County Museum of Art, Gift of Paul F. Walter, M.80.157

Here, we see seven mother goddesses (*matrikas*) captured in motion, knees bent and torsos swaying.[1] The mother goddesses are the "active principle of the god himself"[2] and are not to be conflated with the role of a wife or consort. In addition to Shiva on the left and Ganesha on the right, they are: Brahmani (the embodied energy of Brahma), Maheshvari (Shiva), Kaumari (Skanda/Kumara), Vaishnavi (Vishnu), Varahi (Varaha), Indrani (Indra), and Chamunda (the Great Goddess). The exact number of goddesses depicted together fluctuated and was only formalized to seven comparatively late in the history of their worship. As eloquently explored in Padma Kaimal's essay "Why Do Yoginis Dance?" in this volume (pp. 21–31), their power lies in their multiplicity.—AMC

1. Comparable lintels of the dancing mother goddesses can be found in the collection of Dorothy and Richard Sherwood (published in Desai and Mason, *God, Guardians, and Lovers*, cat. 62); the Denver Art Museum (1964.24); and the British Museum (OA 1880-230).
2. Desai and Mason, *Gods, Guardians, and Lovers*, 246–47.

53

Two fragments from a panel depicting Ganesha and mother goddesses dancing

Approx. 900–1100
Nepal
Copper repoussé
Each H. 16.1 cm × W. 29.5 cm
Art Institute of Chicago, Helen A.
Regenstein Endowment, 1996.431a, b

The vigorous dance of the mother goddesses is seen here through the movement of their garments and scarves, which reverberate to the rhythm of their bodies. While worship of the mother goddesses was established in India by the fifth century, an inscription dated 573 found in Nepal shows a similarly early date for such multiple mother goddess images.[1] In Nepal, the order in which the figures are presented is often altered, as seen in the first fragment from this panel, where Ganesha leads from the left. A comparable and complete metal panel from Nepal (fig. 1) begins with two donor figures followed by Shiva and Ganesha, seven mother goddesses, and ends with Bhairava.

The variety of figures and their placement seen in this and other mother goddess sets speaks to the subtle evolution of Hindu (and Buddhist) practice and belief.[2] The complete object would have portrayed seven, eight, or nine mother goddesses and would have originally covered and protected images made in clay or wood.[3] Note the hand gesture of Chamunda (usually called Kali or Mahakali in Nepal) on the far right of the second fragment. Known in Nepal as *bindu mudra*, this gesture communicates that the goddess is flicking drops of wine or blood toward the deities as a tantric offering.[4] —AMC

1. Dehejia and Coburn, *Devi, the Great Goddess*, 20.
2. Meister, *Regional Variations*, 242.
3. Pal, "Himalayan Art," 78–79.
4. Dehejia and Coburn, *Devi, the Great Goddess*, 232.

Fig. 1 Plaque with dancing deities and donors, 1127. Nepal. Gilt-copper repoussé. *Norton Simon Museum, Gift of Arnold H. Lieberman, P.2000.06.1.*

54

The mother goddess Vaishnavi dancing

Approx. 800–900
India; Madhya Pradesh or Rajasthan state
Sandstone
H. 74.9 cm × W. 36.2 cm
Virginia Museum of Fine Arts, Richmond, Gift of the Nasli and Alice Heeramancck Collcction, gift of Paul Mellon, 68.8.12

> O you who have taken up the best of
> weapons, conch and discus, club and bow,
> Be gracious, O one with Vaisnavi's form;
> O Narayani, praise be to you![1]

With her body dynamically posed as if in full motion, the mother goddess Vaishnavi is the female emanation of the elemental power or essence (shakti) of the male deity Vishnu. She wears his miter-shaped crown and carries with her

Fig. 1 The Hindu goddess Kaumari, 800–850. India; Madhya Pradesh or Rajasthan. Red sandstone. *Los Angeles County Museum of Art, Nasli and Alice Heeramaneck Collection, Museum Associates Purchase (M.82.42.3).*

the weapons and attributes of the god, including his discus, conch shell, and mace, and is accompanied by his mount Garuda, seen here on her right. While shown as pensive and serene, Vaishnavi is anything but benign, as she set upon the demonic force Raktabija with her discus in battle and then danced madly in victory.

While they are most often worshipped at Shiva temples, there are known references to mother goddess shrines where they are depicted either in friezes or as separate steles, as here.[2] A comparable stele portrays the goddess Kaumari (fig. 1) and is most likely from the same set. With torsos leaning in opposite directions, both goddesses have knees deeply bent, their weight on one foot and the toes of the other barely touching the ground.—AMC

1. Devi Mahatmya, 11.15, in Coburn, *Encountering the Goddess*, 75.
2. Meister, "Regional Variations," 233–40. Mother goddesses are also worshipped in temples of other sectarian affiliations.

55

The mother goddess Chamunda dancing

Approx. 800–1000
India; Rajasthan state
Sandstone
H. 58.4 cm × W. 38.1 cm × D. 17.8 cm
Asian Art Museum of San Francisco, The Avery Brundage Collection, B62S39+

A macabre vision, with legs bent in motion, Chamunda is here portrayed with a skull-like face, protruding eyes, drooping breasts, and a sunken belly. Depicted with twelve arms, the goddess brandishes (clockwise from top) the leg of a corpse, a

Chamunda's Rapturous Dance

When worlds collide

explode and shatter

Like bolts of thunder their clamor

provides the beat of your dance.

When in that awesome void

blood-oozing demons

sport and sing aloud

the gleeful refrain of their song

the unceasing beat of their verses

echo the thud of your footsteps.

O Kali, Chamundi, Kankali,

your dance is a dance of ecstasy.

Mother, O Mother,

lured helplessly

I watch your rapturous dance.[1]

"Gruesome and yelping like a hundred jackals,"[2] Chamunda emanated from the body of the Great Goddess, who is herself considered the collective, unconquerable energy—or shakti—of the gods. The fierce goddess Kali was given this epithet after her defeat of two demons, Chanda and Munda, who were intent on destabilizing the universe. Chamunda decapitated them in battle, drinking their blood and decimating their army. Her ecstatic, rapturous dance is performed after she vanquishes the demons and shakes the very foundation of the universe.[3]

While Chamunda is considered one of the mother goddesses (*matrikas*), who are often shown together as a set, she is also portrayed dancing alone along the exterior walls of temples or shrines dedicated to Shiva and to the Great Goddess herself.[4] And yet Chamunda's form stands in stark contrast to most portrayals of the goddess. She is depicted as emaciated (the consumption of the universe cannot sate her hunger), carrying a skull cup full of wine or blood, a necklace of severed heads, and an array of weapons. She embodies both destructive and protective aspects and represents universal power unleashed.—AMC

1. The first stanza of "Dance of Annihilation" by Subrahmania Bharati (1882–1921) as translated by Vidhya Dehejia and Sagaree Sengupta in Dehejia and Coburn, *Devi, the Great Goddess*, 102.
2. Devi Mahatmya, 8.22, in Coburn, *Encountering the Goddess*, 61.

3. Parallels exist between Chamunda's dance and that of Shiva Nataraja, as both deities embody the ability to create, protect, and destroy the universe. See Hazra, *Sakta and Non-Sectarian Upapuranas*, 40.
4. Desai and Mason, *Gods, Guardians, and Lovers*, 174; Dye, *Arts of India*, 150–51.

shield, a skull-topped staff, a bow, a skull cup, a dagger, a trident, a spear, a double-headed drum, the arm of the afore-mentioned corpse, and a now-broken implement. The last hand gestures to her mouth, indicating again her insatiable hunger.—AMC

56

The mother goddess Chamunda dancing

Approx. 901–1100
India; Khajuraho region, Madhya Pradesh state
Sandstone
H. 67 cm × W. 52.7 cm × D. 18.5 cm
Harvard Art Museums/Arthur M. Sackler Museum, gift of Mr. and Mrs. Howard E. Houston, 1974.64

Carved in high relief to emphasize her sinuous form, this image of Chamunda communicates the movement of her frenzied dance through her swaying necklace of skulls and pendulous breasts. Many depictions of Chamunda see her dancing on top of a corpse that represents her vehicle or mount signifying triumph over ego and ignorance.[1] The corpse also suggests a cremation ground setting, where Tantric practitioners meditated to confront their fears and overcome self-attachment.

The mother goddesses (*matrikas*)—Varahi and Chamunda, in particular—embody seemingly contradictory qualities of destruction and compassion. Emaciated Chamunda and the sow-headed Varahi visually contrast with the feminine ideal of the other mother goddesses and occupy roles as the most transgressive of the mothers.[2] Varahi,

positioned in the lower right corner of this relief, feasts on the blood that drips into her skull cup from the decapitated head held in one of Chamunda's hands.—AMC

Cat. 55

1. See also the tenth-century dancing Chamunda reliefs in the British Museum (1872,0701.82) and the Virginia Museum of Fine Arts, Richmond (83.1).
2. Ramos, *Tantra*, 46.

57

Krishna overcoming the serpent Kaliya

Approx. 975–1025
India; Tamil Nadu state
Copper alloy
H. 87.6 cm × W. 35 cm
Asia Society, New York: Mr. and Mrs.
John D. Rockefeller 3rd Collection of
Asian Art, 1979.22

58

Krishna overcoming the serpent Kaliya

Approx. 1400–1500
India; Sundaraperumalkoil, Thanjavur
district, Tamil Nadu state
Bronze
H. 66 cm × W. 33 cm
Asian Art Museum of San Francisco, The
Avery Brundage Collection, B65B72

*Whichever head he raised up, Krishna
forced him to bow low, striking at it with his
feet as he danced.*[1]

In a notable and often-depicted scene vividly described in the Bhagavata Purana, the god Krishna battles the multiheaded serpent demon Kaliya, who was poisoning the sacred Yamuna River. Krishna and his cowherd friends were on the banks of the river with their cattle when several of them died from drinking the river's water. After bringing them back to life, Krishna realized that the mighty serpent Kaliya was living in the river and was responsible for the poisoning. Krishna plunged into the river's depths and began to battle the snake. Krishna soon found himself ensnared in the demon's mighty coils, but he sprang free by summoning the power of the universe and trapping the snake beneath his foot. Perched on the serpent's many hoods, Krishna began to dance. Trampled underfoot, the snake submitted to Krishna's strength, and the river was purified.

In the two figures here, Krishna has emerged victorious from the river and is dancing on Kaliya's many heads, removed

from any narrative context. As Krishna
dances confidently, he holds the end of
the serpent tail delicately in his left hand,
while his right hand offers a gesture of
reassurance. Krishna's body is wrapped
in necklaces, bands of jewels across his
chest, armbands, and anklets, bringing
an evocative aural quality to the dance,
in which the bells on his anklets sound
the snake-demon's defeat. Kaliya gazes
up at the god, with hands together in
homage and in admiration of the god's
strength. It is believed that demons
receive salvation when their power is
overcome by a god. Their proximity to the
divine brings blessing, and their focused
determination during battle is a form of
devotion.[2]—AMC

1. Bhagavata Purana, 10.1.29, in Bryant,
Krishna: Beautiful Legend, 127.
2. Cummins and Srinivasan, *Vishnu*, 191

59 *also p. 82*

Krishna overcoming the serpent Kaliya

Approx. 1775–1800
India; Madhya Pradesh state,
Bundelkhand region
Opaque watercolors on paper
H. 19.3 cm × W. 34.5 cm
Lent by Gursharan and Elvira Sidhu

Krishna vigorously dances atop the snake-headed demon Kaliya while Krishna's family—foster parents Nanda and Yashoda and brother Balarama—await him on shore. The townspeople are also crowded onto the riverbank, watching in rapt attention while the story unfolds below from right to left. Krishna, shown twice, dances the demon into submission before receiving Kaliya's serpent clan (*nagas* and *naginis*) while seated atop a low throne. Finally, Kaliya and his family retreat to the ocean, leaving Krishna victorious.

There are several known paintings from this series, including the two immediately preceding this work, which depict the story in close detail.[1] The first portrays Kaliya poisoning the waters of the Yamuna River, with the cowherders and townspeople fainting along its banks. The second illustrates the underwater battle between Krishna and Kaliya, where god and demon struggle for dominance. Here,

in the third known painting of the series, Krishna is victorious, having vanquished the demon Kaliya through dance.—AMC

1. Thanks are due to Gursharan Sidhu for bringing this painting and the associated series to the author's attention. Rather than the usual Sanskrit version of the Bhagavata Purana, this series illustrates a Brajbhasha retelling of the tale. The other two paintings referenced are in the State Museum, Shimla, and the Jagdish and Kamla Mittal Museum of Indian Art, Hyderabad (76.348 P.348-CI 13). See Seyller and Mittal, *Central Indian Paintings*, 44–49, for a robust discussion of the series.

wives flank the central image of Krishna dancing and are portrayed demurely as they plead for mercy with folded hands. Above, two women, likely villagers, also honor Krishna as they witness the scene. Krishna is shown in an animated dance, holding his flute in his left hand and the tail of the serpent demon in his right.

The presence of the instrument in Krishna's hand conflates this image with Krishna Venugopala, the name applied to the god when playing a flute. Krishna's playing is described in the Bhagavata Purana as having a transfixing effect on women, animals, and even the natural world; perhaps the serpent women are here similarly cast under Krishna's enchanting spell. This wooden sculpture was likely created as, or in the manner of, a panel for a rolling pilgrimage cart that would carry a central image of a god in a temple procession.[1]—AMC

1. Asian Art Museum Objects Conservator Mark Fenn examined this sculpture under high magnification and found traces of gesso, suggesting that the object was once coated with gesso and probably painted. Fenn also found evidence that the entire sculpture had, at some point, been sand blasted, presumably to remove paint and gesso that had begun to flake and look unsightly. Thanks are due to Robert del Bonta for discussing the work with the author.

60

Krishna overcoming the serpent Kaliya

1900–1950
Southern India
Wood, with traces of gesso, and metal
H. 49.5 cm × W. 31.7 cm
Asian Art Museum of San Francisco, The Avery Brundage Collection, B61S51+

Scenes of Krishna overcoming the snake-demon Kaliya often include his wives (*naginis*), who are depicted with serpentine bodies and human torsos and heads. As Krishna dances, the wives cluster around and plead with the god to show mercy to their husband. Krishna acquiesces and, instead of killing the serpent, orders Kaliya to leave the Yamuna River and banishes him and his family to the ocean. Here, Kaliya's

embellishment of one's body acts as an identifier of regional origin, dynastic lineage, or sectarian affiliation. Wearing this armlet identifies the wearer as a devotee of Krishna.—AMC

1. Often incorporated into Hindu and Buddhist architectural programs in South and Southeast Asia, the *kirtimukha* is commonly found above a temple entrance.

62 *also p. 80*

The sage Shuka remains unmoved as Rambha dances before him

see p. 80
Approx. 1600
India; Rajasthan state, possibly former kingdom of Bikaner
Opaque watercolor and gold on paper
H. 21.9 cm × W. 9.8 cm
San Diego Museum of Art, Edwin Binney 3rd Collection, 1990.778

Paintings from this dispersed series illustrate a Sanskrit text called the *Rambha-Shuka Samvad* (The dialogue between Shuka and Rambha).[1] It presents an ageless tale of seduction, where a sage (Shuka, son of Vyasa and narrator of the Bhagavata Purana) is visited by Rambha, a celestial dancer (*apsaras*) of undeniable beauty who emerged as one of the jewels from the churning of the ocean. Rambha enters a philosophical debate with Shuka, where she argues that a life lived without bodily desires is not worth living. He replies that a life is wasted if one cannot

61

Armlet with Krishna overcoming the serpent Kaliya

Approx. 1850–1900
India; Chennai, Tamil Nadu state
Gold, opalescent glass, and topaz
H. 10.8 cm × W. 7 cm × D. 7.9 cm
Los Angeles County Museum of Art, Purchased with funds provided by the Nasli and Alice Heeramaneck Collection, Museum Associates Purchase, M.2002.83

Krishna's dance atop the snake-demon Kaliya is flanked on either side by female attendants who honor the god by waving fly whisks. Other figures punctuating the dense design of vine-like tendrils on this armlet include animals, mythical creatures, and a "face of glory" (*kirtimukha*).[1] This intricately worked accessory would have been worn on the upper arms of women in southern India. Adorning the body is a fundamental part of the South Asian aesthetic, where men and women alike wear jewelry not only to accentuate physical beauty but also as an act of worship. Among other benefits, the

rise above such physical manifestations of longing.[2]

Here, Rambha is seen dancing before Shuka and surrounded by buzzing bees that represent the sweetness of her singing voice. Rambha is cast as a temptress who attempts to seduce and disempower the austere sage with her sexuality. It is a role she often embodies in literary and devotional texts, where her beauty and accomplished dancing and singing abilities are wielded to distract devout men.[3]

The moral-laden tale of this dance was brought to life in the 1953 Hindi film *Shuk Rambha* (dir. Dhirubhai Desai).[4] In a pivotal scene, the austere sage is seated in a forest dwelling, unmoved by the dance of Rambha, who is shown accompanied by numerous other female dancers. Perhaps her powers of seduction are represented by a multitude of dancers for cinematic effect.—AMC

1. The Sanskrit text is available in Bhatavadekar, *Subhashita Ratnakara*, 312–15.

2. Goswamy and Smith, *Domains of Wonder*, 62.

3. On the god Indra's orders, Rambha distracted the saint Javali from his penance as well as the sage Vishvamitra from his meditation. Rambha also appears in the Ramayana, where she is raped by Ravana, who was stricken by lust at the sight of her beauty. Rambha often suffers consequences from her powerful dance: in one telling, she was turned into a statue for a thousand years by Vishvamitra; in another, she was banished from the heavens by Indra and born on earth for being inattentive and missing a step.

4. Clips from the film can be found at Simakshu Mudgel, "Shuk Rambha.MPG," March 20, 2011, video, 2:40, https://www.youtube.com/watch? v=TGlJTPOJ8Pg.

63

The temptation of the Buddha by the demon Mara's daughters

1561
Nepal
Distemper on cotton
H. 108.5 cm × W. 75.5 cm
Museum of Fine Arts, Boston, gift of
John Goelet, 67.846

64

Daughters of the demon Mara

Approx. 1470–1480
Myanmar (Burma); Ajapala's temple,
Bago (Pegu)
Terra-cotta with glaze
H. 44 cm × W. 33 cm × D. 7.6 cm
Asian Art Museum of San Francisco,
Museum purchase, B86P14

As the Buddha-to-be meditated and approached the achievement of Enlightenment, the demon Mara, a symbol of evil and death, unleashed not only his brutish army to overcome the Buddha-to-be by force, but also his daughters, one of whom is named Lust, to turn the Buddha-to-be away from his spiritual goal by seduction. An ancient Buddhist text describes the daughters' tactics: "Some lifted their arms, waving them in the air to reveal their armpits. . . . Some mischievously moved back and forth in a flirtatious manner. Some danced. Some sang. Some flirted and acted shy. Some shook their thighs like a palm tree moved by the wind."[1]

The theme of (seemingly) attractive women using allurements—often including dance—to stymie a male ascetic is

an old and common one. The scholar Liz Wilson notes that "the gods' favorite method for chastising uppity . . . human sages is to send down *apsarāses* or celestial nymphs to disturb their meditation. This divine sex offense almost always succeeds: it is the gods' best defense against those whose celibate practices threaten the balance of power."[2]

Why "seemingly attractive"? Hideous female creatures often take on beautiful forms to work their will. Alternately, the ascetic's eye perceives that inside the desired body are only bones and flesh, urine and phlegm. Throughout the Indian cultural world (as elsewhere) the attitude to the female body was compounded of

admiration, attraction, fear, and repugnance. A woman dancing was especially to be distrusted.[3] (The old texts do not seem to consider whether a male ascetic or monk might not have lustful feelings for a male body.)

The text describing the daughters' behavior was known in Nepal during the period that saw the creation of the painting of the attacks of Mara (cat. 63 and fig. 1). Some other Buddhist texts known elsewhere mention that Mara's daughters dance and some do not. A range of artworks suggests, however, that the idea was widespread, even if not mentioned in the texts most familiar in a certain place and time (for example, fig. 2). But

Fig. 1 Detail of cat. 63.

Cat. 64

various ages in their attempt to distract the Buddha-to-be but does not mention dancing. The tradition of the daughters' dancing must have been familiar, though, as shown by earlier depictions in Myanmar (fig. 2).[4] In the instance of this plaque, as in some other artworks in the exhibition, it is impossible to be sure whether dancing is portrayed or some other sort of movement.—FMcG

1. *Play in Full*, 21.120. On the victory over Mara and his forces in general, see Guruge, "Buddha's Encounters." A helpful review of texts and artworks from throughout the Buddhist world having to do with the daughters of Mara is Stadtner, "Father, Please."

2. Wilson, *Charming Cadavers*, 37.

3. Wilson, *Charming Cadavers*.

4. On the plaques and the temple they were made for, see Stadtner, "Fifteenth-Century Royal Monument." Other plaques from the set showing Mara's daughters can be seen in Oertel, *Note on a Tour in Burma*, pl. 9. The inscription on this plaque has been read and translated by Nai Pan Hla, by U Nyunt Han, and by Christian Bauer. The life story of the Buddha well known in Myanmar is the *Nidana-katha of the Jatakatthakatha*, available in English as Jayawickrama, *Story of Gotama Buddha*.

Fig. 2 Mara's daughters dancing before the Buddha, approx. 1100–1110. Ananda Temple, Bagan, Myanmar.

artworks can themselves be hard to interpret.

The glazed terra-cotta plaque showing Mara's daughters (cat. 64) is from a set intended for a fifteenth-century temple in southern Myanmar. We see two daughters bedecked in jewelry, and the inscription tells us they have assumed the form of women who have not yet had children. Are they performing a slow, seductive dance or just sashaying along? The most common text in Myanmar on the life of the Buddha describes Mara's daughters taking the form of women of

65 *also p. 79*

Indrajaala/Seduction

2012
By Pushpamala N (Indian, b. 1956)
Video, 4:30 min.
Lent by the artist

In this video triptych, Pushpamala N presents a version of a famous episode from the great literary epic the Ramayana, casting herself as the main character. In the story, the exiled hero Rama, together with his wife, Sita, and faithful brother, is living in the forest. A giant demoness named Shurpanakha comes upon the family and, "consumed with passion" for Rama, proposes marriage, offering to eat Sita to get her out of the way. Rama, making fun of Shurpanakha, suggests that she marry his brother instead.[1]

As the video artwork begins, Rama's brother is practicing swordplay with dance-like movements. Shurpanakha appears (twice, at each side of the triptych) in her "pot-bellied, hideous" form but, in a burst of flame, transforms into a beautiful woman. She dances for Rama's brother, but he remains unmoved. He repeatedly slashes his sword, cutting off her ears and nose. On a closeup of Shurpanakha's bleeding face the work ends.

Here, Pushpamala N echoed the look of the low-budget special effects in early Indian movies.[2] Indian viewers, and others familiar with the Ramayana, will recognize what is going on in the story without additional information, but its meaning is harder to interpret. The scene in the epic has always troubled people, mixing, as it does, grotesque humor, hurtful violence, and complicated interpersonal dynamics. (We tend to feel sorry for Shurpanakha,

but she kills and eats human beings and repeatedly threatens Rama's innocent wife.) At the same time, many in modern audiences may admire her boldness in traveling through the world alone, claiming her erotic feelings, and expressing desire for a man directly to him.

Pushpamala N has said that this work was inspired in part by a real-life incident in which a young man cut off the nose and ears of a young woman who did not accept him.[3] Here, though, it is the woman who is rejected and then disfigured by the man who spurns her

advances. The word *Indrajaala* in the title means illusion, delusion, or magically created apparition. Is the reference to the deceptions and self-deceptions experienced by the characters, to Shurpanakha's ability to shape-shift, or to the illusory power of film, light, and pixels? —FMcG

1. The story of Shurpanakha's disfigurement is told in *Araṇyakāṇḍa*, chaps. 16–17, from which the phrases in the quotation marks in this entry come.
2. Tripathi, "Layered World."
3. Tripathi, "Layered World."

66

Mohini killing the demon Bhasmasura by making him touch his own head while dancing

Approx. 1900–1925
India; Ghatkopar, Maharashtra state
Poster
H. 34.5 cm × W. 24.1 cm (image);
H. 35.3 cm × W. 25 cm (sheet)
Asian Art Museum of San Francisco,
Library Special Collections

Dance and seduction are closely linked, and they can work for or against righteous purposes. In the story of Bhasmasura, a mighty and ambitious demon performs extreme austerities and (as usually happens in Hindu myths) thereby gains the attention of one of the great gods—in this instance, Shiva. Shiva offers him a favor, and Bhasmasura asks for the power to turn anyone to ashes by touching them on the head. On receiving the favor, Bhasmasura threatens to use his power on Shiva, who flees, calling on Vishnu for assistance. Vishnu takes the form of Mohini, a beautiful, seductive woman, and challenges Bhasmasura to match her dancing. He gets wrapped up in the erotically charged competition and carelessly mirrors her when she touches her head. He falls to ashes.

This episode—with its comic and salacious aspects, the added titillation of a male god changing into female form, and the satisfying final comeuppance—has long been popular. It was illustrated around 1906 by the well-known Indian artist Ravi Varma and was the subject of the 1913 Indian film *Mohini Bhasmasur*. Several later films recount the story,

Fig. 1 Still from the 1966 Telegu-language film *Mohini Bhasmasura* (dir. N. S. Verma).

making the most of the ample opportunities for both suggestive and humorous dance (fig. 1).—FMcG

Glorification

DANCERS, CELESTIAL AS WELL AS MORTAL, perform to honor both gods and kings. Having a corps of dancers attached to the palace was customary for kings and was seen as an attribute of kingship. It was also a way to connect royal and divine power through association with Indra, the king of the gods. While depicted comparatively rarely in sculpture and painting, Indra is perpetually entertained by heavenly dancers. Likewise, the bodhisattva Lokanatha is seen honored by a group of worshippers that includes dancers and musicians who are humbled in the presence of his compassion and grace.

Dance was (and is) important in some royal ceremonies, where both joy and reverence are communicated through dance. Mughal emperors incorporated dance in major life milestones such as celebrations of weddings and births. Rajasthani rulers sat in attendance in grand palace settings, witnessing dance performances while also being seen by courtiers and attendants. These dances often complicate the idea of reverence as they honor both god and king. The performers and the patrons who commission them are seeking piety and compassion through performances that blur lines between devotion and entertainment.

In this way, ideas of glorification in both divine and earthly realms are conflated with dance expressing or displaying power. Sometimes it is the power of a king, where the symbolism of dance is used to reinforce—indeed, potentially to magnify—his power. Or sometimes power is explicitly linked with an appearance of piety, as when the ruler of an Indian kingdom paid for dancers to enact a sacred story and then has himself painted piously observing.

67 also pp. 18–19

Dancers and musicians entertaining a deity or nobleman

Approx. 1075–1125
Former kingdom of Angkor
Stone
H. 69.8 cm × W. 201.9 cm × D. 19 cm
Asian Art Museum of San Francisco,
Gift of the Society for Asian Art and the
Michel D. Weill Bequest Fund, B72S3

Female dancers perform before a princely male figure. The pattern is familiar. How much more specific about who is who and what is happening is it possible to be? The three dancers on our left move in strict unison, matching one another's posture and gestures, and the single dancer to our right mirrors them. These are disciplined artists who, we may imagine, have undertaken rigorous practice of the kind seen in recent centuries (and sometimes still) in Javanese, Balinese, Thai, and Cambodian court settings. The male figure's high status is marked by the platform he sits on, the parasols flanking him, and the attendant wielding a fan. The row of airborne wild geese indicates, in the conventions of the time and place, that the scene above it is transpiring in a heavenly realm. Thus,

the dancers and musicians are celestial, not earthly, beings.

Not enough clues are present to determine what deity the princely male figure might represent. He holds a flower, perhaps a full-blown lotus, but this emblem does not point to an identification. A princely male figure being entertained by celestial dancers called apsarases in a heaven might be thought to be Indra, the king of the gods. But Indra's frequent attribute, a thunderbolt, is not in evidence, and neither is his multiheaded elephant mount. Because eleventh- and twelfth-century temples in northeastern Thailand often include both Buddhist and Hindu imagery in their reliefs and sculptures, it is not even clear which tradition this lintel is associated with. (It should be noted that

the Buddhist/Hindu distinction may be ambiguous, since a "Hindu" deity like Indra and a "Hindu" epic like the Ramayana have Buddhist functions and interpretations in mainland Southeast Asia.)

The closest parallel to this scene appears on another lintel that shows dancers entertaining a flower-bearing princely figure again held aloft by wild geese (fig. 1). To one side is a row of Buddhas, placing the scene in a Buddhist context, but unfortunately the male figure's identity is unknown.[1]—FMcG

1. Suriyavudh Suksvasti speculates that the large male figure might be Maitreya, the Buddha of the future. Suriyavudh Suksvasti, *Thaplang*, 88. The website of the Phimai Historical Park simply calls the figure a "deity."

Fig. 1 Dancers entertain a deity, approx. 1075–1125. Northeastern Thailand. Sandstone. *Phimai National Museum.*

68

Dancers and musicians

Approx. 100–200
Pakistan; ancient region of Gandhara
Stone (schist)
H. 22 cm × W. 54 cm
Lent by Jimmy Bastian Pinto

Two dancers mirror each other's positions: right leg moving forward, left back, right hand held at the breast, left lifted above the head. We can imagine their graceful circling motion. The musicians flanking them play a harp-like instrument and a flute.

What is going on? Beyond the harpist loom a large animal leg and paw, and fragmentary remains show that a similar leg and paw lay beyond the flutist. These were the legs of a throne, probably for the Buddha. Many images of the Buddha from the same region and period have small scenes positioned below the Buddha and between the throne legs (fig. 1). It is conceivable, then, that the complete image showed the Buddha defeating the demon Mara (see cat. 63) and achieving Enlightenment, with dancers and musicians celebrating the great event.—FMcG

Fig. 1 Seated Buddha on a throne, with a small scene between the throne legs , approx. 300–500. Northern Pakistan. Stone (schist). *Asian Art Museum, The Avery Brundage Collection*, B60S393.

69

Relief with dancer and musicians honoring the turban of the Buddha-to-be

Approx. 100–200
Pakistan; ancient region of Gandhara
Stone (schist)
H. 15.8 cm × W. 65.4 cm
Royal Ontario Museum, Purchase was made possible with the support of The Reuben Wells Leonard Bequest Fund, 939.17.15

When Prince Siddhartha, the Buddha-to-be, resolved to renounce his royal status and enter on a spiritual quest, he removed his headdress and cut off his hair as gestures of renunciation. The headdress and hair were carried by gods to the heaven of Indra, king of the gods, enshrined there, and perpetually worshipped.[1]

Here, the headdress—presumably with the hair inside—is shown positioned on a throne. One worshipful deity stands nearby in a reverent attitude; another throws handfuls of flowers. A little further off a dancer and musicians perform to honor the great relics. Presumably the dancer is one of the female celestial apsarases who adorn and dance in Indra's heaven. To suggest the dancer's dynamic movement, the artist shows her leaning in an unstable position and lifting one leg that is bent sharply at the knee. We understand—we *feel*—that this position cannot be held for long and know that another movement is imminent. A similar scene of dancers performing in worship of the sacred headdress and hair can be found in a relief from the famous early Buddhist site of Bharhut (fig. 1).—FMcG

1. For example, the Mahavastu, an early text recounting the life of the Buddha, mentions that his hair tuft was worshipped and honored in a special festival. See Jones, *Mahāvastu*, 2:161.

Fig. 1 Dancers worshiping the headdress of the Buddha-to-be; detail of the Ajatashatru pillar from Bharhut, India, approx. 100 BCE. *Indian Museum, Kolkata.*

70

The bodhisattva Avalokiteshvara with dancers

Approx. 1050
Bangladesh
Stone (phyllite)
H. 99.7 cm × W. 43.2 cm
Virginia Museum of Fine Arts,
Richmond, Gift of the Council of the
Virginia Museum of Fine Arts and the
Juan March Foundation with additional
funds from the Arthur and Margaret
Glasgow Fund, 90.155

Beneath a gentle if formal and dignified bodhisattva, a female performer and musicians playing a drum and small cymbals dance (fig. 1). It would seem that they glorify the bodhisattva's compassion, a prime characteristic of Avalokiteshvara, manifested and symbolized here by his allowing nectar to drip from his outstretched hand to the starving needle-nosed ghost below. Behind the ghost, other figures pay homage with a reverent gesture and a proffered flower garland.[1]

Is there another possible explanation for the dancing? The famous sacred Buddhist text known as the Perfection of Wisdom in Eight Thousand Lines warns that among the acts of the demon Mara (a personification of ignorance, wrong thinking, and death) intended to distract a bodhisattva are "songs, music, dances, poems, plays."[2] Though this sculpture represents the bodhisattva Avalokiteshvara rather than the Buddha, the unusual position of the bodhisattva calls to mind images of the Buddha in the attitude of overcoming Mara (and his seductive daughters) such as an early twelfth-century example in the Ananda temple in Bagan, Myanmar (see cats. 63–64,

fig. 2). Depictions of Avalokiteshvara with dancers are rare, and the question of whether the dance glorifies him or has other purposes or implications is unresolved.—FMcG

1. See the detailed discussion of this work in Dye, *Arts of India*, cat. 31.
2. Conze, *Perfection of Wisdom*, 166.

Fig. 1 Detail of cat. 70 showing dancer and musicians.

71

Shiva and Parvati on the bull Nandi, with dancers and musicians

956

India; Harshagiri, Rajasthan state
Sandstone
H. 45.7 cm × W. 85.7 cm
The Nelson-Atkins Museum of Art,
William Rockhill Nelson Trust, 35-304

In the center of this deeply carved architectural frieze sit Shiva and Parvati atop the bull Nandi, surrounded by dancers and musicians. The deep angular bends in the limbs of the dancing figures express a frenetic range of movement brought about by the drummer's beat. In contrast, the god and goddess are seated serenely, arms entwined, and eyes locked in an adoring gaze. The divine couple are celebrated here and elsewhere in sculptural reliefs at the tenth-century Rajasthani temple site of Harshagiri through animated depictions of music and dance.

While the hilltop temple buildings of Harshagiri (*harsha* = joy; *giri* = mountain) are no longer standing in their original form, prolific sculptures are associated with the site. Many now reside in the Sikar Museum in Rajasthan and in collections around the world; and many of these also feature musicians and dancers (see cat. 80). This frieze may depict a narrative scene of the divine couple's wedding procession, or it may reference the many offerings of music and dance that occurred at the temple.[1] Dance—in joy, celebration, glorification, and devotion— was a prominent theme in the visual vocabulary of Harshagiri.—AMC

1. Masteller, *Masterworks from India*, 54–57.

72

Threshold of a doorway with dancers and lions

Approx. 950–1000
Central India
Sandstone
H. 22.9 cm × W. 127 cm
Asian Art Museum of San Francisco,
Museum purchase, B69S25

The configuration of this frieze, depicting a lone female dancer flanked by a series of male musicians, appears to be consistent with the iconographical program of north Indian temple architecture from the tenth century and later.[1] Though immobilized in stone, their sculptured forms are not rigidly constrained; rather, they articulate a sense of dynamic movement. Manuals exploring architecture and aesthetics written contemporaneously with this sculpture's creation codified instructions for exactness in the proportions of the body and precision in the placement of these reliefs within the temple's configuration. Bent knees, angled arms, and shifted hips denote the subtleties of a body in motion and are captured here with sensitive observation.

Encountering these figures was a privilege reserved for temple priests and devotees. Though now removed from its original framework, this frieze was once part of the threshold of a temple doorway. Carved figures depicted in elaborate scenes were recurrent narrative or decorative motifs incorporated into a doorway's surround. Temple worshippers would have physically stepped over this door sill to reach the temple's inner chamber where the icon was housed. The significant placement of these dancers at this lowered elevation most likely functioned to herald the visitor to the appearance of the deity and to celebrate its divine manifestation.[2]—TLG

1. The compositional scheme of this threshold follows a pattern similar to a relief depicting a scene of dance and music from a tenth-century temple in Khajuraho, Madhya Pradesh, published in Kramrisch, *Indian Sculpture*, pl. 35, p. 95.
2. For a more comprehensive discussion of the architectural placement of images and other compositional schemes of temple doorways, see Desai and Mason, *Gods, Guardians, and Lovers*, 117–37; cat. 51, 226–28; cat. 56, 233–34. The threshold of a doorway in situ in the Lakshmana Temple, Khajuraho, can be seen in Vatsyayan, *Arrested Movement: Sculpture and Painting*, 81.

73
Frieze with celestial dancers

Approx. 1180–1220
Cambodia; Bayon Temple, Angkor
Sandstone
H. 25.4 cm × W. 87.6 cm
Cleveland Museum of Art, Purchase
from the J. H. Wade Fund, 1938.433

74 *also p. 16*
Pillar fragment with celestial dancers

Approx. 1180–1220
Cambodia; Angkor
Sandstone
H. 83.3 cm × W. 41.9 cm
Metropolitan Museum of Art, Fletcher
Fund, 1936, 36.96.2

Never empty of divine music, dances, and songs, the hall shines magnificently with the hosts of Gandharvas and Apsarās.
—The Mahabharata (2:20:10–14)

Representations of more than six thousand female dancers decorate the walls, corridors, and columns of the Bayon, the state temple of the great Angkorian king Jayavarman VII. They have often been called apsarases—that is, beautiful celestial women who entertain the gods.[1] In fact, just how they should be identified and whether all are the same class of beings have prompted extended scholarly discussion. Recently, the scholar Peter Sharrock has argued that some, at least, are divine female adepts who accompany the Tantric Buddhist deity Hevajra.[2] (This hypothesis is discussed in the essay "Dancing in Circles" in this volume, pp. 33–47.)

Some reliefs at the Bayon show pairs of dancers performing in a palace pavilion accompanied by an instrumentalist (fig. 1). Others, such as the ones on the pillar fragment here (cat. 74), dance on lotuses. This suggests that, though they look very much like those in the palace pavilion, they exist in a different realm.

Bayon-period inscriptions speak of the pious donation of large numbers of female dancers to temples, so presumably on days of rituals and ceremonies

the temples came alive with music and dancing.[3] We may wonder whether the dancers sculpted in relief on temple walls represent celestial dancers or human dancers playing the role of celestial dancers.—FMcG

1. Van Buitenen, *Mahabharata*, 50. On apsarases in general, see "The Apsarases" in Jacobsen, *Brill's Encyclopedia of Hinduism*, 1:568; and Varadpande, *Apsara*.

2. Sharrock, "Yoginīs of the Bayon."

3. The Ta Prohm inscription mentions 615 dancers among donations; the Preah Khan stele notes 1,000 and, again, 1,622: Cœdès and Cordier, "La stèle de Ta-Prohm," 77; and Maxwell, "Stele Inscription of Preah Khan," 76, 90. On dance in Cambodian inscriptions in general, see Pou, "Music and Dance in Ancient Cambodia."

Fig. 1 Relief of dancers accompanied by an instrumentalist, at Bayon Temple, approx. 1180–1220. Cambodia.

75

Dancer accompanied by musicians

Approx. 1150
India; Karnataka state
Stone (chlorite schist)
H. 87.7 cm × W. 41.6 cm
Virginia Museum of Fine Arts,
Richmond, Arthur and Margaret
Glasgow Fund, 82.207

Intricately and dramatically carved,
bracket figures like this one appear under
the interior and exterior eave cornices
of temples. Projecting outward from the
upper portion of a column, the figures are
symbolically in attendance at the events
occurring below. They are most often
carved in the form of beautiful women
dancing, playing an instrument, or at
their toilette. This dancing figure, accom-
panied by two musicians, is richly attired
in heavy jewelry (and little else), includ-
ing large anklets that would add reverber-
ation to her movements.—AMC

76

Female dancer

Approx. 1075–1125
Vietnam; Thu Thien Temples, Binh Dinh
province, former kingdoms of Champa
Sandstone
H. 71.1 cm × W. 34.3 cm
Asian Art Museum of San Francisco,
Gift of Christensen Fund, BL77S3

Who is this figure, and are we sure she is
dancing? The figure and its paired partner
were installed, together with other sculp-
tures, flanking the main image in a temple
built some nine hundred years ago by the
Cham people in today's Vietnam. An old
drawing shows how they were arranged.
The other sculptures from the group are
not easy to identify precisely either, and
the central figure that they surrounded
disappeared from the temple long ago. It
seems likely that a Buddha image found
nearby was once the central figure, but
it is not certain that some other figure—
even a Hindu rather than Buddhist one—
did not once hold pride of place.[1]

Dance seems to have been a frequent part in Cham festivities and religious ceremonies, as numerous sculptural depictions of dancers suggest. This figure's splayed-kneed pose was and is common in artistic representations in South and Southeast Asia (fig. 1) as well as in today's classical dance.[2]—FMcG

1. The mate of this figure is in the Norton Simon Museum (M.1977.20.1.S). A drawing of the ensemble in situ is in Parmentier, *Inventaire descriptif des monuments Čams de l'Annam*, vol. 2. pl. CXXIV.

2. A learned attempt to interpret artistic representations of Cham dance, in terms of the practice and vocabulary of ancient Indian treatises on dance, is Vatsyayan, "Some Dance Sculptures." In recent decades there have been efforts to re-create ancient Cham dances for shows at hotels and historic sites. Since no performance traditions survive, poses from artworks are interspersed with movements that seem intended to please tourist audiences. Examples may be seen by searching the Internet for "ancient Champa dance."

Fig. 1 Dancers and musicians on a lintel, approx. 1000–1100. Vietnam. *Danang Museum*.

77

Mythical bird-woman and bird-man dancing

Approx. 1857–1885

Myanmar (Burma)

Wood with lacquer, gold leaf, and inlaid glass

Bird-woman: H. 97 cm × W. 36 cm

Bird-man: H. 143.5 cm × W. 57.5 cm

Burma Art Collection at Northern Illinois University, gift of Konrad and Sarah Bekker, BC87.01.01 and BC87.01.02

Half-human, half-bird males (*kinnara*) and females (*kinnari*) often appear dancing in the visual, performing, and literary arts of many Southeast Asian cultures (fig. 1). These couples are known for their loving devotion, and, in one famous instance, a kinnari and human prince fall in love, are separated, and must struggle to be reunited. In these sculptures, the bird-man twists his body and the bird-woman gestures in a way that recalls the kinnara-and-kinnari dances of Myanmar, Thailand, and Cambodia.[1] A question that presents itself—though it can't be answered—is whether these sculptures depict the bird-man and bird-woman of legend or dancers portraying them.

The story of the love between the kinnari and the human is the subject of a *jataka*—a tale concerning one of the Buddha's previous lives—of which there are a number of old renditions, including some known in Myanmar. In the story,

Prince Sudhana is a precursor of the Buddha, and the kinnari is Manohara or Manora, a princess of the bird-folk kingdom. In one version of the tale, the moral drawn from their separation, trials, and reunion is: "Thus let all men, abandoning folly, be united with all those dear to them, as on this occasion Sudhana was united with the Kinnarī."[2]

Whether these sculptures represent a generic bird-man and bird-woman or Sudhana and Manohara specifically (or performers playing the roles in either instance) is not clear. The male figure wears a component of Burmese royal finery—a pair of bands hanging from the shoulders and clasped together at the chest—that would be appropriate for Prince Sudhana. Also, the male figure has

human lower legs, unlike the female figure. But Sudhana should not have a bird's tail as he does here, so the identification remains unresolved. Also unclear is where these sculptures would originally have been emplaced. In neighboring Thailand, figures of bird-folk are displayed in both temples and royal ceremonies.[3]—FMcG

1. Examples of kinnara-and-kinnari dances can be found on YouTube. Several Burmese plays incorporating the story, the earliest, written in 1579, are briefly discussed in Jaini, "Story of Sudhana," 555.

2. Jones, *Mahāvastu*, 2:109. For background, see Jaini, "Story of Sudhana"; and Ginsburg, "Manora."

3. For example, both male and female bird-folk at Wat Phra Si Rattanasatsadaram (Wat Phra Kaeo; Temple of the Emerald Buddha) in Bangkok. See also McGill et al., *Emerald Cities*, 190, 196–98.

Fig. 1 Burmese kinnari-and-kinnara dance. Screenshot from video.

78 *also p. 45*

Fragment of a canopy with celestial dancers and musicians

Approx. 1800–1830
India; probably Andhra Pradesh state
Cotton, mordant- and resist-dyed, with painting
H. 148 cm x W. 66 cm
Asian Art Museum of San Francisco, Museum purchase with additional funding from Betty N. Alberts and Alexander Johnson, 2011.2

In this fragment of a larger textile—likely used as a canopy covering for a Hindu shrine—winged female and male dancers are positioned in a repeated lobed medallion pattern.[1] The hand-drawn figures hold a range of attributes that resonate with both the divine and earthly realms, including fly whisks, drums, cymbals, trumpets, and staffs. The dress and jeweled adornments of each mythical being are carefully drawn and colored, adding detail and depth to the overall repeating pattern. When positioned above a shrine, the dancers create connection between the two realms, their lively depictions heralding and celebrating the gods worshipped below.—AMC

1. Other fragments of this canopy textile are in the Jagdish and Kamla Mittal Museum of Indian Art in Hyderabad; see Gittinger, *Master Dyers to the World*, 87; V&A Museum (IS.25-1983; published in Swallow and Guy, *Arts of India*, 128); and National Gallery of Australia, Canberra (NGA 89.350; published in Pal, *Dancing to the Flute*, 122–24).

79

I Saw a God Dance II

2012
By Ayisha Abraham (Indian, b. 1963)
Digital video with 8mm found footage,
6:47 min.
Lent by the artist

Across a three-part screen of moving images are disparate shards of found footage that explore the complex character of the Burmese and Indian dancer Ram Gopal (1912–2003). He is seen dancing on a sunbaked rooftop in Bangalore;[1] applying stage makeup before a performance; performing his most popular and enigmatic dances: *Garuda*, *The Golden Eagle*, and *Shiva's Dance of the Setting Sun*; and speaking to a rapt audience about the transformative nature of posture, pose, and movement in his embodied dance practice. The methodical interplay of images layered with narration, music, and atmospheric noises hints at his nuanced and often purposefully obscured personality. Ayisha Abraham, an experimental artist who often works with found footage to explore the archive and film's fragile materiality, approached this project with a singular question in mind: Who was this stunning man?[2]

Ram Gopal's influential dance practice had a profound influence on how many South and Southeast Asian dance forms were received in Europe and America—indeed globally—in the first half of the twentieth century. Arriving in London in 1939, Gopal challenged the Orientalized interpretative dance then popular, which was based on fabricated imaginings of "the other."[3] Instead, his rigorous training in several dance forms (including kathakali, kathak, and Bharatanatyam), carefully designed and choreographed performances, and authoritative self-presentation propelled him to world recognition.—AMC

1. The footage that inspired several of Abraham's films, including *Straight 8* (2005), *I Saw a God Dance* (2012), and *I Saw a God Dance II* (2012), was captured by Tom D'Aguir in Bangalore in 1938. Abraham interviewed D'Aguir several times near the end of the latter's life, when he reflected that Gopal had invited him to film because Gopal had never seen himself dance in color before. The 8mm footage was found in D'Aguir's home and given to Abraham after his death in the early 2000s.
2. Abraham, "From the Roof Top," 173.
3. David, "Ram Gopal."

80

Dancer and musicians

Approx. 973
India; Harshagiri, Rajasthan state
Sandstone
H. 33.3 cm × W. 95.2 cm
Cleveland Museum of Art, John L.
Severance Fund, 1969.34

A female dancer, with an elongated torso and angular limbs, is at the center of eight musicians in similarly animated poses. From right to left, the musicians play the cymbals, metal rings, a bamboo flute, two types of drums, and a lute; the last two instruments are unidentifiable. With the figures arranged as they are, the composition suggests a strong rhythmic beat as if to accompany the dance.

Music and dance are integral parts of divine ritual, where gods would watch celestial figures dance as well as dance themselves. The tenth-century Rajasthani temple site of Harshagiri abounds with sculptural reliefs that portray divine and celestial figures engaged in music making and dance (see cat. 71); some reliefs reportedly feature twenty to thirty figures in a row.[1]

An important forty-eight-verse inscription found at the site, dated 973, describes the beauty of the temple buildings and celebrates the architect and the ascetic who commissioned the project as well as the ruling Chahamana family who controlled the land. Their shared devotion to Shiva is expressed through this inscription and the multiple musicians and dancers paying joyous homage to their god across the temple walls.—AMC

1. Lerner, "Some Unpublished Sculpture from Harshagiri," 357.

81 *also pp. 43, 90–91*

Raja Prithvi Singh of Orchha watching a performance of Krishna's dance with cowherd women

Approx. 1750
India; Madhya Pradesh state, former kingdom of Datia
Opaque watercolors on paper
H. 28.6 cm × W. 31.1 cm
Asian Art Museum of San Francisco, Gift of Gursharan and Elvira Sidhu, 1991.245

Raja Prithvi Singh (r. 1735–1752) stands with his hands in a gesture of reverence as he watches a peripatetic group of dancers enact a scene from the life of Krishna. The scene depicted is likely meant to recall imagery known to the intended observer: the circular dance of divine love (rasalila), where Krishna frolics in the forest with cowherd women, multiplying himself so that he can simultaneously dance with all present (see cats. 16–19). The performance takes place in a largely unadorned courtyard setting, with attendants holding an orange canopy over the dancers. Two low thrones are to the right, and a white canopy stands above all, connecting the dancers and ruler in this intimate performance.

Traveling troupes of rasalila performers would number at least ten: four musicians who played a stringed instrument, drums, cymbals, and the harmonium; two dancers who portrayed the living forms of the divine couple, Radha and Krishna; and four actors who played the role of the cowherd women.[1]

The troupe displayed here nearly conforms to these conventions, with the four cowherd women and an actor portraying Krishna dancing with hands clasped and surrounded by drummers and other attendants. These troupes were often populated by young male actors who would begin performing by the age of eight or ten; senior child actors (age

eleven or twelve) would perform the roles of the divine couple.[2]

While many elements in this painting are only lightly colored, Krishna is portrayed with a resplendent peacock-feather crown, long flower garland, and many jewels. Draped over his crown are what appear to be gold-threaded textiles, likely scarves. Krishna does wear varied crowns, most often associated with festivals to celebrate changing lunar phases; however, draped textiles are unusual and may reflect a regional practice.[3] The raja—also richly painted in patterned textiles, flower garland, jewels, and sword—is portrayed here at a larger scale, which could speak to both his physical stature and his royal position.—AMC

1. Hein, *Miracle Plays of Mathurā*, 135. Prosperous groups would add further musicians (a second harmonium player as well as another stringed instrument), a costume attendant and cosmetician, and often a tutor for the young children in the troupe's retinue. Hein was studying later dance and theater performances, however elements of the traditions he studied likely resonated with practices as presented in this painting.

2. Hein, *Miracle Plays of Mathurā*, 136; and Topsfield, "Udaipur Paintings of the Raslila," 55. The actors portraying the cowherd women in this painting present physical attributes of a young female body, with budding breasts and a curvaceous form, but it is unknown how closely the pictorial representation of dance relates to an actual performance. See the essay "Painting Performance: Recording Dance at the Later Indian Courts" in this volume (pp. 49–63) on the authenticity of the visual record when recording dance.

3. Thanks are due to Cynthia D. Packert for discussing this painting with the author and offering her insights on Krishna's uncharacteristic headdress.

Monumental Paintings from the Kingdom of Mewar of a Rasalila Performance in 1736

Performances enacting the life of Krishna were popular throughout Rajasthan, including in Mewar, where the rasalila—the circular dance of divine love—was performed annually. A series of paintings from the Mewar capital of Udaipur, commissioned by Maharana Jagat Singh II (r. 1734–1751) and noteworthy for its size and opulent presentation, records a performance at the City Palace that occurred in 1736. Inscribed on the reverse of each painting are six lines of text honoring the ruler, identifying all of the noblemen and close male relatives in attendance, and dating the performance by month (Karttika) and year.[1] The month of Karttika (October–November) corresponds to the time that troupes of performers likely would have been invited to Udaipur. During the main pilgrimage seasons and the rainy months, the troupes would remain at Mathura, but from September onward they traveled widely in northern and western India, playing in temples and private homes.[2]

The Mewar series consists of at least ten large paintings, each depicting a different event. Some are recognizable as particular episodes from Krishna's life; others portray the gods Ganesha, Balarama, or Indra dancing exuberantly in the maharana's presence.[3] In each of the paintings lamps flicker, the moon is full, and the maharana is seated smoking a hookah. The architectural milieu is shown from nearly the same vantage point in each scene, with musicians, performers, and ruler all placed in similar confines in what is now called the Mor Chowk courtyard of the City Palace. While the performance of the rasalila could last anywhere from an extended evening to thirty days, little is known of the duration or order of episodes that made up this event. Pictorial differences from painting to painting—for example, among the dancers, musicians, and the animated figures that populate the lower levels of the palace and immediately beyond the gates—hint at the passage of time and the evocative nature of the performance.—AMC

1. Topsfield, "Udaipur Paintings of the Raslila," 55–58; and Goswamy and Smith, *Domains of Wonder*, cat. 34, p. 99. Those in attendance included Jagat Singh II's brothers Nathji and Baghji, son Pratap Singh, and Nathji's infant son Bhim Singh.

2. Several colonial-era diaries and biographies record witnessing such performances at Udaipur, including Tod, *Annals and Antiquities of Rajasthan* [1971], 2:433–34; and Broughton, *Letters Written in a Mahratta Camp*, 257–61.

3. There are ten known paintings in the series, each depicting a different episode of this performance. These include: the initial fire ritual (*aarti*) conducted before the performance had begun (National Gallery of Victoria, Melbourne; AS129-1980); Ganesha dancing (National Gallery of Victoria, Melbourne; AS130-1980); the cowherd women performing *aarti* before they dance with Krishna (private collection); Brahma dancing (Museum of Fine Arts, Houston; 89.334); Shiva as a yogi, possibly Siv Yogi Lila, also known as Sankar Lila (formerly with Spink & Son, London); Balarama dancing (private collection, London); Indra dancing (private collection, London); the Govardhan lila (private collection, London); Radha and Krishna dancing (Los Angeles County Museum of Art; 2006.78); Krishna and the cowherd women dancing (San Diego Museum of Art; 1990.623).

82 *also p. 52*

Maharana Jagat Singh II and nobles watching the rasalila dance drama

Approx. 1736–1740
India; Rajasthan state, former kingdom
of Mewar
Opaque watercolors and gold on paper
H. 60.2 cm × W. 44 cm (image);
H. 66.2 cm × W. 50.2 cm (sheet)
Museum of Fine Arts, Houston,
Museum purchase funded by Mr. A.
Soudavar and the Agnes Cullen Arnold
Endowment Fund, 89.334

Depicted three times dancing in front
of the maharana, an actor dressed as
Brahma wears a yellow dhoti, a gold
cloak, and a four-faced mask. The god
is seen conversing with the cowherd
women, dancing for the maharana while
holding a red staff and gold ewer, and
clasping the hand of the maharana's
infant son, Prince Bhim Singh. Brahma's
larger size in relation to the other per-
formers probably indicates he was played
by an adult actor.

The scene may be an enactment of
the Brahma Lila. At the birth of Krishna,
Brahma makes a congratulatory visit
to Krishna's foster parents, Nanda and
Yashoda. They honor the god and offer
every sort of gift, but Brahma accepts
only a piece of yellow cloth the baby
had once been wrapped in. The possible
attribution to the Brahma Lila is based
on an iconographic comparison between
the painting and published descriptions
of various stories and events that could

feature in performance. While many
of these events were recorded in the
Bhagavata Purana and other texts, no
textual reference is yet known for the
Brahma Lila.[1]—AMC

1. Hein, *Miracle Plays of Mathurā*, 165–78. Of
course, Hein was studying dance and theater
performances later than those presented in
the Mewar rasalila set, but elements of the tra-
ditions he studied likely resonated with earlier
practices at Udaipur.

83 *also p. 52*

Maharana Jagat Singh II watching the rasalila dance drama

Approx. 1736–1740

India; Rajasthan state, former kingdom of Mewar

Opaque watercolors and gold on paper

H. 60.6 cm × W. 44.5 cm (image);

H. 67 cm × W. 51.1 cm (sheet)

Los Angeles County Museum of Art, Purchased with funds provided by The Broad Art Foundation, Carrie and Stuart Ketchum, Nancy and Dick Riordan, the Marc and Eva Stern Foundation, and Suzanne Stern Gilison and Steven Gilison through the 2006 Collectors Committee, M.2006.78

The gods Krishna and Radha are seen together three times here: standing among the cowherd women, distinguished by a gold textile held aloft over their heads, and holding hands as they enact a whirling dance together. The movement of their skirts and shawls animates their forms, in contrast to the other performers that crowd the space.—AMC

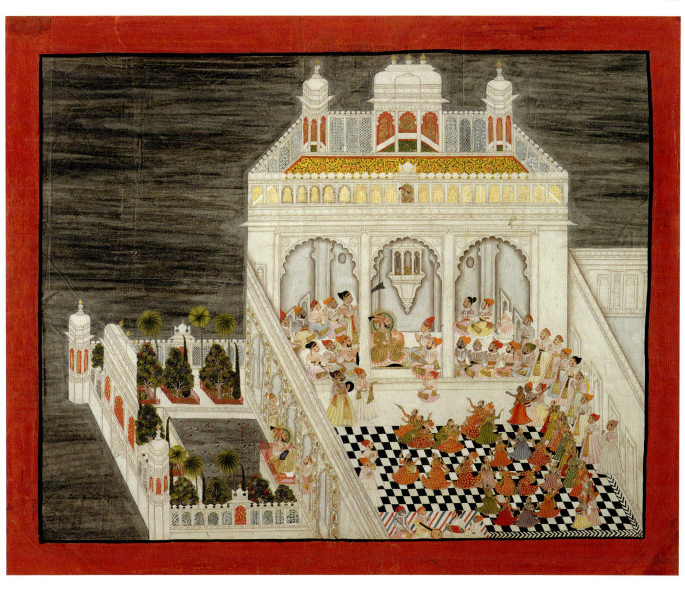

84 *also p. 56*

Maharana Ari Singh with his courtiers being entertained at the Jagniwas Water Palace

1767
Attributed to Bhima, Kesu Ram, Bhopa, and Nathu
India; Rajasthan state, former kingdom of Mewar
Ink, opaque watercolors, and gold on paper
H. 57.8 cm × W. 74.1 cm (image);
H. 67.6 cm × W. 83.5 cm (sheet)
Metropolitan Museum of Art, Purchase, Mr. and Mrs. Herbert Irving, Mr. and Mrs. Arthur Ochs Sulzberger, and Mr. and Mrs. Henry A. Grunwald, gifts in honor of Mr. and Mrs. Gustavo Cisneros, 1994, 1994.116

Eighteenth-century paintings from the Mewar capital of Udaipur that record dance are often situated within a grand architectural setting. By portraying dance from a great distance, often a bird's-eye-view perspective, the images incorporate dance into the larger performative nature of court life.[1] In this instance, a large troupe of dancers, both male and female, crowd a checkerboard courtyard while Maharana Ari Singh is seen twice: seated formally with his large retinue of noblemen, and watching the performance through a cusped archway. Full of movement, the dancers move or sit in small groupings, with arms outstretched and legs active under their long skirts. Several clutch daggers in their hands, perhaps to symbolize the importance of weaponry in the martial life and culture of the rulers of Mewar. A further reading could connect the dance to celebrations in honor of the goddess Durga, the dagger being one of the many weapons she wields.

Another set of dancers in this crowded performance space form a circle around a couple, who twirl with heads thrown back and hands clasped. Circle dances are associated with several annual festivals in Mewar, including Krishna's dance of delight performed as part of the rasalila, and the dance in celebration of Shiva and Parvati's wedded bliss as part of the Gangaur festival. —AMC

1. See the essay "Painting Performance: Recording Dance at the Later Indian Courts" in this volume (pp. 49–63) for more on this painting, comparative examples, and the performative nature of court.

85

Dancers at a Rajput court performing during the Gangaur festival

Approx. 1880s

Gelatin silver print

H. 10.2 × W. 20.3 cm

Museum of Fine Arts, Houston, Gift of Stephen E. Hamilton, 2014.757

Depicting an observance of the festival of Gangaur at a fiefdom in Rajasthan, this photograph gives insight into dance as a festival practice and a performed symbol.[1] Gangaur is a celebration of fruitfulness and abundance through the union of Gauri (Parvati) and Shiva; it centers on circle dances, processions, and other rituals primarily conducted by women. The early nineteenth-century British chronicler James Tod observed the renowned celebration of Gangaur at the Mewar court in Udaipur. In his account, the festival begins with the forced germination of seeds before a main effigy of Gauri and a lesser effigy of Shiva at a place outside the city, at which point "the females join hands and dance round [the germinated seed], invoking the blessings of Gouri on their husbands."[2] Focus later shifts to the City Palace, where the rana of Mewar and his court embark on royal barges to receive decorated Gauri effigies at stations along the shores of Lake Pichola. "The females," Tod continued, "form a circle around the goddess, unite hands, and with a measured step and various

graceful inclinations of the body, keeping time by beating the palms at particular cadences, move round the image singing hymns, some in honor of the goddess of abundance, others on love and chivalry."[3]

In the foreground of this photograph, women encircle a figure of Gauri set on a European-style tripod table within a courtyard, their space bounded by a circular ground cloth.[4] Behind them sits the head of the fiefdom, marked by his raised cushion and kingly accoutrements. The flanking ranks of the males of the household form an orderly frame around the women's performance. Oddly, the central element of the image—a dance—appears completely static. One explanation is that the photographer required stillness during the exposure of the photograph; indeed, the scene is clearly laid out for the camera's lens. Given the picture's careful arrangement, it is notable that there are no musicians in evidence. Might this suggest that the photograph does not capture a real dance at all but a tableau staged for the purposes of generating this image?

Mewar court painters depicted the pageantry of Gangaur on Lake Pichola for more than two hundred years, creating scenes that attested to the rana's status and authority through his role as the most important male to witness women's dance for Gauri, thus paying homage to the goddess.[5] Indeed, while one might argue that Gangaur is a celebration of female power, it sets that power within patriarchal structures of hereditary kingship and procreative heterosexual

marriage. Even Tod perceived elements of the temporal politics of men in the women's dance before the rana.[6] Noble landowners were often invited guests at court festivities, and thus it is likely the chief noble of a Mewar-linked fiefdom would have witnessed the court's elaborate celebration of Gangaur. Perhaps this photograph was intended to generate an analogous, if comparatively less splendorous, emblem of kingly power. If so, it betokens a collaboration between a nobleman and an unidentified photographer, who together wedded a visual representation of court protocol with a set piece referencing the central moment of Ganguar at the City Palace. In that light, the dance is a symbol of the nobleman's position within a pious and righteous social order, seated in fealty to the Mewar court.—NMS

1. While the photograph's sitters and setting have not been definitively identified, staff at Udaipur's City Palace Museum have suggested it may depict Raj Man Singh and three of his sons (members of the Jhala dynasty, which was loyal to the Mewar court) at Gogunda Fort; email correspondence with Bhupendra Singh Auwa, City Palace Museum, December 30, 2020. If this identification is correct, the apparent age of Raj Man Singh's heirs (four sons in total, born 1841, 1848, 1856, and 1858) suggests an earlier date for the negative used to make this photographic print. I thank my colleagues at the City Palace Museum for their efforts. Further, my consideration of this photograph was enabled by Ainsley M. Cameron's suggestion that it relates to Gangaur rather than the rasalila. Finally, I thank my colleagues at the Museum of Fine Arts, Houston, for fielding my questions during a profoundly challenging time in Texas.

2. Tod, *Annals and Antiquities of Rajasthan* [2001], 1:455.

3. Tod, *Annals and Antiquities of Rajasthan* [2001], 1:456.

4. I thank Rosemary Crill for her observations regarding the circular cloth pictured here, which was likely made for this dance or similar performative occasions. For discussion of textile ground cloths in the context of the rasalila, see Hein, *Miracle Plays of Mathurā*, 137. In email correspondence with the author on December 11, 2020, Crill also noted that the relatively ordinary attire of the women raises a question: Are they professional dancers or women of the fiefdom? Following that line of thought, might the lone female figure seated at the leftmost corner of the ruler's ground cloth be a dance teacher?

5. See examples ranging from the eighteenth to the twentieth centuries in Topsfield, *City Palace Museum Udaipur*, figs. 2, 62, and 68; and Topsfield, *Court Painting at Udaipur*, figs. 140, 230, 254, 271, and 272.

6. Tod noted that devotional dancing at Lake Pichola also "embod[ied] little episodes of national achievements, occasionally sprinkled with [mutually acknowledged] *double entendre*." Tod, *Annals and Antiquities of Rajasthan* [2001], 1:456.

86 *also p. 55*

Maharana Amar Singh II, Prince Sangram Singh, and courtiers watch a performance

Approx. 1705–1708

India; Rajasthan state, former kingdom of Mewar

Ink, opaque watercolors, and gold on paper

H. 52.1 cm × W. 90.8 cm

Metropolitan Museum of Art, New York, Gift of Mr. and Mrs. Carl Bimel Jr., 1996, 1996.357

Acrobatic performances were closely related to dance and the theater arts at the Rajasthani courts, in what Kapila Vatsyayan calls "an all-inclusive spectacle where a variety of physical skills can be used creatively."[1] Here, a female acrobat balances atop a pole with male musicians below. Dancing and embracing couples are scattered across the horizontal painted space. The open and expansive field of performers engage in acts of debauchery that allude to intoxication, merriment, and a freedom of expression. This is incongruously joined by the formal presentation of Amar Singh, his son, and retinue within an enclosed columned architectural space. Their formal presentation asserts authority in a composition that otherwise dismantles expected court etiquette. When confronted with quirky and unexpected compositions that represent dance— paintings that subvert dominant visual languages—one must consider the intersection of patronage, artistic agency, and authenticity of record.[2] Did Amar Singh bear witness to such an event? Or did the artist take liberties when recording a performance? —AMC

1. Vatsyayan, *Dance in Indian Painting*, 123.
2. Smith, "Dance Iconography," 120–21.

87 *also pp. 15, 59*

Raja Tedhi Singh of Kulu entertained by dancers and musicians

Approx. 1750
India; Himachal Pradesh state, former kingdom of Kulu
Opaque watercolors and gold on paper
H. 18.4 cm × W. 26 cm (image);
H. 22.2 cm × W. 29.2 cm (sheet)
Cincinnati Art Museum, from the Catherine Glynn Benkaim and Ralph Benkaim Collection, made possible by the generosity of Catherine Glynn Benkaim and Barbara Timmer and by Museum Purchase: Alice Bimel Endowment for Asian Art, 2020.7

Maharaja Tedhi Singh (r. 1742–1767) greets a troupe of dancers and musicians, likely upon their arrival to the small hill court of Kulu. Two musicians hold stringed instruments, one holds cymbals at the ready, and the last plays a set of drums. The two female dancers rhythmically sway to the melody, one with hands clasped in a respectful greeting. The significantly smaller forms of the female dancers may indicate their status as both women and visitors at the court. Alternatively, their diminutive size may reference their youth; peripatetic dancing troupes in north India often employed young performers, dedicated to their art since early childhood.

Hosting a traveling troupe was a demonstration of the ruler's cultured status and wealth, and this painting can be read through a series of visual cues that position Tedhi Singh—seated with a falcon perched on his gloved right hand, a reference to the hunt—as a sophisticated ruler.[1] The inscription in the upper red border thoroughly documents and identifies each figure present.[2] The ruler is greeted by Singh Rae, the attendant holding a peacock-feather fan behind the throne is Ramadhan, and the attendant leaning on a staff is Parasaram. The musicians and dancers who stand nearby are identified, collectively, as *kanchani*. Composed of a group of male musicians accompanying female performers who sang and danced, a kanchani troupe was not integrated within the elite social court structure and should instead be understood as an autonomous peripatetic group of performers.—AMC

1. Other nuanced portraits of Raja Tedhi Singh enjoying the pleasures of court life include Jagdish Mittal Collection, Hyderabad (76.244 P.244-PH 34) and V&A Museum (IS.112-1954).
2. The reverse of this work bears another one-line inscription in Takri: "Sri Raja Tedhi Singh Kola" (Sri Raja Tedhi Singh of Kulu).

88

Circumcision ceremony for Akbar's sons, from an *Akbarnama* of Abu'l Fazl

Approx. 1602–1603
Attributed to Dharam Das (Indian, active approx. 1580–1605)
Opaque watercolors, ink, and gold on paper
H. 22.9 × W. 12.1 cm (image);
H. 34.7 × W. 22.5 cm (sheet with border)
Cleveland Museum of Art, Andrew R. and Martha Holden Jennings Fund, 1971.76

A double-page painting from the *Akbarnama*, the official chronicles of the Mughal emperor Akbar's rule (1526–1605), documents an important event: a celebration on October 22, 1573, of the circumcision of Akbar's three sons, the princes Salim (future emperor Jahangir, b. 1569), Murad (b. 1570), and Daniyal (b. 1572). The left half of the composition, seen here, depicts the emperor's public space, with Akbar seated on his throne and receiving courtiers. The right half (not included here) shows the women's quarters, with the young princes, Akbar's wife, his mother, and their female attendants.[1]

The event marked dynastic continuity and imperial power in a public display of grandeur.[2] The painter (or painters) of these works offered a sense of what must have been a momentous celebration of abundance for Akbar, one denoting the survival of three sons past the dangers of infant mortality to which his previous children had succumbed. Court officials distribute gold coins to the poor and sick as gestures of the emperor's benevolence, while the musicians, singers, and dancers denote the joyous festivities.

The female dancers appear to be Central Asian based on their headgear and clothing, and they are placed on the same visual axis as the enthroned emperor and a sturdy, mature tree. In this alignment, the images of the throne and emperor replace the tree's trunk, making it tempting to see these non-Indian dancers as metaphors for the Central Asian Timurid family roots of the Mughal dynasty, whose shaky beginnings in India were stabilized by Akbar and which now promised to flourish because his Rajput and Turkmen wives had produced three healthy male heirs to continue their forebears' legacy.[3] —QA

1. This painting is presently at the Dallas Museum of Art, on long-term loan from the Keir Collection, UK: https://collections.dma.org/artwork/5341413.
2. Abu'l Fazl Allami, *Akbarnama*, 2:102–04.
3. Parodi, "Two Pages from the Late Shahjahan Album," 270.

89

Grotesque dancers performing

Approx. 1600

India; Mughal period (1526–1857)

Gum tempera, ink, and gold on paper

H. 16 × W. 9 cm (image)

Cleveland Museum of Art, Andrew R. and Martha Holden Jennings Fund, 1971.88

Three oddly attired dancers move to the sounds of the drum, cymbals, and a long reed instrument as they perform for a royal patron.[1] The male dancers at the right and left are a pastiche, combining features and accoutrements of yogis (ash-covered body, tiger-skin wrap, long staff, hoop earrings, and horn pendant) and demons (elephant ears, fiery eyes, unruly hair, horns, bells, short skirts), as seen in contemporary Mughal paintings.[2] The heavyset face of the dancer in the middle does not align with the slenderness of the body, making it likely that the figure is a cross-dressed male dancer and not a woman.[3] This trio and their musicians are probably a troupe of *bhand*s, a community of professional male performers who were praised by the court historian Abu'l Fazl for their skills at singing and playing music on the drum, cymbals, and castanets.[4] Bhand repertoire included mimicking men and animals as well as seductive and homoerotic dancing by young men dressed as women.[5] Without textual evidence, it is unclear whether a specific event or performance type is being documented.[6] A closer look at details suggests that the painting may not simply be a depiction of courtly entertainment: most courtiers are not paying attention to the dancers; they are instead focused on the emperor, who has locked

his gaze and gesture onto the elephant-eared dancer.

The painting, then, functions as an image of ideal kingship as embodied by the emperor Akbar (r. 1526–1605). It draws upon the visual and literary descriptions of the powerful prophet-king Solomon's court, where he commanded demons, communicated with animals, and with wisdom and justice maintained universal peace.[7] The "grotesque" dancers here appear to represent the idealized rule of Akbar, who, as claimed by his tomb inscription, was seen as "(endowed with) Jamshid's power and dignity and Solomon's pomp and majesty."[8] —QA

1. The royal patron here resembles Mughal emperor Akbar in facial appearance, clothing, and pose as seen in several paintings of the *Akbarnama*. See Stronge, *Painting for the*

Mughal Emperor, pls. 2, 25, 27, 43, and 52. For background on music and dance at the Mughal court, see Wade, *Imaging Sound*, 138, which discusses this painting very briefly.

2. Mallinson, "Yogi Insignia in Mughal Painting"; Seyller, *Adventures of Hamza*, cats. 19, 25, and 48; Diamond, *Yoga*, 72; McGill, *Rama Epic*, cats. 38 and 43.

3. I would like to thank Katherine Butler Schofield and Mika Natif for sharing their thoughts on this painting in private communication.

4. Abu'l Fazl Allami, *Ai'n-i Akbari*, 3:272.

5. Brown, "If Music Be the Food of Love," 67.

6. The Persian inscription above the image and the page of text on its reverse are not related to the painting and must have been added at a later moment in this folio's history.

7. See, for example, the painting of the prophet Suleiman's court in the collection of the Asian Art Museum (AAM 2007.14).

8. Parodi, "Solomon, the Messenger," 137; see also Koch, "Mughal Emperor as Solomon."

ଏଲୟଃ ထୁଗ୍ တော်ଃ

90

Ceremonies and festivities of the Burmese royal court

Approx. 1875–1900
Myanmar (Burma); Mandalay
Opaque watercolors, gold, and silver
on paper
H. 42.9 cm × W. 1,664 cm (unfolded)
Asian Art Museum of San Francisco,
Museum purchase, 2016.172

Performances of music and dance—"an accomplishment in which every Burmese man or woman is more or less proficient," according to British colonial official James George Scott[1]—accompanied many of the activities of the royal court of Mandalay. This manuscript (or picture book, since there is no text to speak of) illustrates a variety of royal public activities, such as departing on a royal barge procession, receiving a sacred white elephant, watching war elephants in combat drills, and so on.[2] One illustration shows the royal family observing a dance-drama performance of an episode from the Burmese version of the Ramayana, and others include vignettes of dance displays. It isn't always clear how the dance performances were linked to the main activity other than

being a festive enhancement and demonstrating the king's ability to sponsor a dance troupe.

The scene shown here is labeled "Depiction of the auspicious royal plowing ceremony." In this ceremony, variations of which were carried out by numerous Asian royal courts, the ground was prepared at the beginning of the agricultural season and rice seedlings were planted by the king or his representative to ensure a bountiful crop.[3] To one side of the composition, male dancers in the elaborate costumes of Burmese royals perform accompanied by the drum circles, pot-gong circles, and other instruments of a classical Burmese ensemble (fig. 1). Nearby, court ladies in an ornate pavilion watch the proceedings.—FMcG

1. Shway Yoe, *Burman*, 2:1.

2. Sincere thanks are due Cleo Appleton and Ko Ko Zin for translating inscriptions and helping me understand the events pictured in this manuscript. The illustrations show what happened in the past, or perhaps what was supposed to have happened. For example, it is said that the royal plowing ceremony "fell into abeyance in King Mindon's time, and was entirely discontinued after his death" in 1878. Nisbet, *Burma under British Rule*, 334.

3. For a description of the royal plowing ceremony, including translations of entries from the royal chronicles, see Khin Maung Nyunt, "Le Htun Mingala (The Royal Ploughing Ceremony)," *Myanmar Perspectives* 3, no. 7 (July 1997).

Fig. 1 Detail of cat. 90.

91 *also pp. 184–85*

Maharaja Sher Singh and companions watching a dance performance

Approx. 1850
Pakistan; Lahore
Opaque watercolors and gold on paper
H. 36.1 cm × W. 45.9 cm
San Diego Museum of Art, Edwin
Binney 3rd Collection, 1990.1348

Rulers from all parts of South and Southeast Asia and from a variety of religious and cultural traditions (here Sikh) watched—and apparently wanted to be seen watching—dance performances. In this painting three female performers dance energetically to entertain the maharaja and a crowd of male courtiers and visitors. Male musicians accompany them, playing bowed and plucked stringed instruments, drums, small hand cymbals, and wooden clappers. The only other women shown are a group of waiting dancers and an older woman who is there, perhaps, to assist or manage. Some of the seated dancers have taken off, or are about to put on, strings of ankle bells, and two wear finger cymbals. Another claps her hands, and several gesture encouragement to the dancers in action.

The exact occasion of this performance is not known. The enthroned maharaja, Sher Singh, reigned briefly in the early 1840s over the Sikh kingdom centered on the Punjab region of today's Pakistan and India before being killed in a power struggle. The painting is thought to have been made a few years after the events, but even so, the artist has included vivid details, remembered or imagined. Some audience members pay attention to the dancing, many observe the maharaja, a few chat with their neighbors or stare into space; several men tenderly hold little children. Carefully differentiated clothing and headgear identify several Sikhs of the Akali order (with tall, black, pointed extensions of their turbans) and a bare-headed Hindu ascetic.

The composition of the painting, with audience and musicians arranged in a U-shape in front of palace walls and the dancers placed at lower center, prefigures the composition of photographs showing similar scenes (see cats. 96–97).[1]—FMcG

1. This painting is discussed in Goswamy and Smith, *Domains of Wonder*, cat. 112. A related work is illustrated and discussed in Taylor and Dhami, *Sikh Art*, 157.

92 *also p. 83*

A ruler and his court watching a dancer

Approx. 1850–1900

India; Delhi

Ink on paper

H. 32 cm × W. 24.8 cm

Harvard Art Museums/Arthur M.
Sackler Museum, Gift of Philip Hofer,
1984.531

Dancers and musicians, considered part
of the accoutrements of court, were
central to court performance and enter-
tainment, or *nautch*. A nautch could
be defined as a performance of dance,
music, narrative, or poetry, often in a
court setting and for invited guests. These
were intricately choreographed events
that adhered to court protocol, where
each participant (performer or spectator)
played a significant role.[1] The portrayal
of nautch often shows the patron in a
position of power, while complex social
dynamics are communicated through
the careful placement of those in atten-
dance. Here the ruler is clearly enthroned.
Directly behind him stands an attendant
carrying a fly whisk and a sword, emblem-
atic of both royal status and martial
power. The courtiers and guests at the
performance are carefully arranged below
and on either of the sole dancer. This use
of space is heavily orchestrated as it func-
tions to center the dancer and, to a lesser
extent, the musicians in the foreground
through the placement of the courtier's
swords.

As the dancer's placement here
suggests, courtesans were central to the
display of kingship; patronage of courte-
sans served to authenticate status and
glorify the ruler.[2] The dress of the female
dancer, either bare chested or likely cov-
ered by translucent cotton, suggests the
sexual potential of the scene.[3] The cloth
clings to her torso, highlighting her form,

as noticed by one of the courtiers on the
right who looks directly at the dancer
while most everyone else gazes toward
the viewer.—AMC

1. Jha, "Tawa'if as Poet and Patron," 150.
2. Jha, "Tawa'if as Poet and Patron," 145.
3. Houghteling, "Emperor's Humbler Clothes,"
96.

93

Nautch with Three Dancers

Approx. 1862
By Shepherd & Robertson (British,
active 1862–1863)
Albumen silver print
H. 22.9 cm × W. 27.9 cm
Collection of Catherine Glynn Benkaim
and Barbara Timmer

This photograph is one of a group of at least four images of dancers and musicians in a Delhi courtyard.[1] The group was made in the same location as the courtyard performance depicted at cats. 96 and 97 but features subjects who were clearly engaged to serve as photographic models. Here, the photographer—probably Charles Shepherd (British, active 1850s–ca. 1880)—used deft framing to reduce the courtyard's architecture to an atmospheric, perfectly balanced backdrop for three terpsichorean figures. The dancers' postures create a pleasing compositional interplay for the lens. However, it is unclear whether their poses were adopted from living dance or invented by or for the photographer. If invented for the purpose of creating a satisfying photograph, then what mixture of training and muscle memory, aesthetic activity, and imagination ought we to read from the final image?—NMS

1. See cats. 96 and 97, note 3, for more on this locale. The three other images from the series depict the dancer who is at the far right here in cat. 93. She adopts various performative (though similarly choreographed) poses in front of the same arched colonnade and is flanked by two kneeling musicians. Prints from this series are held by institutions including the British Library and the Getty Museum and have been published with relative frequency.

Photography, Pose, and Power

In the posed photographs illustrated here (cats. 93–95), dance and ideas about dance are explored through costume, attributes, and physical attitudes. All three images deploy a limited set of visual and titular cues, fitting within the colonial practice of reducing persons and practices to types. A fundamental question about the photographic interchange underlies pictures like these. Understanding the nature of the interactions that produced the images—in other words, the degree of agency exercised by those behind the camera and in front of the lens—bears on the insights we can glean from the images. Which aspects of a given photograph document a living tradition, and which are formed to a greater degree by European fantasy? What can we learn about the social world of dancers by considering the roles they may have claimed in shaping photographic representations of dance? The authorship and imagined audience for imagery glorifying dance matters, alerting us to the possibility of both misrepresentation and canny self-representation.—NMS

94

Nautch Girl

Approx. 1880
Probably Johnston & Hoffmann
(active Calcutta, approx. 1880–1950)
Albumen silver print
H. 15.9 cm × W. 20.3 cm
Collection of Catherine Glynn Benkaim
and Barbara Timmer

This photograph raises questions about the interplay between pose and costume. In short, is the central subject's display of her fine muslin vestments a gesture extracted from living dance or one formulated expressly for the camera? The photographic record suggests the gesture of skirt display in depictions of Indian dancers developed in dialogue with the photographic representation of India for European audiences.[1] In many instances, the gesture is performed by dancers in a direct exchange with the camera, carrying connotations of allure, objectification, and availability—or, at the least, feeding viewers' fascination with diaphanous, finely worked textiles. While these ideas were central to European imaginings of so-called Eastern dance and dancers, it is important to note that they were also central to a classed and gendered erotics of dance and dancers in Europe. There are many analogous images of skirt display in a European context, including those related to the fashion for skirt dancing thought to have originated at London's Gaiety Theater in the 1870s.

The relationships of power inherent in photographic representation, gender, and colonialism (among other possible markers of difference at play in the making of such images in the Indian context) make a strong argument that the skirt-display gesture was implicitly or explicitly imposed by photographers who knew how to make appealing images for their own markets. However, there is also reason to hold a space for dancers' agency. For example, in recent unpublished interviews, present-day Kandyan *ves* dancers said they discerned acts of self-representation in the ways their forebears struck display poses for nineteenth- and early twentieth-century European photographers. Often the pose was perceived as advantageous because it displayed the most characteristic and impressive facets of the dancers' costume. Yet, the present-day dancers also perceived the unequal power dynamics involved in the making and consumption of these representations.[2]—NMS

1. I thank Deepali Dewan for sharing her views on this topic.
2. I am indebted to Rebecca Brown for sharing research conducted by her student Sashini Godage.

Dancing girl (Nautch) With musicians

95

Dancing girl (Nautch) with musicians

Approx. late 1880s
Attributed to Fritz Kapp & Co.
(German, active Calcutta)
Albumen silver print
H. 20.3 cm × W. 27.9 cm
Collection of Catherine Glynn Benkaim
and Barbara Timmer

This image exemplifies a common visual strategy and is similar to a series of ethnic and occupational types made by the photographic partnership Shepherd & Robertson in the early 1860s.[1] The troupe—likely selected for its availability as well as because the photographer perceived it as both visually interesting and typical—is isolated in a controlled setting and arranged so that each of its elements is open to examination. In one sense the image is indeed informative; it offers a clear view of costumes, implements, and the relation of both to bodies, much like a museum diorama. That comparison helps illuminate the limitations of photographs as historical documents. Yet, while photographs are inevitably biased, they are also complicated. One can imagine the photographer directing the dancer to hold a pose signaling her vocation for the camera, but the specific position and muscle tension of her arms and hands seems unlikely to have been devised by the photographer. It is possible that—even within an exchange that reduces this dancer to a categorical example—her body is speaking in its own language.—NMS

1. For examples of this series, see Harvard Art Museums (P1981.24 and 56–63).

96 *also p. 83*

Nautch Performance

Approx. 1862
By Shepherd & Robertson,
probably Charles Shepherd (British,
active 1850s–approx. 1878)
Albumen silver print
H. 22.2 cm x W. 28.3 cm
Collection of Catherine Glynn Benkaim
and Barbara Timmer

97

A Nautch in a Delhi Courtyard

Approx. 1862
By Shepherd & Robertson,
probably Charles Shepherd (British,
active 1850s–approx. 1878)
Albumen silver print
H. 23.8 cm x W. 29.5 cm
Collection of Catherine Glynn Benkaim
and Barbara Timmer

These photographs belong to a group of three images depicting a dance performance that took place in a palatial residence in Delhi in the years around 1860. They capture moments from separate passages of dance. In each photograph, a single dancer is seen performing on a courtyard terrace overlaid with textiles. The fabric billowing from beneath the dancers' skirts (probably the voluminous and somewhat inhibiting *farshi payjama* fashionable in Delhi and Lucknow in the mid-nineteenth-century) suggests

Cat. 97

their movements may have been smaller and involved less rotation than modern kathak (a north Indian dance tradition); for these dancers at least, subtle footwork would be signaled to the audience more by the rhythm of ankle bells than sight.[1] Musicians and torchbearers form an activated backdrop behind each dancer, both music and flame sharing in the ephemeral character of dance. Although nearly surrounded by their audience, the performers address themselves to the arched colonnade at the right of the frame, where the head of household or other honorees occasioning the dance are presumably seated. The third image of the group (fig. 1) may represent the troupe in near entirety.[2]

These photographs are remarkable for the impression of witness they provide. Compared to more familiar, often more overtly Orientalizing images of dancers who are clearly posed by or for European photographers during this period, they offer foreign viewers the pleasure of imagining themselves present at a dance in the context of its "real" performance in India. Of course, there are caveats to the idea of authenticity. By the 1860s the notion of the nautch had already been shaped within colonial culture. Moreover, we do not know what role the photographer had in formulating the pictured event; Charles Shepherd was an established figure in Delhi by the 1860s whose social connections and role as a photographer would have afforded him some entree.[3]

Given this, it is noteworthy that Shepherd selected a vantage point that provides both a fly-on-the-wall perspective on the dance and a direct view into the screened space above the courtyard, reserved for the women of the house to overlook events below. The result is that

photographs showing the dance in the lower register of the picture, where the dancers are the only adult women visible in an otherwise male zone, also share a view into an upper zone occupied by a notionally different kind of woman. Was this meant to convey messages about social strata and the spatialized roles of women and men in Indian society? Was it meant to grant European viewers privileged access to both? Or is there a more complex set of insights and pleasures at play? By intention or not, the resulting photographs provide a multilayered representation—both of dance and ideas that have attached to it over time.—NMS

1. I am grateful to Rosemary Crill for observations on the dancers' attire and to Mekala Krishnan for thinking with me about the relationship between clothing and bodily comportment in South Asian dance.

2. The different audience distribution, lack of torchbearers, and static, symmetrical formation adopted by the performers in fig. 1 suggest a set piece outside the dance proper, perhaps a moment when the troupe presented itself to show respect to and receive appreciation from patrons. Both dancers from cats. 96 and 97 are present, along with ten musicians; a younger person whose attire and ankle bells suggest that she, too, is a dancer; and an additional figure in female dress who may play an assisting role in the troupe.

3. Although the site of the dance has not been definitely identified, the setting bears a striking resemblance to the Khazanchi ki Haveli, raising the question of who would have been resident there after 1857. Charles Shepherd seems to have had considerable access to this site in the early 1860s: a related series of dance pictures (cat. 93) was made in the same courtyard, and Shepherd and Arthur Robertson (in partnership circa 1862–1863) are credited with an additional series of "types" depicting various sitters in what may be a forespace of the same *haveli*. For examples of the latter series, see Harvard Art Museums (P1981.24 and 56–63). It is also interesting to note there is at least one picture—an image of "conjurors" set in the same location used for cat. 93—that connects all these image groups to one photographic endeavor; see Getty Museum (84.XA.889.4.17).

Fig. 1 *Nautch*, 1863–1869, by Shepherd & Robertson, probably Charles Shepherd. Albumen silver print. *J. Paul Getty Museum*, 84.XA.889.4.14.

98

"Hindu Nautch," performers portraying Krishna, Balarama, and the cowherd women dancing in a courtyard, page from the Louisa Parlby Album

Approx. 1795–1803
India; Murshidabad, West Bengal state
Watercolors on paper
H. 49.5 cm × W. 75 cm
Cincinnati Art Museum, Alice Bimel
Endowment for Asian Art, 2021.12

This genre scene encapsulates the European penchant for images of Indian festivities and events. A dance troupe is seen in the center of a large audience, seated in a semicircle around the performance space. The two main dancers are dressed as the gods Krishna and Balarama, the others as a male devotee and four cowherd women. The painting has been inscribed "Hindu Nautch" in English. While the term *nautch* is now most often associated with female performers at a male-dominated court, in the

eighteenth century the term was more broadly defined as a dance, music, narrative, or poetry performance in a court setting. This performance may relate to an important day in Krishna's ritual calendar, as yet unidentified. The spectators include a large group of ascetics and, unusually, a smaller group of women seated on the edge of a veranda. The patron of the performance is positioned in the lower right corner, surrounded by the accoutrements of court, including a hookah and the makings of betel quid (a mixture of tobacco, betel nut, and spices), while dressed in religious garb complete with Vaishnavite markings. The prominence of the ascetics in the audience and the position of the patron conflate the practice of religion with the elite setting.

In the eighteenth century, Bengali artists had begun painting in this European-inflected style, having found a new patronage base in the officers of the East India Company based in Murshidabad, Calcutta, and the environs.[1] Instead of the court workshop system, where artists were kept in residence and on retinue to document life, the relationship between patron and artist was

here defined by commercial transactions. These European patrons—such as Louisa Parlby (d. 1808), a British resident of Maidapur—were interested in acquiring individual watercolor scenes of Hindu and Muslim festivities, topographical scenes, and architectural vistas, which they then incorporated into albums or portfolios.[2] With a prolific art market in Murshidabad and demand from British patrons, such stock scenes were often reproduced and included in multiple different albums.[3] This painting, and its inclusion in the Parlby Album, is representative not of an actual event witnessed by Parlby but of an ephemeral experience she deemed reminiscent of her time in India.—AMC

1. "Company" paintings are most often defined as paintings created by Indian artists working for European patrons in a style that combined regional and European artistic influences and techniques. See Archer, *Company Paintings*.

2. Losty, "Painting at Murshidabad."

3. A painting comparable to this one in a brighter color palette can be found in the British Library (Add.Or.3227). Originally in the collection of Colonel James Chicheley Hyde (1787–1867), it was part of the much-published Hyde Album in the British Library's collection.

99

Nautch Dancers and Whirling Dervishes, S. H. Barrett & Co's: New United Monster Rail-road Shows

1882
Printed by Strobridge Lithographing Company, Cincinnati
Poster
H. 75.3 cm × W. 100.4 cm
Cincinnati Art Museum, Gift of the Strobridge Lithographing Company, 1965.684.27

The circus was the most popular theatrical genre in America in the nineteenth century, and the lithographic poster, the icon of circus advertising. The Strobridge Lithographing Company (1867–1960) positioned itself early on at the vanguard of the printing industry, producing vibrant lithographic posters with captivating visual narratives. The company's location in a major urban outpost on the inland river system gave it strategic access to the burgeoning transcontinental railway network. It monopolized the market with its railway distribution system, which supplied posters to most of the touring theatrical shows.[1] Railroad circuses brought promises of thrilling entertainment to working-class populations and small towns, with trains specifically designed and decorated to bring the "exotic" world into local communities.

Representations of distant countries and cultures were often conflated under the big-top tent of the "Oriental" circus. In this poster, the Strobridge artists illustrated a group of nautch dancers in the foreground and "whirling dervishes" along the periphery. The costumes worn by the female performers are not representative of the style of dress worn by north Indian nautch dancers of the mid-to-late nineteenth century but are, rather, exoticized creations meant for a white, male and female, Euro-American audience.[2] Circus proprietors capitalized on their audiences' having little firsthand knowledge of the subcontinent and sold an alluring and sexually charged fantasy of nineteenth-century colonial and courtly India. This advertisement and the performative elements it portrays have more in common with the aesthetics of an Orientalized style of dance popular in Europe and America at the time than with any attempt to emulate the movement-based traditions prevalent in India and the wider region. S. H. Barrett & Co's "Oriental circus" can best be described as a mimetic reproduction by an American ensemble that was less concerned with technique and accuracy than with spectacle.—TLG

1. For a robust discussion of the American circus poster, see Spangenberg and Walk, *The Amazing American Circus Poster*.
2. See cats. 93–97 for photographic examples of nineteenth-century nautch dress.

100

Fly TWA, The Orient

Approx. 1955
Designed by David Klein (American, 1918–2005)
Poster
H. 100 cm × W. 63 cm
Cincinnati Art Museum, Gift from Sanjay Kapoor in loving memory of his father Vineet Kapoor and grandmother Urmil Kapoor, 2020.197

With a robustly growing economy in the United States in the years after World War II, air travel for both business and pleasure increased exponentially. Travel posters were a key element in promoting this burgeoning industry, and David Klein, an American artist known for his influential work in advertising, produced dozens of iconic images for Trans World Airlines.[1] During their time, travel posters were pervasive—in airports, railway stations, travel agencies, ticket offices, hotels, and on advertising kiosks in cities around the globe. Each referenced an elite, highly coveted experience of travel to a far-off exotic destination.

In this design, part of an extensive series to promote tourist travel in the late 1950s and early 1960s, the imagery suggests the allure and mystique of destinations in the "Orient." Creating iconic representations, these posters were often fraught with stereotypes and charged with overtly sexual imagery that objectified and exoticized the countries presented. Here, dance—already emblematic of India by this time—is conflated with multiple religious and cultural identities for a global stage. The image of a South Indian bronze Krishna is positioned against a compilation of architectural and natural landmarks that

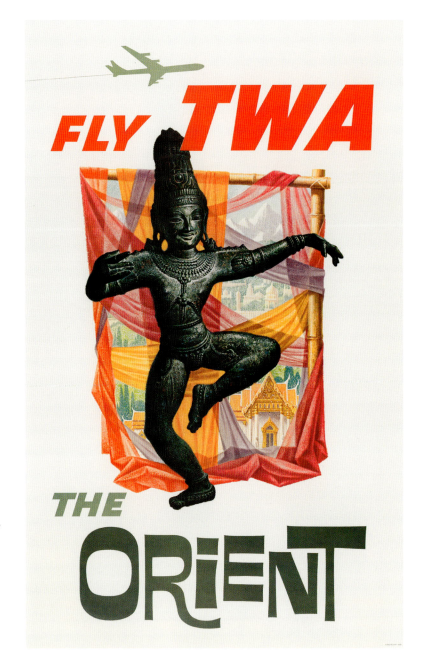

visually reference South Asia, Southeast Asia, and the Himalayas—all positioned within a bamboo-framed window covered with draping fabric. Such illustrations play on the intrigue of the unknown, luring prospective adventurers to the region through the architecture of majestic buildings, stunning landscapes, monumental temple sculpture, and more.—AMC/TLG

1. Trans World Airlines was formed in 1924. Its first route was New York to Los Angeles, followed by other national routes. It expanded to Europe and then across Asia after the war. While Klein is best remembered for his work for TWA, he also produced illustrations for Broadway productions, Hollywood films, the US Army, and corporate clients; see davidkleinart.com, accessed August 12, 2019.

101

Cambodge, Pnompenh, l'Indochine Française

1931
By Joseph Henri-Ponchin (French, 1897–1962)
Poster
H. 111.8 cm × W. 76.5 cm (sheet)
Fine Arts Museums of San Francisco, Gift of Kenneth G. High Jr., 1992.99.1

Fig. 2 Postcard featuring a royal kinnari dancer, approx. 1900–1910.

palace buildings, a royal figure riding enthroned on an elephant, and, front and center, an image—based on a photograph—of a classical dancer costumed as a mythical bird-woman, a kinnari (fig. 2).[2]

Large lettering labels the poster "L'Indochine Française." Surely it is no accident that the poster was issued the same year as a major exposition in Paris, the Exposition coloniale internationale, which featured a Cambodian pavilion and a large-scale replica of Angkor Wat. The exposition displayed carefully chosen aspects of French overseas conquests in an effort to solidify approval for France's colonial efforts.—FMcG

1. Blair, "Cambodian Dancers."
2. Cambodian dancers portraying kinnari had appeared on the June 24, 1906, cover of the magazine *Le petit journal.* The article marked the performances in Marseilles that Rodin had traveled to attend. The cover may be seen by searching online for "Le Petit Journal Exposition Coloniale de Marseilles." See also Sasagawa, "Post/colonial Discourses."

Fig. 1 *Danseuse cambodgienne de face,* 1906, by Auguste Rodin (French, 1840–1917). *Musée Rodin.*

Cambodian classical dance and dancers had fascinated the French since the Cambodian royal troupe performed in France in 1906. Auguste Rodin saw the troupe in Paris and followed them on to Marseilles, producing drawings that have drawn wide attention (fig. 1).[1] Cambodian dance seems to have appealed for its restrained sensuousness, its exoticism, and, no doubt for some, its reminders of the glories of French colonialism. The French had established a protectorate over Cambodia in 1867.

This poster portrays a collection of evocative motifs: the peaked and curving silhouettes of Cambodian temple and

Celebration

WHILE DANCE IS RARELY an uncomplicated expression, there are instances where exuberance and joy prevail. In these moments, motives such as power, hierarchy, ego, fear, devotion, and more may still be evident, but the present instant—one of movement, music, experience, connection—is at the forefront and can be considered the most expressive element. Ganesha dances with abandon, in emulation of Shiva, often alongside his attendants (*ganas*), but also with great wisdom communicated in every step. The boy Krishna clutches a butter ball and dances joyously before his mother; his energetic, youthful nature is reflected through his reaching limbs as he is depicted mid-step, even as his position as a god is conveyed through the same dance.

Paintings and decorative arts depicting isolated dancing figures, often female, explore how divine love, romance, music, poetry, literature, and dance can meld into one expression. These objects underline how dance is infinitely recognizable—and infinitely linked. Music, dance, and drama permeate all forms of cultural and artistic expression. This visceral connection between exuberance and dance is echoed in many disparate artworks showing gods or human beings dancing. Depicted with and for a variety of motives, from sparking romance and seduction to celebrating weddings and other rites of passage, these figures are dancing first and foremost.

Why Does Ganesha Dance?

Scattered throughout various sacred texts are mentions of Ganesha dancing, a form popular in both Hindu and Buddhist contexts.[1] Yet the dance is often described without revealing why the elephant-headed god moves. His dance is therefore often interpreted as one of pure joy, danced in emulation of his father, Shiva, but rarely ascribed any cosmic significance.

Ganesha's story is closely entwined with that of Shiva, and their relationship is suitably complex.[2] If Ganesha's dance is in emulation of his father, the nuance of their relationship takes on greater meaning. The earliest known sculptural forms of dancing Ganesha date to about the fifth century, gaining prominence from the eighth century onward both as an individual form and as protector of the mother goddesses (see cats. 52 and 53). His dance is also referenced in Sanskrit devotional poetry from the tenth century on, most notably by the Kashmiri poet Somadeva. Verses in the eleventh-century compendium known as the Kathasaritsagara (The Ocean of the Sea of Stories) that cite Ganesha dancing are positioned at the outset of numerous chapters, including: "May Ganesha, in the advancing night as he dances his tumultuous dance with his trunk raised up and making a whistling sound and spraying forth light and nourishment to the stars, protect you."[3] This reference to advancing night connects his dance to that of Shiva, who danced the *ananda-tandava* (see cats. 1–2) at twilight, a time considered between day and night. Another verse compares Ganesha to Mount Meru and his erect trunk "flung up straight in the joy of the dance, so as to sweep the clouds" to the cosmic pillar that connects the three worlds (earth and the higher and lower realms)—a further reference to Shiva and his aniconic form of a linga.[4] The many permutations of dancing Ganesha can hold both celebratory aspects as well as cosmic significance in every step, even if the "why" isn't definitively defined. Does Ganesha dance for Shiva's approval? To demonstrate his obedience to his father? Or perhaps to amplify the resonance of Shiva's dance?—AMC

Fig. 1 Shiva and Ganesha dance for Parvati on Mount Kailasa with other gods in attendance. Popular print. Gita Press, Gorakhpur.

1. Ganesha's dance is mentioned in the Linga Purana (ch. 105), the Ganesha Purana (in the Krida-khanda, 105), the Skanda Purana, and the Matsya Purana (261.24–28).

2. Courtright, Gaṇeśa, 116–18. With details varying from text to text, a popular recounting tells how the goddess Parvati created Ganesha as her son and instructed him to guard her door while her husband was away. Upon returning, Shiva was enraged when prevented from entering and beheaded the child. When he understood Ganesha was his son, Shiva replaced his head with that of an elephant and restored him to life. Numerous scholars, including Courtright, have read Oedipean overtones into Ganesha's creation story. Similarities between the dominant myths of Oedipus and Ganesha include a son's attempt to possess a mother and exclude a father that eventually leads to symbolic castration. While Oedipus kills his father, it is important to note that Ganesha is killed and then revived by his father. This difference is fundamental to our understanding. Through Ganesha's beheading and subsequent symbolic rebirth as the elephant-headed god, he comes to understand that Shiva is his father (and not a force that he must protect his mother from), and he accepts his role as the Lord of Obstacles while becoming both a yogi and a dancer in emulation of his father.

3. Kathasaritsagara 109.1, in Courtright, Gaṇeśa, 164.

4. Pal, "Dancing Ganesha," 43.

102

Twenty-armed dancing Ganesha

Approx. 900–1000
India; Madhya Pradesh state
Sandstone
H. 67.6 cm × W. 42 cm
Art Institute of Chicago, promised gift
of James W. and Marilynn Alsdorf,
169.1997

Amid a welter of forms we discern
Ganesha, with his elephant head and
hefty human body. What a task the artist
has faced, to show such a being strutting
in dance and gesturing or brandishing
emblems with no fewer than twenty
hands. At Ganesha's feet several figures
pound drums. Celestial musicians, as well
as a garland-bearer, hover overhead.
Sculptures of Ganesha dancing are com-
mon, especially in north India. They occa-
sionally link Ganesha to his father, Shiva,
and depict him, as here, as a mighty
ascetic wearing the tiger-skin loincloth of
a renunciate. Some of the emblems this
Ganesha holds, such as the snake and
crescent moon, are also associated with
Shiva, but others, such as the conch shell
of Vishnu, suggest links to other deities
as well.

Twenty-armed Ganeshas are rare.[1]
This image may represent Ganesha as the
embodiment of the supreme deity, as he
was believed to be in some traditions.
One such tradition, that of the Ganapatya,
is thought to have been important by the
tenth century, the period of this sculp-
ture.[2] The fact that he holds emblems
associated with several high deities may
point to his being considered here the
totality of divinity.—FMcG

1. Twenty-armed Ganeshas are said to be
found only in the north-central Indian state of
Madhya Pradesh; see Martin-Dubost, *Gaṇeśa*,
159. For the attribution of this sculpture to
Madhya Pradesh, see Desai and Mason, *Gods,
Guardians, and Lovers*, cat. 17. At Khajuraho
there are dancing Ganeshas with from two
to sixteen arms, but apparently none with
twenty: Desai, "Dancing Gaṇeśa," 33. Pal dis-
cusses this image briefly in *Collecting Odyssey*,
cat. 72, but mentions no other twenty-armed
examples in "Dancing Ganesh in South Asia."

2. On the Ganapatya tradition, see Courtright,
Gaṇeśa, 218–19; also Aditya Bhattacharjee,
"Gāṇapatya," Database of Religious History,
updated August 21, 2020, https://religionda-
tabase.org/browse/971/#/.

103

Dancing Ganesha

Approx. 800–900
India; probably Madhya Pradesh state
Sandstone
H. 99.1 cm × W. 51.4 cm
The Nelson-Atkins Museum, Purchase:
William Rockhill Nelson Trust, 70-45

Beginning in the eighth century, individual images of Ganesha dancing were carved in niches along the south exterior wall of Hindu temples that were often, but not always, dedicated to Shiva.[1] These images are positioned to be the first major deity encountered in a clockwise circumambulation of the temple. It is a fitting spot for Ganesha, as both the creator and remover of obstacles—a role granted to Ganesha by Shiva, who also named him leader of his attendants (*ganas*), who are themselves known to be talented musicians and dancers.

 This ten-armed depiction of the god has adoring celestial figures above and musicians and devotees below. Ganesha is swaying gracefully to the drummer's tempo, with one of his left hands resting on his hip in the posture of ease. He stretches a snake in two hands over his head, a pose reminiscent of his father Shiva holding the flayed elephant skin aloft in a dance of victory over the elephant demon Gajasura (see cats. 45–46). His other hands hold a noose, a scarf, sugarcane, an axe, a mace, sweets, and an unidentified attribute, possibly another scarf. As the form of dancing Ganesha gained popularity from the tenth century onward, his depictions became more and more stylized, although subtle variations remain and the number of arms he is seen with could range from two to twenty (see cat. 102).—AMC

1. One of the earliest known images of Ganesha dancing is beside Shiva in the fifth-century carved relief at Badami. By the eighth century, the dancing god was a popular form in the temples of Rajasthan, Madhya Pradesh, and Uttar Pradesh.

104

Dancing Ganesha

Approx. 1500–1700
India; Karnataka state
Copper alloy
H. 50.5 cm × W. 33 cm
Los Angeles County Museum of Art,
Purchased with funds provided by Harry
and Yvonne Lenart, M.86.126

Here, Ganesha holds one leg high,
nearly to the level of the knee of his
standing leg—a posture more common
in Maharashtra and Karnataka than
elsewhere in India.[1] His four arms hold
numerous attributes, including a bunch
of mangos. Unlike the stone sculpture
from Madhya Pradesh (cat. 103), this
bronze work would have lived inside a
temple and was worshipped in situ as
well as during festivals, when it would
have been carried in processions. It is rare
to see a processional image of Ganesha
dancing, as the god is usually portrayed
in a more static posture, standing or
seated.[2] An inscription written in Kannada
on the base dedicates this sculpture to
the god by an unknown figure named
Ramappa.—AMC

1. Desai, *Dancing Ganesha*, 36.
2. Pal, "Dancing Ganesha," 62.

105 *also p. 14*

Dwarfish figure (gana) dancing

Approx. 1700–1900
Southern India
Wood with traces of paint
H. 53.3 cm × W. 25.4 cm
Asian Art Museum of San Francisco, The
Avery Brundage Collection, B60S315

106

Dwarfish figure (gana) playing trumpet

Approx. 1700–1900
Southern India
Wood
H. 50.8 cm × W. 27.9 cm
Asian Art Museum of San Francisco, The
Avery Brundage Collection, B60S316

The great god Shiva is attended by a crew of dwarfish characters known as *ganas*. They have varied physiques and features and are known for their tumultuous energy, whether dancing (as they frequently do), making music, frolicking, or fighting.[1] Their chief is the elephant-headed god Ganesha (*gana* + *isha* = "lord of the ganas").

One gana here seems to be engaged in a war dance, carrying in three of his four arms a club, a sword, and a shield (cat. 105).[2] War dances, as martial arts, preparations for actual battle, or celebrations of victory, are frequently depicted in the visual arts, literature, and performing arts of the Indian cultural sphere (see cats. 114 and 115). The second gana, also four-armed, cavorts while playing a curved trumpetlike instrument called a *kombu* in Tamil (cat. 106). Panels showing ganas such as these would have been part of the decoration of a huge processional chariot carrying the image of a major deity through the streets on religious festivals.[3] —FMcG

1. For details on the wide range of appearances and activities of ganas and the texts from which the descriptions come, see Dhaky, "Bhūtas," 247–49.

2. Another multiarmed gana brandishing weapons is seen on a processional chariot at the Nataraja Temple, Chidambaram, illustrated in *Marg* 43, no. 2 (December 1991): 102.

3. Michell, "Chariot Panels," 52. The two panels here differ in style and details and may not have come from the same chariot.

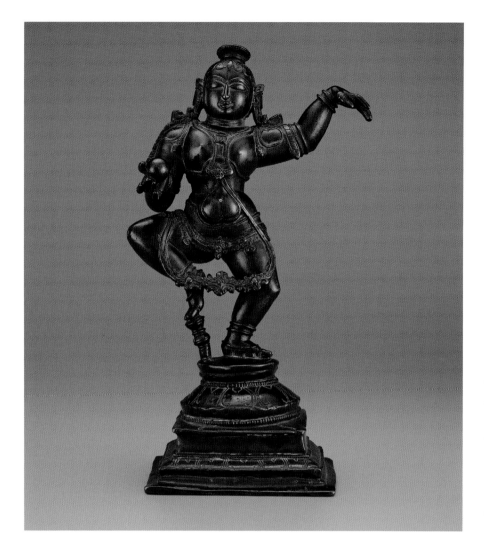

107 *also p. 266*

The boy Krishna holding a stolen butter ball and dancing

Approx. 1600–1700

Southern India

Bronze

H. 19 cm × W. 10.2 cm

Asian Art Museum of San Francisco, The Avery Brundage Collection, B60B192

108

The boy Krishna dancing

Approx. 1500–1600

Southern India

Bronze

H. 68.5 cm

Lent by a New York collector

Pudgy little Krishna, dancing in impish glee after stealing a treat, is adorable in several senses. The child aroused the bemused affection of his foster parents and their neighbors, even though—or because—his divinity was shielded from them. Had they known that this naughty boy was a supreme god they would not have been able to react to him as doting parents or friends rather than as humble worshippers. Then, too, his very toddler's vivaciousness and inclination to get into trouble make him approachable.

In the scene referenced in the first, smaller image (cat. 107), Krishna is caught stealing tasty butter by a young neighbor woman in their cowherder village. Their conversation shows how ordinary—and charming—the interaction of human woman and divine child can be:

> Neighbor: Did I ask you to come in like a thief and steal butter from me?
>
> Krishna: All right, friend, if you don't believe me on that score, let me show you a little dancing.

> Neighbor: All right, you show me how you can dance, and if I like it well enough I'll let you go. If not, I'll tie you up.
>
> Krishna: Right, but what if you like my dancing just fine but then say that you don't? Then what?
>
> Neighbor: No, no. If I like it, I'll let you go.
>
> Krishna dances.
>
> Krishna: So. May I go now?
>
> Neighbor: I wouldn't give a single penny for dancing like that.[1]

What happens in the next moment is telling: when the neighbor starts to tie up Krishna, she is struck that his hands are "as soft as little blossoms" and her "heart is stolen." She experiences the profound love for this child and for the divine that he embodies that is the core of Krishna worship, or self-surrendering devotion (*bhakti*).

The second, much larger image of Krishna dancing (cat. 108) lacks the butter ball and so is distanced from a specific narrative. This statue must have been a significant cult icon. The holes in its base allowed it to be secured to a chariot and conveyed, no doubt gorgeously bedecked in clothing and jewelry, through the streets. Its gracefulness and equipoised energy suggest Krishna's prime activity: *lila*, or "play." As David Kinsley writes, "For the divine to become embodied as a child is eminently suitable, for they behave in similar ways. Each belongs to a joyous realm of energetic, aimless, erratic activity that is pointless, yet significant: pointless, but at the same time imaginative and rich, and therefore creative." The child Krishna "epitomizes the nature and activity of the divine."[2]—FMcG

1. Adapted from a script by the poet, actor, and singer Svami Ramsvarup included in Hawley, *Krishna, The Butter Thief*, 206–07.
2. Kinsley, *The Sword and the Flute*, 15–16.

109

The Wedding Procession of Shri Shankar-ji [Shiva]

1977
By Indira Devi (Indian, b. 1940)
Ink and colors on paper
H. 76.7 cm × W. 259.4 cm
Asian Art Museum of San Francisco, Gift of the Ethnic Arts Foundation, 2021.19

The wedding procession of an Indian groom can be a boisterous affair, but none was as boisterous as that of the god Shiva. He was escorted and celebrated by his semidivine followers: the often unruly, sometimes grotesque ganas, who were known for their dancing and music playing. A revered old text, the Shiva Purana, describes the scene:

> In the marriage procession of Śiva, Nandin and other leaders of the Gaṇas went surrounded by hundreds and twenties of crores [ten millions] of Gaṇas. . . . These . . . joined the procession with joy and enthusiasm. They had a thousand hands. They wore matted hair and crowns. . . . O sage, some of them belonged to this terrestrial world, some came through nether worlds, some came through the sky. . . . Thus lord Śiva, accompanied by his Gaṇas, gods and

others went to the city of Himagiri for the celebration of his marriage (40.25–33).[1]

Why the artist Indira Devi chose Shiva's wedding procession as her subject for a very large work is unclear, but a few clues point directions for future research. Indira Devi spent the earlier part of her life in the somewhat out of the way, not very prosperous region of Madhubani in northeastern India. The region had a long tradition of women artists painting on the walls of village homes. Indeed, Indira Devi participated in this tradition, painting a large figure of Shiva riding his bull on the wall of the marriage chamber in the home of a family she had married into.[2] But that wall painting shows just Shiva and his wife Parvati, not the entire wedding procession. Taking on the procession gave

Indira Devi the opening to let her imagination burst forth in the depiction of the outlandish ganas and their wild carousing. One wonders if she had seen the then recently released Indian movie *Har Har Mahadev* (1974), which featured an engagingly bizarre enactment of the procession (fig. 1).[3]—FMcG

1. Shastri, *Śiva-Purāṇa*, 640–41.

2. This painted wall and the figure of Shiva can be seen in Véquaud, *Woman Painters*, 19. The background on Indira Devi and this wall painting was provided by Shantanu Das and David Szanton, to whom thanks are due.

3. A clip of the wedding procession—in fact, the full film with English subtitles—may be found on YouTube.

Fig. 1 Still of Shiva's wedding procession from *Har Har Mahadev* (1974; dir. Chandrakant).

110

A Sikh wedding procession

Approx. 1850–1900

India; Punjab state or Pakistan, Punjab province

Opaque watercolors on paper

H. 31.8 cm × W. 54.6 cm

Asian Art Museum of San Francisco, Gift of the Kapany Collection, 1998.70

In contrast to the mythic wedding procession of the Hindu deity Shiva (cat. 109), here we see a real-world wedding of a nineteenth-century Sikh groom. The costumes and turban types make clear that this is a Sikh community event, and wedding processions in Punjab and Rajasthan are sometimes still similar today. The groom, in formal attire, rides a horse to the wedding site, which may be the bride's home. Relatives and friends, both male and female, attend him, and there is festive music from instruments such as the oboe-like *shehnai* and a variety of drums—some, in this painting, carried by camels. Nearly lost in the crowd are two gesticulating female dancers. They, like the musicians, may be professional performers hired for the occasion. We don't know whether what is shown is the wedding procession of a historical person who may one day be identified or a generic scene.—AMC

111 *also p. 61*

Dancing villagers

Approx. 1730
Attributed to Pandit Seu
(Indian, 1680–1740)
Opaque watercolors on paper
H. 24.8 cm × W. 36.2 cm (image);
H. 27.3 cm × W. 38.7 cm (sheet)
Los Angeles County Museum of Art,
from the Nasli and Alice Heeramaneck
Collection, Museum Associates
Purchase, M.77.19.24

Seven men dance with abandon to the vigorous tune of four musicians. Arms extended and knees bent, these animated figures are positioned against a monochromatic red background, with only a hint of ground below and an elevated horizon line above. Unusual for a painting from the later Indian courts that portrays dance, the figures are devoid of a larger court, performance, or narrative context. Instead, an intensity is created and communicated through each expressive face and writhing form. This is dance without a discernable organized presentation or recognizable postures.

This painting has also been published as "Dancing Dervishes" and has become emblematic of dance depictions from north India. Neither title captures the essence of the painting, however, where dancers are unabashedly absorbed in movement. The identification as dervishes and a dance related to Sufi devotional practices likely comes from the elongated sleeve of one of the dancers. In earlier Persian and then Mughal painting traditions, elongated sleeves served as a symbol expressing contemplation, transcendence, and intoxication in both the physical and spiritual realms.—AMC

112 *also pp. 228–29*

Hanging with celestial beings dancing and playing music

Approx. 1650–1675
India; Machilipatnam, Andhra Pradesh state
Cotton plain-weave, mordant- and resist-dyed, with painting
H. 67.3 cm × W. 82.5 cm
Museum of Fine Arts, Boston, Gift of John Goelet, 66.230

Within a border of intricate floral medallions, a celestial performance features both female and male musicians keeping tempo for two male dancers. The scene draws heavily on Persian imagery, from the small tufts of flowers that create the lush landscape to each figure's dress and polychrome wings. Here, Persian and Islamic influences merge with South Asian court cultures to create a mythological, religious, and poetic space where an intimate scene of music and dance transpires. Five of the musicians play frame drums, instruments linked to both courtly and religious music that are believed to connect earthly and spiritual realms; beating the drums can at times invoke the presence of angels, prophets, and saints.[1] The dancing figures portrayed in the central field, like most of the figures in attendance, are divine or semidivine

winged figures. This work was likely used as a cover for ceremonial gifts; comparable small textiles feature figures engaged in courtly activities, including drinking wine, listening to musicians, romantic dalliance, and hunting.[2]—AMC

1. Doubleday, *Frame Drum*, 114–27. In courtly Persianate settings, the frame drum was played by both men and women; these musician groups could be all male, all female, or of mixed gender. The frame drum was at times held near the musician's face to amplify and resonate the voice.

2. See Haidar and Sarkar, *Sultans of the Deccan*, for an informative work that relates the history, production, and iconography of *kalamkaris* (pp. 269–276), in particular the entries for three rumals in the Metropolitan Museum of Art (28.159.1–3; cats. 160–62). For comparable works, see V&A Museum (IS.34-1969), Cincinnati Art Museum (1962.465), as well as two pieces in the National Museum of India, New Delhi. See also Weinstein, *MFA Highlights: Arts of South Asia*, 31, for an entry on this piece.

113

A boating party at night with dancers and musicians

Approx. 1700–1720
India; probably Delhi or Lucknow
Brush drawing on paper with added washes of color
H. 26 cm × W. 25 cm
Cincinnati Art Museum, Alice Bimel Endowment for Asian Art, 2020.117

This drawing offers a glimpse into the courtly enjoyments of music and dance at the later Mughal courts. Four boats are clustered together on a river or lake, each with a nobleman or personage of importance seated at the helm. The upper boat features two male musicians dancing to the beat of a drum, while the middle boat has a larger entourage of musicians facing a nobleman and his retinue. The visual distinctions of this nobleman, presented under a canopy, speak to the hierarchy ingrained in court culture, even in moments of diversion.[1] The lower boat

features two female performers dancing exuberantly to a troupe of female musicians.[2] There is a freedom of expression in the fluid lines of the drawn forms, where the artist has captured the intoxicating mood of a joyous ensemble replete with dancers, musicians, and accompanying spectators.

The known provenance of this drawing is also of interest when considering the introduction of Indian dance to American and European audiences in the early twentieth century. Once in the private collection of renowned art historian Ananda K. Coomaraswamy, the work was published in his seminal text *Indian Drawings* (1910), which introduced works on paper from India to a wider audience.[3]—AMC

1. Another work that portrays dancers entertaining a personage of distinction on a boat, in this case Raja Mokham Singh, was published in Pal, *Dancing to the Flute*, cat. 172. Here the raja is positioned high above the dancers, musicians, and noblemen on an elevated platform.

2. The separation of female performers in the lower boat, physically distanced from the male dancers, musicians, and spectators, may relate to the nuanced categorization of space at the Mughal court to denote where dance occurred. See Schofield, "The Courtesan Tale"; and Brown, "If Music Be the Food of Love."

3. Coomaraswamy, *Indian Drawings*, pl. XIX. See Laura Weinstein's essay "Worshippers of Nataraja Still" in this volume (pp. 65–75) for a discussion of Coomaraswamy and dance.

114

A sword dance, page from a dispersed Shah Jahan album

Approx. 1640
India; possibly Delhi
Ink, opaque watercolors, and gold
on paper
H. 26.4 cm × W. 17.9 cm (image);
H. 38.8 cm × W. 25.3 cm (sheet)
Cincinnati Art Museum, gift of JoLynn
M. and Byron W. Gustin, 2016.419a-b

This festive scene depicting a yet to be identified sword dance is set outside a forest dwelling or temporary encampment. Two men sit formally in attendance, perhaps visiting the encampment, while three others drink from small cups. A dancer swings his saber in time to music provided by several musicians in the foreground. When swords are used as props, there is typically only one dancer.[1] The sword with a slight curve to the blade likely comes from the Islamic world or South or Central Asia but is otherwise unremarkable as a weapon. Depictions of sword dances in Mughal India, ubiquitous in imperial celebrations, are often associated with the celebrations surrounding the birth of a male heir.[2] Sword dances are also associated with Rajasthani and Sikh kingdoms, regions with strong connections between martial life and kingship.—AMC

1. Wade, *Imaging Sound*, 83.
2. See British Library (OR.3714, fol. 295r; and Or.12988) and V&A Museum (IS.2-1896 79/117).

115

Celebrations with music and dance, from the "Early Bikaner" Bhagavata Purana

Approx. 1610
India; Rajasthan state, former kingdom of Bikaner
Opaque watercolors on paper
H. 17.1 × W. 24.8 cm (image);
H. 24.4 × W. 29.8 cm (sheet)
The Kronos Collections, L.2018.44.3

This unidentified scene from the Bhaga-vata Purana captures two figures carrying sticks as they perform an animated dance. They are accompanied by two musicians, two courtiers with sticks, and four cattle, and they are positioned along the shore of a river or lake.[1] One of the dancers wears a luxurious transparent robe, a peacock-feather headdress, and a necklace of bells. His dress and demeanor conflate his high social rank with Krishna, who often sports a peacock crown.

The second dancing figure also sports a peacock-feather headdress, is bare chested, and wears large bells around his neck, wrists, and hips. His skirt is not unlike the three-tiered skirt that can be traced to an early sixteenth-century Mrigavati manuscript illustration.[2] Representations of this skirt later gained prominence in Rajasthan, where it was associated with traveling dance troupes

performing the rasamandala and became a visual cue to denote devotional dance in honor of Krishna.

Weapons are not often associated with Krishna; the long sticks seen here bring a martial element to this unidentified dance. Warriors were known to practice dance as a way to hone the skills needed to respond in battle and may perhaps add to our understanding of this scene. Skills such as strength, intuition, and speed are as much a part of dance as they are of war.—AMC

1. Terence McInerney connected this painting to armies by speculating that the two individuals on the right are soldiers; see McInerney et al., *Divine Pleasures*, cat. 11, 72. Thanks are due to Rachel Parikh for discussing weapons and the intricacies of Rajasthani stick dancing (*dandiya gher*) with the author.
2. See cat. 23 for a description of this skirt and its meaning and use in earlier paintings.

116 *also p. 16*

A nobleman dancing, accompanied by musicians personifying the musical mode *madhava ragaputra*

Approx. 1680–1690
India; Himachal Pradesh state, former kingdom of Bilaspur
Opaque watercolors on paper
H. 20.6 cm × W. 14 cm (image);
H. 26 cm × W. 19.4 cm (sheet)
The Kronos Collections, 2015

An inscription on the reverse of this work identifies the musical mode depicted in this ragamala (see p. 127) as *madhava ragaputra* (son of a male raga), a member of the Bhairava raga family.[1] The compositional archetype for madhava ragaputra often depicts a young prince seated on a decorated throne or pavilion holding a lotus flower, usually in the company of female attendants.[2] This imagery is designed to elicit the sentiment of sweetness, as in bees drawn to a lotus flower. Here, however, the Bilaspur artist has chosen to sequester the group within a green landscape setting. Rather than placing the prince in a static seated position, the artist has him leap into the air in a kinetic burst of energy. Instead of grasping a lotus blossom to extend to his female companions, the prince loosely twirls the scarf draped across his shoulders with the same care one would give to a cradled flower stem.[3] The female subjects deftly command their musical instruments in place of the more commonly held prop, a fly whisk.[4] What was the impetus for the artist's departure from the iconographic formulae for madhava ragaputra? Perhaps the harmonious pairing of dance and music can be understood as producing the same sweet pleasure that a bee derives from a flower—or a prince from his companions. —TLG

1. The inscription—two lines in Panjabi written in Takri script—reads: "Raga Madhava/23" with the number "23" written above. See Lerner, *The Flame and the Lotus*, 164–65. This painting is probably from the same dispersed ragamala series as three paintings formerly in the collection of Edwin Binney II and now in the San Diego Museum of Art; see McInerney et al., *Divine Pleasures*, 138–39.
2. For a painting in this compositional format, see "A prince and lady meeting, illustrating the musical mode Raga Madhava," Howard Hodgkin website, accessed April 3, 2021, https://howard-hodgkin.com/indian -collection/artwork/a-prince-and-lady -meeting-illustrating-the-musical-mode -raga-madhava.
3. See Museum Rietberg (RVI 1226).
4. For comparison, see Metropolitan Museum of Art (L.2018.44.13).

117

Art of the Rehearsal

2016
By Sarah Choo Jing (Singaporean,
b. 1990)
Three-channel panorama video,
2:53 min.
Courtesy of Nijkerk-Bogen Collection

A three-channel video reveals the densely packed, narrow backstreets of Singapore lined with homes and shops and interspersed by nine dancers representing the Chinese, Malay, and Indian communities of the city-state. The dancers are dressed in ornate costumes and positioned at ground level and on rooftops, isolated yet integrated into the urban fabric of the scene. They start and stop dancing at different musical intervals, each embarking on an intimate performance that, when combined, explores the cultures and ethnicities of Singapore through dance.

Sarah Choo Jing's video work often delves into the private narratives of her subjects by creating seductive and intimate forays into ordinary life. These intentionally constructed vistas are then stitched together into video composites, creating community by visually linking remote endeavors. *Art of the Rehearsal* unites cultures through the rigorous shared mental and physical preparation of performance-based arts. To further emphasize process and multiplicity over final performance, the artist blurs boundaries between space and time by integrating shots of several Singapore neighborhoods and presenting them at night, brightly lit with the artificial illumination of a cityscape.—AMC

118

Art of the Rehearsal: Portrait Series

2016
By Sarah Choo Jing (Singaporean, b. 1990)
Three simultaneous videos on monitors, 2:53 min.
Courtesy of Nijkerk-Bogen Collection

Filming through a one-way mirror, Sarah Choo Jing captured the ritualistic yet routine preparation of multiple individual dancers and presents them on three screens that play concurrently. These animated portraits capture the mental and physical journeys of dancers as they dress, preen, and prepare for performance. As part of the larger *Art of the Rehearsal* body of work (see cat. 117), *Portrait Series* presents solitary figures that draw viewers into their emotional and physical spaces, creating a sense of connection and intimacy through their isolation.—AMC

119

Comb with depiction of dancing woman

Approx. 1600–1700
Sri Lanka; former kingdom of Kandy
Ivory with traces of pigment
H. 14 cm × W. 8.3 cm
Asian Art Museum of San Francisco, The
Avery Brundage Collection, B60M345

We may think that this scene of a dancer in lively movement gives us a glimpse of an eighteenth-century Sri Lankan dance performance in progress. The costume, with lower garment and scarves of starched and pleated fabric combined with elaborate jewelry, seems to be right when compared with coeval depictions in painting and other mediums as well as the costumes of today's classical dancers. The wide-legged stance, tilted torso, and stylized hand gestures are familiar as well. The remarks of a nineteenth-century British observer indicate that "low-caste dancers and drummers . . . were obligated to perform the ritual service of dancing weekly on Saturdays at the larger shrines near Kandy such as Embekke Devalaya as well as at various festivals."[1] It is possible that we see not so much a dancer in motion as a conventionalized emblem. Numbers of other eighteenth-century Sri Lankan ivory combs and decorative objects show similar dancers, and another is depicted in a wood carving at the religious shrine of Embekke Devalaya (fig. 1).[2]

Sri Lankan ivory combs were made to ornament the hairdos of well-to-do women, not for grooming. They show a wide variety of designs in addition to dancers, such as foliage, mythical animals and beings, and deities. Why did a woman choose one design over another? What did she mean by wearing a comb showing a dancer very similar to one in a carving at a shrine noted for dance

performances? Was the depiction of a dancer on a comb just an appealing, perhaps auspicious, motif, with no deeper significance?—FMcG

1. Reed, *Dance and the Nation*, 80.
2. See, for example, V&A Museum (IS.428-1897 and IM.370-1924) and Philadelphia Museum of Art (1978-126-2). Ten ivory combs of various designs in the Colombo National Museum are pictured in Tokyo National Museum, *Cultural Heritage of Sri Lanka*. The carvings of dancers with shawls at Embekke Devalaya and similar combs are discussed in Raghavan and Manukulasooriya, *Siṅhala Nāṭum*, 29, 51, where it is pointed out that the local Sri Lankan goddess is associated with shawls, so the carvings might refer to her. On Embekke Devalaya in general, see Godakumbura, *Embekke Devale Carvings*.

Fig. 1 Wood carving in the so-called Drummer's Pavilion at Embekke Devalaya, Sri Lanka.

120

Plaque depicting dancer

Approx. 1600–1700
India; Madurai, Tamil Nadu state
Ivory
H. 14.6 cm × W. 9.8 cm
Los Angeles County Museum of Art,
Purchased with funds provided by The
Smart Family Foundation through the
generosity of Mr. and Mrs. Edgar G.
Richards, M.88.66

A female dancer twists so that her lower body and upper body face different directions, and she clasps her hands over her head in a gesture of—so it would seem—distress. Her long braid swings around her. Near her fly or perch several birds; old traditions associate lovelorn women with parrots and other birds, which might serve as confidants or messengers.

"How can you deceive a faithful creature tortured by fevers of Love?" We might imagine this distraught young woman uttering such a plaint, which comes from the *Gitagovinda*, a twelfth-century collection of poems describing the amorous relationships between Krishna and the cowherd women.[1] A scenario might be that Krishna has left this woman for some diversion, perhaps to visit another lover. Her frantic sorrow might be understood as the existential sorrow of a human soul feeling abandoned by God. Of course, it is hard to know whether the artist intended to depict a sorrowing woman or a dancer acting the part of a sorrowing woman.

Plaques such as this were presumably attached to elaborate boxes by pegs or other fasteners through holes. The connoisseur-owner of such a box might admire the plaques and be reminded of the poetry of the *Gitagovinda* and the dance it evokes.[2]—FMcG

1. The quotation is from Miller, *Love Song of the Dark Lord*, 107. The Gitagovinda, though composed in northeastern India, was known and performed in southern India, where the ivory plaque was carved. Today its poems form "an indispensable part of the repertoire" of Bharatanatyam and other southern Indian dance traditions. See Datta, *Encyclopaedia of Indian Literature*, 2:1,418. Thanks are due Agnes Brenneman and Monica Desai Henderson for sharing knowledge of Indian dance moods and postures.

2. Another ivory plaque of similar type is in the collection of the Asian Art Museum (1991.247). It shows a beautiful young woman riding a huge parrot. This may be a reference to the fact that the god of love, Kamadeva, rides a parrot.

121

Dionysian scene with dancers and musicians

Approx. 1–100
Pakistan; ancient region of Gandhara
Stone (schist)
H. 17.2 cm × W. 40.6 cm
Metropolitan Museum of Art, Rogers
Fund, 1913, 13.96.23

Two female dancers cut capers in wild abandon as a drummer and harpist play nearby. What is happening, and why is this merriment shown on a stair riser of an ancient Buddhist monument?

The ancient region of Gandhara in today's Pakistan had long been in touch with the Greco-Roman world. Themes and motifs from Hellenistic and Roman art were popular and turn up even in Buddhist religious contexts there. Ecstatic dance played a significant role in Greek Dionysian worship and apparently did so in Gandharan Buddhist worship as well.[1] The Gandharan specialist Kurt Behrendt notes the possibility that the Greek Dionysus had been reinterpreted in Gandhara as Indra, the heavenly king of the gods. He postulates that, in relation to this particular scene, "there seems to be a correlation between altered states of consciousness associated with the loss of control brought on by wine and dance and the concept of heavens in which one could be reborn."[2]

We have also seen (in cats. 27 and 33) rapturous, unrestrained dancing leading to (or expressing) heightened mystical awareness. Here, as elsewhere, it seems possible that spiritual advances might be gained through active mental— imaginative—participation in such dance, as well as through actual dancing.—FMcG

1. Papaioannou and Lykesas, "Role and Significance of Dance in the Dionysian Mysteries." A quite credible-seeming hypothetical re-creation of a Greek Dionysian dance can be seen on YouTube by searching "Dionysiac Dance performed by Herentas."
2. Behrendt, Art of Gandhara, 29–30.

122 *also p. 256*

Two women dancing

Approx. 1770
India; Rajasthan state, former kingdom
of Bundi
Opaque watercolors on paper
H. 18.1 cm × W. 14 cm
Asian Art Museum of San Francisco,
Gift of George Hopper Fitch, 1996.10

The image of two women dancing—
with hands clasped, eyes locked, knees
bent, and bodies starting to turn away
from each other while suspended in the
air—is often reproduced in Mughal and
Rajasthani painting.[1] The similarities
between these depictions are striking and
include the diaphanous robes, swinging
hair, and arm ornaments worn by the
dancers and the oval shape that frames
each composition. The women in com-
parable paintings are often identified
as kathak dancers, likely based on their
dress. Kathak, a style of dance that fused
Hindu mythological themes and Islamic
culture, gained prominence in north
India from the fifteenth century and is
often associated with the court milieu.[2]
Combining the arts of storytelling with
dance drama, kathak is a celebratory
dance that explores divine love, music,
and poetry mainly through hand, eye,
and foot movements and expressions.
Producing and circulating similar images
of these dancers likely spoke to the
shared and wide-reaching enjoyment of
the form—and of the feminine body in
motion.—AMC

1. See, among others, Art Institute of Chicago
(1919.956) and V&A Museum (132:27-1885)
for examples identified as from eighteenth
century Mughal India; and Bonham's, New
York (Monday, March 19, 2012, lot 1180),
for an example attributed to Bilaspur from
approx. 1700. Closer in comparison to the work
discussed here is a work from Bundi or Kota,
approx. 1750, from a private collection and
illustrated in Pal, *Court Paintings of India*, R54.

2. See Chakravorty, *Bells of Change*, and Walker,
India's Kathak Dance, for more on the history
and development of kathak.

A female performer dances to the music of a harp-like instrument. That much is clear, but little else. Do we see an entertainment or part of a ritual or ceremony? Does it signify anything that the dancer's position, with lower legs crossed and one hand raised high, recalls the often-depicted posture of female nature spirits?[1] Does the use of the plaque give any clues? No, because the purpose of such plaques is not known. Some, like this one, have holes in the upper corners, suggesting that they were hung—but from what and why?[2]

As usual, it is not easy to imagine much about the dance shown here. We are not sure if the dance was fast or slow, swinging widely through the dance area or tending to stay in place. Details may give hints: the dancer's feet, elbow, and upraised hand break through the confines of the pavilion she performs in, perhaps suggesting movement that is more exuberant than delicate.—FMcG

123

Plaque depicting dancer and instrumentalist

Approx. 100–1 BCE

India; Uttar Pradesh state

Terra-cotta

H. 12.7 cm × W. 9.5 cm × D. 2.2 cm

Metropolitan Museum of Art, Samuel Eilenberg Collection, gift of Samuel Eilenberg, 1987, 1987.142.376

1. The instrument seems to be a close cousin of the old *yazh* of Tamil country in southern India; see Venkatasubramanian, *Music as History in Tamilnadu*, 23. Female nature spirits in similar positions are seen, for example, on railings at Bharhut and Sanchi and in the Mathura area. Later, the Buddha's mother assumes a similar position, as seen, for example, in a Gandharan relief of the birth of the Buddha-to-be at the Freer Gallery of Art (F1949.9).

2. The plaques are discussed in Pal, *Dancing to the Flute*, 202–03; and Lerner and Kossak, *Lotus Transcendent*, 56–57.

Bibliography

Abraham, Ayisha. "From the Roof Top into the Mine." *New Cinemas: Journal of Contemporary Film* 11, nos. 2–3 (September 2013): 169–82.

Abu'l Fazl Allami. *Ai'n-i Akbari*. Translated by H. S. Jarrett. Revised and annotated by Jadu-Nath Sarkar. 3 vols. 2nd ed. Calcutta: Asiatic Society of Bengal, 1948.

———. *The Akbarnama*. Translated by Henry Beveridge. 3 vols. Calcutta: Asiatic Society of Bengal, 1897–1939.

Ahuja, Naman P. *Rūpa-Pratirūpa: The Body in Indian Art*. New Delhi: Indira Gandhi National Centre for the Arts, 2014.

Aitken, Molly Emma. *The Intelligence of Tradition in Rajput Court Painting*. New Haven, CT: Yale University Press, 2010.

———. "Pardah and Portrayal: Rajput Women as Subjects, Patrons, and Collectors." *Artibus Asiae* 62, no. 2 (2002): 247–80.

Aquil, Raziuddin. "Music and Related Practices in Chishti Sufism: Celebrations and Contestations." *Social Scientist* 40 nos. 3–4 (March–April 2012): 17–32.

Araṇyakāṇḍa. Vol. 3 of *The Rāmāyaṇa of Vālmīki: An Epic of Ancient India*. Translated and annotated by Sheldon I. Pollock. Edited by Robert P. Goldman. Princeton, NJ: Princeton University Press, 1991.

Archer, Mildred. *Company Paintings: Indian Paintings of the British Period*. London: Victoria & Albert Museum, 1992.

Bade, David. "(Spi)ritual Warfare in 13th-Century Asia? International Relations, the Balance of Powers, and the Tantric Buddhism of Kṛtanagara and Khubilai Khan." In *Esoteric Buddhism in Mediaeval Maritime Asia: Networks of Masters, Texts, Icons*, edited by Andrea Acri, 141–59. Singapore: ISEAS Yusof Ishak Institute, 2016.

Bakhle, Janaki. *Two Men and Music: Nationalism and the Making of an Indian Classical Tradition*. New York: Oxford University Press, 2005.

Bandem, I Made, Ketut Rota, and I Wayan Bagiartha. *Transformasi sastra Calonarang di dalam seni pertunjukan Calonarang di Bali* [Transformation of Calonarang from literature to performing arts in Bali]. Denpasar: Sekolah Tinggi Seni Indonesia, 1989.

Banerji, R. D. *The Haihayas of Tripuri and Their Monuments*. Memoirs of the Archaeological Survey of India 23. Calcutta: Government of India Central Publication Branch, 1931.

Barrett, Douglas. "The 'Chidaṃbaraṃ' Naṭarāja." In *Chhavi-2: Rai Krishnadasa Felicitation Volume*, edited by Anand Krishna, 15–20. Banaras: Bharat Kala Bhavan, 1981.

Bartholomew, Terese. "Spirit King, Demon, and God of Wealth: Ganesh in East Asia." In Pal, *Ganesh, the Benevolent*, 115–32.

Beach, Milo C., Eberhard Fischer, and B. N. Goswamy, eds. *Masters of Indian Painting*. 2 vols. Zurich: Artibus Asiae, 2011.

Beglar, J. D. *Report of Tours in the South-eastern Provinces in 1874–75 and 1875–76*. Archaeological Survey of India 13 (Old Series). 1882; Delhi: Varanasi, 1970.

Behrendt, Kurt A. *The Art of Gandhara in the Metropolitan Museum of Art*. New York: Metropolitan Museum of Art, 2007.

Bhaskar, Ira, and Richard Allen. *The Islamicate Cultures of Bombay Cinema*. New Delhi: Tulika, 2009.

Bhatavadekar, Krishna Shastri, ed. *Subhashita Ratnakara: A Collection of Witty and Epigrammatic Sayings in Sanskrit*. Bombay: Gopal Narayen, 1913.

Bhattacharyya, Benoytosh. *The Indian Buddhist Iconography, Mainly Based on the Sādhanamālā and Cognate Tāntric Texts of Rituals*. Oxford: H. Milford, 1924.

Bisschop, Peter. "The Abode of the Pañcamudrās: A Yoginī Temple in Early Medieval Vārāṇasī." In Keul, *"Yoginī" in South Asia*, 47–60.

Blair, Anna, "Cambodian Dancers, Auguste Rodin, and the Imperial Imagination." *The Appendix* 2, no. 4 (October 2014). http://theappendix.net/issues/2014/10/cambodian-dancers-auguste-rodin-and-the-imperial-imagination.

Bloch, Stella. *Dancing and the Drama East and West*. New York: Orientalia, 1922.

Boeles, J. J. "Two Yoginīs of Hevajra from Thailand." *Artibus Asiae, Supplementum* 23 (1966): 14–29.

Bor, Joep. "Mamia, Ammani and Other *Bayadères*: Europe's Portrayal of India's Temple Dancers." In *Music and Orientalism in the British Empire, 1780s–1940s: Portrayal of the East*, edited by Martin Clayton and Bennett Zon, 39–70. Aldershot: Ashgate, 2017.

Bose, Mandakranta. *Movement and Mimesis: The Idea of Dance in the Sanskritic Tradition*. New Delhi: D. K. Printworld, 1991.

Brauen, Martin. *The Mandala: Sacred Circle in Tibetan Buddhism*. Boston: Shambhala, 1998.

Brenscheidt gen. Jost, Diana. "Indian Influences on Modern Dance in the West." In *On the Paths of Enlightenment: The Myth of India in Western Culture, 1808–2017*, edited by Elio Schenini, 184–214. Milan: Skira, 2017.

———. *Shiva Onstage: Uday Shankar's Company of Hindu Dancers and Musicians in Europe and the United States, 1931–38*. Zurich and Berlin: Lit, 2011.

Broughton, Thomas Duer. *Letters Written in a Mahratta Camp During the Year 1809*. London: John Murray, 1813.

Brown, Katherine Butler. "If Music Be the Food of Love: Masculinity and Eroticism in the Mughal Mehfil." In *Love in South Asia: A Cultural History*, edited by Francesca Orsini, 61–85. Cambridge: Cambridge University Press, 2006.

Brown, Robert L., "Buddhist Deity Hevajra." In *South and Southeast Asian Art: An Online Scholarly Catalogue*. Los Angeles: Los Angeles County Museum of Art, 2013. http://seasian.catalog.lacma.org.

———, ed. *Ganesh: Studies of an Asian God*. SUNY Series in Tantric Studies. Albany: State University of New York Press, 1991.

Bryant, Edwin F., ed. *Krishna: A Sourcebook*. Oxford and New York: Oxford University Press, 2007.

———, ed. and trans. *Krishna: The Beautiful Legend of God (Śrīmad Bhāgavata Purāṇa Book X)*. London: Penguin, 2003.

Bunker, Emma C., and Douglas Latchford. *Khmer Bronzes: New Interpretations of the Past*. Chicago: Art Media Resources, 2011.

Cameron, Ainsley M. *Drawn from Courtly India: The Conley Harris and Howard Truelove Collection*. Philadelphia: Philadelphia Museum of Art, 2015.

Cartier-Bresson, Henri. *Les danses à Bali*. Paris: Delpire, 1954.

Case, Margaret H. *Seeing Krishna: The Religious World of a Brahman Family in Vrindaban*. Oxford: Oxford University Press, 2000.

Chakravorty, Pallabi. *Bells of Change: Kathak Dance, Women, and Modernity in India*. Kolkata: Seagull, 2008.

Chakravorty, Pallabi, and Nilanjana Gupta, eds. *Dance Matters: Performing India*. New Delhi: Routledge, 2010.

Chemburkar, Swati. "Banteay Chhmar: Ritual Space of the Temple." In Sharrock, *Banteay Chhmar*, 151–69.

———. "Dancing Architecture at Angkor: 'Halls with Dancers' in Jayavarman VII's Temples." *Journal of Southeast Asian Studies* 46, no. 3 (October 2015): 514–36.

Clark, Joyce, ed. *Bayon: New Perspectives*. Bangkok: River Books, 2007.

Clooney, Francis X., and Tony K. Stewart. "Vaiṣṇava." Chap. 8 in *The Hindu World*, edited by Sushil Mittal and Gene Thursby. London and New York: Routledge, 2004.

Clothey, Fred W. "Skanda-Ṣaṣṭī: A Festival in Tamil India." *History of Religions* 8, no. 3 (February 1969): 236–59.

Coburn, Thomas B. *Encountering the Goddess: A Translation of the Devī-Māhātmya and a Study of its Interpretation*. SUNY Series in Hindu Studies, edited by Wendy Doniger. Albany: State University of New York Press, 1991.

Cœdès, Georges, and P. Cordier. "La stèle de Ta-Prohm." *Bulletin de l'École française d'Extrême-Orient* 6, nos. 1–2 (January–June 1906): 44–86.

Conze, Edward, trans. *The Perfection of Wisdom in Eight Thousand Lines and Its Verse Summary*. San Francisco: City Lights, 2006.

Coomaraswamy, Ananda K. "The Aims of Indian Art." *Modern Review* 1 (January 1908): 15–21.

———. *The Aims of Indian Art*. Essex House Press, 1908.

———. *The Arts and Crafts of India and Ceylon*. London and Edinburgh: T. N. Foulis, 1913.

———. "The Dance of Siva." *The Light of Truth, or the Siddhanta Dipika and Agamic Review* 13, no. 1 (1912): 1–13.

———. *The Dance of Śiva: Fourteen Indian Essays*. New York: Sunwise Turn, 1918.

———. "Hands and Feet in Indian Art." *Burlington Magazine for Connoisseurs* 24, no. 130 (1914): 204–11.

———. "Indian Bronzes." *Museum of Fine Arts (Boston) Bulletin* 16, no. 95 (1918): 31–41.

———. *The Indian Craftsman*. London: Probsthain & Co, 1909.

———. *Indian Drawings*, London: Essex House, 1910.

———. "Notes on Indian Dramatic Technique." *The Mask* 6, no. 2 (October 1913): 109–28.

———. "Notes on the Javanese Theater." *Rupam* 7 (July 1921): 5–11.

———. "Oriental Dances in America and a Word or Two in Explanation of the Nautch." *Vanity Fair*, May 1917, 60–61.

———. *Rajput Painting: Being an Account of the Hindu Paintings of Rajasthan and the Panjab Himalayas from the Sixteenth to the Nineteenth Century Described in Their Relation to Contemporary Thought*. 2 vols. London: Humphrey Milford; Oxford University Press, 1916.

———. "Shiva's Dance." *The Theosophist* 31 (September 1910): 1620–21.

———. "Śiva as Nataraja." *Central Hindu College Magazine* 9, no. 7 (1909): 174.

———. "Śiva's Dance." *Central Hindu College Magazine* 10, no. 11 (1910): 281.

———. "Spiritual Freedom Expressed in India's Dances." *Modern Dance Magazine* 2, no. 4 (March 1917): 15–16.

Coomaraswamy, Ananda K., and Arun Sen, trans. *Vidyāpati: Bangīya Padābali—Songs of the Love of Rādhā and Krishna*. London: Old Bourne Press, 1915.

Coomaraswamy, Ananda K., and Duggirala Gopalakrishnayya, trans. *The Mirror of Gesture: Being the Abhinaya Darpana of Nandikeśvara*. Cambridge, MA: Harvard University Press, 1917.

Coomaraswamy, Ananda K., and Stella Bloch. "The Appreciation of Art." *Art Bulletin* 6, no. 2 (1923): 61–64.

Cort, Louise Allison, and Paul Jett, eds. *Gods of Angkor: Bronzes from the National Museum of Cambodia*. Washington, DC: Sackler Gallery, Smithsonian Institution, 2010.

Courtright, Paul B. *Gaṇeśa: Lord of the Obstacles, Lord of Beginnings*. Oxford: Oxford University Press, 1985.

Cravath, Paul. "Indigenous Roots of the Cambodian Dance Drama." *Marg: A Magazine of the Arts* 67, no. 2 (December 2015–March 2016): 43–51.

Cuevas, Bryan J. "The Politics of Magical Warfare" in *Faith and Empire: Art and Politics in Tibetan Buddhism*, edited by Karl Debreczeny, 171–89. New York: Rubin Museum of Art. 2019.

Cummins, Joan, and Doris Srinivasan. *Vishnu: Hinduism's Blue-Skinned Savior*. Ocean Township, NJ: Grantha Corp., 2011.

Cunin, Olivier. "Case of the Bayon—the State Temple of Jayavarman VII." PDF of visual presentation given at Jnanapravaha Mumbai, April 2019. https://www.academia.edu/41385315/Case_of_the_Bayon_the_state_temple_of_Jayavarman_VII.

Cunningham, Alexander. *Report on a Tour in the Central Provinces in 1873–74 and 1874–75*. Archaeological Survey of India 9 (Old Series). Calcutta: Office of the Superintendent of Government Printing, 1879.

Cutler, Norman. *Songs of Experience: The Poetics of Tamil Devotion*. Bloomington: Indiana University Press, 1987.

Dark, Jann. "Crossing the Pale: Representations of White Western Women in Indian Film and Media." *Transforming Cultures eJournal* 3, no. 1 (2008): 124–44.

Das, D. R. *Temples of Ranipur-Jharial*. Calcutta: Calcutta University, 1990.

Datta, Amaresh, ed. *Encyclopaedia of Indian Literature*. Vol. 2, *Devraj to Jyoti*. India: Sahitya Akademi, 1988.

David, Ann R. "Ram Gopal: A Challenge to Orientalism, Part I." *Attendance, the Dance Annual of India* (2001): 36–45.

Davidson, Ronald M. *Indian Esoteric Buddhism: A Social History of the Tantric Movement*. New York: Columbia University Press, 2002.

———. *Tibetan Renaissance: Tantric Buddhism in the Rebirth of Tibetan Culture*. New York: Columbia University Press, 2005.

Davis, Richard H. *Ritual in an Oscillating Universe: Worshiping Śiva in Medieval India*. Princeton, NJ: Princeton University Press, 1991.

De Zoete, Beryl, and Walter Spies. *Dance and Drama in Bali*. London: Faber and Faber, 1938.

Dehejia, Vidya. "Iconographic Transference between Krishna and Three Saiva Saints." In *Indian Art and Connoisseurship: Essays in Honour of Douglas Barrett*, edited by John Guy, 140–49. New Delhi: Mapin, 1995.

———. "The Treatment of Narrative in Jagat Singh's 'Rāmāyaṇa': A Preliminary Study." *Artibus Asiae* 56, nos. 3–4 (1996): 303–24.

———. *Yoginī Cult and Temples: A Tantric Tradition*. New Delhi: National Museum, 1986.

Dehejia, Vidya, and Thomas Coburn. *Devi, the Great Goddess: Female Divinity in South Asian Art*. Washington, DC: Sackler Gallery, 1999.

Delmonico, Neal. "Chaitanya Vaishnavism and the Holy Names." In Bryant, *Krishna: A Sourcebook*, 549–75.

Desai, Devangana. "Dancing Gaṇeśa." *Pushpanjali: An Annual of Indian Arts and Culture* 6, no. 1 (November 1980): 30–38.

———. *The Religious Imagery of Khajuraho*. Mumbai: Project for Indian Cultural Studies, 1996.

Desai, Vishakha N. *Life at Court: Art for India's Rulers, 16th–19th Centuries*. Boston: Museum of Fine Arts, 1985.

———. "Timeless Symbols: Royal Portraits from Rajasthan, 17th–19th Century." In *The Idea of Rajasthan: Explorations in Regional Identity*, edited by Karine Schomer et al., 1:313–43. New Delhi: Manohar, 1994.

Desai, Vishakha N., and Darielle Mason, eds. *Gods, Guardians and Lovers: Temple Sculptures from North India: AD 700–1200*. New York: Asia Society, 1993.

DeVaan, Juliana. "Sculpting in Time, Space, and the Dancing Image." *Mediathread* (website; Columbia University). Accessed August 31, 2020. https://mediathread.ccnmtl.columbia.edu/s/CUdnce3985/project/40752/.

Dhaky, M. A. "Bhūtas and Bhūtanāyakas: Elementals and Their Captains." In *Discourses on Śiva: Proceedings of a Symposium on the Nature of Religious Imagery*, edited by Michael W. Meister, 240–56. Philadelphia: University of Pennsylvania Press, 1984.

Diamond, Debra, ed. *Yoga: The Art of Transformation*. Washington, DC: Smithsonian Books, 2013.

Dimock, Edward C., Jr. *The Place of the Hidden Moon: Erotic Mysticism in the Vaiṣṇava-Sahajiyā Cult of Bengal*. Chicago: University of Chicago Press, 1966.

———. "The Religious Lyric in Bengali: An Analysis of Imagery." In Dimock, et al., *Literatures of India*, 157–65.

Dimock, Edward C. Jr., et al. *The Literatures of India: An Introduction*. Chicago and London: University of Chicago Press, 1974.

Dissanayake, Wimal. "Issues in World Cinema." In *World Cinema: Critical Approaches*, edited by John Hill and Pamela Church Gibson, 143–50. London: Oxford University Press, 2000.

Doubleday, Veronica. "The Frame Drum in the Middle East: Women, Musical Instruments and Power." *Ethnomusicology* 43, no. 1 (Winter 1999): 101–34.

During, Jean, Max Peter Baumann, Marianne Bröcker, and Linda Fujie. "Hearing and Understanding in the Islamic Gnosis." In "Cultural Concepts of Hearing and Listening." Special issue, *World of Music* 39, no. 2 (1997), 127–37.

Dye, Joseph M. *The Arts of India: Virginia Museum of Fine Arts*. Richmond: Virginia Museum of Fine Arts, 2001.

Eck, Diana L. *India: A Sacred Geography*. New York: Three Rivers, 2013.

Eisler, B. Lee. "The Origins of Modern Dance." Master's thesis, University of British Columbia, 1980.

Engelhardt, Molly. "The Real Bayadere Meets the Ballerina on the Western Stage," *Victorian Literature and Culture* 42, no. 3 (2014): 509–34.

English, Elizabeth. *Vajrayoginī: Her Visualizations, Rituals, and Forms*. Boston: Wisdom, 2002

Entwistle, Alan W. *Braj: Centre of Krishna Pilgrimage*. Groningen: Forsten, 1987.

Erdman, Joan L. "Rethinking the History of 'Oriental Dance.'" In *Moving Words: Re-Writing Dance*, edited by Gay Morris, 288–305. London and New York: Routledge, 1996.

Farrow, G. W., and I. Menon. *The Concealed Essence of the Hevajra Tantra*. Delhi: Motilal Banarsidass, 1992.

Feldman, Martha, and Bonnie Gordon, eds. *The Courtesan's Arts: Cross-Cultural Perspectives*. Oxford: Oxford University Press, 2006.

Fermor, Sharon, "On the Question of Pictorial 'Evidence' for Fifteenth-Century Dance Technique." *Dance Research* 5, no. 2 (Autumn 1987): 18–32.

Flood, Gavin, and Charles Martin, trans. *The Bhagavad Gita: A New Translation*. New York: Norton, 2013.

Ganser, Elisa. "Ananda K. Coomaraswamy's *Mirror of Gesture* and the Debate about Indian Art in the Early Twentieth Century." In *Asia and Europe Interconnected: Agents, Concepts, and Things*, edited by Angelika Malinar and Simone Müller, 91–129. Wiesbaden: Harrassowitz, 2018.

Garrett, Frances. "Tapping the Body's Nectar: Gastronomy and Incorporation in Tibetan Literature." *History of Religions* 49, no. 3 (2010): 300–26.

Gaston, Anne-Marie. *Śiva in Dance, Myth, and Iconography*. Delhi: Oxford University Press, 1982.

Gazdar, Mushtaq. *Pakistani Cinema: 1947–1997*. Karachi: Oxford University Press, 1997.

Gerstein, Alexandra, ed. *Rodin and Dance: The Essence of Movement*. London: Courtauld Gallery; Paul Holberton Publishing, 2016.

Ginsburg, H. D. "The Manora Dance-Drama, an Introduction." *Journal of the Siam Society* 60, no. 2 (1972): 169–81.

Gittinger, Mattiebelle. *Master Dyers to the World: Technique and Trade in Early Indian Dyed Cotton Textiles*. Washington, DC: Textile Museum, 1982.

Glynn, Catherine. "The Stipple Master." In Beach, Fischer, and Goswamy, *Masters of Indian Painting*, 2:515–30.

Godakumbura, C. E. *Embekke Devale Carvings*. Colombo: Archaeological Department, 1963.

Gopinath, Gayatri. *Impossible Desires: Queer Diasporas and South Asian Public Cultures*. Durham, NC: Duke University Press, 2005.

Goswamy, B. N., and Caron Smith. *Domains of Wonder: Selected Masterworks of Indian Painting*. San Diego: San Diego Museum of Art, 2005.

Green, Phillip Scott Ellis. "Two Internal Pediment Scenes from Banteay Chhmar." *Udaya, Journal of Khmer Studies* 11 (2013): 99–139.

Groslier, Bernard Phillippe. "Danse et musique sous les rois d'Angkor." In *Felicitation Volumes of Southeast-Asian Studies*, 283–92. Bangkok: Siam Society, 1965.

Gul, Aijaz. *Mallika-e-Tarannum Noor Jehan: The Melody Queen*. New Delhi: Vitasta, 2008.

Guruge, Ananda W. P. "The Buddha's Encounters with Māra the Tempter: Their Representation in Literature and Art." *Access to Insight* (website), November 30, 2013. http://www.accesstoinsight.org/lib/authors/guruge/wheel419.html.

Haidar, Navina Najat, and Marika Sardar. *Sultans of Deccan India, 1500–1700: Opulence and Fantasy*. New York: Metropolitan Museum of Art, 2015.

Hardy, Friedhelm. *Viraha-Bhakti: The Early History of Kṛṣṇa Devotion*. Delhi: Motilal Banarsidass, 2014.

Hatley, Shaman. "The *Brahmayāmalatantra* and Early Śaiva Cult of Yoginīs." PhD diss., University of Pennsylvania, 2007.

———. "From Mātṛ to Yoginī: Continuity and Transformation in the South Asian Cults of the Mother Goddesses." In *Transformations and Transfer of Tantra in Asia and Beyond*, edited by István Keul, 99–129. Berlin: Walter de Gruyter, 2012.

———. "Goddesses in Text and Stone: Temples of the Yoginis in Light of Tantric and Puranic Literature." In *History and Material Culture in Asian Religions: Text, Image, Object*, edited by Benjamin J. Fleming and Richard D. Mann, 195–225. London: Routledge, 2014.

———. "Sisters and Consorts, Adepts and Goddesses: Representations of Women in the *Brahmayāmala*." In *Tantric Communities in Context*, edited by Nina Mirnig, Marion Rastelli, and Vincent Eltschinger, 47–80. Vienna: Austrian Academy of Sciences Press, 2019.

———. "What Is a Yoginī? Towards a Polythetic Definition." In Keul, *"Yoginī" in South Asia*, 21–31.

Hawley, John Stratton. *Krishna, the Butter Thief*. Princeton, NJ: Princeton University Press, 1983.

Hawley, John Stratton, and Donna Marie Wulff, eds. *The Divine Consort: Rādhā and the Goddesses of India*. Berkeley, CA: Graduate Theological Union, 1982.

Hazra, R. C. *Sakta and Non-Sectarian Upapuranas*. Vol. 2 of *Studies in the Upapuranas*. Calcutta: Ramakrishna Mission Institute of Culture, 1963.

Heck, Thomas F. *Picturing Performance: The Iconography of the Performing Arts in Concept and Practice*. Rochester, NY: University of Rochester Press, 1999.

Hein, Norvin. Foreword to Schweig, *Dance of Divine Love*, xi–xvi.

———. *The Miracle Plays of Mathurā*. New Haven, CT, and London: Yale University Press, 1972.

Hinchy, Jessica. *Governing Gender and Sexuality in Colonial India: The Hijra, c. 1850–1900*. Cambridge: Cambridge University Press, 2019.

Holdrege, Barbara A. *Bhakti and Embodiment: Fashioning Divine Bodies and Devotional Bodies in Kṛṣṇa Bhakti*. London: Routledge, 2018.

Hooja, Rima. *A History of Rajasthan*. New Delhi: Rupa, 2006.

Houghteling, Sylvia. "The Emperor's Humbler Clothes: Textures of Courtly Dress in Seventeenth-century South Asia." *Ars Orientalis* 47 (2017): 91–116.

Hughes, Russell Meriwether. *The Gesture Language of the Hindu Dance*. New York: Columbia University Press, 1941.

Huntington, John C., and Dina Bangdel. *The Circle of Bliss: Buddhist Meditational Art*. Chicago: Serindia, 2003.

Iyer, Alessandra. *Prambanan: Sculpture and Dance in Ancient Java—A Study in Dance Iconography*. Bangkok: White Lotus, 1998.

Jacobsen, Knut A., ed. *Brill's Encyclopedia of Hinduism*. Vol. 1, *Regions, Pilgrimage, Deities*, edited by Helene Basu, Angelika Malinar, and Vasudha Narayanan. Leiden: Brill, 2009.

Jaffrey. "Shamim Ara: Past, Present, and Future." *Eastern Film* (June 1965): 8–10.

Jaini, Padmanabh. "The Story of Sudhana and Manoharā: An Analysis of the Texts and the Borobudur Reliefs." *Bulletin of the School of Oriental and African Studies* (University of London) 29, no. 3 (1966): 533–58.

Jayawickrama, N. A., trans. *The Story of Gotama Buddha: The Nidāna-Kathā of the Jātakaṭṭhakathā*. Oxford: Pali Text Society, 1990.

Jha, Sachdeva. "Tawa'if as Poet and Patron: Rethinking Women's Self-Representation." In *Speaking of the Self: Gender, Performance, and Autobiography in South Asia*, edited by Anshu Malhotra and Siobhan Lambert-Hurley, 141–64. Durham, NC: Duke University Press, 2015.

Jones, John James, trans. *The Mahāvastu*. 3 vols. Sacred Books of the Buddhists. London: Luzac & Co, 1949–56.

Kaimal, Padma. *Opening Kailasanatha: The Temple in Kanchipuram Revealed in Time and Space*. Seattle: University of Washington Press, 2021.

———. *Scattered Goddesses: Travels with the Yoginīs*. Ann Arbor, MI: Association of Asian Studies, 2013.

———. "Shiva Nataraja: Shifting Meanings of an Icon." *Art Bulletin* 81, no. 3 (September 1999): 390–419.

Karambelkar, V. W. "Matsyendranātha and His Yoginī Cult." *Indian Historical Quarterly* 31, nos. 1–4 (1955): 366–67.

Kersenboom, Saskia. "Ananda's Tandava: 'The Dance of Shiva' Reconsidered." *Marg: A Magazine of the Arts* 62, no. 3 (March 2011): 28–43.

Keul, István, ed. "*Yoginī" in South Asia: Interdisciplinary Approaches*. London: Routledge, 2013.

Khera, Dipti. *The Place of Many Moods: Udaipur's Painted Lands and India's Eighteenth Century*. Princeton, NJ, and Oxford: Princeton University Press, 2020.

Khubchandani, Kareem. "Snakes on the Dance Floor: Bollywood, Gesture, and Gender." *Velvet Light Trap* (University of Texas Press) 77 (Spring 2016): 69–85.

Kim, Jinah. "Faceless Gazes, Silent Texts." *Ars Orientalis* 46 (2016): 199–229.

Kim, Jinah, and Todd Lewis. *Dharma and Puṇya: Buddhist Ritual Art of Nepal*. Leiden and Boston: Hotei, 2019.

Kinsley, David R. *The Divine Player: A Study of Kṛṣṇa Līlā*. Delhi: Motilal Banarsidass, 1979.

———. *The Sword and the Flute: Kālī and Kṛṣṇa—Dark Visions of the Terrible and the Sublime in Hindu Mythology*. Berkeley: University of California Press, 1977.

———. *Tantric Visions of the Divine Feminine: The Ten Mahavidyas*. Berkeley: University of California Press, 1997.

Kisselgoff, Anna. "Merce Cunningham, Explorer and Anarchist." *New York Times*, March 15, 1992.

Koch, Ebba. "The Mughal Emperor as Solomon, Majnun, and Orpheus, or the Album as a Think Tank for Allegory." *Muqarnas* 27 (2010): 277–311.

Kohn, Richard J. "Tibetan Religious Dance." Chap. 6 in *Lord of the Dance: The Mani Rimdu Festival in Tibet and Nepal*. Albany: State University of New York Press, 2001.

Kramrisch, Stella, *Indian Sculpture in the Philadelphia Museum of Art*. Philadelphia: University of Pennsylvania Press, 1960.

———. *Manifestations of Shiva*. Philadelphia: Philadelphia Museum of Art, 1981.

———. *The Vishṇudharmottaram, Part III: A Treatise on Indian Painting*. Calcutta: Calcutta University Press, 1924.

Krishna Deva. "Kalacuris of Tripurī." In *North India, Beginnings of Medieval Idiom, c.* AD 900–1000, edited by Michael Meister, 36–56. Vol. 2, pt. 3 of *Encyclopaedia of Indian Temple Architecture*. New Delhi: American Institute of Indian Studies, 1998.

Krishnan, Hari. *Celluloid Classicism: Early Tamil Cinema and the Making of Modern Bharatanāṭyam*. Middletown, CT: Wesleyan University Press, 2019.

Kumar, Brinda. "Of Networks and Narratives: Collecting Indian Art in America, 1907–1972." PhD diss., Cornell University, 2015.

Ladrech, Karine. "Bhairava et Mahākāla au Népal." *Bulletin d'études indiennes* 33 (2015): 287–311.

Légeret-Manochhaya, Katia. *Les 108 Karana: Danse et théâtre de l'inde*. Paris: S. N. Librarie Orientaliste Paul Geuthner, 2017.

———. *Rodin and the Dance of Shiva*. New Delhi: Niyogi, 2016.

Lerner, Martin. *The Flame and the Lotus: Indian and Southeast Asian Art from the Kronos Collections*. New York: Metropolitan Museum of Art; Abrams, 1984.

———. "Some Unpublished Sculpture from Harshagiri." *Bulletin of the Cleveland Museum of Art* 56, no. 10 (December 1969): 354–64.

Lerner, Martin, and Kossak, Steven. *The Lotus Transcendent: Indian and Southeast Asian Art from the Samuel Eilenberg Collection*. New York: Metropolitan Museum of Art, 1991.

Lewisohn, Leonard. "The Sacred Music of Islam: Sama' in the Persian Tradition." *British Journal of Ethnomusicology* 6 (1997): 1–33.

L'Hernault, Françoise. *L'iconographie de Subrahmanya au Tamilnad*. Pondichéry: Institut français d'indologie, 1978.

Linrothe, Robert N. *Ruthless Compassion: Wrathful Deities in Early Indo-Tibetan Esoteric Buddhist Art*. Boston: Shambhala, 1999.

Linrothe, Robert N., Jeff Watt, and Marylin Rhie. "Smashana Adipati: Lords of the Charnel Ground." In *Demonic Divine: Himalayan Art and Beyond*, edited by Rob Linrothe and Jeff Watt, 126–29. New York: Rubin Museum of Art, 2004.

Lipsey, Roger. *Coomaraswamy: His Life and Work*. Vol. 3. Bollingen Series 89. Princeton, NJ: Princeton University Press, 1977.

Lobo, Wibke. "Reflections on the Tantric Buddhist Deity Hevajra in Cambodia." In *Southeast Asian Archaeology 1994: Proceedings of the 5th International Conference of the European Association of Southeast Asian Archaeologists*, edited by Pierre-Yves Manguin, 2:114–27. Hull: University of Hull, Centre for Southeast Asian Studies, 1998.

Lopez y Royo, Alessandra. "Issues in Dance Reconstruction: Karaṇas as Dance Texts in a Cross-Cultural Context." *Dance Research Journal* 36, no. 2 (2004): 64–79.

Losty, Jeremiah P. "Painting at Murshidabad 1750–1820." In *Murshidabad: Forgotten Capital of Bengal*, edited by Neeta Das and Rosie Llewellyn-Jones, 82–105. Mumbai: Marg Foundation, 2014.

Loud, John A., and G. John Samuel. *The Rituals of Chidambaram*. Chennai: Institute of Asian Studies, 2004.

Lovric, B. J. A. "Balinese Theatre: A Metaphysics in Action." In "Arts of Asia: Divergent Views." Special issue, *Asian Studies Review* 12, no. 2 (1988): 35–45.

Lyons, Tryna. "The Śimla Devī Māhātmya Illustrations: A Reappraisal of Content." *Archives of Asian Art* 45 (1992): 29–41.

Mahapatra, K. N. (Kedarnath). "A Note on the Hypaethral Temple of Sixty-Four Yoginis at Hirapur." *Orissa Historical Research Journal* 2 (1953): 23–40.

Malhotra, Anshu. "Bhakti and the Gendered Self: A Courtesan and a Consort in Mid Nineteenth Century Punjab." *Modern Asian Studies* 46, no. 6 (2012): 1,506–39.

Mallinson, James. "Yogi Insignia in Mughal Painting and Avadhi Romances." In *Objects, Images, Stories: Simon Digby's Historical Method*, edited by Francesca Orsini and David Lunn. Oxford: Oxford University Press, forthcoming.

Mallmann, Marie-Thérèse de. *Les enseignements iconographiques de l'Agni-Purana*. Annales du Musée Guimet: Bibliothèque d'études 67. Paris: Universitaires de France, 1963.

Mankekar, Purnima. "Dangerous Desires: Television and Erotics on Late Twentieth-Century India." *Journal of Asian Studies* 63, no. 2 (2004): 403–31.

Mannathukkaren, Nissim. "Reading Cricket Fiction in the Times of Hindu Nationalism and Farmer Suicides: Fallacies of Textual Interpretation." *International Journal of the History of Sport* 24, no. 9 (2007): 1200–25.

Martin-Dubost, Paul. *Gaṇeśa, the Enchanter of the Three Worlds*. Mumbai: Franco-Indian Research, 1997.

Mason, David V. *Theatre and Religion on Krishna's Stage: Performing in Vrindavan*. Basingstoke and New York: Palgrave Macmillan, 2009.

Masselos, Jim. Afterword to Pal, *Dancing to the Flute*, 304–05.

Masteller, Kimberly. *Masterworks from India and Southeast Asia: The Nelson-Atkins Museum of Art*. Kansas City, MO: Nelson-Atkins Museum of Art, 2016.

———. "Temple Construction, Iconography, and Royal Identity in the Eastern Kalacuri Dynasty." PhD diss., Ohio State University, 2017.

Maxwell, Thomas S. "The Stele Inscription of Preah Khan, Angkor." *Udaya: Journal of Khymer Studies* 8 (2007): 1–114.

McGill, Forrest, ed. *Rama Epic: Hero, Heroine, Ally, Foe*. San Francisco: Asian Art Museum, 2016.

McGill, Forrest, Pattaratorn Chirapravati, Peter Skilling, and Kazuhiro Tsuruta. *Emerald Cities: Arts of Siam and Burma, 1775–1950*. San Francisco: Asian Art Museum, 2009.

McInerney, Terence, Steven M. Kossak, and Navina Najat Haidar. *Divine Pleasures: Painting from India's Rajput Courts—The Kronos Collections*. New York: Metropolitan Museum of Art, 2016.

Meister, Michael W. "Regional Variations in Mātṛkā Conventions." *Artibus Asiae* 47, nos. 3–4 (1986): 233–62.

Michell, George. "Chariot Panels from Tamil Nadu," in *Living Wood: Sculptural Traditions of Southern India*, edited by George Michell. Bombay: Marg Publications, 1992.

Miller, Barbara Stoler, ed. and trans. *Love Song of the Dark Lord: Jayadeva's Gitagovinda*. 1977; New York: Columbia University Press, 1997.

Mitra, Debala. "Dancing Mātṛkās of Bheraghat." *Journal of the Asiatic Society of Calcutta* 22, no. 2 (1956): 237–40.

Mitter, Partha. *Much Maligned Monsters: History of European Reactions to Indian Art*. Oxford: Clarendon Press, 1977.

Morcom, Anna. *Illicit Worlds of Indian Dance: Cultures of Exclusion*. Oxford: Oxford University Press; London: Hurst Publishers, 2013.

———. "Indian Popular Culture and Its 'Others': Bollywood Dance and Anti-*nautch* in Twenty-first Century Global India." In *Popular Culture in a Globalized India*, edited by Moti K. Gokulsing and Wimal Dissanayake, 125–39. London: Routledge, 2009.

Mumaw, Barton, and Jane Sherman. "Ted Shawn, Teacher and Choreographer." *Dance Chronicle* 4, no. 2 (1981): 99–112.

Munsi, Urmimala Sarkar, and Stephanie Burridge, eds. *Traversing the Tradition: Celebrating Dance in India*. Celebrating Dance in South Asia and the Pacific. New Delhi: Routledge, 2011.

Naim, Choudri Mohammed. "Ghazal and Taghazzul: The Lyric, Personal and Social." In Dimock et al., *Literatures of India*, 181–97.

Nanda, Vivek, George Michell, and Bharath Ramamrutham, eds. *Chidambaram: Home of Nataraja*. Mumbai: Marg, 2004.

Nihom, Max. "The Identification and Original Site of a Cult Statue on East Java." *Journal of the American Oriental Society* 106, no. 3 (July–September 1986): 485–99.

Nisbet, John. *Burma under British Rule—and Before*. London: Constable, 1901.

O'Flaherty, Wendy Doniger. *Asceticism and Eroticism in the Mythology of Śiva*. London: Oxford University Press, 1973.

———. "Death as a Dancer in Hindu Mythology." In *Sanskrit and Indian Studies: Essays in Honour of Daniel H. H. Ingalls*, edited by M. Nagatomi, B. K. Matilal, J. M. Masson,

and E. C. Dimock Jr., 201–16. Dordrecht: Reidel, 1980.

O'Shea, Janet. *Bharata Natyam on the Global Stage: At Home in the World*. Delhi: Motilal Banarsidass, 2007.

Oertel, F. O. *Note on a Tour in Burma in March and April, 1892*. Rangoon: Government Printing, 1893.

Oldenburg, Veena Talwar. "Lifestyle as Resistance: The Case of the Courtesans of Lucknow, India." *Feminist Studies* 16, no. 2 (Summer 1990): 259–87.

Orr, Leslie C. *Donors, Devotees, and Daughters of the Gods: Temple Women in Medieval Tamilnadu*. New York: Oxford University Press, 2000.

Padoux, Andre. *The Hindu Tantric World: An Overview*. Chicago and London: University of Chicago Press, 2017.

Pal, Pratapaditya. *Art of Nepal: A Catalogue of the Los Angeles County Museum of Art Collection*. Los Angeles: Los Angeles County Museum of Art, 1985.

———. *The Classical Tradition in Rajput Painting from the Paul R. Walter Collection*. New York: Pierpont Morgan Library and the Gallery Association of New York State, 1978.

———. *A Collecting Odyssey: Indian, Himalayan, and Southeast Asian Art from the James and Marilynn Alsdorf Collection*. Chicago: Art Institute of Chicago; New York: Thames & Hudson, 1997.

———. *Court Paintings of India: 16th–19th Centuries*. New York: Naivin Kumar, 1983.

———. "Dancing Ganesh in South Asia." In Pal, *Ganesh, the Benevolent*, 41–64.

———, ed. *Dancing to the Flute: Music and Dance in Indian Art*. Sydney: Art Gallery of New South Wales, 1997.

———. *Desire and Devotion: Art from India, Nepal, and Tibet in the John and Bertha Ford Collection*. London: Philip Wilson, 2001.

———, ed. *Ganesh, the Benevolent*. 1995; Bombay: Marg, 2001.

———. "Himalayan Art: Selected New Acquisitions." *Arts of Asia* 29, no. 3 (May–June 1999): 75–85.

———. *Indian Sculpture: A Catalogue of the Los Angeles County Museum of Art Collection, Volume 2, 700–1800*. Los Angeles: Los Angeles County Museum of Art, 1988.

———. "May the Immeasurable Wealth of Your Dance Fill My Consciousness: Dancing Deities of India." *Orientations* 28, no. 7 (July–August 1977): 28–37.

———, ed. *Puja and Piety: Hindu, Jain, and Buddhist Art from the Indian Subcontinent*. Chicago: University of Chicago Press, 2016.

———. *Quest for Coomaraswamy: A Life in the Arts*. Calgary: Bayeux Arts, 2019.

Pamment, Claire. *Comic Performance in Pakistan: The Bhand*. London: Palgrave Macmillan, 2017.

———. "A Split Discourse: Body Politics in Pakistan's Popular Punjabi Theatre." In

Gender, Politics, and Performance in South Asia, edited by Sheema Kermani, Asif Farrukhi, and Kamran Asdar Ali, 203–34. Karachi: Oxford University Press. 2015.

Papaioannou, Christina, and Georgios Lykesas. "The Role and Significance of Dance in the Dionysian Mysteries." *Studies in Physical Culture and Tourism* 19, no. 2 (2012): 68–72.

Parmentier, Henri. *Inventaire descriptif des monuments Čams de l'Annam*. 2 vols. Paris: E. Leroux, 1909–18.

Parodi, Laura Emilia. "Solomon, the Messenger, and the Throne: Themes from a Mughal Tomb." *East & West* 51, nos. 1–2 (June 2001): 127–42.

———. "Two Pages from the Late Shahjahan Album." *Ars Orientalis* 40 (2011): 267–94.

Pearlman, Ellen. *Tibetan Sacred Dance: A Journey into the Religious and Folk Traditions*. Rochester, VT: Inner Traditions, 2003.

Phalke, D. G. "Ladies from Cultured Families for Acting in Films." In *Phalke Centenary Souvenir*, edited by Firoze Rangoonwalla. Bombay: Phalke Centenary Celebrations, 1970.

Picard, Michel. "'Cultural Tourism' in Bali: Cultural Performances as Tourist Attraction." *Indonesia*, no. 49 (April 1990): 37–74.

The Play in Full: Lalitavistara. Trans. by the Dharmachakra Translation Committee. Fremont, CA: 84000: Translating the Words of the Buddha, 2013; updated 2020. https://read.84000.co/translation/toh95.html.

Poerbatjaraka, R. Ng. "De Calon-Arang." *Bijdragen tot de taal-, land- en volkenkunde* [Journal of the humanities and social sciences of Southeast Asia] 82, no. 1 (January 1926): 110–80.

Pou, Saveros. "Music and Dance in Ancient Cambodia as Evidenced by Old Khmer Epigraphy." *East and West* 11, nos. 1–4 (December 1997): 229–48.

Prachoom, K. (Prachum Kāňchanawat). *Buddha Images/Nangsue phap phra phutta rup*. Bangkok: 1969.

Pritchard, Jane. "'The Mystery and Sense of Awe Produced by the East': Léon Bakst, Anna Pavlova, and the Interpretation of South Asian Dance." In *A Mediated Magic: The Indian Presence in Modernism, 1880–1930*, edited by Naman P. Ahuja and Louise Belfrage, 98–113. Mumbai: Marg; Stockholm: Axel and Margaret Ax:son Johnson Foundation, 2019.

Qureshi, Regula Burckhardt. "Female Agency and Patrilineal Constraints: Situating Courtesans in Twentieth-Century India." In Feldman, *The Courtesan's Arts*, 312–31.

Raghavan, M. D., and R. C. De S. Manukula-sooriya. *Siṅhala Nāṭum: Dances of the Sinhalese*. Colombo: M. D. Gunasena & Co., 1967.

Rajadhakshya, Ahsish, and Paul Willemen. *Encyclopedia of Indian Cinema*. London: Oxford University Press, 1994.

Ramos, Imma. *Tantra: Enlightenment to Revolution*. London: Thames & Hudson, 2020.

Rao, T. A. Gopinatha. *Elements of Hindu Iconography*. 2 vols. Madras: Law Printing House, 1916.

Ratan Devī. *Thirty Songs from the Panjab and Kashmir*. Translated with an introduction by Ananda K. Coomaraswamy. London: Novello & Co., 1913.

Reed, Susan Anita. *Dance and the Nation: Performance, Ritual, and Politics in Sri Lanka*. Madison: University of Wisconsin Press, 2010.

Rodin, Auguste. "La danse de Çiva." In *Sculpture çivaïtes*, by Rodin et al., 9–13. Ars asiatica 3. Brussels and Paris: Gvan Oest, 1921.

Ruyter, Nancy Lee Chalfa. "The Intellectual World of Genevieve Stebbins." *Dance Chronicle* 11, no. 3 (1988): 381–97.

Sahai, Shrinkhla. "Reading Dance, Performing Research: Meanings, Interpretation, Context, and Re-contextualization in Dance Performance and Research." In Munsi and Burridge, *Traversing the Tradition*, 104–23.

Samuel, Geoffrey. *The Origins of Yoga and Tantra: Indic Religions to the Thirteenth Century*. Cambridge: Cambridge University Press, 2013.

———. *Tantric Revisionings: New Understandings of Tibetan Buddhism and Indian Religion*. Aldershot: Ashgate, 2005.

Sasagawa, Hideo. "Post/colonial Discourses on the Cambodian Court Dance." *Southeast Asian Studies* 42, no. 4 (March 2005): 418–41.

Savarese, Nicola, and Richard Fowler. "1931: Antonin Artaud Sees Balinese Theatre at the Paris Colonial Exposition." *TDR* 45, no. 3 (Autumn 2001): 51–77.

Sax, William Sturman, ed. *The Gods at Play: Līlā in South Asia*. New York: Oxford University Press, 1995.

Schofield, Katherine Butler, "The Courtesan Tale: Female Musicians and Dancers in Mughal Historical Chronicles, c. 1556–1748." *Gender & History* 24, no. 1 (April 2012): 150–71.

Schweig, Graham M. *Dance of Divine Love: India's Classic Sacred Love Story—The Rāsa Līlā of Krishna*. Princeton, NJ: Princeton University Press, 2005.

———. "Divine Feminine in the Theology of Krishna." In Bryant, *Krishna: A Sourcebook*, 441–74.

Seebass, Tilman. "Iconography and Dance Research." *Yearbook for Traditional Music* 23 (1991): 33–51.

Seyller, John. *The Adventures of Hamza: Painting and Storytelling in Mughal India*. Washington, DC: Freer Gallery of Art and Sackler Gallery, 2002.

Seyller, John, and Jagdish Mittal. *Central Indian Paintings in the Jagdish and Kamla Mittal Museum of Indian Art*. Hyderabad: Jagdish and Kamla Mittal Museum of Art (2019).

Shaffer, Holly. "Take All of Them: Eclecticism and the Arts of the Pune Court in India, 1760–1800." *Art Bulletin* 100, no. 2 (2018): 61–93.

Shakya, Milan Ratna. *The Cult of Bhairava in Nepal*. New Delhi: Rupa & Co., 2008.

———. *Gaṇeśa in Medieval Nepal*. New Delhi: Rupa & Co., 2006.

Sharma, R. K. *The Temple of Chaunsatha-Yogini at Bheraghat*. Delhi: Agam Kala Prakashan, 1978.

Sharrock, Peter D. *Banteay Chhmar: Garrison-temple of the Khmer Empire*. Bangkok: River Books, 2015.

———. "Hevajra at Banteay Chhmar." In "A Curator's Choice: Essays in Honor of Hiram W. Woodward Jr." Special issue, *Journal of the Walters Art Museum* 64–65 (2006–07): 49–64.

———. "Smiling Hevajra or Frowning Rāvaṇa in Banteay Chhmar's 'Hall with Dancers.'" *Udaya, Journal of Khmer Studies* 13 (2016): 97–107.

———. "The Tantric Roots of the Buddhist Pantheon of Jayavarman VII." In *Materializing Southeast Asia's Past* by Marijke J. Klokke and Véronique Degroot, 41–55. Singapore: NUS Press, 2013.

———. "The Yoginīs of the Bayon." In Keul, "*Yoginī*" in South Asia, 117–29.

Shastri, J. L., ed. *The Śiva-Purāṇa*. Trans. by a Board of Scholars. Delhi: Motilal Banarsidass, 1970.

Shaw, Miranda. *Buddhist Goddesses of India*. Princeton, NJ: Princeton University Press, 2015.

———. "Dancing Compassion: Cultivating a Body of Love in the Tantric Buddhist Dance of Nepal." *Dance, Movement & Spiritualities* 4, no. 2 (2017): 173–78. doi:10.1386/dmas.4.2.173_1.

———. *Passionate Enlightenment: Women in Tantric Buddhism*. Princeton, NJ: Princeton University Press, 2011.

———. "Tantric Buddhist Dance of Nepal: From the Temple to the Stage." In *Nepal: Nostalgia and Modernity*, edited by Deepak Shimkhada, 101–10. Mumbai: Marg, 2011.

Shway Yoe [James George Scott]. *The Burman: His Life and Notions*. 2 vols. London: Macmillan, 1882.

Singer, Milton, ed. *Krishna: Myths, Rites, and Attitudes*. Chicago and London: University of Chicago Press, 1968.

Slusser, Mary Shepherd, and Paul Jett. *The Antiquity of Nepalese Wood Carving: A Reassessment*. Seattle: University of Washington Press, 2010.

Smith, A. William. "Dance Iconography: Traditions, Techniques, and Trends." In Heck, *Picturing Performance*, 116–22.

Smith, Caron, and Brijinder N. Goswamy. *Domains of Wonder: Selected Masterworks of Indian Painting*. San Diego: San Diego Museum of Art, 2005.

Smith, David. *The Dance of Śiva: Religion, Art, and Poetry in South India*. Cambridge Studies in Religious Traditions 7. Cambridge and New York: Cambridge University Press, 1996.

Snellgrove, David. *The Hevajra Tantra: A Critical Study*. Bangkok: Orchid Press, 2010.

———. *Indo-Tibetan Buddhism: Indian Buddhists and Their Tibetan Successors*. Boston: Shambhala, 1987.

Soundararajan, J., and Raju Kalidos. *Naṭarāja in South Indian Art*. Delhi: Sharada, 2004.

Spangenberg, Kristin L., and Deborah W. Walk. *The Amazing American Circus Poster: The Strobridge Lithographing Company*. Cincinnati: Cincinnati Art Museum; Sarasota: Ringling Museum of Art, 2011.

Sparshott, Francis. *A Measured Pace: Toward a Philosophical Understanding of the Arts of Dance*. Toronto: University of Toronto Press, 1995.

Spear, Jeffrey L., and Avanthi Meduri. "Knowing the Dancer: East Meets West." *Victorian Literature and Culture* 32, no. 2 (2004): 435–48.

Sreenivasan, Ramya. "Drudges, Dancing Girls, Concubines: Female Slaves in Rajput Polity, 1500–1850." In *Slavery and South Asian History*, edited by Indrani Chatterjee and Richard M. Eaton, 136–61. Bloomington: University of Indiana Press, 2006.

Srinivasan, Doris M. "Royalty's Courtesans and God's Mortal Wives: Keepers of Culture in Precolonial India." In Feldman, *The Courtesan's Arts*, 161–81.

Stadtner, Donald M. "'Father, Please Give Us Back Our Beauty': The Daughters of Mara in the Art of Burma." *Arts of Asia* 45, no. 2 (March–April 2015): 93–105.

———. "A Fifteenth-Century Royal Monument in Burma and the Seven Stations in Buddhist Art." *Art Bulletin* 73, no. 1 (1991): 39–52. doi:10.2307/3045777.

Stietencron, Heinrich von. "Cosmographic Buildings of India: The Circles of the Yoginis." In Keul, "*Yoginī*" in South Asia, 70–83.

Stronge, Susan. *Painting for the Mughal Emperor: The Art of the Book, 1560–1660*. London: V&A Publications, 2002.

Subhadradis Diskul. *Sinlapa samai Lopburī* [Art of the Lopburi period]. Bangkok: Fine Arts Department, 1967.

Surdas. *Sur's Ocean: Poems from the Early Tradition*. Edited by Kenneth E. Bryant, translated by John Stratton Hawley. Murty Classical Library of India 5. Cambridge, MA: Harvard University Press, 2015.

Suriyavudh Suksvasti (Suriyawutthi Suksawat), et al. *Thaplang nai Prathēt Thai* [Stone lintels in Thailand]. Bangkok: Mǔang Bōrān, 1988.

Swallow, Deborah, and John Guy eds. *Arts of India: 1550–1900*, London: V&A Publications, 1990.

Swamy, B. G. L. *Chidambaram and Naṭarāja: Problems and Rationalization*. Mysore: Geetha, 1979.

Tanaka, Kimiaki. *An Illustrated History of the Maṇḍala from Its Genesis to the Kālacakratantra*. Boston: Wisdom, 2018.

Tandon, Shivangani. "The Presence of the Marginalised in the Life Sketches of the Ruling Elites: Slaves, Musicians, and Concubines in the Mughal 'Tazkiras.'" *Social Scientist* 43, nos. 5–6 (May–June 2015): 65–75.

Taylor, Paul Michael, and Sonia Dhami. *Sikh Art from the Kapany Collection*. Palo Alto, CA: Sikh Foundation, 2017.

Thobani, Sitara. *Indian Classical Dance and the Making of Postcolonial National Identities: Dancing on Empire's Stage*. London and New York: Routledge, 2017.

Thompson, Ashley. *Engendering the Buddhist State: Territory, Sovereignty and Sexual Difference in the Inventions of Angkor*. London: Routledge, 2019.

Thomsen, Margrit. "Numerical Symbolism and Orientation in Some Temples of the 64 Yoginis." *Art and Archaeology Research Papers* 17 (1980): 53–56.

Tod, James. *Annals and Antiquities of Rajasthan or, the Central and Western Rajpoot States of India*. 3 vols. Edited by W. Crooke. 1829–32. Delhi: Motilal Banarsidass, 1971.

———. *Annals and Antiquities of Rajasthan or, the Central and Western Rajpoot States of India*. 3 vols. Edited by W. Crooke. 1829–32. New Delhi: Munshiram Manoharlal, 2001.

Tokyo National Museum. *Cultural Heritage of Sri Lanka: The Land of Serendipity*. Tokyo: Tokyo National Museum, 2008.

Topsfield, Andrew. *The City Palace Museum, Udaipur: Paintings of Mewar Court Life*. 1990; Ahmedabad: Mapin, 2009.

———. *Court Painting at Udaipur: Art under the Patronage of the Maharanas of Mewar*. Zurich: Artibus Asiae, 2001.

———. "Udaipur Paintings of the Raslila." *Art Bulletin of Victoria* 28 (1987): 54–70. https://www.ngv.vic.gov.au/essay/Udaipur-paintings-of-the-raslila/.

Tripathi, Shailaja. "Layered World." Project Art Worm (website). April 7, 2012. http://projectartworm.com/Media/Details/222/article-layered-world.

Tsuda, Shiníchi. "The Cult of Śmaśāna, the Realities of Tantrism." In *The Sanskrit Tradition and Tantrism*, edited by Teun Goudriaan, 96–108. Leiden: Brill, 1990.

Tula, Meenal, and Rekha Pande. "Re-inscribing the Indian Courtesan: A Genealogical Approach." *Journal of International Women's Studies* 15, no. 1 (2014): 67–82.

Turner, Sarah Victoria. "The 'Essential Quality of Things': E. B. Havell, Ananda Coomaraswamy, Indian Art and Sculpture in Britain, c. 1910–14." *Visual Culture in Britain* 11, no. 2 (July 2010): 239–64.

Van Buitenen, J. A. B., ed. and trans. *The Mahabharata*. Vol. 2, Book 2: *The Book of Assembly; Book 3: The Book of the Forest*. Chicago: University of Chicago Press, 1975.

———. "The *Ramayana* Story." In Dimock et al., *Literatures of India*, 56–71.

Van Manen, Johan. "Shiva as Nataraja." *The Theosophist* 30 (September 1909): 765–66.

Van Zile, Judy. "Interpreting the Historical Record: Using Images of Korean Dance for Understanding the Past." In *Dancing from Past to Present: Nation, Culture, Identities. Studies in Dance History*, edited by Theresa Jill Buckland, 153–74. Madison: University of Wisconsin Press, 2006.

Vanita, Ruth. "Introduction: Medieval Materials in the Sanskrit Tradition." In *Same-Sex Love in India*, by Ruth Vanita and Saleem Kidwai, 55–68. New York: Palgrave Macmillan, 2000.

Varadpande, Manohar Laxman. *Apsara in Indian Art and Literature*. Gurgaon: Shubhi, 2007.

Vatsyayan, Kapila. "The Arrested Movement of Dance." In Pal, *Dancing to the Flute*, 22–25.

———. *Arrested Movement: Sculpture and Painting*. New Delhi: Wisdom Tree, 2007.

———. *Classical Indian Dance in Literature and the Arts*. New Delhi: Sangeet Natak Akademi, 1968.

———. *Dance in Indian Painting*. New Delhi: Abhinav, 1982.

———. "Some Dance Sculptures from Champa." *National Centre for the Performing Arts Quarterly Journal* 7 no. 4 (1978): 1–19.

Véquaud, Yves. *Women Painters of Mithila*. New York: Thames & Hudson, 1977.

Vickery, Michael. "Bayon: New Perspectives Reconsidered." *Udaya, Journal of Khmer Studies* 7, no. 7 (2006): 101–73.

Wade, Bonnie C. *Imaging Sound: An Ethnomusicological Study of Music, Art, and Culture in Mughal India*. Chicago: University of Chicago Press, 1999.

Walker, Margaret E. *India's Kathak Dance in Historical Perspective*. SOAS Musicological Series. London: Routledge, 2017.

Walser, Joseph. *Genealogies of Mahayana Buddhism: Emptiness, Power and the Question of Origin*. Abingdon: Routledge, 2018.

Warren, Vincent. "Yearning for the Spiritual Ideal: The Influence of India on Western Dance 1626–2003." *Dance Research Journal* 38, nos. 1–2 (Summer–Winter 2006): 97–114.

Weinstein, Laura. *MFA Highlights: Arts of South Asia*. Boston: Museum of Fine Arts Publications, 2020.

Wessels-Mevissen, Corinna. "The Early Image of Śiva Nataraja: Aspects of Time and Space." In *Figuration of Time in Asia*, edited by Corinna Wessels-Mevissen and Dietrich Boschung, 298–348; pls. 30–32. Munich: Wilhelm Fink, 2012.

———. "Introducing a God and His Ideal Form: A. K. Coomaraswamy's 'Dance of Siva.' 1912/1918." *Indo-Asiatische Zeitschrift* 16 (2012): 30–42.

White, David Gordon. *Kiss of the Yoginī: "Tantric Sex" in Its South Asian Contexts*. Chicago: University of Chicago Press, 2003.

———, ed. *Tantra in Practice*. Princeton, NJ: Princeton University Press, 2000.

Wilkinson, Christopher. "The Tantric Gaṇeśa: Texts Preserved in the Tibetan Canon." In Brown, *Ganesh: Studies of an Asian God*, 235–76.

Williams, Paul, Anthony J. Tribe, and Alexander Wynne. *Buddhist Thought: A Complete Introduction to the Indian Tradition*. 2nd ed. London: Routledge, 2012.

Wilson, Frances, ed. and trans. *The Bilvamandalastava*. Leiden: Brill, 1973.

Wilson, Liz. *Charming Cadavers: Horrific Figurations of the Feminine in Indian Buddhist Hagiographic Literature*. Chicago: University of Chicago Press, 1996.

Woodward, Hiram, Jr. *The Art and Architecture of Thailand: From Prehistoric Times through the Thirteenth Century*. Leiden: Brill, 2002.

———. "Bronze Sculpture of Ancient Cambodia." In Cort and Jett, *Gods of Angkor*, 30–73.

———. "Esoteric Buddhism in the Light of Recent Scholarship." *Journal of Southeast Asian Studies* 35, no. 2 (June 2004): 329–54.

———. "Tantric Buddhism at Angkor Thom." *Ars Orientalis* 12 (1981): 57–71.

Younger, Paul. *The Home of Dancing Śivaṉ: The Traditions of the Hindu Temple in Citamparam*. New York: Oxford University Press, 1995.

Zéphir, Thierry. "Notes à propos d'un *maṇḍala* d'Hevajra conserve au Musée National de Phnom-penh." In *Orientalismes de l'archéologie au musée: Mélanges offerts à Jean-François Jarrige*, edited by Vincent Lefèvre, 405–25. Turnhout: Brepols, 2012.

Zvelebil, Kamil. *Ānanda-tāṇḍava of Śiva-Sadānṛttamūrti: The Development of the Concept of Ātavallāṉ-Kūttaperumāṭikaḷ in the South Indian Textual and Iconographic Tradition*. Madras: Institute of Asian Studies, 1985.

Acknowledgments

EXHIBITIONS AND CATALOGUES, like dance performances, need not just content creators but organizers, producers, sponsors, advisers, designers, and a host of other key players.

Nothing happens without financial and moral support, of course. A generous grant from the National Endowment for the Humanities was enormously important not only for the resources it provided but also for its confirmation that the project was worthwhile to pursue. Subsequently, a number of kind persons and organizations listed elsewhere here provided essential funding, and we owe them our sincerest thanks.

From its start in 2017, this project benefitted from expert advice from scholars, museum staffers, and community members. Robert and Sally Goodman of the University of California, Berkeley, Davesh Soneji of the University of Pennsylvania, and Hari Krishnan of Wesleyan University provided initial guidance and pointed us to other scholars whose help we might enlist. A workshop brought together Janaki Bakhle of UC Berkeley, Ronald M. Davidson of Fairfield University, Usha Iyer of Stanford University, Padma Kaimal of Colgate University, Janet O'Shea of the University of California, Los Angeles, and Graham M. Schweig of Christopher Newport University. Joining in their conversations were Laura Weinstein of the Museum of Fine Arts, Boston, and two community experts, Kalpana Desai and Monica Desai Henderson, as well as Asian Art Museum staffers Qamar Adamjee, Deborah Clearwaters, Jeffrey Durham, Robert Mintz, Natasha Reichle, and Allison Wyckoff.

The contributors to this publication listed on the title page have not only committed many hours over many months to research and writing but have provided valuable advice on a variety of other matters. If this publication looks beautiful, reads smoothly, and provides a treasure trove of images, that is due to Head of Publications Nadine Little and her colleague Ruth Keffer, designer Joan Sommers and production manager Amanda Freymann, copy editor Tom Fredrickson, proofreader Mark Woodworth, and image and permission consultant Kathy L. Borgogno. The splendid photos of works from the Asian Art Museum collection were taken by Kevin Candland.

Curatorial colleagues at the lending institutions have been hugely helpful, approving loans, suggesting alternate artworks, and answering innumerable questions. Our appreciation goes to Ladan Akbarnia, Makeda Best, Dany Chan, Malcolm Daniel, Karl Debreczeny, Deepali Dewan, Pujan Gandhi, Madhuvanti Ghose, Bindu Tushara Gude, John Guy, Sarah Laursen, Stephen Little, Sonya Rhie Mace, Kimberly Masteller, Amy Poster, Adriana Proser, Catherine Raymond, John Henry Rice, Jennifer Swope, and Laura Weinstein. In addition, to the registrars and conservators at the lending institutions we owe our gratitude. Then there are the kind individuals, both collectors and artists named below, who have lent works and answered our questions. We appreciate their entrusting their cherished artworks to us.

Many other erudite persons have helped us with research either directly or by directing us to others with specialized knowledge. They are named and thanked in the notes to the essays and catalogue entries.

We as curators are all too aware that we get credit for accomplishments that in fact belong largely to colleagues at our institutions. Ainsley M. Cameron would like to thank Joe Civitello, Rita DiBello, Kim Flora, Jennifer Hardin, Susan Hudson, Trudy Gaba, Jenifer Linnenberg, Cecile Mear, Kelly Rectenwald, Kristin Spangenberg, Nathaniel M. Stein, and Lauren Walker alongside other esteemed colleagues in the departments of Conservation, Design and Installation, Learning and Interpretation, Marketing and Communications, Philanthropy, Photographic Services, and Registration at the Cincinnati Art Museum. Director Cameron Kitchin has advocated for this project since the beginning, offering encouragement, enthusiasm, and support.

Forrest McGill wishes to thank his Asian Art Museum colleagues in the departments of Conservation, Development, Education, Finance, Image Services, Marketing and Communications, Preparation, Publications, and Registration, and he calls out for their special support through the years of the project's development Deborah Clearwaters, Nadine Little, and Robert Mintz. Finally and ultimately most crucially, Director Jay Xu approved the initial proposal and has encouraged us throughout.

Forrest McGill
Wattis Senior Curator of South and Southeast Asian Art, Asian Art Museum

Ainsley M. Cameron
Curator of South Asian Art, Islamic Art and Antiquities, Cincinnati Art Museum

Lenders to the Exhibition

Ayisha Abraham

Anonymous

Art Institute of Chicago

Asia Society

Asian Art Museum of San Francisco

Catherine Glynn Benkaim and Barbara Timmer

Sarah Choo Jing

Cincinnati Art Museum

Cleveland Museum of Art

Julia Emerson

Fine Arts Museums of San Francisco

Harvard Art Museums

Kronos Collections

Los Angeles County Museum of Art

Metropolitan Museum of Art

Minneapolis Institute of Art

Museum of Fine Arts, Boston

Museum of Fine Arts, Houston

Nelson-Atkins Museum of Art

Northern Illinois University, Burma Art Collection

Jimmy Bastian Pinto

Pushpamala N

Simon Ray

Royal Ontario Museum

Rubin Museum of Art

San Diego Museum of Art

Collection of Gursharan and Elvira Sidhu

Virginia Museum of Fine Arts

Walters Art Museum

Index

Image Sources